● CLUJ-NAPOCA

● BEIRUT

● HO CHI MINH CITY

BEIRUT

CALI

CLUJ-NAPOCA

HO CHI MINH CITY

SAN FRANCISCO

TANGIER

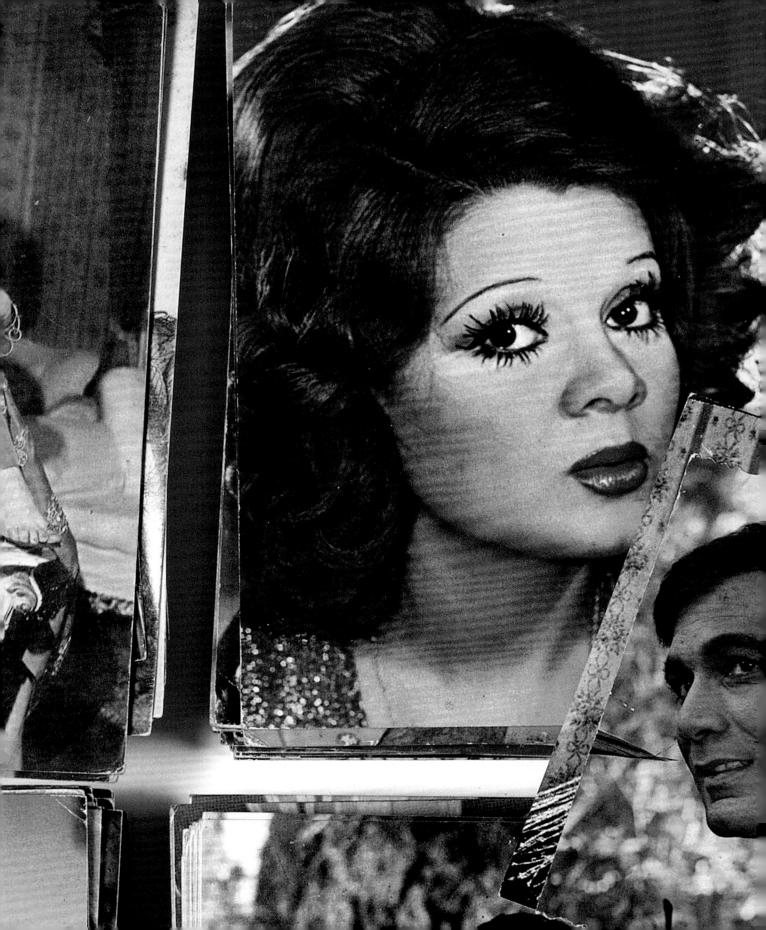

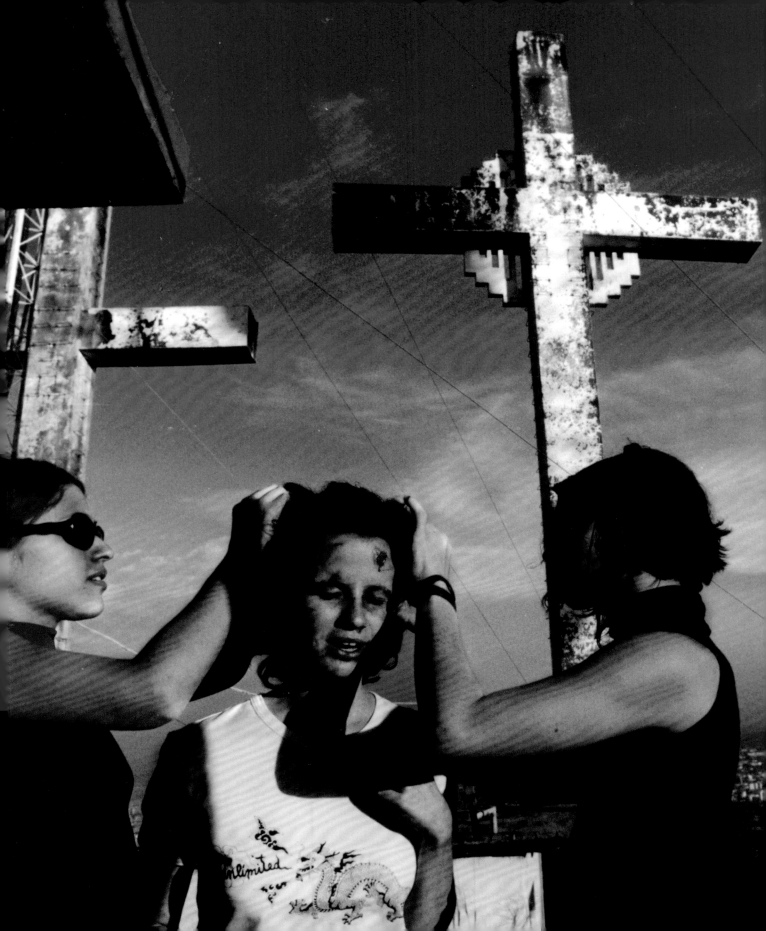

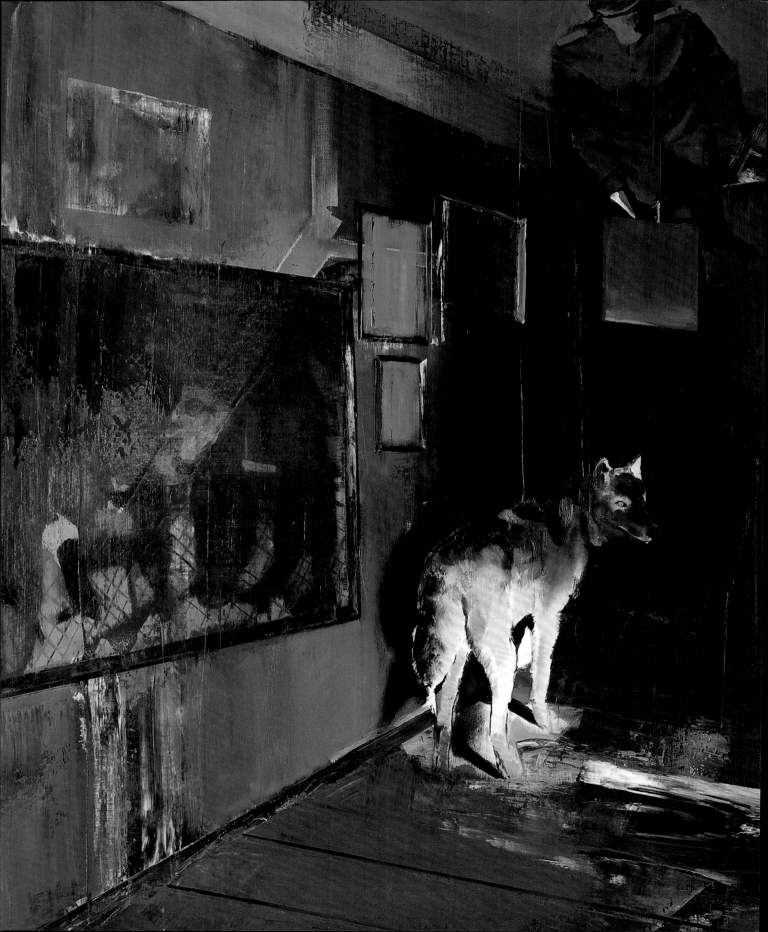

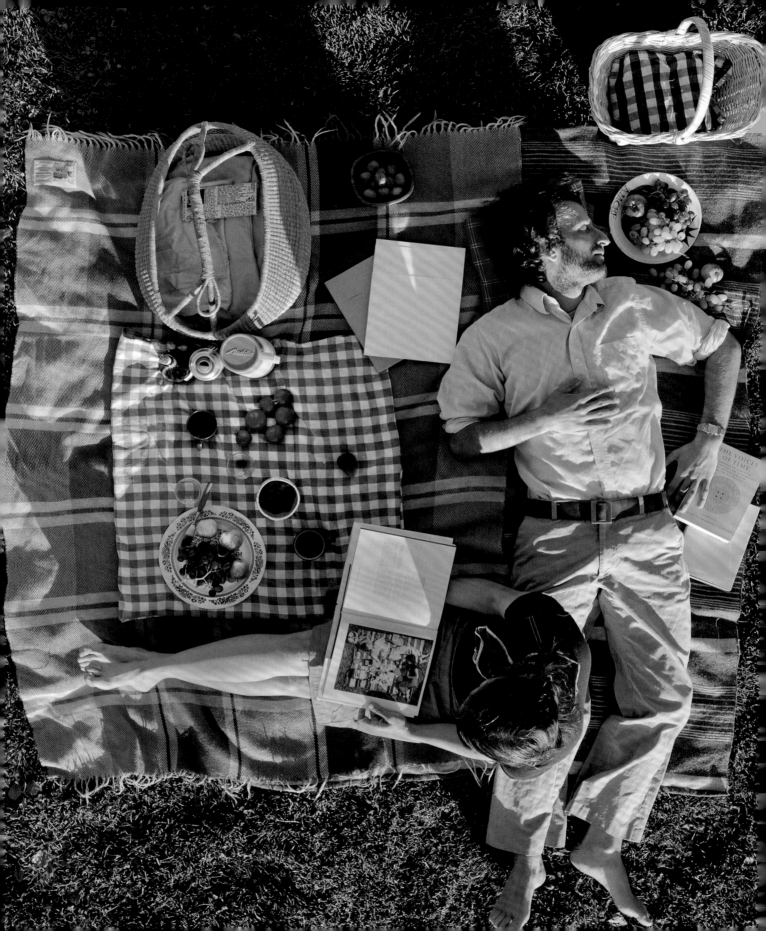

SIX LINES OF FLIGHT: SHIFTING GEOGRAPHIES IN CONTEMPORARY ART

EDITED BY APSARA DIQUINZIO

SAN FRANCISCO MUSEUM OF MODERN ART

UNIVERSITY OF CALIFORNIA PRESS
BERKELEY LOS ANGELES LONDON

Contents

With texts on the artists by María del Carmen Carrión, Brian Droitcour, Michèle Faguet, Tomoko Kanamitsu, Catalina Lozano, James M. Thomas, and Xiaoyu Weng

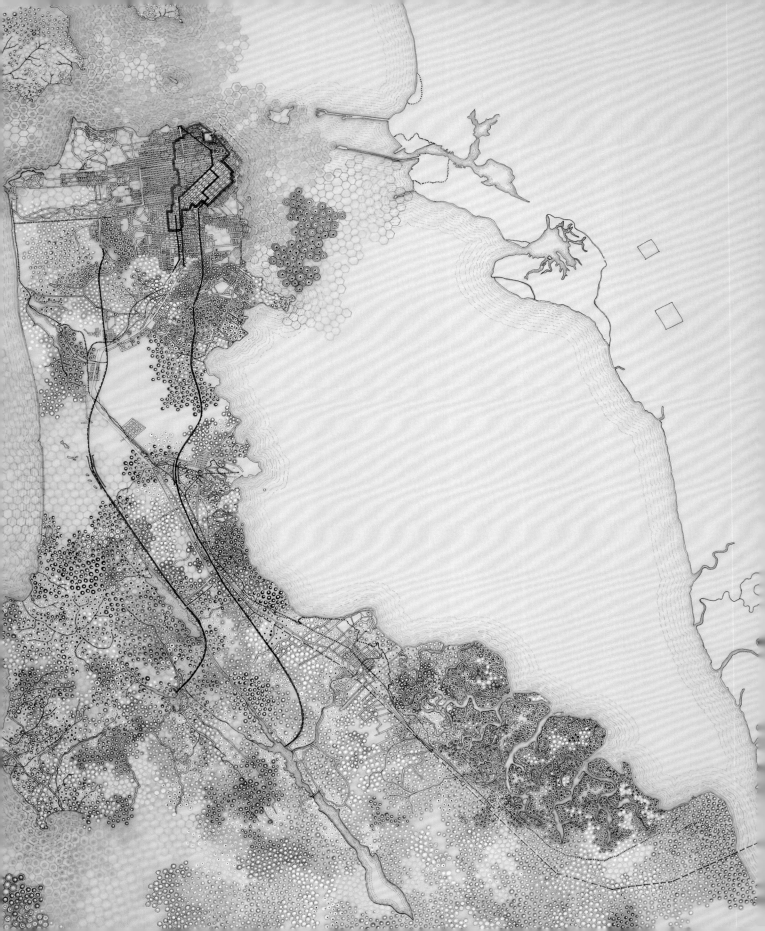

DIRECTOR'S FOREWORD

The past two decades have profoundly transformed the cultural landscape. The rise of internet culture and the rapid pace of technological and social change have made the art world more interconnected and international than ever before. Indeed, the centers of contemporary art are expanding, pushing beyond traditional hubs such as New York, Paris, Los Angeles, and London to include an ever-broader network of communities. *Six Lines of Flight: Shifting Geographies in Contemporary Art* explores the hybrid nature of this evolving landscape by presenting works from six burgeoning art scenes, using the activities of each locale's artist-initiated organizations and collectives as a lens through which to examine artistic production regionally and beyond. The cities of focus—Beirut, Lebanon; Cali, Colombia; Cluj-Napoca, Romania; Ho Chi Minh City, Vietnam; Tangier, Morocco; and SFMOMA's own hometown, San Francisco—have all seen remarkable development in their art communities since the mid-1990s. The vital work being done by the Arab Image Foundation (founded 1997) and Beirut Art Center (2009) in Beirut; Helena Producciones (1998) and Lugar a Dudas (2005) in Cali; Plan B gallery (2005) and Fabrica de Pensule (The Paintbrush Factory, 2009) in Cluj; The Propeller Group (2006) and Sàn Art (2007) in Ho Chi Minh City; Cinémathèque de Tanger (2005) in Tangier; and Futurefarmers (1995) in San Francisco reveals the importance of creating and sustaining community—both locally and internationally—as we navigate the new horizons of contemporary art and culture.

Six Lines of Flight was conceived by former SFMOMA assistant curator of painting and sculpture Apsara DiQuinzio and developed with the support of The Andy Warhol Foundation for the Visual Arts. A spring 2010 Warhol Foundation curatorial research fellowship enabled Apsara to travel to the cities mentioned above, and many others, as she refined the scope of the project. The featured organizations and collectives are distinctive for sharing a rootedness in their local histories and cultures while also recognizing the transformative potential of cross-cultural exchange and collaboration. These qualities are likewise reflected in the works brought together in the exhibition. The participating artists—Yto Barrada, Tiffany Chung, Wilson Díaz, Futurefarmers, Adrian Ghenie, Joana Hadjithomas and Khalil Joreige, Helena Producciones, Lamia Joreige, Dinh Q. Lê, Victor Man, Carlos Mayolo and Luis Ospina, Oscar Muñoz, Ciprian Mureşan, The Propeller Group, Graziella and Jalal Toufic, and Akram Zaatari—are all deeply engaged with their local contexts, and many of them are actively involved with the organizations central to this project. Yet while their artistic work offers an index of the interests and concerns specific to their respective art scenes, it also, when considered collectively, presents a greatly enriched picture of the dynamic, global spirit of contemporary art.

I applaud Apsara for her vision and commitment in bringing this project to fruition, and I join her in thanking the dedicated staff members acknowledged on pages 218–20 for their work on the exhibition and publication. This fall Apsara left SFMOMA to become the curator of modern and contemporary art and Phyllis C. Wattis MATRIX curator at the Berkeley Art Museum and Pacific Film Archive. I thank her for the many contributions she has made to SFMOMA over the past six years, and I wish her continued success. On behalf of this museum I also offer thanks to The Andy Warhol Foundation for the Visual Arts for their generous and sustained support. In addition to the fellowship that enabled the research and development of this project, the Foundation awarded the museum an exhibition grant for *Six Lines of Flight* in 2012. We are also grateful for the generosity of the following lenders to the exhibition: James Keith Brown and Eric Diefenbach; Dolly and George Chammas; the Museum of Fine Arts, Houston; and Dean Valentine and Amy Adelson.

Finally, I extend sincere appreciation to the artists, collectives, and organizations highlighted by this project. Their work incites fresh awareness of art's power to inspire new ways of connecting and engaging with the world we share.

Neal Benezra
San Francisco Museum of Modern Art

1. Tiffany Chung, *San Francisco, 1907 USGS map: the burned district, the city, and the principal conduits in the water supply system,* 2012 (detail). Micropigment ink, gel ink, and oil marker on vellum and paper, 37¾ × 24½ in. (96 × 62.5 cm). Courtesy the artist and Tyler Rollins Fine Art, New York

2. Victor Man, *Untitled (E.O.P)*, 2012. Oil on canvas, 11¹³⁄₁₆ × 15¾ in. (30 × 40 cm). Courtesy the artist and Plan B, Cluj/Berlin

PROVISIONAL HORIZONS

APSARA DIQUINZIO

Between two worlds life hovers like a star,
'Twixt night and morn, upon the horizon's verge.
How little do we know that which we are!
How less what we may be! The eternal surge
Of time and tide rolls on, and bears afar
Our bubbles; as the old burst, new emerge,
Lash'd from the foam of ages; while the graves
Of Empires heave but like some passing waves.

—*Lord Byron*, Don Juan, *canto XV*

Nestled on the verge of six horizons one finds the cities of Beirut, Lebanon; Cali, Colombia; Cluj-Napoca, Romania; Ho Chi Minh City, Vietnam; San Francisco, USA; and Tangier, Morocco. These places are separated by vast bodies of water, geographically sited on variegated land, and differentiated by unique spatiotemporal realities. And yet if one moves across the contours of this shifting terrain, one eventually finds that at the verge of each horizon is a continuous line: the horizon that circumscribes these locales, orienting them in time and space, also connects them. Occasionally, various cultural and economic forces at play push certain regions into the perceptible fore-ground, while others occupy less discernible zones.[1] This exhibition explores the correspondences of these six distinct yet interconnected cities, highlighting a few key artists living and working within each of them. The individuals included here have a common interest in and a strong commitment to their own locality, and through their combined collaborative work have formed, or been a part of, unique platforms of various kinds, whether organizations or collectives, that have over time forged connections between their sphere and the larger constellations that constitute the world-horizon.[2] Through their efforts, the artistic and cultural position of each city has increasingly shifted

into focus. Each of these endeavors has produced what Gilles Deleuze and Félix Guattari might refer to as a line of flight, or "a connection, one that takes place between self and others, pushing the subject beyond self-centered individualism also to include non-humans or the earth itself."[3] Like vectors on the horizon, lines of flight deterritorialize (de-center), opening up to new encounters and possibilities, and, ultimately, new forms of knowledge, thus expanding fields of understanding for our heterogeneous, rhizomatic, and networked world. Invoking the conceptual playfulness of Deleuze and Guattari, this project aims to "proliferate lines of flight that extend across the social field."[4]

Now more than ever, artistic enterprises operate as cross-cultural platforms among interconnected constellations that possess the ability to broaden one another's initiatives through the development of exchange with divergent communities. Over the past several decades it has become increasingly apparent that contemporary art is no longer defined by a few primary centers; it is now composed of many centers, small and large, each possessing unique histories, constituencies, and ethnic identities. The emergence of platforms has been a defining characteristic within this landscape—a phenomenon that has over time congealed into a new global paradigm of artistic connectivity and interdependency. In many ways this change has been a result of the emergence of an "informational society" within the context of a global economy restructured by new flows of capital.[5] Internet platforms such as Facebook and Twitter are obvious enhancers of this new world system of simultaneous feedback and participation. Globalization has in essence brought us closer together, but in doing so it has left vast portions of society behind. As the French anthropologist Marc Augé has aptly described, "globalization refers to the existence of a free, or allegedly free, market and of a technological network that covers the entire earth, to which a large number of individuals do not yet have access."[6] This expanding network has eroded the divisions between inner and outer spaces of visibility and communication. "One primary effect of globalization," write Michael Hardt and Antonio Negri, "is the creation of a common world, a world that, for better or worse, we all share, a world that has no 'outside.'"[7] Informational flows, emboldened by technological advancements, have enabled increased connectedness

and knowledge production, altering methods of communication and perception along the way. Moreover, the natural forces of entropy have set in, producing a murky gray horizon of frenetic activity too often dictated by speed, excess, capital, and technology, where diverse global forces all travel along the same routes and become imbricated within one another's intertwining networks.

In the field of contemporary art the trajectory of this evolution—of platforms and interconnectivity—involves many important international exhibitions and biennials (all supported and complicated by emergent and resurgent capital flows).[8] One might even surmise that the proliferation of biennials around the world stems from this very impulse to increase visibility and information routes, inevitably resulting in the current "precarious infrastructure."[9] *Documenta XI*, organized in 2002 across five different temporal and geographic platforms, emblematized this phenomenon. Its curator and artistic director Okwui Enwezor referred to this situation as the "postcolonial constellation," observing, "the postcolonial today is a world of proximities. It is a world of nearness, not an elsewhere." In his essay for the exhibition catalogue he defines a platform as "an open encyclopedia for the analysis of late modernity; a network of relationships; an open form for organizing knowledge; a non-hierarchical model of representation; a compendium of voices, cultural, artistic, and knowledge circuits."[10] Over the past twenty years a profusion of platforms has emerged from specific localities around the globe, many of which stem from collectively established independent art organizations, associations, exhibition spaces, and residencies all seeking to join networked relations within the world-horizon.[11]

This phenomenon largely began in cities worldwide during the 1960s and 1970s. In 1965 the collective Artists and Writers Protest Against the War in Vietnam was "one of the first post–World War II groups to use the fame of individual members to forge a platform to effect its political goals."[12] To a large extent this "movement" of alternative spaces and collectives developed to counter the prevailing social institutions and political agendas that were considered too homogeneous and narrowly defined within urban cultural domains. Through critical positioning, these various agencies sought to break open the exclusivity and conservatism of many existing cultural structures in order to bring greater diversity, inclusivity,

and a vital mix of voices into the contemporary art arena. Although in the United States the "alternative arts movement" may seem to be a mere "vestige"[13] of what it once was, it is now a burgeoning global phenomenon, having grown to new levels in the last decade alone. Enwezor describes this landscape as being "enmeshed in a field of activities in which various agents and position takers collaborate in an ever-expansive set of relations that define, conceive, conceptualize, and reformulate norms and methods within the field of cultural production."[14]

Six Lines of Flight convenes artists who have created and helped to build unique platforms on a grassroots level in six cities around the world, presenting works that index the distinctive locations in which they were made.[15] Through their divergent endeavors, the artists have helped make all of these cities important artistic centers that are now key cross-cultural platforms for other artists living and working in those areas, in essence forging "a new society within the shell of the old."[16] Often supported by private, outside funding sources, the featured organizations play a defining role in determining the cultural constitution of their own spheres. As George Yúdice notes, "the most innovative actors in setting agendas for political and social policies are grassroots movements and the national and international NGOs that support them. These actors have put a premium on culture, defined in myriad ways, a resource already targeted for exploitation by capital (e.g., in the media, consumerism, and tourism), and a foundation for resistance against the ravages of that very same economic system."[17] The deployment of the term *platform* is now as integrated into the language of contemporary art as it is in the techno-global system, as evidenced by the descriptions of the associations represented here. For example, one of the mission statements for the Cinémathèque de Tanger is to "act as a platform for cross-cultural exchange and dialogue." Beirut Art Center refers to itself as "a space and platform dedicated to contemporary art in Lebanon." Futurefarmers also describe their studio as "a platform to support art projects, an artist in residency program, and our research interests." Moreover, the *sàn* of Sàn Art is Vietnamese for "platform." In his essay for the *Documenta XI* catalogue, Sarat Maharaj calls the platform "a test and try laboratory site"; this reverberates in the description of Lugar a Dudas (A Place to Doubt): "a laboratory

to foment knowledge of contemporary art, facilitate development of the creative process, and provoke the community to interact through artistic practices."[18] Other organizations and collectives included here are the Arab Image Foundation, The Propeller Group, Helena Producciones, and Fabrica de Pensule (The Paintbrush Factory), all of which are similarly defined and conceived.

Through the cultivation of new connections among these disparate horizons, the exhibition itself emerges as another cross-cultural platform, while being simultaneously enmeshed in the various cultural forces at play in a major Western art museum. In essence, it may be envisioned as a potential site of transformation, not only for visitors encountering the artwork but also for the hosting institution and the artists involved. Significantly, essays by curators and writers who live in each region (or have in the past) are included here to give further shape and dimension to these artistic associations, placing them within the historical and cultural milieus of their landscapes and offering an empirical lens onto each area's artistic activity.

At the conceptual center of the project lie a series of conversations between artists who have formed some of the organizations and collectives mentioned above, SFMOMA staff, and members of art communities in the San Francisco Bay Area (many of whom were meeting for the first time). These exchanges took place in San Francisco between August 29 and September 1, 2011, and an excerpt from a transcript of one conversation is included in this volume (see pp. 182–91). This transcript is in many ways the key to the project and serves as an important starting point for unlocking cross-cultural understanding.[19] The roundtable revolves around a discussion of "the periphery," the notion that variously circumscribes each city and to a certain extent undergirds this project. The six cities represented here are not considered primary international art centers (for example, New York, Berlin, Los Angeles, Beijing, or London), and none of them hosts a major biennial. Yet they all have active, localized art communities that extend beyond their own regions and become international places of exchange. The artist R. H. Quaytman has said that "the peripheral has to invent itself,"[20] a statement that reflects the larger impulse behind the construction of each localized platform. Throughout the conversation the term *periphery* is repeatedly

rejected, contested, and reassumed, demonstrating its status as a shifting signifier. Yet despite the convivial disputation, in this conversation one notices patterns of shared experience, the development of nomadic, "contrapuntal thinking"[21] between geographic regions, and, perhaps most importantly, empathy toward those with decidedly different backgrounds.

In creating platforms, the artists in this exhibition have cultivated hospitable environments for critical thinking and artistic production within their communities.[22] Their initiatives have served as important models, or anchors even, within these disparate regions, while also exposing local artists and producers to cultural activities happening abroad, establishing a richly textured ground for exchange. These manifestations have assumed myriad forms: residency programs, educational programs, public lectures, performance festivals, archives, and invitations to locals and nonlocals to develop exhibitions. At Lugar a Dudas, Cinémathèque de Tanger, Sàn Art, the Arab Image Foundation, and Beirut Art Center, one finds growing libraries (largely dependent upon donations) where artists and local residents are invited to visit and conduct research, and can often borrow books. This was indeed the inspiration behind the founding of Sàn Art in Ho Chi Minh City, where there is a paucity of literature available on postwar art, and where books sent into the country via mail are often censored by local authorities. In the open-air courtyard at Lugar a Dudas in Cali, artists and the general public can attend nightly screenings of films by renowned directors, from international favorites such as Jean-Luc Godard to the city's own Luis Ospina and Carlos Mayolo. Notably, all of these organizations assume many different roles within their communities, acting as vital centers for social connection in areas that generally lack a greater infrastructure for contemporary art. The motivation underpinning all of these spaces, through wide-ranging gestures of generosity and inclusivity, is to invite their fellow urban dwellers inside, and to strengthen forms of cultural participation and critical exchange while also reaching beyond their own local spheres.

The efforts of these artists to build hospitable environments have been achieved through various collaborative endeavors. This is underscored through the inclusion of several collectives and collaborative projects where the local manifests as an important, vital consideration. In their evolving project

A Variation on the Powers of Ten (2010–12, p. 6, pl. 256), the San Francisco collective Futurefarmers takes the conversation as their model, hosting a number of picnics and discussions inspired by the Charles and Ray Eames film made for IBM in 1968. The original film begins with a one-meter-wide scene, shot from above by a camera three meters away, of a couple sitting on a picnic blanket along the lakeside in Chicago. Every ten seconds the camera moves upward by another power of ten until, in little more than four short minutes, the viewer traverses the galaxy and eventually arrives at empty space—the outer limits of knowable vision—having covered a distance of 1,024 meters and landed more than one hundred million light years away. At that point the narrator states: "This emptiness is normal. The richness of our own neighborhood is the exception."[23] The camera then rapidly descends until it reaches its starting position, where it hovers for a few moments before diving into the epidermal layer of the human body to traverse the inner edges of knowledge in the nanospheres. In their installation and series of photographs, Futurefarmers ask a simple, poetic question: What happens when you stay on the picnic blanket and engage in dialogue? They play out this question in ten recorded interviews with scholars whose disciplines and ideas relate to one of the magnitudes of ten. Like the Eames film, *A Variation on the Powers of Ten* is a journey through fields of inquiry—from microbial ecology to astrophysics, philosophy to anthropology—that illuminate aspects of our changing world. All conversations are eventually uploaded as podcasts to the project's website and visually represented by aerial photographs taken at a distance of three meters above the picnic blanket.

The cultivation of an artistic community is at the heart of many of the organizations in this exhibition, and it is an ongoing motivation for Helena Producciones. Since its founding in 1998, this Cali-based collective has been engaged in supporting cultural production in Colombia through numerous artistic examinations of the country's historical, political, and economic contexts. Their wide-ranging interdisciplinary work has encompassed concerts, exhibitions, and film clubs; *LOOP* (2001–4), a local television series; a mobile school that travels to a range of Colombian communities; a "video magazine"; and the performance festival in Cali that began in 1997 and prompted the collective's founding. Initially a regional project, the festivals grew to include international artists after the establishment of "a network of people who recommended artists to invite."[24] Dozens of performances have been produced for the festivals over the past fifteen years, ranging from controversial presentations by Cali's own Rosemberg Sandoval to Carolina Caycedo's memorable survey of Cali residents to Santiago Sierra's placement of an enormous American flag on the exterior of the Museo La Tertulia in 2002—when the widespread spraying of pesticides over Colombian land by the American company Monsanto dramatically heightened tensions between Colombia and the U.S. The selected chronology in this volume (pp. 78–93) highlights many of the pivotal performances that have taken place during the six Festivales de Performance de Cali organized by Helena since 1998, further mining the rich history of these events.

The history of art collectivism in Cali begins primarily with the formation of the alternative space (and de facto collective) Ciudad Solar in the 1970s, established in the home of the artist Hernando Guerrero. One of the members of this influential collective, the Cali-based curator Miguel González, has remarked that "surviving in Colombia is already a success" and notes that the formation of collectives, in addition to establishing an independent infrastructure, was a mode of survival for many artists.[25] Additional members of Ciudad Solar included Ever Astudillo, Enrique Buenaventura, Andrés Caicedo, Fernell Franco, Carlos Mayolo, Oscar Muñoz, Luis Ospina, and Sandro Romero. Having grown out of the Teatro Experimental de Cali and the Cine Club de Cali (founded by Caicedo in 1971), Ciudad Solar coalesced around photography, the graphic arts, film, writing, and criticism, as well as the exhibitions organized by González. The space became a creative hub in Cali and a model for future generations. It was his experience in Ciudad Solar that inspired Muñoz to create Lugar a Dudas, a place for artists to gather and question the world around them (or "a place to doubt," as the name suggests). Significantly, both Muñoz and Franco had their first exhibitions at Ciudad Solar, curated by González, and the space was the base for their magazine *Ojo al cine* (Eye on Film), which was inspired by the influential French film journal *Cahiers du cinéma*.

As Michèle Faguet notes in her essay on Cali in this volume, a number of important film collaborations

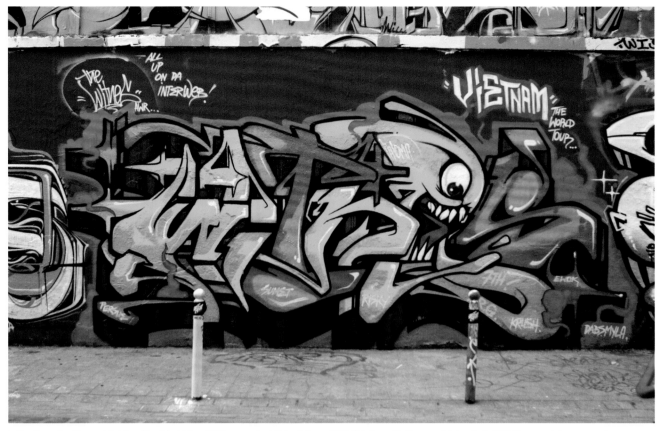

3. The Propeller Group, *Viet Nam The World Tour* (2010–or going): Tyke Witnes AWR, *Painting with Ogre and Astro*, Paris, 2010. Spray-paint on concrete, 11½ × 19¾ feet (3.5 × 6 meters). Courtesy The Propeller Group

occurred during that fertile period of creativity in the 1970s, including those by Ospina and Mayolo, which maintain an important place in the legacy of "Caliwood."[26] Among the pair's most influential projects was the 1978 short film *Agarrando pueblo* (known in English as *The Vampires of Poverty*, pls. 155–57), which was conceived as a critique of the proliferation of documentaries being made in the 1970s that focused on the poverty of Latin Americans. This phenomenon led them to coin the term *porno-miseria*, or "pornography of misery," referring to the objectification and subsequent exploitation of the Latin American indigent for the consumption of international audiences, which in effect promoted a problematic stereotype of deprivation in the third world.[27] Shot in the streets of Cali, *Agarrando pueblo* is a satiric experimental mockumentary about making a film about homeless people in Cali. Entirely

self-aware, the film alternates between black-and-white footage from the documentary itself and color footage shot by the protagonists (one of whom is played by Mayolo) while filming it; this juxtaposition deconstructs the act of filmmaking and throws the viewer's gaze into question.

Tuan Andrew Nguyen, cofounder of Sàn Art and The Propeller Group (TPG), has referred to the latter as "a collective within a collective,"[28] given that it is headquartered at Sàn Art, the independent space in Ho Chi Minh City initiated by Nguyen and fellow artists Tiffany Chung, Dinh Q. Lê, and Phunam in 2007. Nguyen and Phunam informally founded The Propeller Group in 2006, when they began collaborating on documentary films; the artist Matt Lucero joined them a couple of years later. Functioning partially as a production company for commercial projects, The Propeller Group situates itself on

4. Ciprian Mureșan, *Leap into the Void, After 3 Seconds*, 2004. Gelatin silver print, 39⅜ × 23⅝ in. (100 × 60 cm). Collection of Dean Valentine and Amy Adelson, Los Angeles

the cusp of contemporary art and popular culture, and the collective's involvement in one realm often informs their work in the other, challenging the lines that demarcate both categories in the process. For example, they channel their experiences making pop-music videos or corporate commercials into their critically informed art projects and vice versa. Positioning themselves simultaneously inside and outside of each domain, their aim is to make projects that exist beyond the confines of the white cube and circulate in ever-mutating public spheres—in the infinite media spaces of television, radio, and the internet, as well as other digital platforms. This is the case with *Viet Nam The World Tour* (*VNTWT*) (2010–ongoing, pls. 3, 236, 245), which occurs in many far-flung locations and lives through its dissemination online. It is at once a

brand, a cross-cultural phenomenon, and a reinvention of a national identity long fettered by its associations with war. Described by TPG as "a movement of creative thinkers, artists, writers, performers, film-makers, documentarians and cultural producers whose creative engagements attempt to challenge a global status quo,"[29] *VNTWT* is set in motion by a dynamic group of hip-hop dancers, graffiti artists, and cultural agents, all inhabiting distant spaces around the world and circulating their work across global networks. In *The Guerrillas of Cu Chi* (2012), the collective visits the Cu Chi Tunnels—an intricate network of under-ground caves dug by hand by the Viet Cong and known to have played a pivotal role in their victory during the Vietnam War (which in Vietnam is referred to as the American War). The tunnels, located on the outskirts of Ho Chi Minh City, now primarily serve as a tourist destination, with a shooting range where visitors can pay a dollar per bullet to fire an AK-47 or M16 assault rifle, iconic weapons of the war. Through a cinematic video shot from the perspective of the target, The Propeller Group examines the lingering stereotypes of war in a country transitioning more and more into a horizon dominated by commerce.

Collaboration and the artistic community of Cluj have been at the heart of much of Romanian artist Ciprian Mureșan's work, which is marked by wit and a clever deployment of appropriation that often speaks allusively on both local and international registers. Mureșan's photograph *Leap into the Void, After 3 Seconds* (2004, pl. 4) reenacts Yves Klein's seminal 1960 photomontage of the artist leaping off the cornice of a two-story building in Paris—a parodic expression of freedom and optimism. Mureșan stages his sequel in the streets of Cluj, showing a man lying facedown on the pavement. Here the blind idealism portrayed in Klein's image meets the cold, hard reality of life in Cluj in a tribute to a people who had to rebuild their spirits after having lived for decades under totalitarianism. To a resident of Cluj, this image further recalls episodes of ethnic violence that occurred in Transylvania, a region that has long been a contested site for Hungarians and Romanians.[30]

A conversation inspired *Untitled (Ceaușescu)* (2008, pls. 5–9), a collaborative work by Mureșan and fellow Romanian artist Adrian Ghenie. In 2008, they discussed whether it was possible for a Romanian to create a portrait of Nicolae Ceaușescu that, while criti-cal of the brutal communist dictator, could nonetheless

5–9. Adrian Ghenie and Ciprian Mureşan, *Untitled (Ceauşescu)*, 2008. Oil on canvas and single-channel video, color, sound, 12 min. Courtesy the artists; Plan B, Cluj/Berlin; and Mihai Nicodim Gallery, Los Angeles

pass as an official portrait of which Ceauşescu himself would have approved. Mureşan challenged Ghenie to paint the portrait, and Ghenie accepted. Mureşan filmed him as he painted, and once Mureşan was satisfied that Ghenie had succeeded in his task, he turned off the camera. The work was deemed complete, with the painting deliberately left unfinished. Ghenie had never before dared to paint the dictator; however, after realizing it was possible, he revisited the subject on several occasions, perhaps most forcefully in his magnum opus *The Trial* (2010, pl. 173). The scene that Ghenie depicts was a decisive moment in the Romanian Revolution: it shows Ceauşescu and his wife Elena confined in a room, shortly after they were finally captured and a few moments before they were shot to death on December 25, 1989. Both this image—of the couple tightly barricaded behind a table during their "trial"—and the image of their corpses lying on the ground are iconic, having been widely broadcast on national television and seared into the psyches of the many Romanians who remained glued to their TVs during the revolution.

The importance of community has manifested in myriad forms throughout Mureşan's career, including his founding of the magazine *Version* with the artists Mircea Cantor (pls. 160–63) and Gabriela Vanga, his work with the theory-based magazine *IDEA: arts + society*, and regularly opening the doors of his studio for games of Ping-Pong at Fabrica de Pensule (the converted paintbrush factory that now houses dozens of studios for artists, designers, and dancers, in addition to several galleries). In fact, the art community of Cluj is filtered through many of his works. In his suite of drawings *Heart of a Dog* (2008), one can recognize Ghenie and many other artists animating scenes from Mikhail Bulgakov's eponymous satiric novel, which was written in 1925 in the newly formed Soviet Union and widely understood as a critique of the Communist Revolution. The main character, a dog named Sharik (a parody of the New Soviet Man), is humorously rendered by Mureşan's pencil, with an inscription beneath each drawing indicating which scene is being portrayed. In his ironic *Untitled (Monks)* (2011, pls. 181–92), Mureşan films his friends and fellow artists Cristian Opris, Şerban Savu (pl. 159), Radu Comşa, Eugen Rosca, and Mihai Pop as monks dutifully copying from the exhibition catalogues of Joseph Beuys, Susan Hiller, Sturtevant, Kazimir Malevich, and Piet Mondrian—a few of Mureşan's favorite artists.[31] Shot in the Universitatea de Artă şi Design Cluj-Napoca (Cluj-Napoca Art and Design University), which many artists in the city attended, the video is a visual metaphor for the limitations of their formal educational experience and the self-education they embarked on after graduating, when they had to "unlearn what they were taught,"[32] because the university is still based on the French academic model of the nineteenth century.

13. Wilson Díaz, *Untitled*, from the series *La flor caduca de la hermosura de su gloria* (The Flower Fades from the Beauty of Its Glory), 2011. Charcoal on paper, 13¾ × 17¹¹⁄₁₆ in. (35 × 45 cm). Courtesy the artist and Valenzuela Klenner Galería, Bogotá

presidential elections is explored in Wilson Díaz's body of work *La flor caduca de la hermosura de su gloria* (The Flower Fades from the Beauty of Its Glory, 2011, pls. 13, 104–8). For his exhibition at Bogotá's Galería Santa Fe (as part of the Luis Caballero Award), Díaz presented a series of acrylic paintings, drawings, audio tracks, and found record albums that collectively examined the situation of war in Colombia between 1970 and 2002, a period that spanned eight presidencies. Viewed together, these works loosely evoke the history of major political factions (politicians, guerrillas, and paramilitaries) vying for power, told through layers of music and parody. In one painting Díaz monumentalizes

the musical duo Los Tolimenses (popularly known as Emeterio and Felipe), whose performances and recordings supported Misael Eduardo Pastrana's presidential campaign in 1970. The musicians, playfully rendered in pastel colors, ride a donkey while playing guitars and smiling brightly, sombreros and all (pl. 104). Another painting portrays a group of young guerrillas posing as gangsters, but Díaz has replaced some of their weapons with musical instruments; their friendly, smiling faces contradict the violent stereotypes associated with leftist revolutionaries. These paintings incisively explore the phenomenon of political satire as reflected in the comic antics of musicians who became popular figures and were put to the

service of well-oiled propaganda machines. One such figure—whom Díaz describes as the ghost behind this body of work—was Jaime Garzón, a beloved journalist-cum-activist-cum-mayor-cum-comedian who used parody and satire as political weapons. After publicly advocating for peace talks among leftist guerrilla groups and helping facilitate the release of people kidnapped by the Revolutionary Armed Forces of Colombia (Fuerzas Armadas Revolucionarias de Colombia: FARC), Garzón was assassinated in 1999 by Carlos Castaño's right-wing paramilitary group, which was believed to have ties to the Colombian military.[36] Díaz thoughtfully relates the complicated stories of war in Colombia in his works, lacing them with a naive style that reflects on the people, events, and phenomena that have been silenced and forgotten over time. This is perhaps nowhere more evident than in his *Los rebeldes del sur* (The Rebels of the South, 2002), a video created by the artist in the "safe zone" established in 1998 by Colombian president Andrés Pastrana, which briefly allowed warring factions to come together under the banner of a fleeting armistice. In this poignant footage, citizens, guerrillas, and members of the government mingle and dance to one another's music; some playfully tap their weapons in time with the beat.

The desire to articulate the embedded histories of each city visually—and the impossibility of adequately doing so—is manifested through many of the works in this exhibition. This is especially true for artists in Beirut, where history has been utterly fragmented by war and sectarian violence, making it a complicated subject about which the city's many religious sects and multiethnic groups can rarely reach a consensus. In that city, many traces of personal and national histories have been physically erased over decades of war, through lives lost and homes and other buildings destroyed. These remnants are now further disappearing due to urban development projects like those spearheaded by Solidere in the city's center. The impulse to render the traces of war visible undergirds the collaborative project by Joana Hadjithomas and Khalil Joreige, *Wonder Beirut, the Story of a Pyromaniac Photographer* (1997–2006, pls. 23–43), which is based on a constructed narrative about a photographer and an actual set of popular postcards produced in the late 1960s (and still available in Lebanon) that show images of the pre–civil war city: an inviting, cosmopolitan metropolis along

the sandy beaches of the Mediterranean. Prints made from manipulated negatives taken of these postcards anchor an installation that illustrates the history of devastation that the original postcards render mute.

This urge to document history, or rather to consider how one speaks about the impossibility of comprehensively narrating a given history, is further manifested in Lamia Joreige's *Beirut, Autopsy of a City* (2010, pls. 48–53). This monumental time line attempts to depict the sieges, relics, occupations, and natural disasters of Beirut, beginning in 1200 BC and ending in AD 2010. Unfolding in fragments across three chapters—including texts, videos, and archival photographs—the work ambitiously explores the anxiety inherent in the attempt to construct a grand narrative. In the first chapter, *A history of Beirut's possible disappearance*, Joreige deploys poetic associations between recovered images (both moving and still) from different periods of time, connecting them with corresponding texts. Together these remnants push the work into a fictional terrain and question whether such a narrative could ever exist. In the second, *Beirut, 1001 views*, an enlarged projected image forms a composite visual narrative of Beirut, made from many photographs that show the city at various historical moments. In the final chapter, *Beirut, 2058*, Joreige channels this anxiety into an apocalyptic vision of the future, which concludes with an erasure of the cityscape. She writes of the work:

> What does this anxiety inhabit? Where does it reside? Traces lead us to more traces; they seem to always situate anxiety where it is least palpable: in the remains of a Crusader castle, the calm waters of an unpredictable sea, in lost photographs. [. . .] As I collected these various elements, some questions were raised: What has been deliberately preserved and why? What is a trace and what is a relic? How to materialize what has been lost? Are some things unrepresentable? How to express the recurrence of past events?[37]

The presence of that which evades representation in a work of art has frequently been explored by Jalal Toufic in his writing and videos. In his *(Vampires): An Uneasy Essay on the Undead in Film* (2003) he writes about the invisibility of the vampire before the mirror. The phenomenon of being concurrently present and absent is explored further in his book

14. Oscar Muñoz, *Horizonte* (Horizon), 2011. Charcoal powder on acrylic, four pieces, each 33½ × 28⅞ in. (85 × 73.5 cm). Courtesy the artist; La Fábrica Galería, Madrid; Galerie Mor • Charpentier, Paris; and Sicardi Gallery, Houston

The Withdrawal of Tradition Past a Surpassing Disaster (2009) and his related film *Credits Included: A Video in Red and Green* (1995). These works elucidate the notion that, as a result of a "surpassing disaster," certain works of art and literature reveal an immaterial withdrawal of "what has materially survived the disaster"[38] and thus demonstrate what is no longer accessible, what eludes the viewer even as it remains extant. This withdrawal echoes the disappearing vampire that is no longer visible but present nonetheless. In his book *Forthcoming* he writes, "Tradition is not merely what materially and ostensibly survived the test of time: in normal times a nebulous entity despite the somewhat artificial process of canon formation, tradition becomes delineated and specified by the surpassing disaster."[39] For Toufic, a surpassing disaster discloses itself through works of art that become immaterially unavailable, and it is these that eventually constitute tradition. He avers that it is only the "thinkers, writers, artists, filmmakers, musicians, and dancers" who can resurrect works that have withdrawn.[40] In the haunting video *Attempt 137 to Map the Drive* (2011, pls. 55–59), he and his wife Graziella visualize a temporal labyrinth, a repeated attempt to go back in time. Toufic originally shot portions of the work in 2000 while driving through the central district in Beirut, a ruined area that was still largely under construction. The "drive" that occurs in the video, rendered with manipulated footage, serves as a metaphor for the Freudian notion of the death drive, in which people are compelled to relive or repeat traumatic events that occurred in the past. The work

suggests that in order to be taken to the ruined zone of the video, and thus go back in time, the passenger of the taxi must die. As the narrator in the video suggests, "The taxi driver in Beirut was dying to figure out why his customer would specify the year of his destination, 'the Central Business District, 2000.'"

The evanescence of significant moments in time is further articulated in Cali-based Oscar Muñoz's continuing investigation of the role that images, and particularly historical documents, play in shaping and informing memory and tradition. In *Haber estado allí* (Having Been There), *El testigo* (The Witness), and *Horizonte* (Horizon), all from 2011, Muñoz brings together images that were widely reproduced in Colombian newspapers of the 1950s. Although they function as important records of *La Violencia*, over time they have lost "their ability to move as documents" due to their widespread dissemination.[41] Through subtle manipulation of his signature medium of charcoal powder (printed here on acrylic) he reactivates the images, prompting viewers to see them differently. In *Haber estado allí* he selects an image of Colombian politician Jorge Eliécer Gaitán, the beloved leader of the populist movement, made after he was assassinated during his 1948 presidential campaign. The photo shows Gaitán's autopsy—the document of his death—but instead of emphasizing the iconic subject of the photo, Muñoz brings into focus the faces and details of others present, those on the periphery. In the faint prints that comprise *Horizonte* (pl. 14) and *El testigo* (pls. 148–49) he foregrounds the guerrilla fighters of Los Llanos

Orientales (the eastern plains of Colombia), who in 1953 signed a treaty with the government and surrendered their weapons. Photographs taken at the time were later used to identify and eradicate many of those pictured. Again in *El testigo*, rather than highlighting the well-known rebel leaders (Guadalupe Salcedo and Dumar Aljure), Muñoz homes in on the face of an anonymous witness at the treaty signing—a witness who, moreover, looks as if he might have been blind. In the related video, also titled *Horizonte* (pl. 150), Muñoz manipulates excerpts from documentary footage recorded by filmmaker Marco Tulio Lizarazo of the six hundred guerrillas surrendering their weapons, rendering it a blurry white except for a few highlighted details that appear in sharper focus (yet are still undecipherable) throughout the video. In these works the artist emphasizes aspects of Colombian history that over the years have faded into the recesses of collective memory.

The research, preservation, and documentation of forgotten moments in time—in photography, video, and film—have also been at the heart of Akram Zaatari's work for the last couple of decades; these interests likewise underlie the mission of the Arab Image Foundation, an organization he cofounded in 1997 for the collection and preservation of photographs taken in the Middle East that would have otherwise been discarded. Since 1999, Zaatari has been closely studying and working with the photographer Hashem el Madani—the first person to own a 35mm camera in Zaatari's native city of Saida, in southern Lebanon. Since 1953, Madani has had a photographic studio there, Studio Shehrazade, where he has offered professional portraiture services and bought and sold photographic and film equipment. Clients have also visited his studio to learn how to use cameras and develop film. Zaatari's ongoing archaeological investigation of Studio Shehrazade has evolved in three extensive projects, realized as publications and exhibitions, that have explored Madani's practices and how they illuminate social, political, and economic aspects of Lebanese society.

Zaatari's work with Madani and his excavation of a living studio includes the research not only of the half a million pictures (and one million negatives) that constitute Madani's archive but also of the objects that communicate how photographic studios functioned in the second half of the twentieth century. "These were not only places that produced pictures for people," he says, "these were places of transaction—a crossroads."[42] This study of material evidence and cultural history is at the core of *Twenty-Eight Nights and a Poem* (2010), a multimedia project (and initially a film) that mines the life of Studio Shehrazade. Zaatari photographed the minutiae of the studio: various utilitarian instruments, cameras, film stock, and old projectors (a few of which still function). The project is anchored by a wooden cabinet with twenty-eight labeled "drawers" that are in fact framed pictures of supplies such as brushes, pencils, and reels of Super 8 film (p. 2, pls. 15, 65–92). On top of the cabinet, a Super 8 film projector, a video projector, and an iPad communicate the "development of image diffusion."[43] The Super 8 projector, originally from Madani's studio, shows a film that Zaatari shot of Madani on a roll of expired stock (from 1974) that he found in the studio. Another old Super 8 projector can be seen in the video, which Zaatari recorded in Madani's studio as it played "L'enlèvement" (The Kidnapping), an episode of the 1970s British TV series *The Protectors*. In this work, the artist's most developed response to the archive of Studio Shehrazade, we see how his investigation of image making has evolved. In his earlier projects, he considered how the image acted as a container of codes that revealed aspects of the photographer and his culture; in *Twenty-Eight Nights and a Poem*, Zaatari looks at how the image, and in turn the studio itself, is situated within the larger industry of image production. The narratives that are told and interwoven in this installation underscore the complexity of the artist's work: there is the story of Madani the photographer, including his preferences and conventions as revealed in the pictures of his tools and other objects; the story of the technological evolution of media in the studio; and the story of the ongoing relationship between Zaatari and Madani. The project also highlights the activation and intersection of various archives: Madani's, a portion of which now resides in the archive of the Arab Image Foundation, as well as the new archive that was established through the process of the work's creation.

Many of the organizations assembled here have worked from or created archives. Cinémathèque de Tanger—the only art-house cinema in North Africa—is an archive for the collection and preservation of African and Arab films. Lugar a Dudas has created a traveling archive of videos, photographs, and newsletters that can be shipped to other institutions and

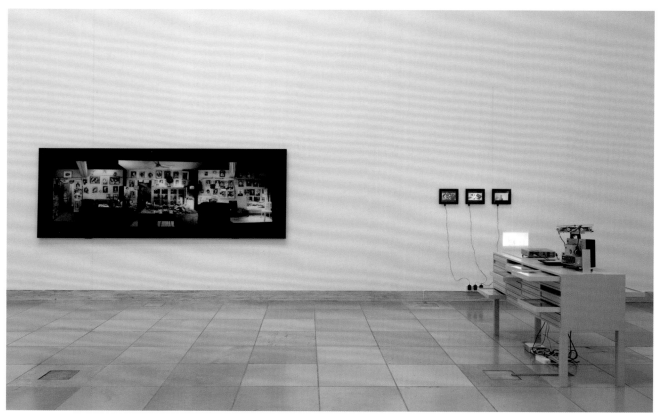

15. Akram Zaatari, *Twenty-Eight Nights and a Poem*, 2010. Mixed-media installation, dimensions variable. Installation view at Haus der Kunst, Munich, 2010. Courtesy the artist and Sfeir-Semler Gallery, Beirut and Hamburg

expanded into exhibition formats. These organizations reveal the archive as a vital, contingent entity—a living organism dependent on institutional structures. Each institution plays a pivotal role in the construction and ongoing evolution of the cultural histories of its city, which have developed "through mutations of connections and disconnections."[44] Through the links in the informational network of the archive, fortified through its preservation, one develops a richer understanding of the multifaceted and often overlooked terrains of history, making it possible to better reflect upon the conditions of the present.

In the 1920s, Aby Warburg developed his *Mnemosyne Atlas* for similar purposes: to deploy the archive as a multidimensional instrument, one composed of endless images of cultural fragments that enabled a reading of time along its many forking and discontinuous paths, one that is more synchronic than diachronic.[45] Through juxtapositions of objects

from many different cultures, new connections, new lines of flight, and new revelations emerge that revisualize history as an ongoing series of layered, rhizomatic, and nonlinear narratives. This is a method that the Romanian painter Victor Man also deploys, inspired by Warburg and James Joyce, among others. Man juxtaposes unrelated images and objects, forging a terrain rife with references—literary, cultural, and historical—that inspires new connections, new points of contact. In his installations and paintings he works with myth as much as history, often beginning with a "historical" subject that then gets displaced and interpolated with myth—a metaphor for what happens in life. T. S. Eliot, reflecting on Joyce's synthesizing method in *Ulysses*, wrote, "In using the myth, in manipulating a continuous parallel between contemporaneity and antiquity, Mr. Joyce is pursuing a method which others must pursue after him. [. . .] Instead of narrative method, we may now use the

16. Victor Man, *Untitled (Judith and Holofernes)*, 2011. Oil on canvas, 39⅜ × 26⅜ in. (100 × 67 cm). Courtesy the artist and Gladstone Gallery, New York

mythical method."[46] Man, too, employs this labyrinthine approach, collating various moments in time derived from personal narratives, historical events, myths, and legends.

In a new series of portraits, Man explores the many faces of Stephen Dedalus—the main protagonist of *A Portrait of the Artist as a Young Man*—who for him has become a kind of alter ego. Adopting the grand scale of history painting in *Untitled (The Lotus Eaters)* (2009–11, pl. 174), he portrays a moment in Joyce's *Portrait* when the young artist awakens at dawn and writes his first villanelle about temptation. Man paints Dedalus in an imagined encounter with "the fallen seraphim" of the poem. Yet the seraphim of the painting assumes the form of the fallen heretic from Renaissance painter Sassetta's *Death of the Heretic on the Bonfire* (1423, National Gallery of Victoria, Melbourne), who is pictured next to a very contemporary rendering of Stephen with bicycle in

tow. Man achieves a spatial depth in the canvas that appears sculptural, carved with his restricted, dark palette, and nowhere is this more evident than in Stephen's penetrating gaze, partially hidden in oblique shadows. The painting completes what Man refers to as a trilogy of monochromatic black paintings, which together form an ambiguous coming-of-age narrative that builds to a self-awakening, realized in the figure of Dedalus. In other portraits of Stephen, Man draws on Joyce's belief that the artist should possess both masculine and feminine qualities, painting him as an androgynous-looking young man in *Untitled (portrait of S.D.)* (2011, pl. 175). In this small composition with lush visible brushwork on the surface, a crepuscular blue light suffuses the figure, casting an ethereal glow onto his face as he softly meets the viewer's gaze. In another nearly all-black portrait, Stephen has assumed the form of the biblical heroine Judith (2011, pl. 16), with the head of Holofernes presented as an African mask, the appropriated "seed of modernism."[47] Man uses Dedalus as a transitional character within his oeuvre that signals his struggle to move beyond the black monochromes of the past—the dark terrain of history. As Dedalus famously proclaims in *Ulysses*, "History . . . is a nightmare from which I am trying to awake."[48] For Man, the awakening involves a process of discovery realized through thoughtful conceptual juxtapositions that slowly coax new understandings into existence. By infusing his works with an air of intrigue and instability, the artist articulates a field of potential where disjuncture leads to insight, where a backdrop of violence eventually evolves into a new beginning.

In this exhibition diverse subjectivities and perspectives commingle and create a "'plateau' of variation that places variables of content and expression in continuity."[49] The effect of such an assembly points to a cultural urgency that requires the decentering of a singularly inscribed gaze, a sociopolitical awakening, and a broadening of one's frames of reference to reflect on the profusion of localities and identities all around us—all contingent upon one another and inhabitants of the same world-horizon. At its best, *Six Lines of Flight* serves as a modest contribution to the process of understanding the increasingly complex and rapidly changing terrain we share, leading to newly radiant, perceptible horizons of possibility where the fields of "determinateness"[50] become clearer and wider.

1. Edmund Husserl writes about the "misty" and "never fully determinable" horizon, and the distinction between perceptible and imperceptible spheres within it, in *Ideas Pertaining to a Pure Phenomenology and to a Phenomenological Philosophy* (The Hague: Martinus Nijhoff, 1982), 52.

2. Maurice Merleau-Ponty developed the concept of the world-horizon to designate the structure of perception in the world, which fluctuates between stages of determinacy and indeterminacy. For him, the natural world was the "horizon of all horizons." See his *Phenomenology of Perception* (New York and London: Routledge, 2002), 47, 385.

3. Rosi Braidotti, "Lines of Flight + Suicide," in *The Deleuze Dictionary*, ed. Adrian Parr (New York: Columbia University Press, 2005), 149.

4. Tamsin Lorraine, *Irigaray & Deleuze: Experiments in Visceral Philosophy* (Ithaca, NY: Cornell University Press, 1999), 180.

5. Manuel Castells, *The Information Age: Economy, Society, and Culture*, vol. 1, *The Rise of the Network Society*, 2nd ed. (Oxford, UK: Blackwell Publishing, 2000), 21.

6. Marc Augé, *Non-places: An Introduction to Supermodernity*, 2nd ed. (London: Verso, 2008), xi.

7. Michael Hardt and Antonio Negri, *Commonwealth* (Cambridge, MA: The Belknap Press of Harvard University Press, 2009), vii.

8. The aim of this essay is not to chart a genealogy of this postcolonial phenomenon but rather to gesture toward it. For further discussion of this subject, see Hou Hanru's essay on pages 207–13 of this volume. Some of the significant exhibitions that have helped to shape this paradigm include the Third Havana Biennial (1989); *magicienes de la terre* (1989); the 1993 Whitney Biennial; *Documenta X* (1997); *Global Conceptualism: Points of Origin, 1950s–1980s* (1999); the 4th Gwangju Biennale (2002); *Documenta XI* (2002); the 50th Venice Biennale (2003); *How Latitudes Become Forms: Art in a Global Age* (2003); and *Brave New Worlds* (2007).

9. Jan Verwoert has written, "But what cross-cultural modes of sharing experience are we looking for, then? After nearly twenty years of biennials proliferating worldwide, this question still begs for an answer, especially now that a (notoriously precarious, yet still somewhat feasible) infrastructure has been created, while the initial idealism of the biennial spirit may be on the verge of becoming exhausted by its routine invocation." See "The Curious Case of Biennial Art," in *The Biennial Reader: An Anthology on Large-Scale Perennial Exhibitions of Contemporary Art*, ed. Elena Filipovic, Marieke Van Hal, and Solveig Øvstebø (Bergen, Norway: Bergen Kunsthall; Ostfildern, Germany: Hatje Cantz, 2010), 186.

10. On the postcolonial today, see Okwui Enwezor, "The Black Box," in *Documenta 11_Platform 5* (Ostfildern-Ruit, Germany: Hatje Cantz, 2002), 44; for his definition of *platform*, see page 49.

11. This list is, again, too vast to develop here comprehensively, but it is interesting to note that a number of concurrent endeavors have sought to survey the independent spaces that have developed globally in recent years. Some examples include *No Soul For Sale*, first staged at X Initiative, New York (June 24–28, 2009) and then at the Tate Modern, London (May 14–16, 2010); "New Methods Symposium," at the Museum of Contemporary Art, North Miami (May 4–6, 2011); "State of Independence: A Global Forum on Alternative Practice," a symposium that took place at REDCAT in Los Angeles (July 23–24, 2011); "Networked: Dialogue and Exchange in the Global Art Ecology," a conference hosted by the Triangle Network in London (November 26–27, 2011); and the New Museum's *Art Spaces Directory* (2012), a resource guide to more than four hundred independent art spaces around the world, copublished by *ArtAsiaPacific* magazine.

12. Julie Ault begins her chronology of the "alternative arts movement" in New York with this group; see Ault, ed., *Alternative Art New York, 1965–1985: A Cultural Politics Book for the Social Text Collective* (Minneapolis: University of Minnesota Press, in collaboration with The Drawing Center, New York, 2002), 17.

13. Ibid., 9.

14. See Okwui Enwezor, "The Postcolonial Constellation," in *Antinomies of Art and Culture: Modernity, Postmodernity, and Contemporaneity*, ed. Terry Smith, Okwui Enwezor, and Nancy Condee (Durham, NC: Duke University Press, 2008), 234n24.

15. In selecting the featured cities, I had aspired to include one from each continent, in acknowledgment of the global landscape of contemporary art. (Due to the profusion of activity in Beirut, I ultimately favored the Middle East over Australia.) Although each country I visited over the course of my research has become home to multiple new artistic centers in recent decades, the places featured in this exhibition are unique for the prominence and impact of their artist-run spaces and collectives. Given the importance of the local among the broader themes of this project, as well as to the works in this exhibition and the efforts of these collectives, it was essential to include my own locality, San Francisco, among the cities of focus.

16. Hardt and Negri, *Commonwealth*, 8.

17. George Yúdice, *The Expediency of Culture: Uses of Culture in the Global Era* (Durham, NC: Duke University Press, 2003), 83. I thank Pamela M. Lee for bringing this book to my attention.

18. For Cinémathèque de Tanger, see http://www.cinemathequedetanger.com/texte-22-3-2.html, accessed March 22, 2012; for Beirut Art Center, see http://beirutartcenter.org/presentation.php, accessed March 22, 2012; for Futurefarmers, see http://futurefarmers.com/about, accessed March 22, 2012; and for Lugar a Dudas, see http://www.lugaradudas.org/lugar_a_dudas.htm, accessed March 22, 2012. For Sarat Maharaj, see his "Xeno-Epistemics: Makeshift Kit for Sounding Visual Art as Knowledge Production and the Retinal Regimes," in *Documenta 11_Platform 5*, 75.

19. The desire to host such a conversation was largely inspired by the philosopher Kwame Anthony Appiah's use of the conversational model "between people from different ways of life" as an instrumental method for understanding localized ideas or values in order to learn from difference and envision what our shared values of responsibility toward one another might entail. See his *Cosmopolitanism: Ethics in a World of Strangers* (New York: Norton, 2006), xxi.

20. The artist is quoted in "R. H. Quaytman: Interview by Paulina Pobocha," *Museo Magazine* (2010), http://www.museo-magazine.com/802508/R-H-QUAYTMAN, accessed March 22, 2012.

21. For Edward Said, contrapuntal reading entails considering what has been left out of historical or cultural narratives as much as what has been included; in this way, one can discern traces of both imperialism and resistance. He has written: "To rejoin experience and culture is of course to read texts from the metropolitan center and from the peripheries contrapuntally, according neither the privilege of 'objectivity' to 'our side' nor the encumbrance of 'subjectivity' to 'theirs.'" See Said, *Culture and Imperialism* (New York: Vintage Books, 1994), 259.

22. Hospitality was, perhaps most famously, one of three foundational rights Immanuel Kant outlined in his seminal essay *Perpetual Peace* (1795), which attempted to identify the possibilities for world peace: "Hospitality means the right of a stranger not to be treated as an enemy when he arrives in the land of another." Since then it has become an important cornerstone of cosmopolitanism, on which an ethical and mutually agreed upon groundwork is laid, so that the Other can be welcomed into the "homeland"; national borders are not merely predicated on erecting impenetrable fortresses of security but rather are accepting of difference, which is approached through openness and discourse as an invitation to share the same horizon.

23. *Powers of Ten* is available online at the Eames Office site, http://powersof10.com/film, accessed March 22, 2012.

24. Wilson Díaz, in conversation with the author and María del Carmen Carrión, November 23, 2010, Cali, Colombia.

25. Miguel González, in conversation with the author and María del Carmen Carrión, November 22, 2010, Cali, Colombia.

26. The film history of Cali dates back to the 1920s, most notably to the popular 1922 silent film *María*, based on the novel by Jorge Isaacs and directed by Máximo Calvo Olmedo and Alfredo del Diestro.

27. See also Michèle Faguet, "*Pornomiseria*: Or How *Not* to Make a Documentary Film," *Afterall* 21 (Summer 2009): 5–15.

28. Tuan Andrew Nguyen, in conversation with the author, August 30, 2012, San Francisco.

29. See *Viet Nam The World Tour*, http://www.vietnamtheworldtour.com /about.html, accessed March 22, 2012.

30. During Nicolae Ceaușescu's reign, entire Hungarian communities were razed under an urbanization plan that began in March 1987, resulting in the resettlement of eight thousand villages, mostly in Transylvania. See Carolin Emcke, *Echoes of Violence: Letters from a War Reporter* (Princeton, NJ: Princeton University Press, 2007), 139.

31. Before 2002, when Romanians were issued travel visas for the first time, the border was closed to them and travel was impossible. Artists had to learn about art through poor reproductions in books. Many of the artists living in Cluj, and now involved with The Paintbrush Factory, traveled to other countries for the first time between 2002 and 2005.

32. Șerban Savu, in conversation with the author, August 7, 2010, Cluj, Romania.

33. In 1923 Tangier was declared an international zone presided over by the sultan, and many Western powers established outposts in the city, including France, Spain, Britain, Belgium, Portugal, Sweden, and the United States. See William S. Burroughs, *Interzone* (New York: Penguin Books, 1990).

34. Yto Barrada, *A Life Full of Holes: The Strait Project* (London: Autograph ABP, 2005), 57. The title of this project is taken from a novel by Driss Ben Hamed Charhadi, first recorded and translated by Paul Bowles in the 1960s. See Charhadi, *A Life Full of Holes* (New York: HarperCollins, 2008).

35. Yto Barrada, *Palm Project*, artist's edition, published by Yto Barrada, Rabat, Morocco, 2009.

36. For more information, see "Who Killed Jaime Garzón?" at the National Security Archive (September 29, 2011), http://www .gwu.edu/~nsarchiv/NSAEBB/NSAEBB360 /index.htm.

37. Lamia Joreige, email message to the author, October 13, 2011.

38. Jalal Toufic, email message to the author, March 18, 2012.

39. Jalal Toufic, *Forthcoming* (Berkeley, CA: Atelos, 2000), 70.

40. See Jalal Toufic, *The Withdrawal of Tradition Past a Surpassing Disaster* (Forthcoming Books, 2009), 82, http://www.jalaltoufic.com/downloads /Jalal_Toufic,_The_Withdrawal_of_Tradition_ Past_a_Surpassing_Disaster.pdf.

41. Oscar Muñoz, interview with the author, August 31, 2011, San Francisco. *La Violencia* begins with the assassination of Jorge Eliécer Gaitán in 1948; it is the term used for the beginning stages of the war between the Colombian government and the guerrillas, who would later become widely associated with FARC, the largest, longest established, and wealthiest guerrilla group in the country. For a good introduction to the history of the ongoing war in Colombia between the guerrillas, paramilitaries, and the government, see Alma Guillermoprieto, *Looking for History: Dispatches from Latin America* (New York: Vintage Books, 2002).

42. Akram Zaatari, interview with the author, August 30, 2011, San Francisco.

43. Ibid.

44. Hal Foster, "An Archival Impulse," in *The Archive: Documents of Contemporary Art*, ed. Charles Merewether (London: Whitechapel Gallery; Cambridge, MA: MIT Press, 2006), 145.

45. Hal Foster discusses how artists "work horizontally, in a synchronic movement from social issue to issue, from political debate to debate, more than vertically, in a diachronic engagement with the disciplinary forms of a given genre or medium." See Foster, *The Return of the Real: The Avant-Garde at the End of the Century* (Cambridge, MA: MIT Press, 1996), 199.

46. T. S. Eliot, *Selected Prose of T. S. Eliot*, ed. Frank Kermode (New York: Farrar, Straus and Giroux, 1975), 177–78. I thank Victor Man for bringing this essay to my attention.

47. Victor Man, email message to the author, January 18, 2012.

48. James Joyce, *Ulysses* (London: Penguin Books, 2000), 42.

49. Gilles Deleuze and Félix Guattari, *A Thousand Plateaus: Capitalism and Schizophrenia*, 5th ed. (London: Continuum Books, 2004), 563.

50. Husserl, *Ideas Pertaining to a Pure Phenomenology and to a Phenomenological Philosophy*, 52.

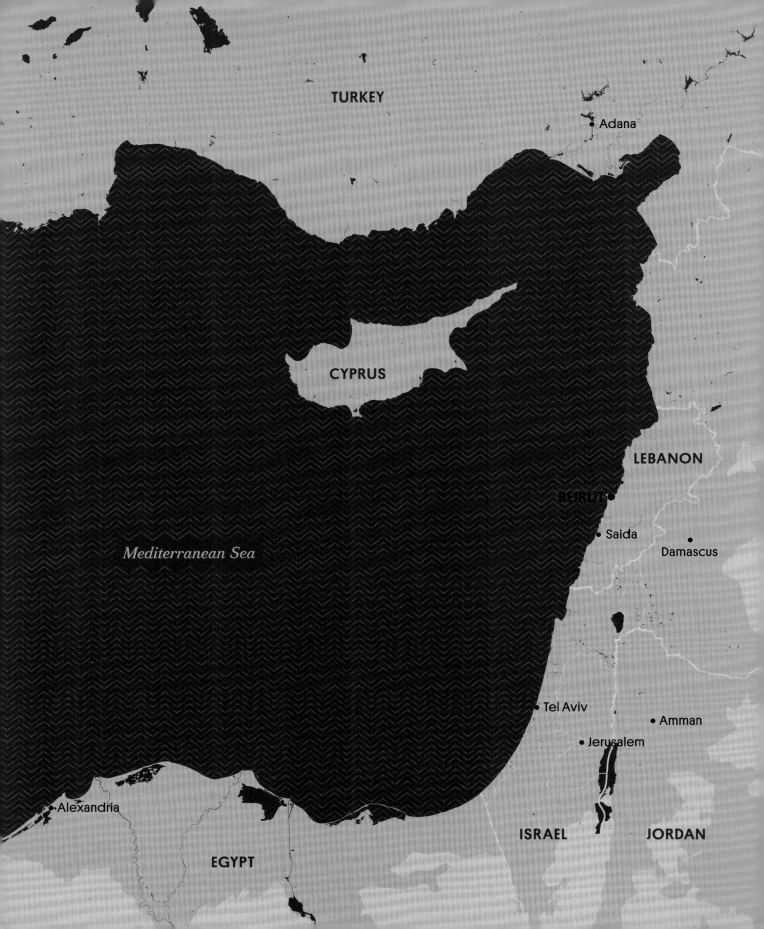

TURKEY

Adana

CYPRUS

LEBANON

BEIRUT

Saida

Damascus

Mediterranean Sea

Tel Aviv

Amman

Jerusalem

Alexandria

ISRAEL JORDAN

EGYPT

SYRIA

IRAQ

Baghdad

SAUDI ARABIA

CULTURE '45 AND THE RISE OF BEIRUT'S CONTEMPORARY ART SCENE

SARAH A. ROGERS

On October 3, 1945, Beirut's francophone newspaper *L'Orient* published an article, "Culture '45," in which the author pronounced the previous decade an artistic and intellectual renaissance for Lebanon.[1] Throughout the French mandate era (1920–43),[2] the area, which previously had supported only a few easel painters, had transformed into a vibrant art scene: a sufficient number of artists to be considered a generation; a burgeoning press that included art journalism; an audience for exhibitions; and a private, degree-granting art academy.[3] Within two decades, Beirut would assume its role as a cultural capital, bringing together regional and international artists, architects, graphic designers, gallerists, poets, and writers.[4] By the late 1960s, the small area of Ras Beirut (located between the American University of Beirut and Hamra, the city's main commercial street) was crowded with more than twenty galleries featuring the works of local, regional, and international painters, sculptors, and designers. Some of these galleries closed during the Lebanese Civil War (1975–90); others still remain, although they have relocated downtown, to the upscale arts district of Saifi Village.

The article in *L'Orient* underscored the significant role that concerted individual efforts within the private sector have played in Beirut's artistic history. According to the author of "Culture '45," the founding of L'Académie Libanaise des Beaux-Arts (ALBA) in 1937, which created the first opportunity for formal, institutionalized arts education in the country, was the crowning achievement of Lebanon's cultural flowering and a landmark contribution to its

artistic landscape.[5] Tellingly, ALBA was the initiative of amateur musician Alexis Boutros. With support for artistic practice abandoned by the state, a number of determined individuals, and particularly the artists themselves, galvanized Beirut's creative community. When these efforts were most effective—seen in the example of Boutros and the founding of ALBA—they resulted in the establishment of institutions and sustained support for contemporary practices.

Related to these singular efforts is the persistence of a fragile and volatile political situation that haunts Lebanon, lending its national history a long-standing trope: a cycle of destruction and renewal, of identity-based violence and cosmopolitan diversity. In fact, the artistic renaissance detailed in "Culture '45" would continue until the spring of 1975, when the eruption of the Lebanese Civil War shifted Beirut's standing from vibrant urban capital to unsettled site of sectarian violence. Often simplified in the Western media as a Muslim-Christian conflict, the war was a series of battles fought along sectarian, political, and proxy lines that brutally segmented the city into militia-controlled territories. After nearly two decades of violent upheaval, mass population displacement and emigration, and numerous failed cease-fires, the country entered into a fragile truce in autumn 1989, brokered with the Document of National Understanding, an agreement signed on October 22 in Ta'if, Saudi Arabia, and thus more commonly known as the Ta'if Accords. The Ta'if Accords ushered in an official yet extremely tentative end to the fighting, and Beirut eventually resumed its role as a hub for experimental artistic practice.

The end of the war coincided with the rise of celebratory globalism in the international art market, and in the following decade contemporary postwar artists earned the attention of European and American curators and critics. In the absence of an institutional structure for ephemeral practices—installations, performances, leaflets—artists circulated their work in the urban environment. Labeling Beirut as "proto-institutional," Western critics would later imply that this body of work emerged from a postwar tabula rasa: no organizations, no market, and no audiences.[6] Yet as the author of "Culture '45" had underlined forty-five years earlier, this certainly was not the case. Moreover, it is important to remember that life persisted during

17. Joana Hadjithomas and Khalil Joreige, *Circle of Confusion*, 1997. Photographic print, repositionable glue, and mirror, 118¼ × 157⅝ in. (300 × 400.4 cm). Installation view at CRG Gallery, New York. Courtesy the artists and CRG Gallery, New York

the war years, even as the violence occasionally overshadowed existence at different moments, in various geographies, and with shifting degrees of intensity. Through the efforts of dedicated individuals, the art scene resisted complete collapse, thanks in part to the fundamental role played by the private sector in creating spaces for artists. Not only did certain local organizations and galleries remain open sporadically but those cultural workers and artists who lived abroad continued their work.

What is therefore remarkable about the postwar period is the return of a generation of artists who had matured during the war years. Fleeing in the aftermath of the 1982 Israeli invasion, a time distinguished by intense violence, a number of these artists trained in Europe and the United States in a variety of disciplines. Upon their return to Beirut during the early 1990s, these friends and collaborators developed a loose association: some had trained abroad, while others had remained in Lebanon; some had known one another through family ties, while others had met through informal networks. The 1990s thus constitute a critical decade in which new and recovered cultural spaces and sociabilities catalyzed innovative platforms for experimental practices deeply embedded in postwar Beirut.

This first generation of Lebanese contemporary artists—known throughout the international art community under the rubric of the postwar generation—is most often considered to include Tony Chakar, partners Joana Hadjithomas and Khalil Joreige, Lamia Joreige, Bilal Khbeiz, Rabih Mroué, Walid Raad, Walid Sadek, Lina Saneh, Jalal Toufic, and Akram Zaatari, with the occasional participation of Ziad Abillama, Fouad Elkoury, Bernard Khoury, Marwan Rechmaoui, Jayce Salloum, and Paola Yacoub. Yet long before these artists, architects, writers, performers, and filmmakers (to name just a selection of their disciplines) exhibited internationally, they initiated a series of conversations, collaborations, projects, and exhibitions in Beirut during the early 1990s that were deeply concerned with the role of art in the aftermath of the civil war, which to many Lebanese seemed far from over. A body of work followed in which the traumatic history of the war becomes both the subject and lens of analysis as the artists probe issues of memory, history, and archive— perhaps most notably in such projects as Raad's *The Atlas Group* (1989–2004) and Hadjithomas and

Joreige's *Wonder Beirut, the Story of a Pyromaniac Photographer* (1997–2006, pls. 23–43).

Although these artists insist on not being considered a collective in any sense, their individual projects nonetheless share a critical and aesthetic interest in the visual document as a mediation of history. Resonating with postmodernist strategies that question grand narratives, postwar art in Lebanon is also intimately grounded within the immediate circumstances of its production. The disruption of narrative cohesion alludes to the inability to establish a hegemonic history of the civil war. No "master plan" existed in the postwar agreement, except for an amnesty law that enabled warlords to transition seamlessly into government positions. The national curriculum concluded Lebanon's history in 1946, after a committee of historians repeatedly failed to produce a narrative of the civil war that satisfied all of the country's sectarian factions. With remembrance deemed volatile, no national celebration decisively marks the war's conclusion. Moreover, despite the abandoned and bombed-out buildings—scars of both the fighting and failed postwar economic promises— the presence of the civil war seems to converge most visibly around the concept of what is missing: justice, history, and countless individuals.[7] In interrogating the possibility of—and even the desire for—History and Truth, this generation deploys formal strategies to confront the historical specificities of the Lebanese Civil War.[8]

Equally important to the work produced during this formative period are the cultural organizations and festivals that provided a platform for these newly emerging experimental and politically engaged artistic practices, including Ashkal Alwan, the Beirut Theater, and the Ayloul Festival. It is significant that these organizations matured along with the artists, whose presence and work ensured their necessity, particularly in a gallery-dominated market that favors painting and sculpture. Ashkal Alwan represents one of the most successful of these platforms that address art's contemporary relevance through an engagement with civil society. Since its founding in 1995, Ashkal Alwan has been organizing exhibitions in historically significant public spaces throughout Beirut; these include its internationally recognized Home Works, a multidisciplinary program that aims to generate creative exchange and critical inquiry. In the context of an art community that is extremely

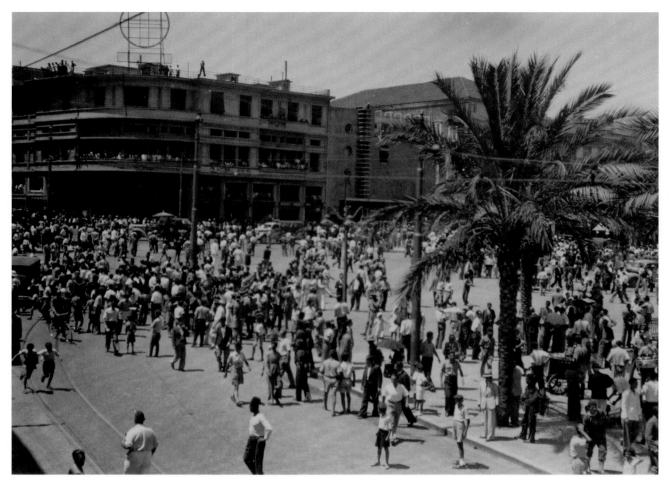

18. Ain el Mreisseh (Downtown Beirut), 1945. Collection AIF/Rose Kettaneh, courtesy the Arab Image Foundation

intimate and deeply imbued with a sense of political urgency, it is unsurprising that practicing artists themselves hold a critical role in the development and sustainability of initiatives that have come to characterize contemporary art in Beirut. And although certain projects, such as the Ayloul Festival,[9] were short-lived, the dedication to experimental practices, building art audiences, the reintegration of art within the urban environment, and the manifestation of the relationship between art and politics continue to play an important role. The Arab Image Foundation and Beirut Art Center, two of the city's most important art organizations today, were conceived and developed in part by artists as a response to the aesthetic needs of Lebanon's contemporary postwar context. Both institutions suggest that, far from being outdated rhetoric, the description in "Culture '45" of Beirut's artistic milieu and the mechanisms defining its cultural efflorescence remain vital today.

In many respects, the formal and theoretical intersections between archival document and artistic project that have come to define contemporary art, particularly in Beirut, are closely aligned with the history of the Arab Image Foundation (AIF). A nonprofit archive dedicated to collecting, preserving, and displaying photography from the region, AIF was established in Beirut in 1997 by photographers Fouad Elkoury, Samer Mohdad, and Akram Zaatari. Mohdad left the organization a few years later; Elkoury and Zaatari subsequently developed its mission and have become closely associated with Beirut's postwar contemporary art scene.

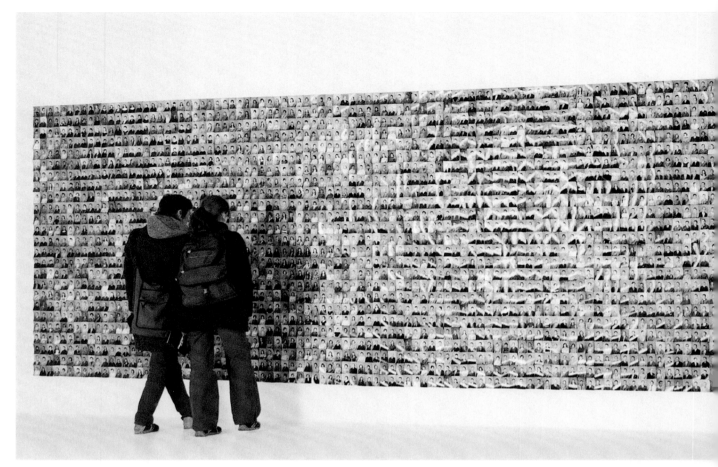

19. ID photos from Studio Anouchian (Tripoli, Lebanon) dating from 1935 to 1970. Part of *Mapping Sitting: On Portraiture and Photography* (2002), a project by Walid Raad and Akram Zaatari / the Arab Image Foundation. Installation view at the House of World Cultures, Berlin, 2003. Courtesy the Arab Image Foundation (M. Yammine Collection)

Zaatari in particular has based much of his work on collections he brought to the foundation. One aspect of AIF's mission, in fact, is to encourage artists (both members and nonmembers) to conduct research based on thematic or geographic interests rooted in the region, introduce related photographic materials to the AIF collection, and develop projects based on those materials. In addition to its founders, AIF's members include some of the Middle East's most internationally accomplished artists, such as Lara Baladi, Walid Raad, and Yto Barrada, whose practices engage with the multivalent genealogies of the photograph as historic document, visual image, and aesthetic representation.

The groundwork for AIF developed in the mid-1990s when Elkoury, then residing in Paris, arranged to meet with Mohdad, who was living in Switzerland. The two connected with Zaatari, who had recently returned to Beirut to work in television after receiving his master's degree from the New School for Social Research in New York. Each of the founders invited two additional members to form the board, and AIF was registered as a nonprofit. After acquiring the foundation's inaugural holdings on generous terms from Elkoury's family (the Pharaon Collection), Zaatari, Elkoury, and Barrada (who was then an AIF board member) spent the next eighteen months locating, researching, and collecting photographs that were in private and commercial collections throughout the Middle East, North Africa, and the Arab diaspora. Subsequent years witnessed the creation of an impressive archive of more than four

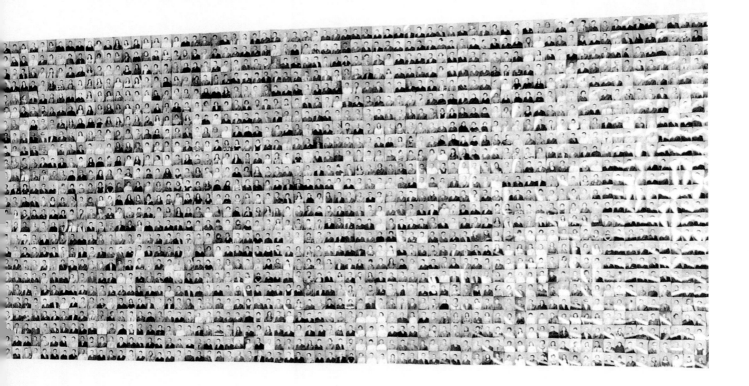

hundred thousand photographs, to a large extent from Lebanon, but also from Syria, Palestine, Jordan, Egypt, Morocco, Iraq, Iran, Mexico, Argentina, and Senegal, and dating from the mid-nineteenth century to today. Significantly, these images are made available to the public on-site and through an extensive online data-base. The board, and particularly founding director Zeina Arida, has secured local funding and numerous grants, in addition to forging partnerships that have enabled AIF to produce more than fourteen traveling exhibitions and accompanying publications.

AIF is noteworthy for its pioneer status as a regional photography archive and historically signifi-cant for its unconventional approach to archiving. It maintains a policy of noninterference with the image that prohibits alterations such as cropping or digital

manipulation when its holdings are used. Claiming neither comprehensiveness nor cohesiveness, the AIF collection is generated through artist- and research-based projects. This aspect has manifested itself through visually and intellectually absorbing exhibitions that simultaneously examine historical, theoretical, and aesthetic themes. For example, *Mapping Sitting: On Portraiture and Photography* (2002, pl. 19), which in 2005 was the first AIF project to travel to the U.S., incorporated curatorial practice and artistic work through the presentation of different modes of portraiture. Conceived by Zaatari and Raad, the presentation featured a variety of media and display strategies—including photography, video, vitrines filled with vintage photographic materials, and a modernist grid of thirty-six hundred wallet-size ID

20. Photomontage by an anonymous photographer, Fez, Morocco, n.d. Collection AIF/Yto Barrada (A. Tazi), courtesy the Arab Image Foundation

photos taken between 1935 and 1970—and emphasized a documentary and historical approach to the understanding of photographic practice as well as attention to the critical issues that are engaged and communicated artistically. Such creative approaches to collection and display (in addition to the more traditional task of preservation) have established AIF as an innovative institutional model for the relationship between contemporary art and the archive.

Like AIF, Beirut Art Center (BAC) is the first institution of its kind in Beirut. The city's only nonprofit museum wholly focused on contemporary art, BAC is the project of Lamia Joreige and Sandra Dagher, each of whom represents an individual perspective on Beirut's art scene. Previously, Dagher had been director of Espace SD, a commercial gallery

that concentrated on emerging artists. Its innovative supplemental programming, including film and lecture series, and its small bookshop made Espace SD a unique place within a Beirut gallery system that was almost completely centered on presenting established artists and traditional forms such as painting and sculpture. Joreige, meanwhile, approached the establishment of BAC from the viewpoint of a young multimedia artist. Born in Beirut in 1972, she trained in France before receiving her BFA from the Rhode Island School of Design in 1995, after which she returned to Beirut. In many ways, Joreige's work reflects the interests and approaches explored in much of Beirut's contemporary postwar art: she deploys archival photographs and video footage to engage with the relationship between individual and

21. Beirut Art Center, Jisr el Wati, Building 13, Street 97, Zone 66 Adlieh, Beirut

collective histories, particularly those that circulate around the Lebanese capital and urban memories of its civil war.

The concept for Beirut Art Center emerged from conversations between Joreige and Dagher that began in 2004. More than an exhibition space, BAC was intended to be a local and international nonprofit center dedicated to contemporary art while also providing a platform for artists operating outside the commercial circuit. As a multimedia artist, Joreige believed it was critical that they offer public access to video works, and it was determined that BAC would also have a mediatheque to archive contemporary video work and serve as a resource for texts, images, video, and sound pieces. Thus, like many of the artists associated with AIF, Joreige has demonstrated a

sustained investment in the social uses of the archive while simultaneously producing work that challenges those conventions.

One of the most difficult challenges Dagher and Joreige faced, in addition to finding a location, was securing sustained financial support. Although private foundations fund most nonprofit art organizations in Lebanon, the partners sought an alternative source through the private sector, believing that garnering financial support from the Lebanese community would not only guarantee local investment in BAC but also encourage a broader interest in contemporary visual art. In the summer of 2006, when renovations on a historic building were in the planning stage, a sudden outbreak of violence between Hezbollah and Israel brought the project to

22. *Place at Last: Walid Sadek,* a solo exhibition organized by Beirut Art Center. Installation view at Beirut Art Center, 2010

an abrupt halt. Although the difficulties of securing funding, navigating Beirut's real estate market, and overcoming Lebanon's insistent political instability almost rendered the BAC project impossible, Dagher and Joreige renewed their efforts in summer 2007 after finding a suitable space. BAC opened in January 2009, in the city's Jisr el Wati, and it rapidly became one of Beirut's leading centers for the visual arts. The creative expertise of BAC's founding board is greatly responsible for the organization's success. Dagher and Joreige had brought together individuals distinguished by their diverse perspectives on and experiences with the contemporary art scene: artist and designer Bassam Kahwaji; Maria Ousseimi, of the Ousseimi Foundation; and actor, director, playwright, and visual artist Rabih Mroué. In 2010, Nathalie Khoury, former director of Beirut's Sfeir-Semler

Gallery, which represents Zaatari and Raad, joined the board.

While BAC contributes to the creation of an audience for contemporary practices by cultivating funders from Lebanon's private sector, it also offers a diverse range of programming designed to appeal to a wider public. In addition to exhibitions, lectures, audiovisual performances, workshops, and film screenings, BAC hosts the annual emerging artists' exhibition *Exposure,* inviting jury members from different disciplines and locales to exhibit the work of artists living in Lebanon.[10] BAC also organizes solo shows for Lebanese artists who have not yet had retrospectives; for example, although Paola Yacoub, Walid Sadek (pl. 22), and Fouad Elkoury are considered some of the most important artists in the region, before their BAC exhibitions their work

had only been represented by individual projects in group shows most often organized along regional or national criteria. BAC's retrospectives offer a critical opportunity to contextualize an artist's work within a larger body of practices, thereby refraining from the thematics of identity politics that often plague regional artists. Mona Hatoum, who had never shown in Beirut, was given a solo show by BAC in 2010. The organization has also developed exhibitions with noted artists and filmmakers from abroad, including Kara Walker, Chris Marker, and Harun Farocki, inviting them to show their work in Beirut for the first time.

In addition to collaborating with Ashkal Alwan on Home Works, Dagher and Joreige recently partnered with the New Museum in New York to present "Museum as Hub: Beirut Art Center" (2011–12), a project that exemplifies BAC's dedication to expanding its audience and connecting artists to new contexts. This undertaking, which included an exhibition at the New Museum titled *Due to unforeseen events . . .* as well as public performances and screenings organized by BAC, underscored the difficulties of producing and practicing art in the volatile political context of Lebanon. BAC invited architect Tony Chakar, art historian Kirsten Scheid, and artists Ziad Abillama, Mroué, and Hadjithomas and Joreige to collaborate on the project and to consider the ways in which external factors force transformations in the production or presentation of works of art, thereby forging new and unpredictable formal and theoretical configurations. In a poetically meaningful way, the exhibition reflected broadly on BAC's institutional genealogy, one that documents the complexities of forging an infrastructure in Lebanon for multimedia visual practices. And yet BAC's location—it is in the same neighborhood as Sfeir-Semler Gallery and Ashkal Alwan's new Home Workspace—proves the vitality of Beirut's contemporary art scene despite, or perhaps more accurately because of, the most challenging of circumstances. To a degree that the author of "Culture '45" could scarcely have imagined, Beirut's cultural landscape continues to be ripe with dynamic initiatives and future possibilities.

1. Saed, "Culture '45," *L'Orient*, October 3, 1945: 2.

2. Following World War I, the League of Nations mandated that the territories of the Ottoman Empire be given independence or divided among the victorious European countries. The territory of present-day Lebanon came under French mandate. Greater Lebanon, created in 1920 under the mandate, united previously semi-autonomous Ottoman regions that had been considered part of Greater Syria: Mount Lebanon, the Beqaa Valley, and the coastal cities of Tripoli, Tyre, Sidon, and Beirut.

3. Daoud Corm (1852–1930) is regarded as the first professional painter and the father of Lebanese modern art. When grouped together, Corm and painters Habib Srour (1860–1938) and Khalil Saleeby (1870–1928) are considered to constitute the country's first generation of artists. See Maha Aziza Sultan, *Rūwād min nahdah al-fann al-tashkili fi Lubnan: Corm, Srour wa Saleeby* (The Pioneers of the Renaissance of Painting in Lebanon: Corm, Srour, and Saleeby) (Beirut: Kaslik University, 2006).

4. Beirut's mercantile history as a Mediterranean port city and its intercultural orientation have been credited with making Lebanese art exceptional in the Arab world for its lack of concern with the development of a vernacular visual language, particularly in the aftermath of Lebanon's independence from the French mandate. See, for example, Kamal Boullata, "Modern Arab Art: The Quest and Ordeal," *Mundus Artium* 10, no. 1 (1977): 121.

5. Saed, "Culture '45," 2.

6. Stephen Wright, "Tel un espion dans l'époque qui naît: la situation de l'artiste à Beyrouth aujourd'hui" [Like a Spy in a Nascent Era: On the Situation of the Artist in Beirut Today], *Parachute* 108 (October–December 2002): 13.

7. Kidnapping, a common tactic of the militias during the civil war, left some seventeen thousand individuals missing. The only form of closure is legal: a 1995 law that defines the status of missing persons as "unknown" enables families to legally declare the missing person deceased after a period of five years.

8. The 2012 selection of works submitted for BAC's annual emerging artists' exhibition indicates a shift toward a less skeptical approach to archives and the memory of the Lebanese Civil War.

9. This contemporary art festival, organized by writer Elias Khoury and cultural broker Pascale Feghali, was held every September from 1997 to 2001.

10. Here, "emerging" refers not to age but rather to level of experience and exposure.

Joana Hadjithomas and Khalil Joreige

both b. 1969, Beirut; live and work in Beirut

Since their earliest collaborations in 1999, Joana Hadjithomas and Khalil Joreige have drawn upon Lebanon's political history—and its impact felt at more personal registers—to create a variety of projects, including photography-based art installations, videos, and feature-length films. Their artwork is frequently (and obliquely) informed by domestic and regional geopolitical events such as the Lebanese Civil War (1975–90), the Israeli occupation of southern Lebanon (1982–2000), and the reunification of Yemen in 1990. However, Hadjithomas and Joreige neither rehearse straightforward documentary accounts of adversity nor seek to re-create "mythic" depictions of wartime heroics. Instead, their practice—self-described as a generalized concern with image—navigates between these two poles, questioning the role of both the photograph and the document as they shape the representation of war, memory, and history itself.

In their installation *Circle of Confusion* (1997, pl. 17), a large aerial photograph of Beirut is cut into three thousand small pieces and placed onto a large mirror. Visitors are invited to remove individual pieces from the vista, causing a simultaneous erosion of the city of Beirut and the eventual construction of a reflection, an image of the viewer. Thus, *Circle of Confusion* slyly enacts the distance between facile representation and fragmentary abstraction. Each small part of the photograph may hold individual meaning for the viewer, yet it can only represent something that is incomplete and unable to point to the complex reality of Beirut.

Wonder Beirut, the Story of a Pyromaniac Photographer (1997–2006), an installation-based project centered on the Lebanese photographer Abdallah Farah, further engages the complexity of recording and reproducing such images before, during, and after conflict. Purportedly commissioned in 1968 by the Lebanese Tourism Agency for a series of postcards promoting Beirut, Farah's photographs—replete with luxurious hotels, skyscrapers, alluring beaches, bustling souks, and tourist sites—conjure a halcyon era of the city, emphasizing its role as an exotic yet thoroughly modern destination. Realized through the support of various civic and private concerns, the postcards have enjoyed a lasting impact: years after many of the city's noted buildings and monuments have been destroyed, new reprints of the postcards can still be found in numerous stores, a curious reminder of Beirut as an idyll. Through the excavation and restaging of these materials and images, *Wonder Beirut* presents reproductions of the postcards (pls. 23–40) alongside enlarged photographs. While the postcards reinforce our understanding of the proliferation and continued consumption of an irretrievable place (e.g., Beirut as "Paris of the East," a site of both Western and non-Western modernity), the enlargements of the negatives are a sensuous blistering of myth: carefully damaged by fire and light, the photographs (pls. 41–42) appear fried or blown-out, establishing a compelling and contradictory relationship between the destruction of one image and the simultaneous creation of another. As the story goes, during this same period of war (and while frequently confined to his home or a bomb shelter) Farah took many pictures, shooting those people and locales nearest to him. Because of extremely limited resources, Farah meticulously annotated (but did not develop) these negatives, a process Hadjithomas and Joreige have described as an engagement with the "latent image." Hadjithomas and Joreige's restaging of Farah's images and texts blends fact with fiction and thus assumes a novelistic quality, implicitly asking: Under what conditions might such latent images be allowed to reappear?

—James M. Thomas

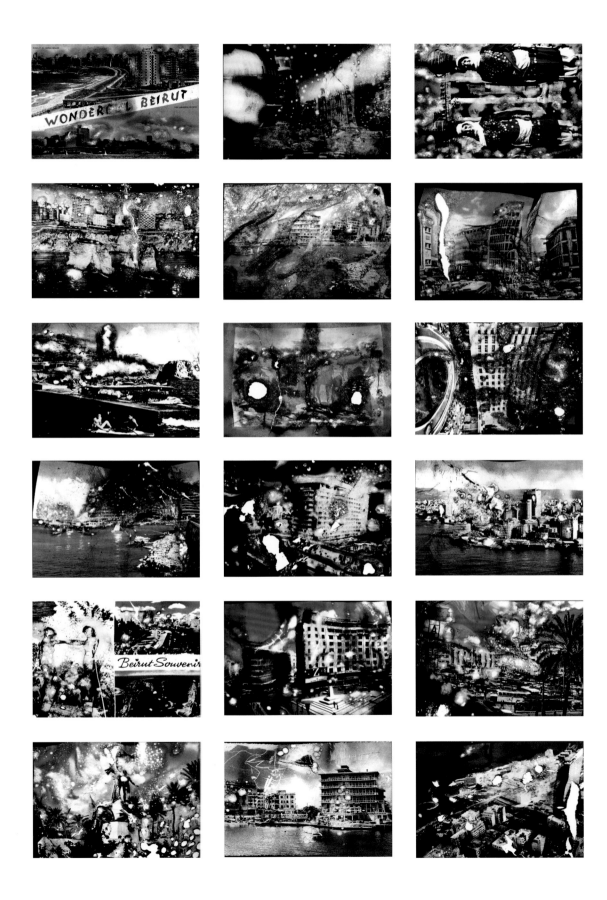

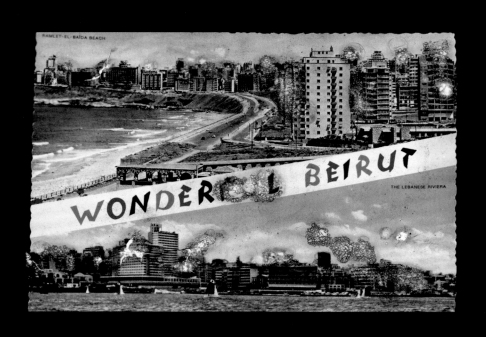

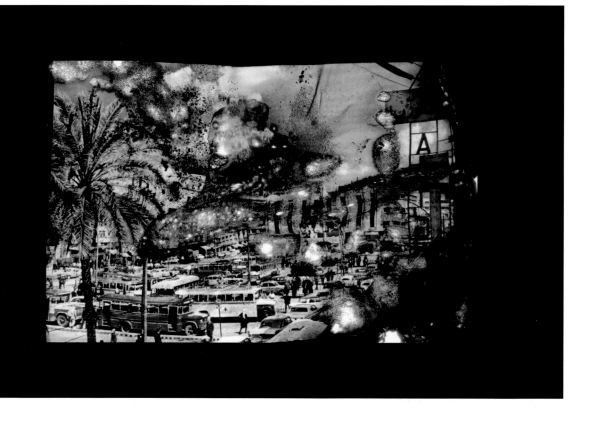

41–42 (left, top to bottom)

Joana Hadjithomas and Khalil Joreige, *Wonder Beirut #1*, *Greetings from Beirut*, from the project *Wonder Beirut*, the Story of a Pyromaniac Photographer, 1997–2006

Chromogenic print mounted on aluminum, 27¾ × 41½ in. (70.5 × 105.4 cm)

Collection of Dolly and George Chammas

Joana Hadjithomas and Khalil Joreige, *Wonder Beirut #15*, *Rivoli Square*, from the project *Wonder Beirut*, the Story of a Pyromaniac Photographer, 1997–2006

Chromogenic print mounted on aluminum, 27¾ × 41½ in. (70.5 × 105.4 cm)

Courtesy the artists and CRG Gallery, New York

23–40 (page 45)

Joana Hadjithomas and Khalil Joreige, *Postcards of War*, from the project *Wonder Beirut*, the Story of a Pyromaniac Photographer, 1997–2006

Eighteen original postcards, each 4⅛ × 5¾ in. (10.5 × 14.7 cm)

Courtesy the artists and CRG Gallery, New York

43

Joana Hadjithomas and Khalil Joreige, *Latent Images*, from the project *Wonder Beirut*, the Story of a Pyromaniac Photographer (films 809–956), 1997–2006

Chromogenic print mounted on aluminum, 18½ × 22⅛ in. (47 × 56.2 cm)

Courtesy the artists and CRG Gallery, New York

Lamia Joreige

b. 1972, Beirut; lives and works in Beirut

Lamia Joreige is a Lebanese visual artist and filmmaker whose work is grounded in her country's history, specifically its representation during periods of war and conflict. Although trained as a painter, Joreige has for more than a decade worked primarily with video, blending archival materials, interviews, and fictional elements to suggest a relationship between individual storytelling and collective memory. Her projects routinely probe the subtle beauty of quotidian items, using their aesthetics as a means of conveying experiences and shaping perceptions. A formal survey of her *Objects of War* (pls. 44–47), a series of videos and accompanying objects, succinctly frames this approach. Ongoing since 1999, the series consists of interviews recorded in chapter-like segments, in which individuals describe a prized or favorite possession. Through the objects, which frequently appear in the videos, each subject expounds upon his or her experience of the fifteen-year Lebanese Civil War (1975–90).

These items—cassette tapes, old photographs, water bottles, suitcases, flashlights, and so on—often function as extensions of the person's body, kept within arm's reach, used daily or in mundane ritual fashion in ways that suggest conditions of crisis, triage, or survival. Joreige displays the objects alongside the interviews, which are presented on monitors or projected on the gallery walls. The episodes recounted by each storyteller form authoritative and cohesive histories. Yet when viewed in succession, they inevitably appear as fragments, suggesting the impossibility of constructing a complete narrative or uncritically representing a naturalized historical truth. The objects, meanwhile, are methodically cataloged in great detail, quietly prompting questions about the politics of museological display while challenging straightforward documentary representation.

If *Objects of War* invites viewers to consider their own biased role in the reconstruction of memory, Joreige's *3 Triptychs* (2009) even more explicitly foregrounds individual subjectivity. An interactive video installation produced for the 2009 Sharjah Biennial, the work is triggered by sensors that are activated as visitors pass through a series of nine rooms. Inspired by Andrei Tarkovsky's *Solaris* (1972), Jean Cocteau's *Orphée* (Orpheus, 1950), David Lynch's *Twin Peaks* (1990–92), and

Jalal Toufic's concept of the "over-turn,"[1] the installation—which features cameras, video projections, colored light, and sound—re-presents its viewers with real-time images and recordings of themselves. Evocative of cinematic abstraction (in particular Tarkovsky's obsession with oceanic vastness) as well as Francis Bacon's disfigured portraiture, the sensuous and immersive environment of *3 Triptychs* posits lapses and ruptures in the experience of time, suggesting an estrangement from the construction of the self.

For the last fifteen years, Joreige has also been making essayistic films that probe life in postwar Beirut and question the documentary mode of recording the world around us. In *Here and Perhaps Elsewhere*, as in *Objects of War*, the personal narratives she accumulates form an incomplete history. Walking the (now) invisible Green Line that divided the city for more than a decade of war, Joreige approaches strangers and asks them if they knew anyone from the area who was kidnapped during the conflict. Her recordings of these encounters poignantly evoke a complicated history of loss. Some of the interviewees are reluctant to talk to her at all, while others feel compelled to speak out against the silence surrounding the missing that continues to pervade postwar Beirut.

—*James M. Thomas and Apsara DiQuinzio*

1. For further discussion of the over-turn, see Jalal Toufic, "Over-Turns," in *(Vampires): An Uneasy Essay on the Undead in Film* (Sausalito, CA: Post-Apollo Press, 2003), 188–200. Joreige interprets the over-turn as "a rupture of time and loss of the self." See Lamia Joreige, "Notes on *3 Triptychs*," *Afterall/ Online*, February 23, 2010; http://www.afterall.org/online/notes.on3.triptychs.

44–47

Lamia Joreige, *Objects of War*, 1999–ongoing

Mixed-media installation, dimensions variable. Tate, London

Top row: stills. Bottom row: installation views at the Nicéphore Niépce
Museum, Chalon-sur-Saône, France, 2003, featuring *Objects of War no. 1* (2002)
and *Objects of War no. 2* (2003)

Courtesy the artist

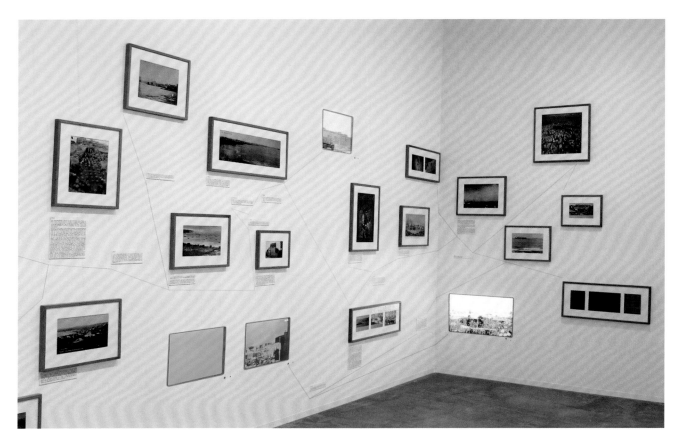

To conquer a history for myself.

48

Lamia Joreige, *Beirut, Autopsy of a City*, 2010

Mixed-media installation, dimensions variable. Commissioned by Mathaf.
Installation view as part of the exhibition *Told, Untold, Retold* at Mathaf, Doha,
Qatar, 2010

Courtesy the artist

49

**Lamia Joreige, a remake of a scene from *Wings of Desire*,
created for *Beirut, Autopsy of a City*, 2010**

Video based on a scene from the film *Der Himmel über Berlin*
(1987; known in English as *Wings of Desire*) by Wim Wenders, 3:19 min. (still)

Courtesy the artist

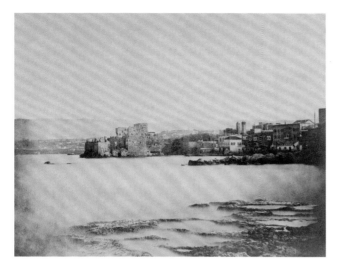

50–53
Selected images from *Beirut, Autopsy of a City*, 2010

Above left:

Othon Von Ostheim, *View of Beirut harbor taken from al-Shamieh, Beirut, Lebanon*, 1860s
Collection AIF/Nawaf Salam, courtesy the Arab Image Foundation

Anonymous, *Beirut, Lebanon*, 1977
Courtesy An-Nahar Research and Documentation Center

Above right:

Gulbenk, *Beyrouth, le port* (Port of Beirut), n.d.
Courtesy the Fouad Debbas Collection

Fulvio Reuter, *Aerial view of Beirut*, 1972–73
Courtesy the photo library of the Ministry of Tourism, Lebanon

Jalal Toufic

b. 1962, Beirut; lives and works in Istanbul

In his book *Distracted*, an ambitious collection of essays, letters, and literary fragments, Jalal Toufic discourages Lebanese filmmakers and videographers from producing works that attempt "to understand and make understandable what happened during the war years." Arguing against the reductive binary—of understanding or incomprehension—that social science, straightforward documentary practice, and journalism collectively presuppose, he instead champions a strain of art and literature supporting "intelligent and subtle incomprehension."[1]

This appeal to incomprehension, clearly reflected in the obliquely political artwork of other Lebanese artists in *Six Lines of Flight*, amounts to a nuanced and productive misreading: of a so-called postwar Lebanon still locked in conflict, of the telling of its history, and of the claim to represent fully its complexity. Toufic's provocative declaration about the state of contemporary Lebanese affairs may also be the imperative he most consistently demands of his own widely varied practice. A prolific writer of Lebanese and Iraqi descent, Toufic is at the fore of a generation of Lebanese artists, authors, and cultural agents who have helped shape a contemporary, critical, and theoretical discourse of the Arab region.

A writer, film theorist, and videographer whose own works reflect a thorough and far-reaching command of both Western and Arabic literary and philosophical influences, Toufic has a varied output that includes but is not limited to short stories, collections of aphorisms, booklets, epistolary exchanges, diaristic accounts, short videos, and book-cover designs. Throughout, he enacts an awareness of writing-as-process, touching on topics as wide ranging as film theory, sleeplessness, boredom, schizophrenia, and the ritualistic everyday. Brimming with references to Gilles Deleuze and Friedrich Nietzsche (among many others), these texts are the embodiment of Toufic's own call for "untimely collaboration." The artist's insights are conveyed through a blend of earnest prose, parenthetical asides, footnotes, and marginalia.

Toufic's provocative engagement with 'Āshūrā', a yearly commemoration whose sensationalized depiction in the media often reduces it to a Shi'ite display of self-flagellation and bloodletting, is a vivid example of such an approach. Drawing upon the Twelver Shi'ite days of remembrance in the month of Muharram, he aligns Nietzsche's writings on the torturous nature of memory—that which is literally inflicted upon us in order to make us remember—with medieval Islamic accounts of bloody martyrdom. His short video *Lebanese Performance Art; Circle: Ecstatic; Class: Marginalized; Excerpt 3* (2007) features a two-minute clip—shown once at normal speed, then at half-speed—of shirtless Lebanese men beating their chests in a ritualistic display of mourning. A related book of text and photographs, *'Āshūrā': This Blood Spilled in My Veins* (2005, pl. 54), investigates the relationships between languages, cultures, and the aesthetics of violence. In the aforementioned video, Toufic explores the martyrdom of Ḥusayn ibn 'Alī, the grandson of Muhammad, as resonating with Nietzsche's fabled breakdown of 1889: while in Turin, the philosopher is rumored to have come upon a horse being beaten and to have thrown himself upon it in an effort to save its life. In the ensuing weeks, Nietzsche, bedridden, fell into a haze of madness, growing increasingly estranged from his own body. Here, Toufic probes the historical representation of violence, musing on how Nietzsche might have reacted to witnessing the actions of the Shi'ite mourners, who are acutely aware of their own corporeality.

—*James M. Thomas*

1. Jalal Toufic, *Distracted*, rev. ed. (Berkeley, CA: Tuumba Press, 2003), 91.

54
Jalal Toufic, 'Āshūrā': *This Blood Spilled in My Veins*, 2005
Chromogenic print, 15¾ × 21 in. (40 × 53.4 cm)
Courtesy the artist

55–59

Graziella and Jalal Toufic, *Attempt 137 to Map the Drive*, 2011

Single-channel video, color, sound, 8 min. (stills)
Courtesy the artists

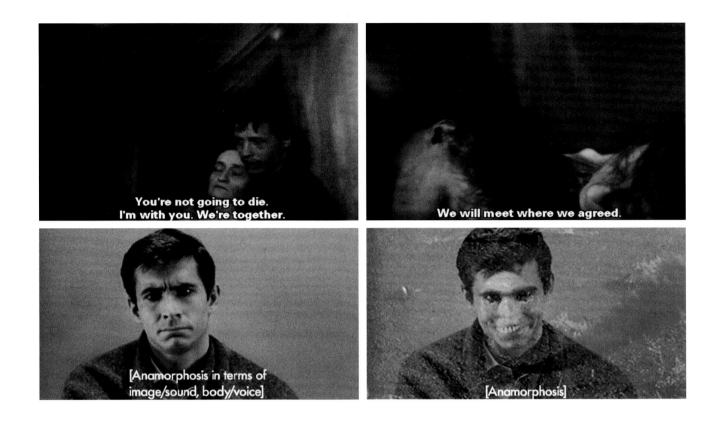

60–63

Jalal Toufic, *Mother and Son; or, That Obscure Object of Desire*
***(Scenes from an Anamorphic Double Feature)*, 2006**

Single-channel video, black and white and color, sound, 41 min. (stills)

Courtesy the artist

Akram Zaatari

b. 1966, Saida, Lebanon; lives and works in Beirut

Black-and-white photographs of young men posing in studios with props, expired Super 8 film portraits of outdated cameras and audio cassettes, the retrieval of clandestine resistance letters: these are just some of the images and subjects that shape Akram Zaatari's multi-faceted art. In unearthing and documenting objects that speak to the complex cultural and political dimensions of Lebanese society, the artist engages in a rigorous process of research, or what he often refers to as "field work," to describe the myriad activities of collecting, curating, filmmaking, and image making that define his artistic output. Zaatari's practice, which began with documentary film, is perhaps best understood as a continuous process of thoughtful exhumation and intervention: he assembles, arranges, and subtly re-presents quotidian objects that have been forgotten, overlooked, or otherwise lost to time, exhibiting photographs and videos in incisive, understated installations. These images, executed with deference to both formal elegance and the complex geopolitical phenomena that surround them, suggest a politics of intimacy amid war, conflict, and resistance without reversion to nostalgia or stereotype.

His wide-ranging body of work *In This House* (2005) to a certain extent exemplifies his conceptual process of historical and archaeological excavation through the literal unburying of a single object. In the film he records the retrieval of a letter that had been written by a member of the former Lebanese National Resistance Front, deposited in a garden, and subsequently lost for more than ten years. The film's split-screen format simultaneously presents the former resistance member telling the story of his experiences, the seemingly endless digging up of the garden, and the eventual discovery of the canister containing the letter. As tension develops, viewers begin to grasp Zaatari's skill in creating depictions that otherwise linger beyond historical reach: unearthing documents and obliquely restaging irretrievable histories. This investigation is again taken up to different effect in his project *Nature Morte* (2007, pl. 64), a series of photographs in which he visualizes the details of the landscape around the town of Shebaa in southern Lebanon, near the historically contested territory of the Shebaa Farms, still occupied by Israel. From these large images one can imagine the invisible presences that have scarred this land. In the related

video completed in 2008, Zaatari films two Lebanese men making bombs under intermittent gas light. The result, a subtle combination of fiction and reality, is a project that is as much about the viewer's projection onto the subject as it is about the subject itself, which Zaatari keeps open-ended. With both *In This House* and *Nature Morte*, the artist deftly examines how the earth carries its historical traces, which are alternately suppressed and surfaced over time. The object is ultimately uncovered in *In This House* and its story revealed, but in *Nature Morte* the objects and traces are many and remain invisible, suggesting the earth as the ultimate archive, a place of endless secrets.

For over a decade the artist has examined artifacts from Studio Shehrazade, the Saida-based establishment of photographer Hashem el Madani (b. 1928), whose practice dates to the late 1940s. Madani offered professional portraits, bought and sold photographic and film equipment, developed film, and sold cheap pinup postcards. Zaatari has completed many projects based on Studio Shehrazade through a sustained and ongoing study of Madani the photographer and the various elements housed in the studio. Throughout the process he reveals Studio Shehrazade as a densely layered site of social production, where the making and exchanging of images was socially codified and valued over a prolonged period of time. An installation comprising many different media formats, Zaatari's *Twenty-Eight Nights and a Poem* (2010, pls. 15, 65–92) excavates the dozens of objects in the studio—the minute parts within a larger whole—to reveal how these diverse elements cumulatively tell a story about the nature of the image in the mid-twentieth century and beyond.

—James M. Thomas and Apsara DiQuinzio

64

Akram Zaatari, *Nature Morte—Landscape,* **2007**

Chromogenic print, 57½ x 70⅞ in. (146 × 180 cm)

Courtesy the artist and Sfeir-Semler Gallery, Beirut and Hamburg

kram Zaatari, *Twenty-Eight Nights and a Poem*, 2010

ixed-media installation, dimensions variable. Pictured: twenty-eight
romogenic prints

ourtesy the artist and Sfeir-Semler Gallery, Beirut and Hamburg

Archive 01
Super 8 film reels

Archive 02
Metallic boxes containing Hashem
el Madani's 35mm negatives

Archive 03
etallic boxes containing Hashem
el Madani's 35mm negatives

Archive 04
Metallic boxes containing Hashem
el Madani's 35mm negatives

Archive 05
Metallic boxes containing Hashem
el Madani's 35mm negatives

Archive 06
Cardboard boxes containing
Hashem el Madani's 6.5 × 9 cm
sheet film negatives

Desk Tools 01
Watercolor and China-made
math sets

Desk Tools 02
Pencils sorted by size

Desk Tools 03
Mechanical pencils, lead sets,
and white sandpaper

Desk Tools 04
Pencils, lead set, and black
sandpaper

Desk Tools 05
Retouching tools

Desk Tools 06
Super 8 film splicers and Kodak
film cement

Desk Tools 07
Mini guillotine paper cutter and
Studio Shehrazade receipt book

Desk Tools 08
Studio Shehrazade stamp, date
stamp, ink pad, and red pad ink

Desk Tools 09

Desk Tools 10

Desk Tools 11

Desk Tools 12

Vitrine 01
Kodak Colorburst 250
Polaroid camera

Vitrine 02
Binoculars

Vitrine 03
Yashica-Mat 124 G 6 × 6 camera

Vitrine 04
Yashica and Zenit 35mm cameras
with Pentax and Starblitz flashes

Vitrine 05
Postcards 01: Blondes

Vitrine 06
Postcards 02: Arab film stars

Vitrine 07
JWACO radio cassette recorder

Vitrine 08
"L'enlèvement" (The Kidnapping),
an episode of the 1970s British
television series *The Protectors*
(Super 8 film reel) found in
Hashem el Madani's studio

Vitrine 09
Pentax MX 35mm body and
five flashes

Vitrine 10
Chinon 1206 Super 8 camera
with microphone

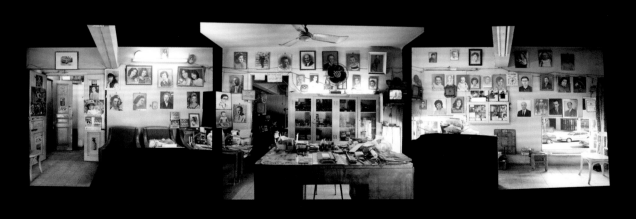

Akram Zaatari, *Studio Shehrazade*, **2006**
Digital chromogenic print, 43⁵⁄₁₆ × 118⅛ in. (110 × 300 cm)
Courtesy the artist and Sfeir-Semler Gallery, Beirut and Hamburg

NICARAGUA

COSTA RICA

San José ●

PANAMA

Panama City ●

Pacific Ocean

ME VOY PA' CALI: RECLAIMING A REGIONAL IDENTITY AND PRACTICE[1]

MICHÈLE FAGUET

In a recent essay narrating the history of Helena Producciones, the Cali-based artist collective he cofounded in 1998, Wilson Díaz contextualizes the Colombian art scene of the late 1990s against a back-drop of violence, economic depression, and general cultural malaise that characterized the decade.[2] For a city still reeling from the impact of the brutal drug cartel that had been active there between 1977 and 1998,[3] and shaken by a phase of corruption and greed in the 1980s that nearly destroyed its already delicate social fabric, this period seemed particularly bleak even in a region long accustomed to the effects of war and social conflict. Significantly, the pessimism that motivated Díaz and a group of like-minded art professors and recent art school graduates to actively contribute to bettering the cultural landscape of Cali was premised upon a nostalgia for the city's golden age—the 1970s—when an incredibly vital artistic community had emerged, transforming this small, peripheral city into an important cultural center that became a reference point for successive genera-tions of cultural practitioners from other parts of the country and throughout Latin America. With its first major project, *Terror y escape* (Terror and Escape), in 1999, Helena explicitly reclaimed this historical lineage by drawing upon "tropical gothic"—a local tradition articulated in the writings of Andrés Caicedo and the films of Carlos Mayolo and Luis Ospina, among others.[4] *Terror y escape* included a film series, a pub-lication, and an exhibition featuring canonical works from the 1970s as well as more recent projects by young artists from Cali and Bogotá.

The 1970s was a time of tremendous growth in Cali, spurred by an influx of rural migrants who had been displaced by the armed conflict that began in 1948, following the assassination of presidential candi-date Jorge Eliécer Gaitán. Industrialization also played a significant role in the city's transformation: after the United States drastically limited the import of Cuban sugar in 1960, Colombia became a leading sugar exporter, with Cali as its largest production hub. This tropical city is famous for its lively street culture, its status as a burgeoning center of salsa music, and the friendly disposition of its inhabitants, whose warmth and willingness to look beyond class and racial barriers stand in contrast to the guarded, mistrustful tempera-ment often attributed to Bogotanos, the residents of Colombia's capital city. Cali has nevertheless suffered from the problems endemic to a hierarchical society whose economic structure is based on exploitation and inequality. Such contradictions naturally drew the attention of artists such as Caicedo, a young writer and aspiring filmmaker with an obsession for macabre subjects, the stories of Edgar Allan Poe, and American horror films. Although his prolific output was chiefly published after his suicide in 1977, Caicedo became a leading figure in the creation of a literary and visual language that addressed the precarious and conflicted nature of Colombian urban culture but was influenced as well by the global countercultural, revolutionary spirit characteristic of those years.

Caicedo was part of a group of visual artists, filmmakers, and writers associated with Ciudad Solar, the country's first alternative space. Founded by Hernando Guerrero in a nineteenth-century mansion his family owned in downtown Cali, Ciudad Solar (1971–77, pl. 95) featured an art gallery, a darkroom, a printmaking studio, a store selling artisan goods, and temporary living quarters for participating artists, whose presence lent the space a communal atmosphere. Caicedo screened films every week in the building's large central courtyard, and these gatherings—called the Cine Club de Cali and frequented by Mayolo and Ospina as well as film historian Ramiro Arbeláez—were seminal to the development of the unique film culture in the city that was later dubbed "Caliwood."[5] The activities of Ciudad Solar provided many young filmmakers, artists, and curators with the opportunity to initiate

94. View of Cali from Cristo Rey hill

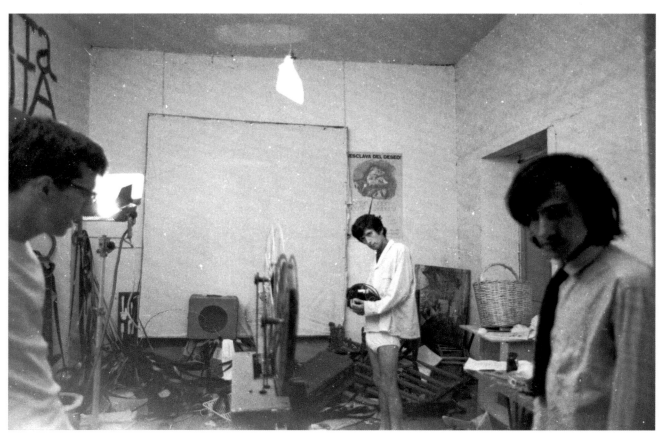

95. Ciudad Solar during the filming of *Angelita y Miguel Ángel* (1971; directed by Andrés Caicedo and Carlos Mayolo). Production photo by Eduardo Carvajal. Pictured, from left: Andrés Caicedo and actors Jaime Acosta and Guillermo Piedrahita. Courtesy Eduardo Carvajal

their practices. Mayolo and Ospina gave the space production credit for their first collaborative film, *Oiga vea* (Listen Look, 1971), although, in reality, this was purely a gesture of solidarity. That same year, Miguel González (today an established cultural figure who long held the position of curator of the Museo La Tertulia in Cali) was in charge of the Ciudad Solar art gallery, where artists including Oscar Muñoz and Fernell Franco first showed their work. According to González, those associated with the space were united by their interest in urban themes that had previously been unexplored in Colombian art, film, and literature. Perhaps the most emblematic work in this vein was that of Franco, a photographer whose traumatic biography mirrored much of the drama and instability of a society in conflict.[6] Unlike many of his friends at Ciudad Solar, Franco did not come from an affluent family; he was among the thousands

who had fled the countryside to settle in Cali's poor, marginalized neighborhoods. As a photojournalist in the 1960s he documented rural massacres as well as riots in some of the city's toughest areas before meeting Alegre Levy, a young cultural reporter who introduced Franco to the realm of art and culture, allowing him to discover the aesthetic possibilities of a medium whose technical aspects he had mastered so well. Although Franco would never establish himself as a full-time, professional artist and continued for many years to sustain his photographic practice by working in advertising, he produced several extraordinary series documenting the various stages of urban destruction and transformation in Cali and neighboring areas, becoming something of a cult figure for subsequent generations. Among his most celebrated series is *Prostitutas* (Prostitutes, 1970, pl. 96), a group of black-and-white photographs of

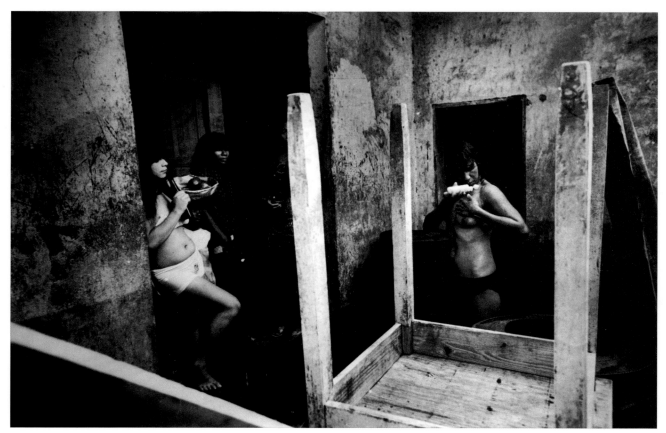

96. Fernell Franco, *Untitled,* from the series *Prostitutas* (Prostitutes), 1970. Gelatin silver print, 19¼ × 27⅝ in. (49 × 70 cm). Courtesy Fundación Fernell Franco

women and girls working in one of the last brothels in Buenaventura, a declining city that had once been a prosperous port. He first showed the work at Ciudad Solar, and it was restaged by Helena Producciones almost three decades later—along with works by Caicedo, Mayolo, Ospina, and Muñoz—in an effort to preserve the achievements of that generation while positing the need for a renewed aesthetic engagement with a society still in crisis.

Shortly after *Terror y escape*, Helena began focusing exclusively on the activity for which it has become best known: the organization of the Festival de Performance de Cali. Initiated by Wilson Díaz and Juan Mejía (prior to the existence of the collective) in 1997, the festival began as a relatively informal one-day event that featured (among other actions) an artist who quietly defecated in the corner and then ate what he had excreted with slices of bread and

apples;[7] an invitation to snort lines of cocaine forming letters that spelled out the names of canonical figures such as Joseph Beuys and Hélio Oiticica; and a serenade to a lover on the eve of his departure from the country. Like the collective itself, with its constantly shifting configuration of members, the festival experienced many transformations, mostly related to funding, over the next decade.[8] Yet its spontaneous, sometimes chaotic, and democratic character endured. As a forum in which a great many artists— both emerging and established, Colombian and international—have participated, the festival helped resuscitate the vitality and status of the cultural scene of a city that once contributed greatly to the country's artistic and cultural patrimony. The medium of performance, with its economical nature and inherent element of surprise (as Mejía has pointed out, you never know what the work will be until it has taken

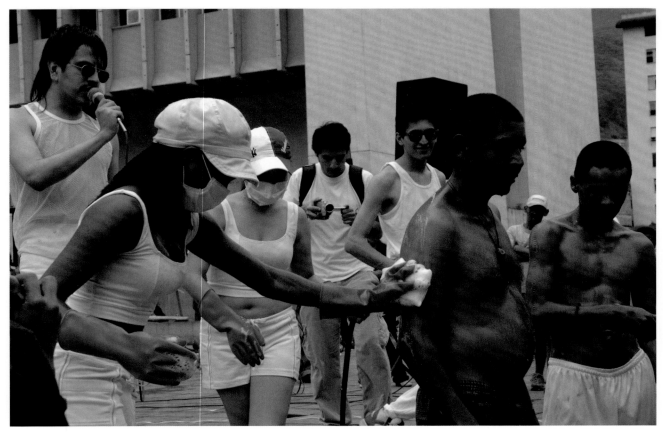

97. Colectivo Pornomiseria, *Limpieza social: Un espectáculo de rehabilitación* (Social Cleansing: A Rehabilitation Spectacle), 2006. Performance at the Festival de Performance de Cali VI, April 29, 2006. Courtesy Helena Producciones

place), has proved most appropriate to the precarious, unstable context of life in Cali.

A review of the performances, interventions, workshops, exhibitions, lectures, and other events that have been part of the Festival de Performance de Cali over the years (see pp. 78–93) provides a comprehensive picture of contemporary art in Cali and Bogotá. The festival's very structure encourages artists to engage critically with the local context, and the opportunity to create interventions in public spaces has led to diverse performances. Carolina Caycedo, for *Ser caleño* (Being from Cali, 1999, pl. 116), videotaped conversations with locals who were asked to describe the city and their attitudes toward it. Santiago Sierra's 2002 *Lona suspendida de la fachada de un edificio* (Canvas Suspended from a Building Facade, pl. 131), a giant American flag mounted on the exterior of the Museo La Tertulia, was vandalized within days by local

agitators, much to the artist's dismay, and had to be removed.[9] *El Vicio TV* (2006, pl. 138) was a mobile television studio mounted by the Bogotá video collective El Vicio Producciones; passersby as well as other festival artists were invited to perform spontaneously, and the resulting variety show–type footage was edited into a documentary about the festival later broadcast on national television. The emergence of dialogues between festival works from different years has been particularly interesting; for example, Rosemberg Sandoval's performances with homeless adolescents in the second and third festivals (1998 and 1999) were protested in the sixth festival (2006) by Colectivo Pornomiseria (Poverty Porn Collective), a group of artists who bathed homeless people in a busy plaza and then asked them to don white T-shirts with *Obra social* (Social Work) printed on them (pls. 97, 132). In addition to critiquing the ethics of

98. A book from the collection of La Escuela de Esgrima con Machete de Puerto Tejada (Puerto Tejada School of Machete Fencing), n.d. Courtesy Helena Producciones

Sandoval's work, the group cited an important local cultural reference: Mayolo and Ospina had coined the term *pornomiseria* in *Agarrando pueblo* (known in English as *The Vampires of Poverty*), their 1978 satire of exploitative Colombian documentary films (see pp. 98, 100–101). The festival has also fostered an engagement with political and social issues that have connected with a wider audience. For example, the fifth festival (2002) received extensive media coverage in response to an act of self-mutilation by French artist Pierre Pinoncelli (pl. 130), who cut off part of his pinky to protest the kidnapping of presidential candidate Ingrid Betancourt by the Revolutionary Armed Forces of Colombia (Fuerzas Armadas Revolucionarias de Colombia: FARC) earlier that year.

In 2005 Helena was selected to curate the *11 Salón Regional de Artistas, zona Pacífico*, one of many annual exhibitions organized by the Colombian

cultural ministry. In response to the methodology of these conventional Colombian salón-style exhibitions,[10] which tend to favor a predictable roster of local artists and works likely seen numerous times before, Helena conducted field research in remote cities and towns in the departments (that is, states) of Cauca, Chocó, and Valle del Cauca, large portions of which have long been isolated due to the extreme violence experienced there. The resulting exhibition not only included a number of self-taught artists but also sought to expand the terrain of the visual arts to include a broader arena of cultural and social practices, thus breaking with the elitist, hierarchical character of typical salóns. One of the most interesting participants was a fencing school from Puerto Tejada (pl. 133), where descendants of slaves continue to practice a tradition unique to the area, fencing with machetes. They use the blades in their daily lives as

sugarcane workers; however, because the machete was frequently employed as a weapon throughout Colombian history, it also carries powerful symbolism. During the wars for independence, slaves were trained in the art of fencing and then sent to battle. Many of those who survived were able to escape, and the practice of this once aristocratic activity was appropriated and transmitted, secretly, from generation to generation. The sport was transformed and further developed through a series of illustrated handmade books that were carefully preserved by the school's founders (pl. 98).

The experience of curating the salón proved significant to Helena, prompting its members to conceive of new working methods and formats with which to research and help preserve small slices of cultural history and tradition such as the Puerto Tejada story—an important contribution in a country fragmented by geographic barriers, class and racial hierarchies, and violence. Since 2005 they have conducted numerous workshops and community-oriented projects throughout the country's Pacific region as part of an initiative they call La Escuela Móvil de Saberes y Práctica Social de Helena Producciones (Helena Producciones Traveling School of Knowledge and Social Practice, pl. 110), which is funded by the cultural ministry. Always collaborative in nature, the projects are informed by discussions with community members that clarify local interests and how Helena's presence can be of benefit. They have initiated a wide range of activities, including (to name just a few) a painting workshop with children at an indigenous reserve where community leaders are actively trying to resuscitate a language and culture threatened with extinction; a palm-weaving workshop in a *palenque*, or settlement of former slaves, that also involved discussions about the sustainability of microenterprises; and, in the provincial city of Popayán, a symposium at which Colombian art professionals discussed the viability of practicing art in their country. Social engagement enacted by visual artists is often a polemical issue, and in Colombia it has been a point of contention for decades. The Escuela Móvil is unusual because it functions as a pedagogical project, the results of which are meant to be retained by the communities it serves rather than used as raw material for artworks made and disseminated in a very different context. The school gives Helena the rare experience of engaging with social and historical

formations that have been systematically excluded from official cultural discourse in Colombia (and are often much more interesting than what transpires in the Colombian art world), while it challenges the conventional understanding of what it means to be an artist. It also provides the economic means to sustain the collective and the practices of individual members.

Despite the renewal of the art scene in Cali in the late 1990s and early 2000s, many artists continued to migrate to the capital, Bogotá, to attend school and/or to sustain their practices as artists by accepting teaching positions at the country's major universities. Although Cali had long been recognized for producing a disproportionately large number of interesting visual artists given its size and distance from the capital city, Bogotá was still very much the center of activity. Its more conventional infrastructure of museums as well as commercial, university, and municipal galleries had managed to create an active, if fragmented, art scene while nevertheless failing to contribute productively to the development of critical or experimental tendencies within it. There were important if fleeting precedents in Bogotá for independent, self-organized initiatives, including Gaula (1990–91), followed by Espacio Vacío (Empty Space),[11] which endured for six years (1997–2003) but, as artist Víctor Albarracín wrote, "ended up honoring its own name, as its final exhibitions progressively lost the public's interest, resulting in a space that was almost literally empty."[12] The early 2000s were marked by two initiatives that developed more coherent models of institutional critique. With its notably structured, international program, Espacio La Rebeca (2002–5) became the first independent space in Colombia to receive funding from international foundations.[13] Its unexpected closure precipitated the opening of El Bodegón—an exceptionally vital, locally oriented space that also closed prematurely (in 2008), after several inexplicably unsuccessful attempts to acquire operating grants from both Colombian and non-Colombian sources. It seems that the very lack of a stable cultural infrastructure in Cali—along with its character as a tropical city whose slow pace and sociability contrasted markedly with the cold and rainy climate and conservative mind-set of Bogotá—has necessitated the kind of artist-run culture that has yet to be fully appreciated in the capital.

In 2003 Oscar Muñoz began to conceive an ambitious new project for Cali based on his experience

99. Lugar a Dudas, Calle 15 Norte no. 8N–41, Barrio Granada, Cali

with Ciudad Solar as well as his knowledge of similar initiatives throughout Latin America. Inaugurated two years later in a beautiful old house that Muñoz purchased and restored, Lugar a Dudas (A Place to Doubt)[14] attempted to create a stable, sustainable cultural center in Cali but also fulfilled Muñoz's desire for greater personal interaction with both his peers and a growing community of emerging artists.[15] It is important to note that Lugar a Dudas (pls. 99–103) was neither posited as an alternative to local institutions (such as the Museo La Tertulia or Cali's art school, the Instituto Departamental de Bellas Artes) nor intended to critique them; rather, it was positioned as a complementary space that welcomed collaboration and partnerships, aiming to preserve the city's cultural and artistic legacy while providing greater incentive for young artists, writers, curators, and filmmakers to stay in Cali.

Lugar a Dudas—located in a traditional residential neighborhood that has seen many homes leveled or converted into bars, restaurants, and boutiques catering to the nouveaux riches engaged in the city's drug trade—also represents a small but significant gesture toward preserving an urban fabric threatened with imminent destruction. Adjacent to the front courtyard is a small gallery, always visible to passersby through a plate-glass window, which regularly features new exhibitions. It is here, and in a larger gallery space inside the house, that Lugar a Dudas presents a range of art—from new pieces by young Colombian artists to canonical works by established international figures. But art exhibitions are not the emphasis of this project; rather, Lugar a Dudas has focused on developing a residency program for local and international artists and organizing a film club with weekly screenings. Arguably the organization's most significant

100–103. Recent events at Lugar a Dudas: Latin American Studies reading group organized by Cocodrilo Azul, March 22, 2012 (top left); "No es gestión, es arte," a talk by artist in residence Kadija de Paula and Claudia Patricia Sarria-Macías of Helena Producciones, February 4, 2012 (top right, bottom right); and Paola Gaviria, *En vitrina*, live drawing performance, August 13–September 2, 2010 (bottom left)

contribution is its library and archive, which is free and open to the public; its holdings include previously scarce or inaccessible primary sources documenting Cali's cultural history as well as publications covering contemporary art and theory in a global context. The library's collections were formed primarily through gifts, and they include, for example, an impressive and comprehensive archive of Colombian film history donated by Ramiro Arbeláez. By offering a broad range of resources to its community and providing a base of operations for artists visiting Cali, Lugar a Dudas has succeeded in supporting many layers of

local culture—as a research center, a platform for dialogue and exchange, a place to see art and attend lectures, and simply as an inviting space to meet with friends and hang out on the café patio, enjoying the afternoon breeze for which the city is famous.

Ten years ago, Cali would probably not have been on the itinerary of an artist or curator visiting Colombia for the first time. Today, thanks in part to the activities of Helena and Lugar a Dudas, this has changed. In the precarious context of cities like Cali, claiming a place on the global cultural map strengthens the local scene and the visibility of its

artists; however, sustainability, consistency, and longevity are equally important goals. In the face of such challenges, efforts to identify, package, and export local art scenes for international consumption (an occupation of which the art world has become quite fond in the last two decades) can seem trivial. The tension created by these competing interests can be felt within Colombia, where there has been a tendency to generate a great deal of hype around the city's so-called revival: in 2008 the *Salón Nacional de Artistas* was moved from its usual setting in Bogotá to a group of venues in Cali—including and subsuming, to some extent, both Helena and Lugar a Dudas. The salón's extensive roster of international artists was unprecedented, and it attracted an equally international audience to what seemed to be yet another large-scale biennial in an exotic location. Visitors who ventured away from the exhibition's major installations, however, had the opportunity to see Ciudad Solar reconstructed at its original site—a testament to a time when the city was still unburdened by the demands and expectations of a globalized art world. Ciudad Solar's re-creation for the salón was an important reminder that this previous generation in Cali remains present in the minds of those committed to preserving and building upon the cultural legacy of that period in local history.

1. "Me voy pa' Cali," which translates as "I'm Going to Cali," is the title of a hit 1992 song by Venezuelan salsa star Oscar D'León.

2. See Wilson Díaz, "Una versión de la historia de Helena Producciones," in Helena Producciones, *Festival de Performance de Cali-Colombia* (Cali, Colombia: Helena Producciones, 2006), 7–25.

3. Sadly, outside Colombia, Cali is perhaps best known for the product exported by the cartels.

4. Mayolo described "tropical gothic" as a Latin American variant of British or Southern gothic literature and film. His two feature-length films, *Carne de tu carne* (Flesh of Your Flesh, 1983) and *La mansión de araucaima* (The Mansion of Araucaima, 1986), are paradigmatic of the genre, as are Ospina's *Pura sangre* (Pure Blood, 1982) and Caicedo's unfinished novel *Noche sin fortuna* (Unfortunate Night, 1976).

5. For a brief overview and comprehensive bibliography of Colombian cinema in the 1960s and 1970s, see my article "*Pornomiseria*: Or How *Not* to Make a Documentary Film," *Afterall* 21 (Summer 2009): 5–15.

6. Between 2001 and 2004, Colombian curator and researcher María Iovino conducted a series of fascinating conversations with Franco about his life and the development of his work. An extracted, translated version can be found in Fernell Franco, *Fernell Franco: Amarrados [BOUND]* (New York: Americas Society, 2009), 28–57.

7. A concise interpretation of this rather extreme action is offered by Juan Mejía: "[Fernando] Pertuz had traveled all night by bus from Bogotá and arrived that morning. He went to Cali to eat his own shit and then returned to Bogotá. I've always said, if that's not art, nothing is. Aside from the metaphor, which can be read in several different ways, was the conviction and motivation behind this important gesture." See Mejía, "Welcome," in Helena Producciones, *Festival de Performance de Cali-Colombia*, 166, my translation.

8. With the exception of a four-year lag precipitated by a failed experiment with private funding, the festival has for the most part taken place annually or biennially. Since 2006 it has received financial and organizational support from major international foundations as well as the Colombian cultural ministry.

9. The protestors, a group of students from the Universidad del Valle, burned a small portion of the flag. They then stormed into the artist's talk carrying a Colombian flag, although they neither identified themselves nor made any statements. Sierra cancelled his talk in frustration.

10. Although the legitimacy of these archaic and expensive presentations has been debated for years, they have nevertheless persisted, to the detriment of perhaps more efficient and productive uses of the state's uneven allocation of cultural funding.

11. Both spaces were headed up by artist Jaime Iregui, who went on to create *esferapública*, an online forum that has greatly contributed to the development of institutional critique in Colombia.

12. Víctor Albarracín, "Antagonismo y fracaso: la historia de un espacio de artistas en Bogotá," in Ministerio de Cultura, Universidad de los Andes, *Ensayos sobre arte contemporáneo en Colombia, 2008–2009* (Bogotá: Universidad de los Andes, 2009), 90, my translation. Albarracín is one of the founders of El Bodegón.

13. Espacio La Rebeca was a project I conceived for Bogotá following my tenure as director of La Panadería in Mexico City from 2000 to 2001. It was based on an academic model of institutional critique as well as my interest in artist-run spaces in Switzerland and Canada. La Rebeca received a three-year grant for programming support from The Daros Foundation. The Foundation later provided the funding used to purchase the house where Lugar a Dudas is based.

14. Although Lugar a Dudas does not translate easily into English, A Place to Doubt is a good approximation.

15. Muñoz has stated that an important motive behind opening Lugar a Dudas was to resist his tendency to isolate himself in his studio. See Humberto Junca, "Sin Lugar a Dudas," *Arcadia* 17 (February 2007): 13.

Wilson Díaz

b. 1963, Pitalito, Colombia; lives and works in Cali

Since the mid-1990s Wilson Díaz has been creating works centered around the production and distribution of the coca plant, addressing issues such as geopolitics, land use rights, agro-industrial monopolies, drug trafficking, propaganda, and the connections between popular culture and war. With an acute sensibility to the complexities of Colombia's political and social situation, he employs a variety of media—including installation, performance, video, photography, music, and painting—to create art that resists simplistic interpretations.

Music is a key element in the artist's work, and is used both as a medium and as a focus of research and investigation. In addition to recording music—notably mock protest songs created in collaboration with the Colombian band Las Malas Amistades (pl. 122)—Díaz has amassed a collection of LP records, including popular music by an array of Colombian bands, albums created for political campaigns, and recordings by musical groups from both the army and the guerrilla factions. He has produced large canvases based on a few of their covers, working in pastel colors following an aesthetic that resonates with traditional Colombian sign painting. The simple, graphic quality of these works, however, is infused with parody: Díaz intricately layers references to propaganda, political discourse, popular music, and visual culture with symbols that reflect the country's ongoing surplus of violence.

Many of Díaz's works attempt to disrupt the communications monopoly of the mass media—which functions both at local and international levels to transmit messages that respond to specific interest groups—by introducing subaltern voices alongside fictional elements that erode the occlusive discourse produced by mainstream news outlets. In 2000 Díaz visited what at the time was the demilitarized zone, an area of nearly twenty-six thousand square miles (forty-two thousand square kilometers), which in 1998 had been given by Andrés Pastrana, then president of Colombia, to the Revolutionary Armed Forces of Colombia (Fuerzas Armadas Revolucionarias de Colombia: FARC). The artist created his own representations of an official encounter organized there, producing a series of videos, including *Baño en el cañito* (Bathing in the Canal, 2000) and *Los rebeldes del sur* (The Rebels of the South, 2002). These thoughtful works open up to a multiplicity of interpretations, mirroring the diversity of public opinion.

Díaz is particularly focused on the impact that coca cultivation has had on rural areas, an interest that stems from his own background: he was born and raised in the countryside in the region of Huila, where coca farming remains extensive. By concentrating on the rural context, he brings to the fore the connections between farming and land control, whether imposed by the Colombian government or by armed insurgent groups. In 2008 Díaz began collaborating with Bay Area artist Amy Franceschini, developing the project *Movement of the Liberation of the Coca Plant*, which includes a series of botanical drawings made with coca charcoal and natural pigments. The drawings—which formally reference the aesthetic of José Celestino Mutis, a Spanish botanist who in the eighteenth century led the Royal Botanical Expedition in New Granada—depict the coca plant alongside the native flora commonly cultivated by farmers in the zone of conflict. For more than a decade, aerial fumigation of Colombian coca has occurred as part of Plan Colombia, an integrated strategy launched in 2000 by the Colombian and United States governments to eradicate illegal crops. The drawings highlight the devastating impact that the application of Roundup Ultra, a broad-spectrum herbicide developed and distributed by the U.S.-based multinational company Monsanto, has had on farming in general: the herbicide contaminates legal crops, such as avocado and yucca plants,[1] as well as the local soil, air, and water. Since the second half of the twentieth century, the living conditions of Colombian farmers have been brutally transformed, and the countryside, which was once idyllic and bucolic, has become a site of violence and destruction.

—*María del Carmen Carrión*

1. For further discussion of the impact of aerial fumigation, see J. P. Messina and P. L. Delamater, "Defoliation and the War on Drugs in Putumayo, Colombia," *International Journal of Remote Sensing* 27 (January 2006): 121–28; http://www.glifocidio.org/docs/impactos%20ambientales/ia12.pdf.

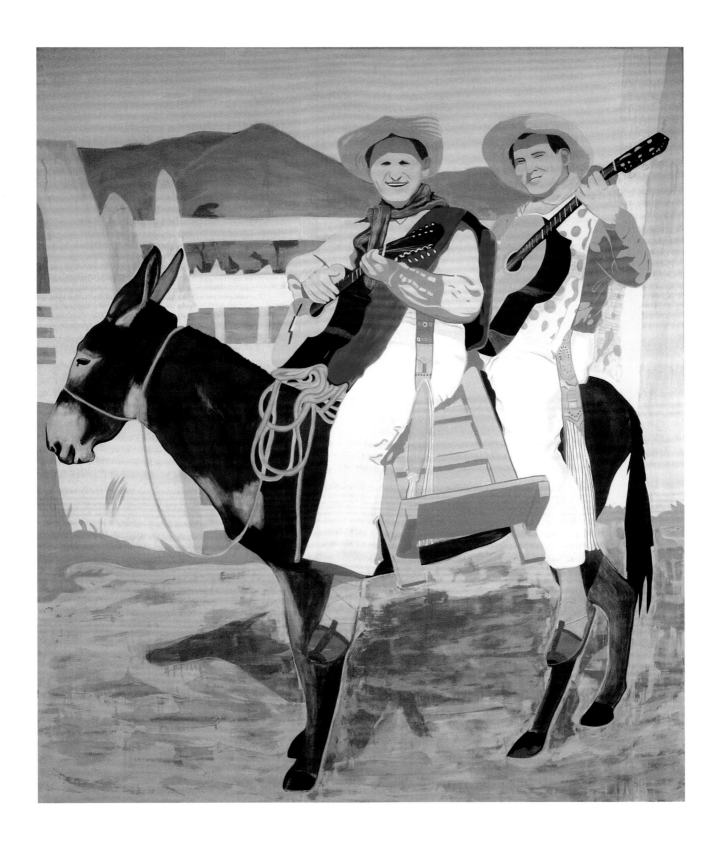

104 (previous page)

Wilson Díaz, *Untitled,* **from the series** *La flor caduca de la hermosura de su gloria* **(The Flower Fades from the Beauty of Its Glory), 2011**

Acrylic on canvas, 87 ¹³⁄₁₆ × 72 ⁷⁄₁₆ in. (223 × 184 cm)

Courtesy the artist and Valenzuela Klenner Galería, Bogotá

105–8

Wilson Díaz, *Untitled,* **from the series** *La flor caduca de la hermosura de su gloria* **(The Flower Fades from the Beauty of Its Glory), 2010**

Charcoal on paper, four of five drawings, dimensions variable (clockwise from top left): 13 ¾ × 19 ⅝ in. (34.9 × 49.9 cm), 13 ¾ × 19 ⅝ in. (34.9 × 49.9 cm), 11 ¾ × 15 ⅛ in. (29.9 × 38.4 cm), 14 ⅜ × 18 ¾ in. (36.5 × 47.6 cm)

Courtesy the artist and Valenzuela Klenner Galería, Bogotá

109 (right)

Wilson Díaz, *Untitled,* **2006**

Acrylic on canvas, 18 ⅛ × 13 ⅜ in. (46 × 34 cm)

Courtesy the artist and Valenzuela Klenner Galería, Bogotá

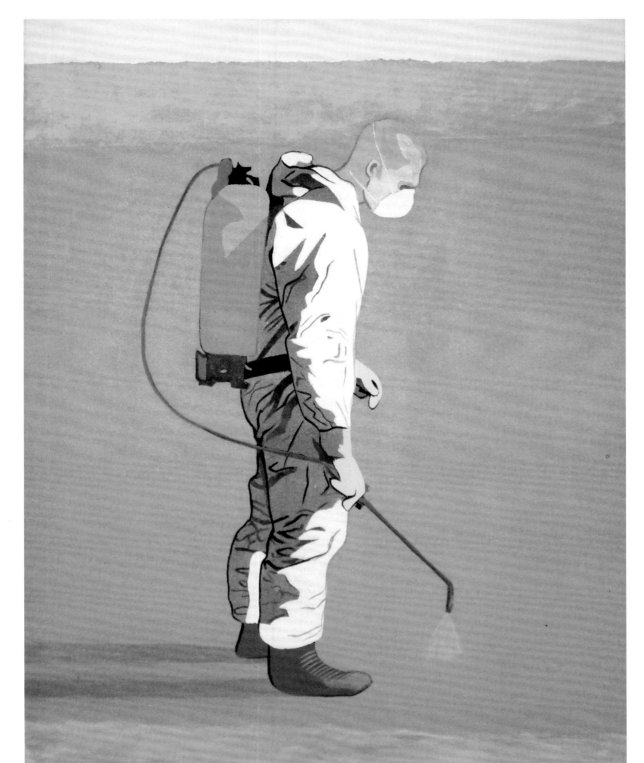

WILSON Diaz 06

Helena Producciones

Helena Producciones, an independent collective established and managed by artists, was founded in 1998 in Cali.[1] Its members research contemporary Colombian art and explore an array of exhibition and educational formats in order to produce their projects and publications. Their joint artistic efforts began when Cali was in economic and social crisis as a result of the previous decade's excess and violence. At a moment when there were few opportunities for a new generation of artists, Helena Producciones acted as a catalyst for local and regional art production, fostering intergenerational dialogue and approaching vital social and cultural issues with a fresh perspective. The collective's first projects evolved around parties with an exhibition component, which were followed by more ambitious ventures such as *LOOP*, a television program that aired in Cali from 2001 to 2004 on the Universidad del Valle's campus television channel. The program introduced local artists and bands, using a performance-cum-variety show format in an effort to subvert the televised medium from inside. When the programming turned controversial the university suspended its support, and *LOOP* evolved into a video project.

The group's most notable project is the Festival de Performance de Cali (pp. 78–93). Initially a platform for experimentation by local artists, the festival has evolved over time, expanding to genres beyond performance and becoming international in scope. During these one-week events, art projects and performances take over the city's plazas, streets, galleries, and art spaces. There have been seven festivals to date, with programs that included lectures by curators and art historians, exhibitions, workshops, video screenings, and media interventions. Although the festival has received logistic and production support from various institutions, it continues to be conceived independently by Helena Producciones and reflects the collective's grassroots spirit.

In 2005 Helena Producciones curated the *II Salón Regional de Artistas, zona Pacífico*, a juried exhibition funded by the Colombian government. The collective extensively researched the three departments (states) of Cauca, Chocó, and Valle del Cauca, exploring topics such as social geography, history, colonialism, economics, and political power. The exercise of physically traveling to these rural areas, and temporarily leaving behind the city of Cali, proved to be formative. Later that year, members of the collective returned to the countryside with the goal of developing a forum for dialogue and exchange between artists and craftspeople, and they initiated a program called La Escuela Móvil de Saberes y Práctica Social de Helena Producciones (Helena Producciones Traveling School of Knowledge and Social Practice). The school generates projects that empower the community through local cultural practices, aiming to produce long-term sustainable processes on both the economic and the social level. Its curriculum is determined by the desires and needs of the participants and includes discussion groups about local history, development of products that can support the local economy, and even a class that teaches the traditional art of fencing with machetes (pls. 110, 133).
—*María del Carmen Carrión*

1. See page 78 for a list of past and current members. According to Wilson Díaz, one of the group's founders, the name Helena Producciones was inspired by the fact that in Colombia many "properties such as buildings [and] farms are named after women. . . . Everyone wanted a female name and a female character for our project." Wilson Díaz, email to Apsara DiQuinzio, January 30, 2012.

110

**Helena Producciones, La Escuela Móvil de Saberes y Práctica Social
(Traveling School of Knowledge and Social Practice), 2005**

Demonstration by La Escuela de Esgrima con Machete de Puerto Tejada (Puerto Tejada
School of Machete Fencing)

Courtesy Helena Producciones

FESTIVALES DE PERFORMANCE DE CALI, 1998–2008

Introduction and descriptions of selected performances by Catalina Lozano.

Thanks are due to Jennifer Boynton, Michèle Faguet, and Amanda Glesmann for their assistance in gathering and verifying information.

The first Festival de Performance de Cali, organized by artists Wilson Díaz and Juan Mejía, was held on November 20, 1997, at an old billiards hall. This relatively small and informal one-day event represented an important step in the development of a generation of Colombian artists. The following year, many of the festival participants (who were then art students) joined to form Helena Producciones and carry forward the momentum the festival had established. The group has since organized six iterations of the Festival de Performance de Cali. In tandem with the diversification of Helena's artistic practice, the festival itself has expanded beyond one day of continuous performances to include exhibitions, screenings, and multiple days of lectures, workshops, and other activities. Held at a variety of venues throughout the city, these events take advantage of the temporality of performance art and are open to all segments of society. Despite the festival's growth and relative institutionalization in recent years, its founders' independent spirit has prevailed. The Festival de Performance de Cali remains an important creative catalyst for Colombian artists and the international art community.

The performances, interventions, and workshops highlighted on the following pages were presented at the festivals organized by Helena Producciones since 1998. Locations of individual performances are listed only in cases where the festival events were held at more than one venue. A complete alphabetical listing of participants in festivals I–VII appears on pages 92–93. The VIII Festival is scheduled to take place from November 20 to 24, 2012.

Images are courtesy Helena Producciones. Photography credits appear on page 93.

HELENA PRODUCCIONES
Andres Sancoval Alba*
Alberto Campuzano
Wilson Díaz*
Marcela Gómez
Leonardo Herrera
Diana Lasso
Johana Martínez
Juan David Medina
Juan Carlos Melo
Ana María Millán*
Ernesto Ordoñez
Gustavo Racines*
Claudia Patricia Sarria-Macías*
Giovanni Vargas
Mauricio Vera
*Current member as of January 2012

111. María José Arjona, *Alimento* (Food). Performance and installation at the Festival de Performance de Cali II, November 7, 1998

112

María José Arjona, *Alimento* (Food)

Performance and installation, 40 min.

Arjona lay naked on a table, enclosed in a plastic bag with a small breathing hole. Evoking both the packaging of food in supermarkets and a corpse in a body bag, Arjona's performance simultaneously intensified and questioned the physicality and vitality of her body. The display of her packaged body on a table in turn forced viewers to examine the meaning of various forms of consumption.

113

Leonardo Herrera, *Sin título* (Untitled)

Performance by Leonardo Herrera, Julio Materón, and Mauricio Vera, 20 min.

Inspired by the second festival's venue, Herrera installed a boxing ring in the center of the gymnasium and challenged audience members to fight him. The three-round fight ignited in the audience the emotional reactions that occur when watching competitive, full-contact sports.

114

Claudia Patricia Sarria-Macías, *Tutor: soluciones urbanas* (Tutorial: Urban Solutions)

Performance, 30 min.

Sarria-Macías staged a parodic presentation on a new typology of urban furniture that would beautify Cali by concealing the city's homeless and indigent. By adopting the appearance of an official city manager and appropriating the rhetoric of the local government's proposals for veiling uncomfortable realities of urban life from the public eye, the artist delivered a sharp critique of the city's usual blindness to the conditions of its most marginal inhabitants.

115

Mauricio Vera, *Sin título* (Untitled)

Performance by Mauricio Vera, Yeimy Acosta, and Mauricio Corradini, 30 min.

In this performance, Vera examined gestures of everyday urban violence, staging carefully orchestrated encounters between antagonistic bodies (thieves and victims). Following a reading by Vera from texts that described four different ways to mug someone, performers enacted sequential choreographed robberies.

116

Carolina Caycedo, *Ser caleño* (Being from Cali)

Performance and installation, 10 hours

Caycedo sat on a red sofa outside La Tertulia and asked passersby if they were originally from Cali. Those who answered yes were invited to take part in recorded interviews in which the artist asked them about topics such as where they lived, how the city had changed after the fall of the drug cartels, and what they liked most and least about Cali. Through these intimate conversations Caycedo created a multifaceted portrayal of Cali, as seen through the lens of the interviewees' perspectives and experiences.

117

El Grupo, *Sin título* (Untitled)

Performance, 30 min.

The members of El Grupo (Nini Johanna Bautista, Alfonso Castillo, Ángela Baena, Mauricio Corradini, Javier Morales, Fernando Olivella, and Carlos Ortega) sat in the bed of a dump truck in La Tertulia's sculpture garden, buried up to their necks in dirt; for about half an hour, they looked back at the audience while the audience looked at them. The tire tracks left behind after the performance acted as an unofficial sculptural element alongside the artworks at the performance site, reflecting El Grupo's difficult relationship with the museum.

118

Yury Forero, *Lavatorio* (Washstand)

Performance, 30 min.

Using a traditional washstand as a plinth, Forero repeatedly poured water over a soap bust of an unidentified Colombian national hero. The performance served as an act of historical cleansing in a country where the drug economy has permeated nearly all sectors of society and politics. The dissolution of the bust alluded to the death of the nation's heroes and ideals and also evoked the weakening of traditional cultural values.

119

Luis Eduardo Mondragón, *Minuto de silencio* (A Moment of Silence)

Performance by Edna Avendaño and Alfredo Cardozo, 10 min.

Mondragón structured this performance, which served as the festival's opening ceremony, around a moment of funereal irony marking his own absence. As part of a program that featured fireworks and a trumpet reveille, a woman dressed in white placed a wreath bearing the absent artist's name outside the museum.

120

Boris Marlon Galvis, *El artista campeón del mundo* (The World Champion Artist)

Performance by Boris Marlon Galvis and the members of Cali Karts, 40 min.

In a reflection on the importance of the automobile to urban culture, Galvis (who neither owns nor drives a car) organized a go-kart race outside La Tertulia, complete with banners with his picture and other race-related props. Galvis had fixed the race so he would win, thus becoming the world-champion kart-racing artist and receiving flowers, champagne, and a trophy from the museum's curator, Miguel González.

121

Alejandra Gutiérrez, *De estacionaria a ambulante* **(From Stationary to Itinerant)**

Performance, 10 hours

After the police violently evicted downtown Cali's street vendors, the artist gathered examples of the diverse wares offered for purchase through such informal markets. By displaying the goods in a cart outside La Tertulia, Gutiérrez emphasized the persistence of the alternative economic system the street vendors represented.

122

Las Malas Amistades, *Sin título* **(Untitled)**

Musical performance by Wilson Díaz, Humberto Junca, Manuel Kalmanovitz, Teddy Ramírez, and Freddy Arias, 1 hour

This was the first public concert by Las Malas Amistades, an experimental acoustic band formed by a group of artists who are also amateur musicians. The band's idiosyncratic songs, with lyrics inspired by the everyday, playfully describe both the local scene and the world at large.

123

Fernando Pertuz, *Quiebrapatas* **(Landmines)**

Performance, 8 hours

Pertuz—dressed as a soldier whose left leg had been amputated below the knee, ostensibly as the result of encountering a landmine (known in Spanish as *mina quiebrapatas* or "legbreaker mine")—moved around La Tertulia on crutches. On his back he wore a petition against the use of these weapons, which he asked people to sign in solidarity. Colombia's distressing history of violence is often ignored in the mass media, but Pertuz's performance illuminated its effects on everyday life in the country.

124

Jairo Pinilla, *Un libro de ultratumba* (A Book from beyond the Grave)

Film produced during the festival, 24 min. Filmed on location in Cali. Written and directed by Jairo Pinilla. Executive producer: Helena Producciones. Production: Ana María Millán and Andres Sandoval Alba. Cast: Ana María Millán, Mónica Andrade, Ernesto Ordoñez, Lina Rodríguez, María Cecilia Sánchez, Andrea Velasco, Lizha Montaña, Julio Materón, and Paola González. Cinematography: Leonardo Villegas and Norman Suescún. Editing and special effects: Andres Sandoval Alba and Ana María Millán

Festival IV included a film retrospective that paid homage to Jairo Pinilla (b. 1944), a Colombian B-movie director known for his horror and science fiction films. During the festival, Pinilla and Helena Producciones collaborated to make *Un libro de ultratumba*, a film featuring a girl who, having been drawn into an evil book by the devil, is liberated by the prayers of her friends.

125

Rosemberg Sandoval, *Rose-Rose*

Performance, 20 min.

In *Rose-Rose*, Sandoval, dressed in white and sitting on a small stool on a white platform, brutally tore apart bunches of roses. As the thorns ripped at his hands, his blood stained his clothes and the floor. Through this action, the flowers, traditionally associated with love and beauty, became instruments of violence.

126

Nini Johanna Bautista, *Nini Johanna, Nini Johanna*

Performance, 30 min.
Performers: Nini Johanna Bautista (the artist) and three women also named Nini Johanna
Museo La Tertulia

Standing in front of a mirror, their IDs clearly visible, Bautista and three women who shared her given name and birth year recounted the events and circumstances that had preceded their births. They had been named after Nini Johanna Soto, who was crowned Miss Colombia in 1980, the year Bautista and the other women were born. The performance highlighted the importance of beauty pageants in Colombian society and explored how identity and individuality are shaped by culture.

In addition to the traditional day of performances, the Festival de Performance de Cali V included interventions, workshops, and exhibitions, as well as a conference, a rave, and an education day for local high schools and universities.

127

Antonio Caro, *Taller integral de creatividad visual* (Integral Visual Creativity Workshop)

Workshop, 10 hours (over 5 days)
Centro Cultural Comfandi

Caro, a seminal figure in Colombian conceptual art who has explored educational perspectives in his work since the early 1990s, developed this creativity workshop as a laboratory in which to experiment with collective approaches to art making. The five-day class culminated in an exhibition of the participants' work for family and friends.

128

Raúl Naranjo, *Ofertorio* (Offertory)

Performance, 1 hour
Museo La Tertulia

Wearing a complicated iron device that doubled as a table and a serving tray, Naranjo offered oranges to passersby. Through this action, he prompted reflection on the mechanization of society and the objectification of humanity, as well as the challenges of life in Colombia. According to the artist: "*Ofertorio* . . . presents the tension of being both an eating machine, and a machine to be consumed."

129

Boris Perez, *Laberinto* (Labyrinth)

Performance and installation, 10 min.
Museo La Tertulia

Perez's sculpture of bamboo columns was intended to recall a labyrinth. In a demonstration of strength and will, he climbed naked up the bamboo to the ceiling, fighting to remain within the labyrinth because "the way out [down] was inevitable." According to Pérez: "It's like a metaphor for our own existence, where every second that we can live and enjoy should be intense because, over time, the fragility, the weakness of life, will become evident as we get closer to death."

130

Pierre Pinoncelli, *Un dedo para Ingrid* **(A Finger for Ingrid)**

Performance, 1 hour
Museo La Tertulia

Prior to the opening of the festival in 2002, Pinoncelli had announced from his native France that he was going to look for Colombian politician Ingrid Betancourt, who had been abducted earlier that year by the Revolutionary Armed Forces of Colombia (Fuerzas Armadas Revolucionarias de Colombia: FARC) during her presidential campaign. At the festival, he protested her kidnapping by cutting off part of the little finger of his left hand with an ax and offering it to La Tertulia's curator in a jar. He then used his blood to write "FARC" on the white wall behind the stage.

131

Santiago Sierra, *Lona suspendida de la fachada de un edificio* **(Canvas Suspended from a Building Facade)**

Intervention, 5 days
Museo La Tertulia

At a moment when tensions between Colombia and the U.S. were building over the American company Monsanto's application of pesticides to Colombian land in an effort to combat rebels and drug trafficking, Spanish artist Sierra installed an American flag measuring almost sixty by fifty feet (twenty by fifteen meters) on La Tertulia's facade. The making of the flag was overseen by Luis Abel Delgado, a renowned tailor and embroiderer in Cali whose work has been commissioned by political and religious leaders around the world. The talk given by Sierra in conjunction with this intervention was protested, and the flag itself was removed after being vandalized.

132

Colectivo Pornomiseria, *Limpieza social: Un espectáculo de rehabilitación* **(Social Cleansing: A Rehabilitation Spectacle)**

Performance by Colectivo Pornomiseria (Edwin Sánchez, Kevin Mancera, Francisco Toquica, Cindy Triana, Víctor Albarracín) and local homeless people, 2 hours
Plazoleta del CAM, Centro Administrativo Municipal (Municipal Administrative Center Park)

Colectivo Pornomiseria (Poverty Porn Collective) questions contemporary manifestations of so-called socially engaged art, with an emphasis on spectacles that revel in the rehabilitation of the marginalized. The term *pornomiseria*, which inspired both their name and their practice, was coined by Cali filmmakers Luis Ospina and Carlos Mayolo in the late 1970s to critique the gratuitous images of socioeconomic hardship then prevalent in Colombian documentaries. In this performance, a group of artists bathed homeless people in a busy plaza and then asked them to don white T-shirts with *Obra social* (Social Work) printed on them.

VI FESTIVAL
APRIL 29, 2006
MULTIPLE VENUES

In addition to the traditional day of performances, the Festival de Performance de Cali VI included interventions, workshops, exhibitions, and a conference.

133

Escuela de Esgrima con Machete de Puerto Tejada, *Proyecto de Escuela de Esgrima con Machete de Puerto Tejada* (Project by the Puerto Tejada School of Machete Fencing)

Workshop featuring performances by members of Puerto Tejada's Escuela de Esgrima con Machete (Isabelino Díaz, Silvino Fory, Miguel Vicente Lourido, Abelardo Miranda, Osías Palacios, Luis Alberto Vidal), 16 hours (over 4 days)
Former warehouse of the Industria de Licores del Valle

In colonial times, the sugarcane plantations of Puerto Tejada thrived, partly because of the labor of the region's slaves. It is said that black slaves learned to fence from their Spanish masters, although the slaves used machetes instead of foils and eventually developed their own techniques. In this workshop, members of the machete-fencing school demonstrated and taught the local style of fencing, which over the years has been transmitted from one generation to the next. The project effectively recontextualized an instrument of violence now commonly used by guerrilla forces, playfully transforming it into an aesthetic object.

134

Les Gens d'Uterpan, *X-Event 2*

Dance performance by Carolina Arcila, Natalia Cajiao, Gino Castro, Tania Girón, Julián Grijalva, Carlos Hernández, and Juan Pablo Restrepo, 4 hours
Former warehouse of the Industria de Licores del Valle

X-Event, a series of dance performances created by French choreographers and dancers Les Gens d'Uterpan (Franck Apertet and Annie Vigier), pushes the boundaries between the visual and performing arts. This performance of *X-Event 2* engaged semiprofessional and amateur local dancers in movements that explored the constraints posed by the performance space and the limits of their own bodies. The naked dancers circled the space, their bodies repeatedly touching one another, while the intensity of hours of continuous movement brought them to the edge of exhaustion.

135

Miki Guadamur, *Sin título* (Untitled)

Musical performance, 50 min.
Former warehouse of the Industria de Licores del Valle

Guadamur is a popular Mexican entertainer who has been described by *VICE* magazine as the "dancing, techno-backed leader of a cartoon militia that's shaking up the Mexican art scene." His repertoire includes covers of popular songs that the artist reinterprets with his own lyrics, which are inspired by his life in Mexico City. Influenced by vaudeville, his performances are intended to entertain and amuse a wide audience, from art aficionados to children to the elderly.

136

Federico Guzmán, *Mercado violento* (Violent Market)

Installation and action, 1 hour
Former warehouse of the Industria de Licores
del Valle

Guzmán arranged a large ring composed of different types of fruit on the warehouse floor, and another man drove toward it with a steamroller. The spectators became participants in the action when they stopped the impending destruction of these agricultural goods by stepping in front of the steamroller and picking up the fruit. Guzmán's performance was a critique of the proposed 2006 Colombian-U.S. Free Trade Agreement, which would dramatically affect local food production.

137

Andrés Triviño, Ana María Millán, and Andres Sandoval Alba, *Campeonato local de skateboard* (Local Skateboarding Championship)

Installation and action, 5 hours
Former warehouse of the Industria de Licores
del Valle

Triviño, Millán, and Sandoval built a temporary skateboard park in the shuttered rum distillery where the sixth festival was held and invited all local skateboarders to use it. The facility continued to serve as a meeting place for this community long after the festival.

138

El Vicio Producciones, *El Vicio TV* (Mobile TV Studio)

Installation and performance, 4 days
Parque Centro Administrativo Municipal

After setting up a TV studio in an empty storefront, the video collective El Vicio Producciones (Simón Hernández, Simón Mejía, and Richard Decaillet) placed an open call for Cali locals as well as other artists to come down and be filmed performing, discussing culture, or engaging in whatever they felt like doing. (Participants included a street clown and a dwarf reggaeton singer, among many others.) The resulting video, shown on national television, combined clips from these studio performances with documentary presentations about the history of the festival.

2008

In addition to the traditional day of performances, the Festival de Performance de Cali VII included interventions, workshops, exhibitions, and a conference.

139
Rolf Abderhalden, *Sin título* (Untitled)

Performance and installation, 10 hours
Titán del Valle, a former flour mill

In Abderhalden's complex installation, the narrative of a transvestite was projected and multiplied throughout the space by a disco ball. Against this backdrop, the artist's continuous theatrical performance, which took place in and around a vintage car, reflected on different attitudes toward homosexuality and cross-dressing.

140
El Camión, *Sin título* (Untitled)

Performance by members of El Camión (Lisseth Balcázar, Adrián Gaitán, Daniel Tejada, Carolina Ruiz, Jimmy Villegas, and Sergio Andrés Zapata) and a group of other artists and supporters, 4 hours
Titán del Valle, a former flour mill

Although these Cali-based artists were not originally scheduled to take part in the festival, they had been invited to participate in the *41 Salón Nacional de Artistas*, a two-week event that took place in Cali around the same time. Using the salón's resources, they appeared at the festival on a truck (*camión*), singing rousing songs that criticized the salón and the agenda of its curators.

141
Phil Collins, *el mundo no escuchará* (the world won't listen), 2004

Part one of *the world won't listen* (2004–7). Three-channel synchronized video installation, color, sound, 57 min. Production still courtesy Shady Lane Productions
Screening and panel discussion co-organized by Phil Collins and Michèle Faguet, approximately 90 min.
Museo La Tertulia

In 2004 British artist Collins teamed up with Espacio La Rebeca in Bogotá, where he worked with local musicians to record fans performing karaoke versions of their favorite tracks from *The World Won't Listen*, a compilation album by the popular 1980s band The Smiths. Video footage of these recording sessions formed *el mundo no escuchará* (the world won't listen), the first installment of a three-part project that would later include recording sessions in Istanbul (Turkey) and Jakarta and Bandung (Indonesia). This screening by Collins and Faguet was the first presentation of *el mundo no escuchará* in Colombia. A panel discussion that included independent curator Pablo León de la Barra and artist Humberto Junca introduced the artwork.

142

**María Alejandra Estrada,
Préstamo (Loan)**

Performance, 9 hours
Titán del Valle, a former flour mill

By entering the space delimited by
a yellow oilcloth, visitors agreed to
lend their bodies to the artist, who
handled and manipulated them as
much as they would permit. Through
this action Estrada explored peo-
ple's feelings about bodily contact
with a stranger and the boundaries
they establish.

143

**Juan Linares and Erika Arzt, *Taller
para la construcción colectiva de un
paisaje indefinido* (Workshop for
the Collective Construction of an
Indefinite Landscape)**

Workshop and installation, 20 hours
(over 5 days)
Titán del Valle, a former flour mill

In this workshop, Linares and Arzt built
cardboard furniture to be used by
other artists in their performances. The
cardboard also served as a platform
for the festival's broadcasting equip-
ment, which transmitted commentary,
interviews, and avant-garde noise
music over the internet and short-
wave radio.

144

**Carlos Monroy, *La performola*
(The Performance Jukebox)**

Installation and performance, 12 hours
Titán del Valle, a former flour mill

At Monroy's request, artists submit-
ted one hundred instructions for
various actions, creating a "perfor-
mance jukebox." The audience chose
random performances from among
these actions, which Monroy exe-
cuted at the festival nonstop for
twelve hours.

145

Edinson Quiñónes, *Invasión, resistencia y experiencia de vida* (Invasion, Resistance, and Life Experience)

Installation and performance, 9 hours
Titán del Valle, a former flour mill

Working with found materials, Quiñónes built a shack that evoked his early life in a shantytown and used it as a platform for discussion of his experiences with visitors. The title of the work, as well as the shack's location at the outer edge of the festival space, references the fact that inhabitants of these informal neighborhoods—which are typically constructed on unused land at the outskirts of urban areas—are often characterized as unwelcome invaders by city residents.

146

Juan Javier Salazar, *Intervención a la estatua de Sebastián de Belalcázar* (Intervention on the Statue of Sebastián de Belalcázar)

Intervention, 1 hour
Sebastián de Belalcázar's hill

Using a piece of fabric, Peruvian artist Salazar covered a statue of Sebastián de Belalcázar, a Spanish conquistador and the "founder" of Cali. By rendering Belalcázar invisible, the artist questioned the veneration of colonizers who built an empire on the appropriation of natural resources and the forced labor of indigenous populations.

FESTIVAL PARTICIPANTS

I FESTIVAL
Marlan Ampudia
Paul Arias
Wilson Díaz
Connie Gutiérrez
Leonardo Herrera
Leonardo Herrera and
 Tomás Reyes
Fernando Hidalgo
Aldo Marcelo Hurtado
Guillermo Marín
Helen Martán and
 Andrea Valencia
Johana Martínez
Juan Mejía Ana María
 Millán, Juan Pablo
 Velásquez, Fabio
 Melecio Palacios,
 and Paula Andrea
 Agudelo
Luis Eduardo
 Mondragón and
 Mauricio Vera
Cesar Alfaro Mosquera
Fernando Pertuz
Carlos Quintero
Salomé Rodríguez
Mauricio Vera and
 Ernesto Ordoñez

II FESTIVAL
Liliana Abaunza and
 Asdrubal Medina
Marlan Ampudia
Paul Arias
María José Arjona
Janeth Blanco
Francisco Camacho
Antonina Canal
Casa Guillermo
 (Renato Benavides,
 Diego Benavides,
 Juliana Santacruz, and
 Fernando Pertuz)
Club Catódico
 (Dimo García and
 Pedro Pablo Tatay)
Wilson Díaz
El Esquimal
 (Edilson Muñoz Ortiz)
Yury Forero and
 Alejandro Rey
Miguel González
Grupo A-Clon
 (Claudia P. Rincón,
 Jimena Isabel Orozco,
 Jose Ignacio Ospina,
 Juan Arturo Piedrahita,
 Luis Andrés Castaño,
 Margarita María
 Pineda, Mariluz
 Álvarez, and
 Valentina Hoyos)

III FESTIVAL
Paul Arias
Oscar Campo
Carolina Caycedo
Yury Forero
Marcela Gómez
Miguel González
El Grupo
 (Nini Johanna Bautista,
 Alfonso Castillo,
 Ángela Baena,
 Mauricio Corradini,
 Javier Morales,
 Fernando Olivella,
 and Carlos Ortega)
Grupo Duodeno
 (Fabio Melecio
 Palacios and Juan
 David Medina)
Grupo Nómada
 (Rafael Mora, Máximo
 Aponte, Mario Parra,
 Rubén Muñoz)
Juliana Guevara
Alejandra Gutiérrez
Leonardo Herrera
Marc Jean-Bernard
Humberto Junca
Diana Lasso
Mónica del Llano and
 Francisco Camacho
Juan Carlos Melo

Grupo Nómada
 (Rafael Mora, Máximo
 Aponte, Mario Parra,
 Rubén Muñoz)
Alejandra Gutiérrez
Elías Heim
Leonardo Herrera
Fernando Hidalgo
Carlos Jiménez
Freddy Jiménez
Maria Margarita
 Jiménez
Humberto Junca
Mónica del Llano
Guillermo Marín
María Angélica Medina
Luis Eduardo
 Mondragón
Raúl Naranjo
Tomás Reyes
Rosemberg Sandoval
Claudia Patricia
 Sarria-Macías
Juan Fernando Toro
Giovanni Vargas and
 Diana Lasso
Mauricio Vera
Alonso José Zuluaga
Daniel Zuluaga

Luis Eduardo
 Mondragón
Ricardo Arcos Palma
Boris Perez
Fernando Pertuz
Manuel Romero
Silvia Aceneiba
 Sánches
Rosemberg Sandoval
Juan Fernando Toro
Giovanni Vargas
Mauricio Vergara

IV FESTIVAL
Gina Arizpe and
 Marcela Quiroga
Silvie Boutiq
Yury Forero
Boris Marlon Galvis
Marcela Gómez
El Grupo
 (Nini Johanna Bautista,
 Alfonso Castillo,
 Ángela Baena,
 Mauricio Corradini,
 Javier Morales,
 Fernando Olivella,
 and Carlos Ortega)
Alejandra Gutiérrez
Los Lichis
 (Manuel Mathar,
 Gerardo Monsivais,
 and Jose Luis Rojas)
Las Malas Amistades
 (Manuel Kalmanovitz,
 Wilson Díaz,
 Humberto Junca,
 Teddy Ramírez, and
 Freddy Arias)
Juan Mejía
Luis Eduardo
 Mondragón
Boris Perez
Fernando Pertuz
Jairo Pinilla
Humberto Polar
Rosemberg Sandoval
Fernando Uhía
Carlos Arturo Zúñiga

V FESTIVAL
María José Arjona
Nini Johanna Bautista
Antonio Caro
Adolfo Cifuentes
Lilliana Díaz
Yury Forero
Inés Gaitán
Marcela Gómez
Alejandra Gutiérrez
Federico Guzmán

Lina Hincapié,
 Guillermo Marín, Jim
 Fannkugen, Claudia
 Figueroa, Carlos
 Enrique Pombo,
 and Leidy
Pancho López
Luis Eduardo
 Mondragón
Raúl Naranjo
Adriana Pérez
Boris Perez
Fernando Pertuz
Pierre Pinoncelli
Proyecto Medusa
Pus
 (Carlos Franklin,
 Simón Hernández,
 Santiago Caicedo,
 Richard Decaillet, and
 Elkin Calderón)
José Alejandro
 Restrepo
Victor Manuel
 Rodríguez
Rosemberg Sandoval
Santiago Sierra
Juan Fernando Toro
Tres Libras
 (Fernando Nieto,
 Alejandro Bolívar,
 José Morales,
 John Garzón, and
 Felipe Alfaro)
Juan Pablo Velásquez

VI FESTIVAL
Wilfrand Anacona
Alessio Antoniolli
Fernando Arias
Belcro
 (Karime García and
 Juan David Medina)
El Camión
 (Lisseth Balcázar,
 Adrián Gaitán, Daniel
 Tejada, Carolina
 Ruiz, Jimmy Villegas,
 and Sergio Andrés
 Zapata)
Colectivo Cambalache
 (Carolina Caycedo,
 Adriana García Galán,
 Alonso Gil, and
 Federico Guzmán)

Colectivo
 Descarrilados
 (Viviana Guarnizo,
 Diana Carolina Torres,
 Florencia Mora,
 Alfonso Correa,
 Jaes Caicedo,
 Gonzalo González,
 Shirley Sáenz, José
 Luis Avilés, Andrea
 Benítez, and Néstor
 Gamboa)
Colectivo Estrato Cero
 (Javier Álvarez,
 Michael Barona,
 Hernan Salazar, and
 Neal Alexander)
Colectivo Gratis (Kirby
 Gookin and Federico
 Guzmán)
Colectivo Pornomiseria
 (Edwin Sánchez,
 Kevin Mancera,
 Francisco Toquica,
 Cindy Triana, and
 Víctor Albarracín)
Juan Carlos Davila
Etienne Demange
Wilson Díaz and William
 Gómez
El Vicio TV
 (Simón Hernández,
 Simón Mejía, and
 Richard Decaillet)
Escuela de Esgrima con
 Machete de Puerto
 Tejada (Isabelino
 Díaz, Silvino Fory,
 Miguel Vicente
 Lourido, Abelardo
 Miranda, Osías
 Palacios, and Luis
 Alberto Vidal)
Familia Díaz
 (Edward Díaz,
 Jackeline Díaz, Neidy
 Díaz, Jessika Guzmán,
 and Ana Polanco)
Yury Forero
Carlos Franklin and
 Claudia Gómez
La Gallada Mestiza
Boris Marlon Galvis
Karime García
Les Gens d'Uterpan
 (Franck Apertet and
 Annie Vigier)
Miki Guadamur
Federico Guzmán
Leonardo Herrera

Los Impedidos
(Leonardo
Carrara, Juan Pablo
Velásquez, and
Leonardo Villegas)
Live Art Development
Agency
Las Malas Amistades
(Freddy Arias,
Wilson Díaz,
Humberto Junca,
Manuel Kalmanovitz,
Ximena Laverde, and
Teddy Ramírez)
Luis Eduardo
Mondragón
Mucho Maché
(Mauricio Pérez and
Diana Buitrago)
Mugre
(Carlos Bonil and
German Bonil)
Caitlin Newton-Broad
Fabio Melecio
Palacios
Agustín Parra
Juan Peláez
Alfonso Pérez
Fernando Pertuz
Leandra Plaza and
Jorge Suzarte
Pope Noveau
(Víctor Albarracín,
Ximena Laverde,
Lorena Morries,
Gabriel Mejía, Felipe
Juan Uribe, Carlos
Bonil, and Juan
Peláez)
Martha Posso and
Lorena Zúñiga
Edinson Quiñónes
The Rimembers
(Edwin Sánchez,
Andres Mauricio
Rojas, Santiago
Castro Borda, Jorge
Enrique Espinoza,
Marcelo Ignacio
Verastegui, and
Felipe Andrés
Cardozo)
María Inés Rodríguez,
Virginia Torrente,
and Teodora
Diamantopoulos
Oskar Romo
Maria Isabel Rueda
and Beatriz López
Helena Ruiz
Sangre de Palomo
(Mónica Restrepo,
Angela García, and
Carolina Ruiz)

Armando Silva
Silverio (Julián Lede)
Malcolm Smith, Claudia
Salamanca, and
Leonardo González
Juan Pablo Solarte
THC
(Victor Tachuela,
Andrés Triviño,
Heiler, Eduardo
Motato, Iván Arcesio,
and Rotten)
Andrés Triviño, Ana
María Millán, and
Andres Sandoval
Alba
Tropical Effect
(Malcolm Smith,
Claudia Salamanca,
and Leonardo
González)
Fernando Uhía
Rened Varona
Gustavo Villa
Vincent + Feria
(Françoise Vincent
and Elohim Feria)

VII FESTIVAL
Rolf Abderhalden
Jorge Acero
Liliana Angulo
Pablo León de la Barra
Helmut Batista and
Jennifer Mojica
Helmut Batista, Juan
Javier Salazar, Omar
Puebla, Yuri Firmeza,
Wilbert Carmona,
and Ana María Millán
Belcro (Karime García
and Juan David
Medina)
Ana María Bernal and
Lucia Quijano
El Bodégon
(Cindy Triana,
Francisco Toquica,
Edwin Sánchez,
Kevin Mancera,
Natalia Ávila, Juan
Peláez, Paola
Sánchez, Lorena
Espitia, Maria Isabel
Rueda, Humberto
Junca, and Víctor
Albarracín)
Silvie Boutiq
Cain Press
(Francisco Toquica
and Juan Peláez)
Elkin Calderón

El Camión
(Lisseth Balcázar,
Adrián Gaitán, Daniel
Tejada, Carolina
Ruíz, Jimmy Villegas,
and Sergio Andrés
Zapata)
Wilbert Carmona
La Central
(Beatriz López and
Katy Hernández)
La Colcha de Retazos
Colectivo use el
timbre
Phil Collins and
Michèle Faguet
Juan Carlos Cuadros
Dadanoys
(Julio Giraldo and
Jorge Rosero)
Dick el Demasiado
María Alejandra
Estrada
Yuri Firmeza
Fundecima
(Camilo López)
Adrián Gaitán
Marcela Gómez
Grupo Comtempus
María Teresa Hincapié
and Luis Carlos
Molina
Jens Hoffmann
Kalibadaver
Karen Lamassone
Juan Linares and
Erika Arzt
Las Malas Amistades
(Wilson Díaz,
Humberto Junca,
Manuel Kalmanovitz,
Ximena Laverde, and
Teddy Ramírez)
Carlos María + Atala
Bernal
Adriana Mejía,
Alejandro
Jaramillo, and Rolf
Abderhalden
Adriana Mejía,
Alejandro Jaramillo,
and students from
the Performance
and Community
workshop
Juan Mejía
Luis Carlos Molina
Carlos Monroy
Hila Peleg and Anton
Vidokle
Omar Puebla
Edinson Quiñónes
Luis Fernando Ramírez
and Pelanga Ligera

Royal Waffles
(María Angélica
Madero and David
González Jiménez)
Juan Javier Salazar
Bettina Semmer
Silverio (Julián Lede)
Students in the master's
program in Live Art
at the Universidad
Nacional
Tranxistor (Giovanny
Terranova)
Tropical Effect
(Malcolm Smith,
Claudia Salamanca,
and Leonardo
González)
Veronica Wiman
Alonso José Zuluaga

**Helena Producciones
wishes to thank
the following
photographers and
camera operators
for producing the
performance images
on pages 79–91:**

Andres Sandoval Alba
Wilfrand Anacona
Holanda Caballero
Alfredo Cardozo
Pablo Castro
Carlos Andrés Cruz
Juan Carlos Cuadros
Wilson Díaz
Karime García
El Hechicero
Leonardo Herrera
José Kattán
Adolfo Leon
Juan David Medina
Juan Carlos Melo
Ana María Millán
Gabriel Morales
Jaime Ricardo Muñoz
Carolina Navas
Jennys Obando
Ernesto Ordoñez
Gustavo Racines
Juan David Ramírez
Álvaro Ruales
Maria Isabel Rueda
Juan Pablo Varela
Giovanni Vargas
Juan David Velásquez
Leonardo Villegas

Oscar Muñoz

b. 1951, Popayán, Colombia; lives and works in Cali

Oscar Muñoz has built an oeuvre that reflects on the transitory nature of life and the fleeting quality of human affections. He questions the conditions of representation by imploding the solidity of images through a set of formal strategies. At the core of his artistic practice lies an investigation of the contemporary status of the image, its cultural uses, and its limitations. Working across different media—drawing, photography, printmaking, video, and installation—Muñoz explores the correlation between presence and absence, image and memory, and remembering and forgetting. By setting in motion a number of processes in which his material changes and reacts, he modifies each representation along the way. Whether by placing security glass over photographs of his hometown of Cali (the glass shatters when the viewer walks over it), or by silkscreening his self-portrait on the surface of the water filling shallow vitrines and allowing it to be transformed as the liquid evaporates, as in his series *Narcisos secos* (Dry Narcissi, 1994, pl. 147), Muñoz examines resonances between the impermanence of images and the temporality of the human condition.

Images are constantly fading away in his works; with this inherent instability, the artist questions the ethical status of memory and signals a contemporary tendency toward cultural and political amnesia. His work proposes meditation on the role played by the production and consumption of images in complex sociopolitical contexts such as that of his native Colombia, which over the past six decades has experienced a succession of domestic wars that have torn the social fabric of its communities. In the multichannel video projection *Proyecto para un memorial* (Project for a Memorial, 2005), Muñoz, using photographs from local obituaries as his source, draws portraits with water on hot pavement. As soon as he has completed the outline of one portrait and moved on to the next, the first drawing begins to evaporate. His effort to complete these works in the face of their dissolution reads as an act of resistance, while also poetically questioning the efficacy of media images to convey human loss or serve as mementos.

If photography's power resides in its indexical quality—serving as proof that someone existed at a specific moment in time—what additional role does it play in a conflicted cultural context, where an image is all that remains of a disappeared person? Does it suffice as a remembrance of the absent one? Or is there a need for agency in order to activate the memory of those who are missing? *Aliento* (Breath, 1996–2002), a series of mirrors placed on the wall at eye level, addresses how we deal with the fragility of human existence and the evanescence of the real when we confront them in a traumatic context. It requires the audience's active involvement for the image to emerge. The breath of a viewer on the mirror's surface temporarily brings out a portrait, printed with grease, of someone who disappeared through social and political violence. As the vapor of warm breath fades, so does the portrait. It has been said that absence is the highest form of presence, and the precise visual economy used by Muñoz in *Aliento* alludes to the strength of that which evades representation.

—*María del Carmen Carrión*

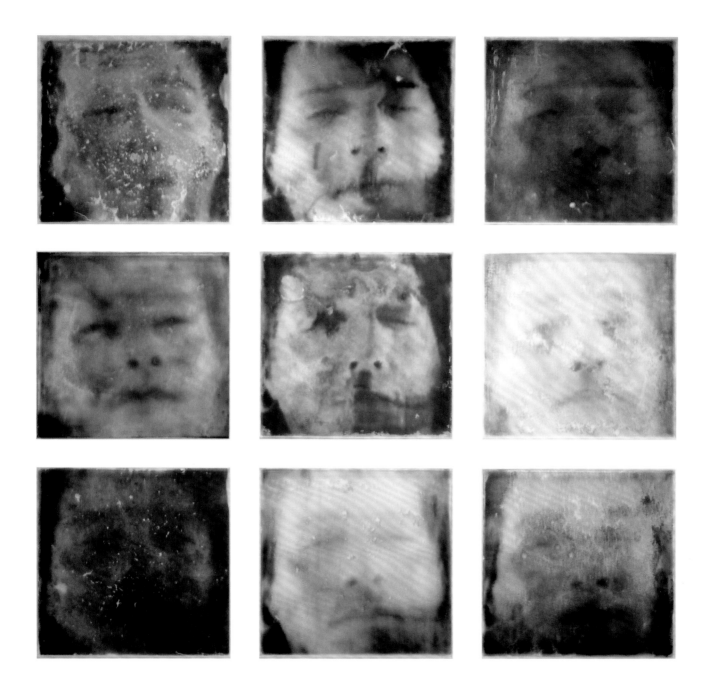

147

Oscar Muñoz, *Narcisos secos* (Dry Narcissi), 1994

Charcoal powder on paper and Plexiglas, nine pieces, each 28 × 28 × 1⅛ in.
(71 × 71 × 3 cm)

The Museum of Fine Arts, Houston; gift of Leslie and Brad Bucher, Dr. Luis and
Cecilia Campos, Mary and Roy Cullen, Margaret C. and Louis Skidmore, Jr.,
Samuel F. Gorman, Frank Ribelin, Frances and Peter C. Marzio, Dr. and Mrs. Miguel
Miro-Quesada, and Dr. Don Baxter at the Latin Maecenas Gala Dinner, 2003

148–49 (left)

Oscar Muñoz, *Untitled*, from the series *El testigo*
(The Witness), 2011

Charcoal powder on acrylic, two pieces, dimensions variable

Courtesy the artist; La Fábrica Galería, Madrid; Galerie Mor • Charpentier, Paris;
and Sicardi Gallery, Houston

150

Oscar Muñoz, *Horizonte* (Horizon), 2011

Single-channel video, black and white, sound, 17 min. (still)

Courtesy the artist; La Fábrica Galería, Madrid; Galerie Mor • Charpentier, Paris;
and Sicardi Gallery, Houston

Luis Ospina

b. 1949, Cali; lives and works in Bogotá

Among the most influential and prolific filmmakers in Colombia, Luis Ospina is an emblematic figure in the recent cultural history of his native Cali—a city that much of his work represents critically, although with a fondness illustrative of what he has often described as a love/hate relationship. While still a film student, he collaborated with Carlos Mayolo (1945–2007), another vital figure in Cali's cultural life and in the history of Colombian cinema, to produce *Oiga vea* (Listen Look, 1971). This short, black-and-white experimental film documented the 1971 Pan American Games, which were held in Cali, depicting the masses of spectators who had been excluded from this essentially elitist, politically motivated event. This was followed by another short film, *Cali: de película* (Cali: On Film, 1973, pls. 151–54), a hauntingly beautiful, impressionistic series of color sequences recording the euphoria, excesses, and sometimes grotesque nature of the Feria de Cali, a yearly carnival.

Although influenced by the militant cinema that became prevalent across much of Latin America in the 1960s, following the Cuban Revolution, Mayolo and Ospina distanced themselves from that genre's overtly formulaic, pedantic narrative structures by incorporating political critique, a sense of aesthetics, and, perhaps most importantly, humor. In addition, they displayed a healthy skepticism about the moral authority of the socially engaged filmmaker. In 1978 they produced their last major collaboration, the iconic *Agarrando pueblo* (known in English as *The Vampires of Poverty*, pls. 155–57), a fictional documentary that satirized what Mayolo and Ospina described as *pornomiseria* (poverty porn), a type of exploitative documentary filmmaking funded by the Colombian state but produced almost exclusively for European audiences, to satiate the demand for images of poverty and underdevelopment. With the coining of this term,[1] Mayolo and Ospina consolidated a legacy that extends far beyond film history to a broader cultural discourse about contemporary art practice in Colombia.

With *Pura sangre* (Pure Blood, 1982), a feature-length horror film based on a 1960s urban myth in Cali about a sugar magnate sustained by the blood of innocent boys, Ospina made a brief foray into fiction while continuing to address the issues specific to his context, including exploitation, violence, and class conflict. Set in both the claustrophobic domestic interiors of an affluent family and the dark streets of a nocturnal city inhabited by drug addicts and vagrants, *Pura sangre* depicts the sordidness of a society plagued by ignorance and corruption.

In 1986 Ospina made the first of a series of feature-length documentaries that sought to preserve the memory of cultural figures who were in danger of being forgotten by a society prone to historical amnesia. *Andrés Caicedo: unos pocos buenos amigos* (Andrés Caicedo: A Few Good Friends) narrates the biography of the writer and founder of the highly influential Cine Club de Cali and the film journal *Ojo al cine* (Eye on Film); Caicedo took his life at age twenty-five, but not before leaving an enormous mark on a generation of the city's artists, writers, and filmmakers. More recently, Ospina received critical acclaim for *Un tigre de papel* (A Paper Tiger, 2007), a documentary about the fictional artist Pedro Manrique Figueroa, whose trajectory as Colombia's pioneer in the creation of political collages coincides with the complicated and divisive history of the Colombian Left. Ospina is currently the artistic director of the Cali International Film Festival.

—*Michèle Faguet*

1. For further discussion of the origins of the term, see my article "*Pornomiseria*: Or How *Not* to Make a Documentary Film," *Afterall* 21 (Summer 2009): 5–15.

151–54

Carlos Mayolo and Luis Ospina, *Cali: de película*
(Cali: On Film), 1973

35mm film transferred to DVD, color, sound, 14 min. (frame enlargements)

Courtesy Luis Ospina

155–57
**Carlos Mayolo and Luis Ospina, *Agarrando pueblo*
(aka *The Vampires of Poverty*), 1978**

16mm film transferred to video, black and white and color, sound, 28 min.
Left: frame enlargements; above and right: production photos by
Eduardo Carvajal

Courtesy Luis Ospina

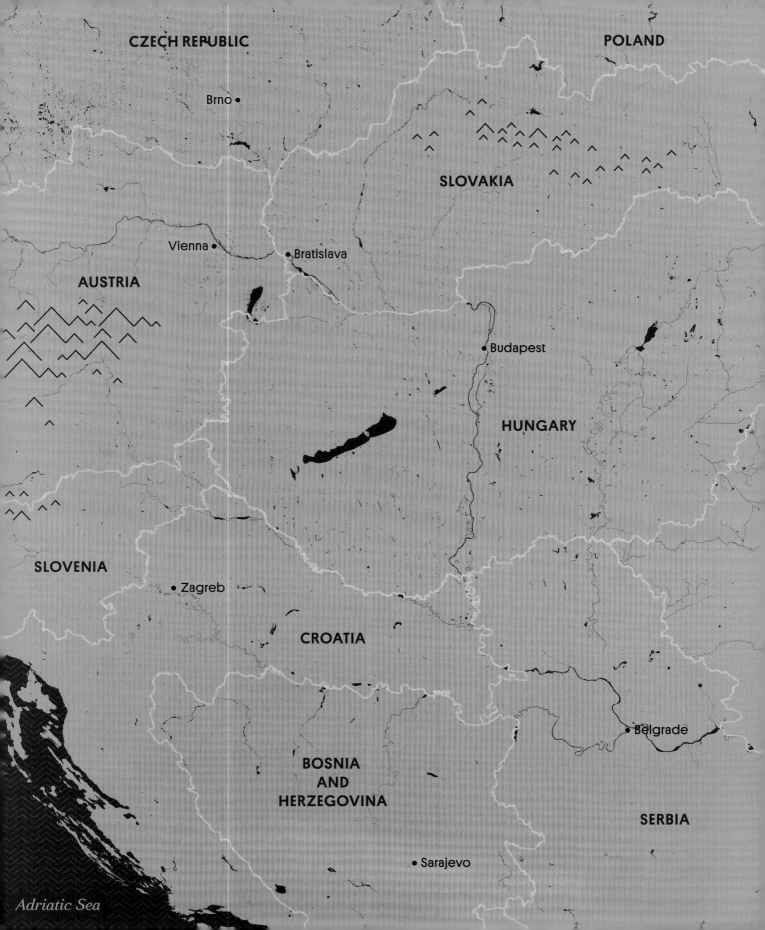

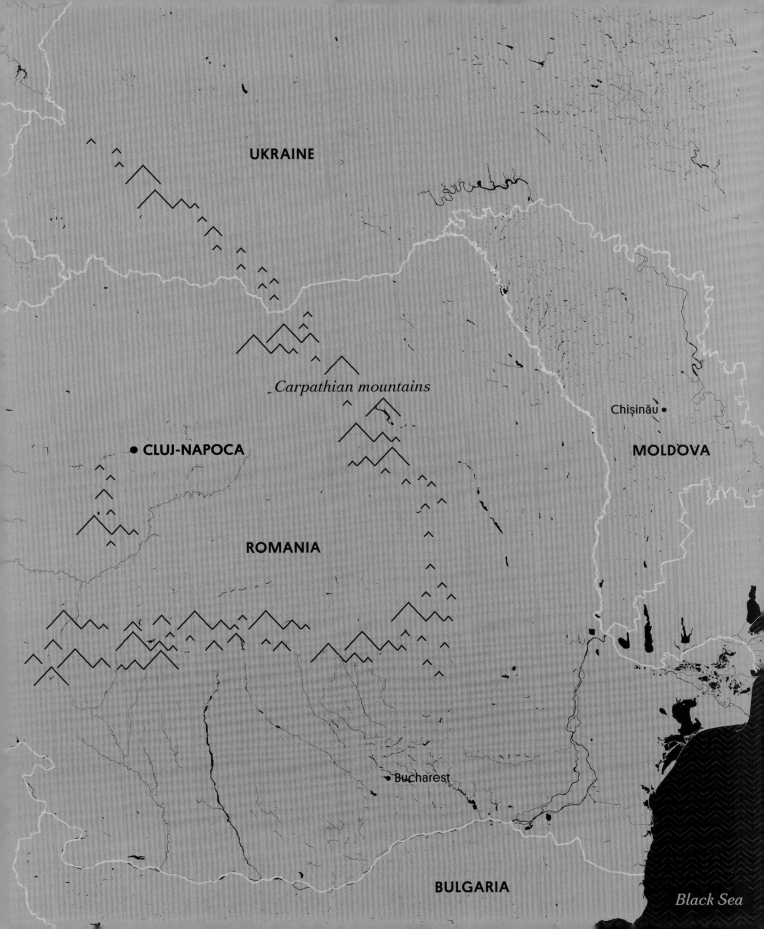

PAINTBRUSHES
AND BROOMS

MIHNEA MIRCAN

In the second half of the 1980s, the specter of change was haunting the communist half of Europe. This change was not a preamble to the Golden Epoch, the absolute renewal of mankind and the abolishment of power relations that was Communism's secular theology, but was rather an explosive accumulation of dissent and unrest. The imagination of political alternatives either stemmed from identifiable sources—as was the case in Poland, with Catholic faith and the activity of the Solidarność (Solidarity)[1] syndicate as twin pillars of resistance—or was a diffuse, samizdat activity, materializing sporadically in protest and promptly stifled by regimes whose brutality was directly proportional to their fragility. It was vertiginous or agonizing; it was personified, in the case of Czechoslovakia, by resonant voices in the anti-communist intelligentsia; or it seemed to emerge from a progressively visible second rank of communist rule, bringing to the fore of political debate the hitherto unthinkable metaphors of "reconstruction" and "transparency." The institution of these political alternatives also took vastly different forms in terms of intensity, violence, and immediate results. There was the "velvet revolution," the exuberant un-building of the Berlin Wall, and a variety of modes in which revolutionary pathos dissipated in incremental transfers of power. (In China, for example, the 1989 Tiananmen uprising was the key to Communism's survival, or a way of ensuring that Chinese post-Communism would never begin.) Romania borrowed something from all these forms of direct or oblique revolutionary action, adding one crucial element: the Romanian revolution was broadcast live on television. The sinuous paths by which change was effected (and the more than one thousand lost lives for which no perpetrator was

ever indicted) transformed the events of December 1989, precisely because of their televisual transparency and spectral verifiability, into the enigmatic, insecure foundation of Romanian democracy. In addition to revolutionary kairos, 1989 brought the prospect of both political and cultural reunification in Europe. Regardless of the different local strategies for occupying the ideological vacuum and using the levers of communist political power as conduits for the "new" (be it moral cleansing or market economy), the resonance of European discourse in 1990—its gesticulations and tropes, pitfalls and blind spots—allows for a bird's-eye view of the cultural East: the feverish imagination of "what could be said" or "thought" temporarily supplanting the dire urgencies of "what is to be done."

Before introducing Cluj-Napoca's Fabrica de Pensule (The Paintbrush Factory) and one of the founders of that initiative, the gallery Plan B, a historical detour can illuminate some of the symptoms of the static irresolution that marks conventional discourse on post-1989 Europe. The purpose of such a history is to pinpoint some of the elements—assets, transactions, debts, and losses—in an economy of affects and representations that unites and divides Europe's incongruous "halves," as they are pictured in the East. It may be said that an allegorical note marks the following paragraphs; such indirect engagement is inspired in part by two compelling theoretical formulations of East-West cultural exchange, but it also finds some poetic justification in the fact that The Paintbrush Factory—one of the few viable venues for artistic production in contemporary Romania— occupies a disused industrial plant that once manufactured paintbrushes. These were used to paint unnecessary pieces of machinery that had been built not for functionality but to reinforce the illusion of a mechanized, effortless future, or to depict Nicolae Ceaușescu, president of communist Romania, as the ubiquitous protagonist of thousands of paintings that during the 1980s consolidated the national variant of Socialist Realism. By the sheer quantity of output, and by the involuntary irony of employing the history of painting (from Simone Martini to Jasper Johns) as an inventory of ornamental formulas around the central political glorification, Romanian propaganda art of the 1970s and 1980s defeats the purpose

158. View of Fabrica de Pensule (The Paintbrush Factory) and its surrounding neighborhood, Cluj-Napoca

159. Şerban Savu, *The Edge of the Empire*, 2008. Oil on canvas, 49½ × 74¾ in. (126 × 190 cm). Hall Collection, New York

of realist rhetoric and comes close to a kind of Socialist Surrealism.

One point at which to begin an inquiry into the spaces of imagination that were breached or foreclosed after 1989, into the history of exchanged glances, emulation, and perplexity set in motion by the "catching-up revolution," is to examine the metaphoric obstruction that had thwarted such reciprocity in the preceding decades. An Iron Curtain had been in the way: an ominous caesura between how subjectivities were fashioned on its two sides. The echoes of both political propaganda and appeals for a common European history bounced off or refracted against an impermeable surface, which was of uncertain size (but presumably very large) and occupied an indeterminate location (but presumably zigzagged through the very heart of what had been "Europe"). The vast and intractable hiatus in cultural and political exchange

metaphorized in the Iron Curtain is incommensurate with the efficiency with which this obstacle was ultimately dismantled and dispatched to the historiographic junkyard in 1989. Yet nothing is ever lost, as we know from Vladimir Nabokov's endearingly stuporous Professor Pnin. One of the characters in Nabokov's 1957 novel has a speck of dust removed from his eye and then cannot make peace with the "dull, mad fact" that this "black atom" still exists somewhere, echoing Pnin's furious attempts to make sense—and a home—of America, frustrated by mnemonic fits and a corrosive sense of dislocation.

What, then, has become of the Iron Curtain? In what space does it continue to exist, even if broken down into myriad reddish atoms and swept away? How, and with what effects, is a defunct metaphor taken apart or decommissioned? How do metaphors dissolve into the very ethereal substance that kept

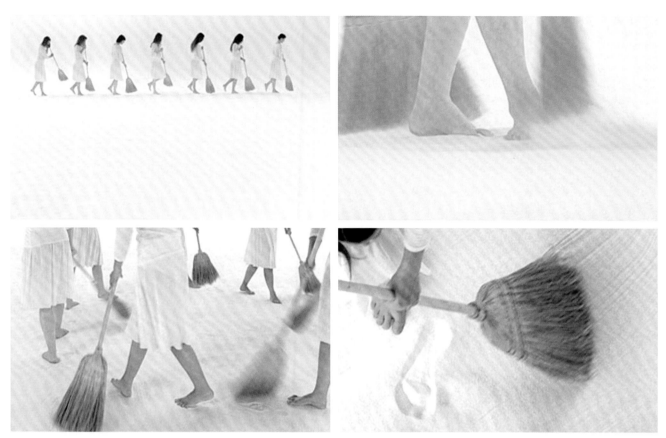

160–63. Mircea Cantor, *Tracking Happiness*, 2009 (stills). 16mm film transferred to DVD, color, sound, 11 min. Sound by Adrian Gagiu. Courtesy the artist; Yvon Lambert, Paris; and Dvir Gallery, Tel Aviv

them affixed to their distant object, or lubricated their work of transportation? Is there a warehouse in which material and immaterial detritus—the set designs of the Cold War, the nuclear dei ex machina and the instruments of symbolic brutality—rots away? And what function did the Iron Curtain perform within a territory that it made theatrical through its own oblique name? Whether the curtain concealed spectacle from audience, play from play, or audience from audience, it also held all these metaphoric possibilities in check, in a space of unresolved co-presence. Once the show was over, did the curtain begin to disintegrate, gradually covered by the very decrepitude it once sought to mask? Has it been repurposed to build the ruinous postindustrial landscapes that Europe wishes to forget, or has it transmuted into the alkahest of a new European sociability? With the curtain suddenly lifted, each side revealed to the

other incomplete identities, excessive or insufficient selves unprepared for co-optation in a story with a singular denouement. After the self-refutation of Eastern Communisms, understood either metonymically or prophetically as the demise of Communism, the liberal cosmology was free to unfold toward whatever messianic destiny awaited it. The disappearance of a brutally enforced paradigm of consensus and the emergence of a paradigm of indignation and restitution—with vastly different rhetorical and practical manifestations across the Eastern Bloc—was followed by the historically unique episode of another free, absolute consensus around liberalism. Throughout the 1990s, experiments in market liberalization collided with nationalist Sturm und Drang, and the arias of populism were sung against the hastily executed backdrop of globalization. The European Union papered over the fissure between its quasi-mythological

164. Ciprian Mureşan, *Communism never happened*, 2006. Vinyl lettering cut from propaganda records, dimensions variable. Installation view at Raster, Warsaw, 2007. Courtesy the artist; Plan B, Cluj/Berlin; David Nolan Gallery, New York; and Mihai Nicodim Gallery, Los Angeles

origin and its economic and geopolitical motivations in ways that betrayed a severe iconographic deficit: Euro banknotes, and the ghostly monuments that illustrate them, were the sole symbolic site of intersection for what should have been a polyphony of nations. In the East, there was a general oscillation between the melancholy of catching up with such a future and a susceptibility to embrace any providential ideology, however patchy, vociferous, or corrupt, that would infuse the daily bathos with some sense of (local) exceptionality.

The artistic and curatorial exchanges of the 1990s were structured by this network of symbolic transfers, as well as the concurrent negotiation of European identity through the play of synonyms and antonyms, the staging of the Other as marginal or central. In his essay "Notes on Self-Colonising Cultures" (1995), Alexander Kiossev characterizes the condition of Eastern Europe as one of discursive self-effacement, describing an act of colonial violence inflicted in the absence of a colonist. Kiossev's cultural periphery is absorbed by its own marginality—and, like Achilles, his East is logically (and in this case structurally) incapable of catching up with the tortoise. The East attempts to constitute its identity in relation to what it lacks. He writes: "In the genealogical knot of the Bulgarian national culture there exists the morbid consciousness of an absence—a total, structural, non-empirical absence. The Others—i.e., the neighbors, Europe, the civilized World, etc. possess all that we lack; they are all that we are not. The identity of this culture is initially marked, and even constituted by, the pain, the shame . . . the trauma of this global absence. The

origin of this culture arises as a painful presence of absences and its history could be narrated, in short, as centuries-old efforts to make up for and eliminate traumatic shortages."[2] Kiossev speaks of a morbid model of civilization evenly spread across Eastern cultures, fueled by the systematic import of models and painstaking self-colonization. Since the second half of the nineteenth century, Eastern European cultures have narrated themselves as not central, not timely, and not big enough (European, but perhaps not to a real extent); but also as insufficiently alien, not distant and backward enough to be relegated to an entirely different, "non-European" paradigm of political representation. They portray themselves as commensurate and inadequate at the same time. We, Easterners seem to mumble to themselves, are not others—not our own Other, but also not this Other's other: just its lesser, damaged self. What informs and propels this is, of course, a theological model, but one with an alien, universal civilization in the structural place where transcendence used to be. It is important to note that this is not an exit from modernity but rather the core engine of modernity in reverse gear, a perfectly modern act of self-definition made to implode, as the criteria that could verify its pertinence are situated beyond the reach of definition. Playing "same" to the Other's other was a tortuous game of echoing assumptions in the art of the 1990s, as could be observed in two retrospective looks at this period organized in 2003. In *Blut & Honig* (Blood & Honey) at the Essl Museum, Vienna, and *In den Schluchten des Balkan* (In the Gorges of the Balkans) at Kunsthalle Friedericianum, Kassel, intensely exoticizing curatorial perspectives colluded with artworks that lent themselves immediately to—or were created for voluptuous inclusion in—a simplifying scheme in which art came close to being not-really-art by virtue of its proximity to contemporaneous news reports about fratricidal bloodshed and through its quasi translation of lingering political dysfunction in the East.

Another theoretical elaboration of the East-West divide comes from Boris Buden's 2004 essay "Re-Reading Benjamin's 'Author as Producer' in the Post-Communist East."[3] The interval between Buden's and Kiossev's essays is significant (if self-colonization diagnoses the after-the-Wall condition, then Buden's analysis engages what I would call the after-the-mall period, and the progressive deflation

of liberal optimism in the East), as are the continuities and reversals between the scenarios articulated in the two texts. Kiossev posits the allegorical place of the colonizer, vacant but nonetheless productive, as it encourages the imagining of the anthropological exhibits that could have been shown in a colonial museum: Would this museum have functioned as an illustration of the colonizer's own political history? Or as a laboratory for rehearsing various relationships to alterity? Operating within the new post-Marxist canon, the aesthetic regime of recent artistic experimentation, Buden turns Kiossev's allegory upside down, or rather backward, by inverting the cardinal points: the geographical fixity that East and West assign to themselves and to each other. In yet another truncated comparison, he proposes a "disoriented" rereading of Walter Benjamin's "Author as Producer" as a key to understanding Eastern art's uncomfortable inscription in the post-Marxist canon, emphasizing the feelings of elision and unbelonging that accompany the pursuit of seamlessness with dominant discourses. In a 1934 paper for the Institute for the Study of Fascism in Paris, Benjamin asks: To what degree does political awareness in a work of art become a tool for the deracination of the autonomy of the work and that of the author? Buden argues that Benjamin's original answer—that the author operates in solidarity with the proletariat's needs—must be reexamined in light of the disjunctive ideological horizons between which the East finds itself. Seen from the Eastern "desert of the Left," writes Buden, the representational regime of Western Marxism appears as a fata morgana: "if there is something like a left-wing initiative in the East today, it must have had its origins in the West and has come to the East along with all the other influences that essentially inform the conditions of life in the East today." As the East learns from the West the strategies of advanced art, the rules of engagement and the faux pas of cultural activism, it accepts that "there is nothing in the historical experience of the European East, that is, of the former communist societies that a leftist idea of today could catch up on or hold on to." Rereading Benjamin happens, then, in an interpretive space without existential coordinates, thoroughly depleted of the genuine experience against which theory could be fleshed out, in a virtual site of enunciation that replicates Benjamin's own distance, writing about the revolutionary Russia of two decades earlier. Essentially, Buden suggests that, as an intellectual

experiment, we take Benjamin's dislocation and the contemporary relevance of his dubitative answer about the work of art, as well as its implications in relation to cultural production in his time, as fixed vanishing points for the perspective lines that frame contemporary shape-shifting locations, carving out safe places within an unfixed geopolitical landscape.

Plan B opened in 2005 and was initiated by Mihai Pop with Adrian Ghenie. It functions as a production space for contemporary art and as a research center focusing on the Romanian art of the last fifty years, showing works by remarkable artists who have not previously had international exposure. The gallery's name is a reference to the general situation of art spaces in Romania. Because they are mostly reliant on insufficient public resources, the "plan B" fallback is animated by individual involvement, a different understanding of the institutional, and a coherent managerial policy. Plan B was the organizer of the Romanian Pavilion at the 52nd Venice Biennale (2007), and it opened a permanent gallery in Berlin in 2008. The Paintbrush Factory is a collective space for multidisciplinary contemporary arts in Cluj. A reaction to the lack of production and exhibition spaces in the city, the project was launched in 2009 as an independent initiative to bring together the ideas, events, and projects of cultural groups, galleries, and artists. The Paintbrush Factory is the first large-scale collective project on the Romanian cultural scene, and it is committed to delivering relevant cultural content, both for the artistic community and for a wider audience. In addition to providing working space for forty visual artists and five galleries, the Factory houses ten cultural organizations, including theater and contemporary dance groups. It also hosts events organized by both local and international partners.

Discussed along the axis of their relationship to history, initiatives such as Plan B and The Paintbrush Factory pierce through the trompe l'oeil of canons, revealing the asymmetry between the diverse elements they order hierarchically and seem to reconcile: centers and peripheries (cultural or commercial), mainstream art histories and local incidents. *Communism never happened* (2006, pl. 164), a work by Plan B collaborator and Paintbrush Factory resident Ciprian Mureșan, provides an entry point for such a discussion, as well as a decisive anticlimax in the amorphous discourse of chasms, reparations, and impossible plenitude that defines contemporary Romanian culture. Realized in vinyl letters cut from political propaganda record albums, this text piece represents either a pure, implacable revisionism—one without an ideology—or a complex anachronism, revealing the fact that post-communist anti-Communism is not a discourse but rather a perplexing conflation of anxiety and oblivion. Bound up with the certainty that one version of Communism did happen, its counter-factual detonation has an immediate consequence: if more people agree to its intrepid claim (or act of perjury), the possibility of a community arises, one not yet demarcated ideologically. The work proposes to move on without forgetting, or rather by an act of un-forgetting to undo the fixity with which trauma is regarded and with which it regards us. It breaches a circular space of mobility and resonance around an object that it no longer elucidates, validates, or indicts. The object—even if not complete—is declared finished, definitively closed upon itself, yet also still present as absence, like an impenetrable fold that resists our examination. Separated from history proper and from history fictionalized, from the rhetoric of the manifesto or the counter-manifesto, this puzzling nonnegative definition of the European condition holds all these discursive possibilities up for scrutiny. It sustains its central truth by delineating a void around it that is made so palpable as to appear solid.

Plan B founder Mihai Pop (also a cofounder of The Paintbrush Factory) was a frequent and generous interlocutor over the course of my work on this text. Before I began writing, we embarked on an experimental anamnesis: an attempt to reconstruct the atmosphere of Cluj around the year 2000, when things began to make communal sense. Our conversation led to an arborescent database of names and significant collaborative projects that renounced the dogma of solitary artistic pursuit still taught at the Universitatea de Artă și Design Cluj-Napoca (Cluj-Napoca Art and Design University), but it was marked by the difficulty of pinpointing the precise emotional and professional mechanisms in the critical mass that the art scene in Cluj would later attain, both locally and internationally. Thinking about solidarity in post-communist Romania (which has the smallest number of civic associations per capita in Europe) is daunting, because solidarity was the principal enemy of the country's version of communist rule, which pursued the eradication of distinctive communities in favor of

165–70. Duo van der Mixt (Mihai Pop and Cristian Rusu), selections from *The Very Best of Red, Yellow and Blue*, 2002–5. Photographs, dimensions variable. Courtesy Duo van der Mixt

171. Fabrica de Pensule (The Paintbrush Factory), Strada Henri Barbusse no. 59–61, Cluj-Napoca

faceless collectivism. Paradoxically, it was precisely against such a backdrop of symbolic brutality—contiguous with Communism's orgies of destruction—that the artistic aughts took shape in Cluj, when the city was run by Gheorghe Funar, a far-right mayor on a mission. Funar's main political mandate was to issue a permanent warning to the city's sizable Hungarian minority, in the form of a paroxysm of tricolor decoration celebrating the Romanian patrimony and casting the Other as trespasser. Virtually anything in the public space in Cluj that could lend itself to a display of patriotic inanity was painted red, yellow, and blue, the colors of the Romanian national flag. Calling themselves Duo van der Mixt, Pop and fellow artist Cristian Rusu set out to document not only the direct expressions of this nationalistic carnival but also the meandering ways in which it infiltrated the mental and social reflexes of Cluj's inhabitants, who waged symbolic war against a dimly perceived enemy by adorning their own possessions with the territorial emblem (pls. 165–70). Pop recalls that the massive and disquieting archive of images and artifacts he and Rusu compiled—a red, yellow, and blue ski mask was especially noticeable, despite its stated purpose of camouflaging its wearer—was a first occasion for interdisciplinary exchange, as it mobilized researchers in various fields to converge in an investigation of the present and its collective Freudian slips. This, and other instances of schizoid political action, religious intolerance, or ecological mismanagement triggered a host of reactive, guerrilla-like actions, the main proponent of which was Mindbomb, a collective of artists and writers that was based in Cluj but whose interventions frequently reached other Romanian cities.[4]

Politics, oscillating with such rapidity between communist atavisms and liberal frenzy that these extremes appeared to be one, was a catalyst for projects by other artists' groups. *Version*, for example, studied the mechanisms of protest, while Supernova's *Art for the Masses* collapsed the vacuous ambitions of socialist art and assembly-line aesthetics in projects such as Supernova Cola and the mass-produced Supernova glass cleaner, perfect for museum display cases. The magazine *IDEA: arts + society*, with which Mureșan is involved, is one of the most credible bastions of critical theory in the region.[5] Mircea Cantor (pls. 160–63), whose artistic practice stems from the same formative context, is one of the essential players in expanding the historical scope of

these conversations. Significantly, Cantor's collaborations with two Cluj galleries, Protokoll and Plan B, focuses on recuperating marginal but crucial positions from an art history that has yet to be written: that of the last few decades in Romania. Pop insists that these artistic gestures were not meant to establish ancestry, or to express the vastness of what is not known about the conditions of art in communist and post-communist Romania; instead, they were open invitations to "members of the same family"[6] such as artists Ion Grigorescu, Miklos Onucsan, and Rudolf Bone, each of whom was eminently capable of demonstrating his contemporary relevance and resonances. While in itself this strategy is not revolutionary, the art historical outlook of Cantor's generation stands in stark contrast to the laments of dispossession that run through Romanian art history, poor in its output of critical texts and marked by the systematically repeated expatriation of its founding fathers: Tristan Tzara, Constantin Brâncuși, André Cădere, Paul Neagu, Daniel Spoerri. The dark matrix of this discourse is the communist reprocessing of Brâncuși, whose Romanian-ness—in the sense of an unadulterated, almost objective sublimation of folk art—was painstakingly overdetermined and overinterpreted, as well as perversely doubled: Brâncușian motifs decorated the precarious, endless suburbs built before 1989 as inhospitable incubators for the New Man, the anonymous subject of communist emancipation. A rejuvenated sense of art history and a reflection on the formation and ideological resilience of canons situates the artists of Cantor's generation in an in-between territory: they adhere neither to a model of homogeneous, pervasive correspondences of identities to objects and worlds, nor to its nihilist converse as an archive of disruption and entropy. Rather, they think about the historicization of the present within a territory of unsettled indexes or selves, where hindsight and foresight become entwined, and where the rapports and transactions between remembrance and prognosis are invigorated.

The Paintbrush Factory brought all these energies together, coagulating the visions and projects of individual and institutional participants. Its success is an invitation to Cluj to reconsider policies centered on decrepit notions of cultural heritage and populist gain. It is also a model to be emulated in other Romanian cities, where the emergence of artistic scenes is stifled by the precariousness of institutional frameworks and the accelerated disintegration of the social tissue. Today's artists are often referred to as the School of Cluj, a name coined far away from Cluj, and with the hope that its promise of immediate legibility would replicate the commercial success of the School of Leipzig. The moniker, used indiscriminately by the Western art market, is less interesting as an attempt to draw parallels between the paintings of Victor Man, Adrian Ghenie, Șerban Savu (pl. 159), or Radu Comșa, reading them in a unilateral perspective of post-communist melancholy; what makes the name compelling is that it is a lesson on the inseparability of personal and collective growth, as well as a promise that the forum of debate and calibration established at The Paintbrush Factory inaugurates a new episode in Romanian culture's turbulent relationship with itself.

1. Solidarność (Solidarity), an anti-communist trade union and social movement, emerged in Poland in September 1980, was suppressed by the Polish government in December 1981, and reemerged in 1989, when it became the first opposition movement since the 1940s to participate in free elections in a Soviet-bloc nation. Since forming a coalition with Poland's United Workers' Party, Solidarność's leaders have dominated the national government.

2. Alexander Kiossev, "Notes on Self-Colonising Cultures," in *After the Wall: Art and Culture in Post-Communist Europe*, ed. Bojana Pejić and David Elliott (Stockholm: Moderna Museet, 1999), 115.

3. Boris Buden, "Re-Reading Benjamin's 'Author as Producer' in the Post-Communist East," *Transversal* (October 2004), http://eipcp.net/transversal/1204/buden/en. All Buden quotations are from this source.

4. For the story and strategies of most Mindbomb projects, as well as the group's affiliation with the San Francisco Print Collective, see Dan Mercea, "Exploding Iconography: The Mindbomb Project," *EastBound* (2006), eastbound.eu/site_media/pdf/060112mercea.pdf.

5. *IDEA: arts + society* is available online at http://idea.ro/revista/?q=en/home. Some of the articles are available in English, although most are in Romanian.

6. Mihai Pop, email conversation with the author, February 2012.

Adrian Ghenie

b. 1977, Baia Mare, Romania; lives and works in Berlin and Cluj

For Adrian Ghenie, painting is a process of accretion: through the thickness of his pigments, the directionality and force of his brush, he layers allusions and information on found images. His painterly method resonates with his approach to immaterial tools such as memory and affect. In his works, the figures' faces are often blurred and obscured, covered by heavy daubs of paint that resemble strips of melting flesh. While the blatant mixture of history and fiction is a search for the universality of myth in specific moments captured discretely on film, it nonetheless visualizes the violence of appropriation and interpretation.

Ghenie culls images from a variety of sources—news media, classic films, state archives, social media sites—and many of his paintings are composed as though they were seen through a lens; it is often ambiguous, however, whether the hypothetical camera that captured these images belongs to a cinematographer or a surveillance system. Whether they were originally moving or still, contemporary or historical, the pictures lifted by Ghenie share atmospheric qualities of loneliness and alienation, fear and strangeness. His gaze synthesizes Edward Hopper and Franz Kafka.

For his revisualizations of history, Ghenie draws on collage tactics that were developed and popularized by Dada, a movement that came together with the influence of Tristan Tzara, a fellow Romanian. A photograph of several artists viewing the *Erste internationale Dada-Messe* (First International Dada Fair), held in a Berlin hotel in 1920, has occupied Ghenie's imagination for several years. The artists stand underneath John Heartfield and Rudolf Schlichter's *Preußischer erzengel* (Prussian Archangel, 1920), a uniformed mannequin that is suspended from the ceiling and looms over them like a specter of death. Ghenie re-created the scene in a 2009 mixed-media collage, but he depopulated the room and added a wolf that stands amid the partially obscured artworks, gazing toward a source of light, as though someone opened a door beyond the paper's edge. The work on paper was a study for an oil painting, *Dada Is Dead* (2009, p. 4, pl. 172), in which he entirely obscured the works visible in the original photograph, coating them with the dense, black grime of his brush. The wolf's maw is shrouded in shadow. The light on the animal has diminished, now appearing more like a ghostly luminous wisp than the blaze of an electric lamp.

If Ghenie, in his collage, doubled the techniques of cutting and appropriation used in the works visible in the original photograph, his painting covers everything up, blending all in a single, haunting image. And his restaging of the photograph in *The Dada Room* (2010), an installation, tears it apart again. The walls are stripped and rough, creating a sense of decay and abandonment, and the garishly colored lounge chairs embody Modernism's profanation in mass design. The primary link to the photograph is the copy of *Preußischer erzengel*—the unchanging specter of death. "The First World War . . . marked a change in attitude and sensibility toward rebellion, fanaticism, and revolution," Ghenie has said. "Hysteria, scandal, and inappropriate conduct were now in the public realm."[1] His painting exaggerates these qualities to renew their shock for the modern viewer, while his sensuous brushwork suggests a visceral sympathy with the gritty pain of the past.

The movement between painting and installation found in Ghenie's *Dada* series is a large-scale version of his studio process. For each of his canvases, Ghenie first makes miniature "soundstages" from wood, cardboard, and glass, so that he can experiment with light, shadows, and the placement of figures. Hovering over the set, Ghenie becomes the Big Brother in the fictional world of his found images—a position that blurs the everyday voyeurism of the reader or moviegoer with practices of surveillance and control.

—Brian Droitcour

1. Quoted in Matt Price, "From the Darkest Places toward the Stars," in *Adrian Ghenie*, ed. Jeurg M. Judin (Ostfildern, Germany: Hatje Cantz, 2009), 80.

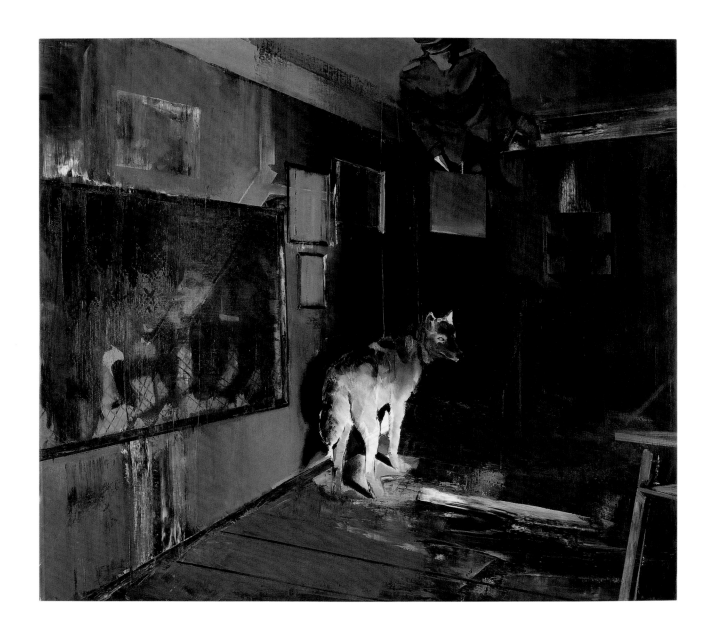

172

Adrian Ghenie, *Dada Is Dead*, 2009

Oil on canvas, 78¾ × 86⅝ in. (200 × 220 cm)

Collection of Dean Valentine and Amy Adelson, Los Angeles

173 (following pages)

Adrian Ghenie, *The Trial*, 2010

Oil on canvas, 79 × 143 in. (200.1 × 363.2 cm)

San Francisco Museum of Modern Art, gift of the artist and
Mihai Nicodim Gallery, Los Angeles

Victor Man

b. 1974, Cluj; lives and works in Berlin and Cluj

In the art of Victor Man, historical and personal narratives become transformed through contact with the realms of myth, the occult, and the imaginary. Made nearly invisible by the passage of time, events and people nonetheless leave traces, images, and obscure objects. Rather than subscribe to the historian's belief that these traces enable us to possess knowledge of the past, Man uses them to orchestrate aesthetic encounters in the immediate present. History and politics are ephemeral; the sphere of signs and psyches persists.

Man's distinctive process is epitomized by his series of nearly all-black paintings, in which figures are sharply contoured and distinctly separate in relation to the tenebrous background, seemingly occupying a separate plane. Many evoke scenarios from medieval paintings. But Man skirts direct appeals to the art of the past. For models he frequently looks to figures who have fallen into obscurity; the Renaissance artist Sassetta, for example, is an important influence. He pairs his references with literal obscurity: the dark coloration that lies over his fine drawing. His aesthetic forces viewers to look hard at the pictures and to enter the works' field of perception. The scenes are strange and evocative—individuals wearing animal costumes stand in front of a painted backdrop, one perhaps holding the others at gunpoint; demons assemble around a black form for a violent ritual; a spiral object hovers over a wooden crate as the people in the room look on—and it is impossible to discern what is happening. In medium, tone, and texture his black paintings stand in opposition to his earlier project *Mihai Viteazu* (2006), in which he dramatized the battles of the sixteenth-century Romanian national hero Mihai the Brave. The installation takes a comic strip that the artist drew of the legend when he was a boy and enlarges it, reproducing it as wallpaper. His revisitation of the comic strip functions as a parody of history painting: events related to the origins of Romania as a unified country look two-dimensional and cartoonish, especially when appropriated in a time of post-socialist patriotism.

Man once said in an interview with curator Hans Ulrich Obrist that he rarely plans works or exhibitions in advance. Rather, he collects images and objects in his studio and waits for ideas to congeal from the proximity.[1]

He welcomes open-ended encounters, and his finished works are efforts to capture that alchemical spontaneity. Dissimilar substances and images collide and yield a third element that might be described as an approximation of the distance between present and past. It is a sensation that eludes language and reason, but the single page of appropriated text in Man's *attebasile* (Ikon Gallery, 2009)— an artist's book in which the pages interweave found images from Man's archive with installation shots of works they have appeared in—can pass as a description of it, and even as an idiosyncratic manifesto for Man: "I should also add that at each reading of the bulletin I was surprised at, among other things, the persistent poverty of the collective fantasy, if I may express myself this way; beside some extremely rare and old obsessions the ultra-scarce amount of news demonstrated, even back then, that this field was either in a period of impasse, which wouldn't be cause for surprise, or had moved its proofs of manifestation to other, still obscure, zones."[2]

—*Brian Droitcour*

1. Hans Ulrich Obrist, "A Conversation with Victor Man," in *Victor Man* (Bergamo, Italy: Galleria d'Arte Moderna e Contemporanea), 39–40.

2. The origin of the text is Romanian author Gellu Naum's *Zenobia*, trans. James Brook and Sasha Vlad (Illinois: Northwestern University Press, 1995), 36.

174
Victor Man, *Untitled (The Lotus Eaters)*, 2009–11
Oil on canvas, 86¼ × 126 in. (219.1 × 320 cm)
Courtesy the artist and Gladstone Gallery, New York

175
Victor Man, *Untitled (portrait of S.D.)*, 2011

Oil on canvas, 20 ¾ × 16 ¾ in. (52.7 × 42.6 cm)

San Francisco Museum of Modern Art, Accessions Committee Fund purchase

176

Victor Man, *Virgács (St. Nicholas),* **2011**

Oil on linen mounted on panel, 13⅜ × 18⅛ in. (34 × 46 cm)

San Francisco Museum of Modern Art, promised gift of Mary Zlot

Ciprian Mureşan

b. 1977, Dej, Romania; lives and works in Cluj

In the spring of 2007, Ciprian Mureşan registered a site on Blogger, *Pet Shop Beuys*. The first post, "Traducerea în păsărească a manifestului . . . ," was a Romanian translation of *The Communist Manifesto*, which by the insertion of the letter *p* and an extra vowel into every syllable had been garbled into a secret language. (An English equivalent might read: "Thepe hipistoporypy opof apall hipithepertopo epexipistiping sopocipiepetypy ipis thepe hipistoporypy opof clapass strupugglepes.") Who was the target of Mureşan's raspberry? The Romanian Communist Party (may it rest in peace)? Or the readers of his blog? Although several posts to *Pet Shop Beuys* involved similar experiments with text, language, and concepts, most of the entries were images of Mureşan's work, including video clips, studio photographs, and installation shots. The blog, in other words, fulfilled the ordinary function of an artist's website: to make images of his work more readily available. For artists working at the margins of the art world, the internet offers the tantalizing potential of reaching a broad, international audience, and Mureşan's use of the popular, U.S.-based Blogger platform highlights that fantasy of erased borders. Yet even in the first post he asserts the persistence of language and cultural barriers in dividing artists and viewers.

In his works, Mureşan traces those boundaries not only to show where they lie but to puncture them. He came of age in the wake of the Revolutions of 1989, when the ideological forces organizing Romanian society were in flux. In this chaotic period, socialism was transitioning into capitalism, and the two systems overlapped: the socialist structures and habits were not yet gone, and the capitalist practices were not yet culturally ingrained. Throughout the second world—from Poland to China—members of his generation have an aloof, even wise-ass attitude toward ideology.

In the video *Choose . . .* (2005, pls. 177–80), Mureşan's son sits in a kitchen typical of Romania's communist-era housing, contemplating cans of Coke and Pepsi. The boy playfully mixes them, undermining the integrity of their brands, and drinks the contaminated flavors. Mureşan directs his irreverence toward the art world as well, reminding us that "contemporary art" is itself a set of ideological codes, a highly conventionalized way of producing and reading images. He makes this apparent by laying these codes bare beside those of old Romanian officialdom (the doubly translated *Communist Manifesto*) and capitalist popular culture (the Pet Shop Boys, forced in Mureşan's pun to adopt Joseph Beuys as their eponymous member). In a 2004 storyboard and video, Mureşan mashed *Un chien andalou* (1929), Luis Buñuel's textbook surrealist film, with the characters from the animated film *Shrek* (2001). In *The End of the Five-Year Plan* (2004), the artist remade Maurizio Cattelan's iconic sculpture of the pope getting hit by a meteorite, replacing John Paul II with the former patriarch of the Romanian Orthodox Church.

Visit *Pet Shop Beuys* (petshopbeuys.blogspot.com) today, and it is evident that Mureşan has not made the changes necessary to keep pace with Blogger's upgrades. Almost all the images he posted since 2007 have been replaced by a white target on a black field—the image file that Blogger uses to represent the crosshairs of digital deletion. However inadvertently, Mureşan has exposed "censorship" with a new face: the constant, self-devouring updates of technology at the heart of contemporary capitalism, and the control they exert over images on a supposedly free and open platform for expression.

—*Brian Droitcour*

177–80
Ciprian Mureşan, *Choose . . .*, 2005
Single-channel video transferred to DVD, color, sound, 0:45 min. (stills)
Courtesy the artist; Plan B, Cluj/Berlin; and Mihai Nicodim Gallery, Los Angeles

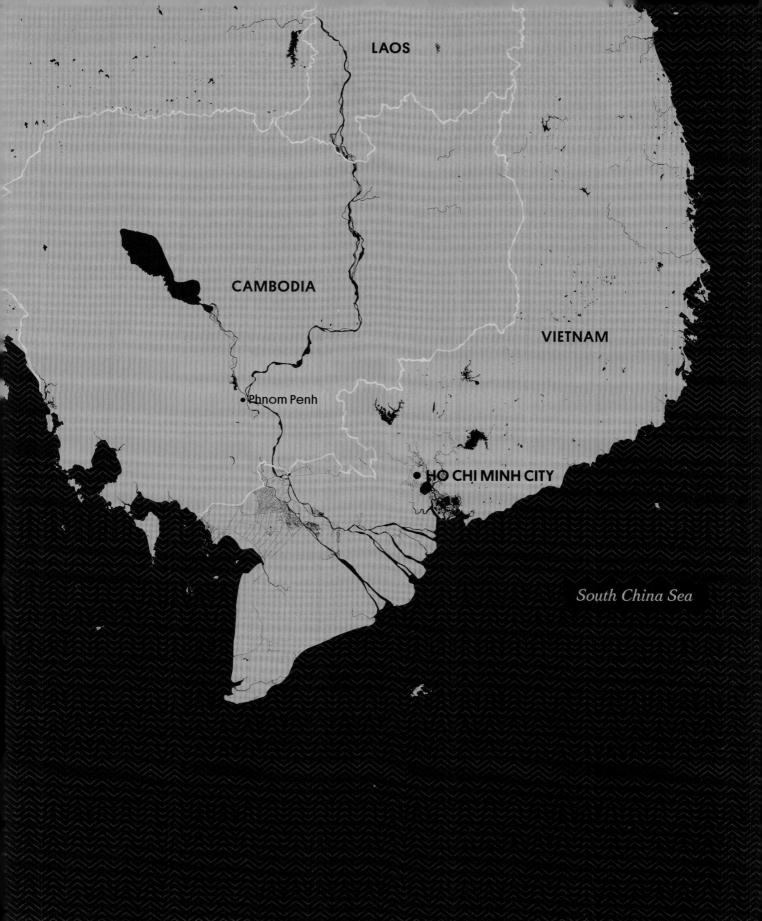

LAOS

CAMBODIA

VIETNAM

• Phnom Penh

• HO CHI MINH CITY

South China Sea

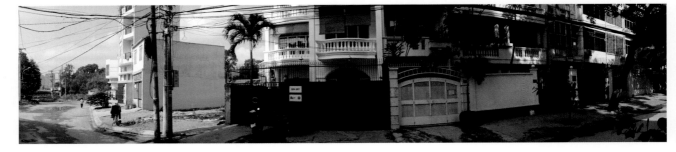

193–95. Views of Ho Chi Minh City and Sàn Art, 3 Mê Linh, District Bình Thạnh

XE ÔM DRIVERS OF THE MIND: THE JOURNEY OF SÀN ART

ZOE BUTT

Xe ôm[1]: *On the corners of most congested intersections a man can be found atop his* xe, *his feet casually crossed and resting on the handlebars as he reads the paper. He waits for his passengers, who will straddle his motorbike and entrust themselves to him as he carries them to their desired address. The route he takes will be his own—perhaps the fastest, or the most scenic, or the least congested, or the most indirect (to hike the price). Regardless, it is his path that yields the destination.*

Street pavements are a curious and multipurposed territory in Vietnam. At times the paving is wide, its girth and colorful patterning remnants of the colonial era that still echoes in the heart of a city now heavily monitored by diplomatic agencies. Elsewhere it is a hand-sculpted wash of cement that divides business properties from the street vendors selling *bánh cuốn*, *bánh mì*, and *cà phê sữa đá*[2] to customers squatting on iconic red plastic stools scattered along the road. On other streets the pavement is quite simply nonexistent. Here traffic collides with those destitute or brave enough to travel in the absence of a *xe máy*, or motorbike. What is striking about this ubiquitous two-wheeled vehicle, a Vietnamese fifth limb, is its ability to facilitate movement. Nothing is too large or too cumbersome for it to carry. Its uncontested claim on any pedestrian pathway in Vietnam is testament to its necessity. The tourists may complain that pedestrians have no right-of-way in this urban everyday, but locals argue for the xe máy's right to climb these pavements when they are choked by traffic or a heavy load needs to be collected at a crowded doorway. The ways that xe máy are guided, maneuvered, and fitted to suit personal needs are emblematic of Vietnamese society and its stunning ability to make use of existing tools. But what occurs when a problem has no adaptive tool? In the context of Vietnamese contemporary art, the lack of instruments for artists to work with is a critical issue. Today's artist must build a pavement for the movement of thought, while also becoming a xe ôm of the mind.

Amid the growing sprawl of colored concrete and mirrored steel skyscrapers, and along the metal shanty–lined canals of Saigon,[3] there are plenty of xe máy traversing the familiar pavements of the city's commercial trade, but few xe ôm carrying the minds of the artistic community toward greater innovation and experimentation. The opening night of the first exhibition at Sàn Art (on October 3, 2007) in Saigon was a significant moment. The crowds that gathered for the event were an eager and genuine lot, buzzing with energy and keen to embrace the social friction that came with combining the three tiers of the community: local, foreign, and Việt Kiều.[4] The exhibition showcased the skill of Saigonese draftsmen, and it is this constituency—the local—that Sàn Art has continued to nurture and promote. As an artist-initiated, independent, nonprofit contemporary art center and reading room, Sàn Art (*sàn* means "platform") offers a space for artists to participate in and transform, operating as an essential hub for experimentation and the meeting of talent, both local and foreign. In southern Vietnam, however, such pavements of thought must be negotiated with particular care.

Historically, southern Vietnam held the seat of a traitorous community in league with the United States. Its central port of Saigon, once cultivated by expatriates as the "Pearl of the Orient," has had most of its heritage plundered and torn asunder by a wealthy elite who collects the coin bags for the ruling government officials of the north in Hanoi, Vietnam's capital. Today, Saigon is also the international economic hub of the country, and steady droves of youths from rural as well as other urban locales set their sights on the city, hoping for professional success. Politically, the communist seat of power in Hanoi gazes south with great suspicion at any entrepreneur who is pushing new limits, particularly when these individuals are Việt Kiều and not sympathetic to the communist cause. (Ironically, the Vietnamese government is aware that many international trade relationships would not progress without the skill

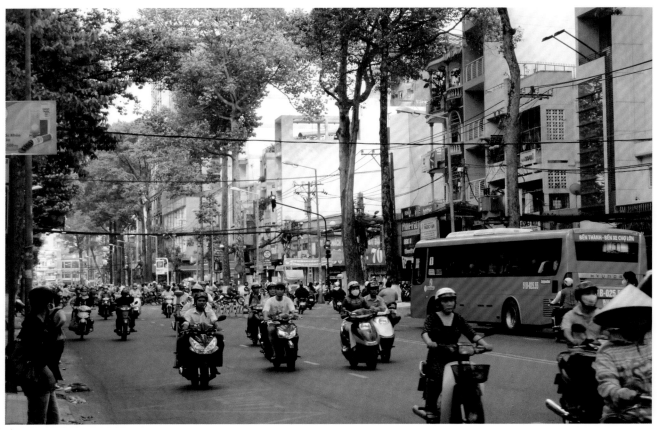

196. *Xe máy* (motorbikes) on the streets of Ho Chi Minh City, 2012

base of the Việt Kiều; the nation's educational system does not produce a labor force that can meet the demands of a global economy.) The Bộ Văn hoá (Vietnamese Communist Cultural Ministry) carefully monitors all public organized cultural activity and, like Orwell's Squealer, stamps its trotters in a flurry of paper detritus, unleashing bureaucratic demands and restrictions on anything to do with history, politics, or social conflict. Art events are particularly bothersome to the robotic, directives-as-bible, power-hungry officials who police such activities. Gatherings of more than five people require a permit, and, not surprisingly, the application's lingo is rarely transparent and often deliberately evasive. The monitors in the south are particularly stringent; their ideological seeding machine favors and encourages the materialistic urges of its citizenry at the expense of local culture. The newly built, neon-lit Prada and Louis Vuitton stores, along with the increasing number of glass towers with breathtaking rooftop views of the city's continued expansion, reflect the interests of Saigon's most socially influential class, which has framed the country's definition of *culture* as "commodity." Meanwhile, the historical relics of Vietnam's past are pursued only by the avid tourist. Underfunded and undervalued, institutions such as the Bảo tàng Mỹ thuật Thành phố Hồ Chí Minh (Ho Chi Minh City Fine Arts Museum) occupy majestic French colonial buildings in great need of repair, their collections requiring urgent conservation. Commercial galleries catering to the tourist market clamor for space in the central avenues of the city, their focus predominantly on artists who repeatedly revisit successful imagery and subjects in the interest of a sure sale (a nationwide phenomenon). The national arts education curriculum proudly clings to the now outdated École des Beaux-Arts system, an import of the French occupation, and its reverence for the plastic arts. Regrettably, no

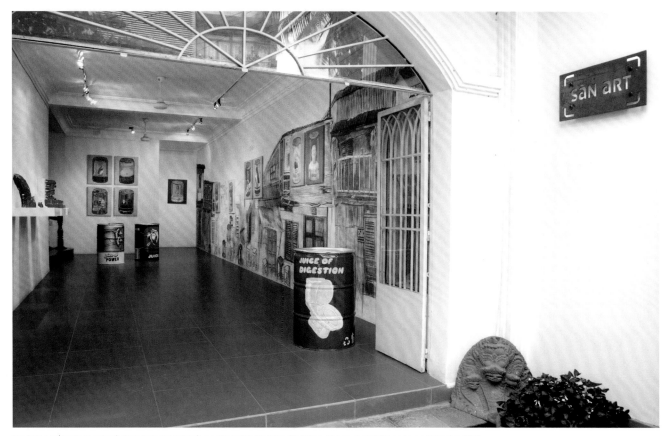

197. *Cuộc sống là tiêu thụ'* (Life Is Consumption), a solo exhibition by Bùi Công Khánh. Installation view at Sàn Art, 2010

public university in the country teaches the history of contemporary art. The field's emerging practitioners are thus doubly challenged, faced with a local audience that has had no exposure to its interdisciplinary forms and concepts and stymied by museums-for-hire that routinely fail to offer critical scholarship or to showcase and collect works that reflect the growing experimentation of art making today.

While the government continues to support sanctioned art associations across the country, membership in these once highly regarded clubs is no longer a bright horizon for young artists who aspire to international relevance. Instead, this generation must seek support from among a handful of Hanoi-based nongovernmental organizations (NGOs), such as L'Espace (France), the Cultural Development and Exchange Fund (Denmark), and the Goethe-Institut (Germany). The capital city has always been favored as the center of art production; it was in Hanoi that

experimentation with conceptual and abstract art first flourished in Vietnam, creating a scene that by the mid-1990s was gaining an international reputation and included artists such as Vũ Dân Tân, Nguyễn Xuân Tiệp, Nguyễn Câm, and Đặng Thị Khuê. During the following decade, video and performance pioneers such as Trần Lương and Trương Tân (based in Hanoi) were also showcased in major overseas exhibitions, and they organized local events that have since been recognized as key turning points in international thought about what constitutes contemporary Vietnamese art. At that same time Hanoi saw the rise of artist-run initiatives such as Salon Natasha, founded by Vũ Dân Tân; Nhasan Duc, initiated by Trần Lương and Nguyễn Mạnh Đức, with Nguyễn Mạnh Hùng and others; and Ryllega, established by Nguyễn Minh Phước. There was an enormous lack of financial support and gallery space then for artists in southern Vietnam, and Saigon artists often

struggled for inclusion in Hanoi events. It must not be forgotten that a great many cultural producers in the south fled the country around 1975, following the close of the Vietnam War and the unification of the country under communist rule, creating a presumed vacuum of historical memory in the cultural community. Perhaps as a result, the limited writing on the birth of Vietnamese contemporary art by local art historians and foreign scholars tends to focus on northern artists and includes little acknowledgment of the fact that abstraction emerged in Saigon in the 1990s, practiced by figures such as Nguyễn Trung and self-taught artist Trần Trung Tín. Also missing from the record is Blue Space Contemporary (now located within the grounds of the Ho Chi Minh City Fine Arts Museum), which from the time of its establishment in 1997 had a significant impact on the development of the art scene in the south. As the first independent organization in the south to highlight Vietnamese contemporary art, Blue Space often collaborated with Hanoi artists while also showcasing talent from southeastern and northern Asia. It was there that Jun Nguyen-Hatsushiba displayed his first *Water on Air* installations in 1998; Bùi Công Khánh undertook some of his first performances; and senior Cambodian painter Svay Ken became the first contemporary artist from his country to show his work in Vietnam. And it was at Blue Space that established critics and university lecturers of the war period pondered performativity and new media, modes of artistic expression that continue to occupy contemporary aesthetics.

The personal reflections of Việt Kiều artists Tiffany Chung, Dinh Q. Lê, Tuan Andrew Nguyen, and Phunam on their experience of present-day Vietnam, coupled with the great lack of contemporary art expertise and resources in the local community, were central to the founding of their contemporary art space and reading room, Sàn Art, in 2007. When Lê relocated to Saigon from the United States in 1996 he was struck by the resilience of Vietnamese artists, who continued to create even in a country where humid libraries without Wi-Fi access offered little glimpse of the world after about 1954, and travel demanded so many queues, stamps, and seals that any hope of exploration beyond the borders was quickly extinguished by red tape. Lê remembers visiting Blue Space Contemporary in those early years and realizing how much of the distant and recent past was mentally reconstructed by

artists who shared the cultural blindness of the hand-painted propaganda signs that circulate continuously throughout the country.[5] Chung and Nguyen recall similar impressions of Vietnam when they returned from the U.S. (in 2000 and 2004, respectively). They were fascinated by the ways Vietnam's past was being reinterpreted through popular culture—namely Korean, Japanese, and American music, film, fashion, and graffiti—and became interested in exploring how young Vietnamese were using gleanings from a mish-mash of random, decontextualized visual signifiers to come to grips with the country's history. Phunam could relate to those who battled to make the inconsistencies of history profitable. A self-taught photographer who trained in Thailand in fine art conservation, he was fully aware of the controversial practice of making copies of art and artifacts as a strategy of "cultural" survival.[6] Determined to find some way to contribute to the local art scene, Lê founded the Vietnam Foundation for the Arts (VNFA) in Los Angeles in 2006 (at that time in Vietnam, nonprofit status did not legally exist) with a mission to promote and support the discussion and production of Vietnamese contemporary art and culture within and beyond the nation's borders. Its first project, a response to the limited textual and visual resources on contemporary art and culture in the country, was to establish a reading room in Saigon. However, finding a home for this contemporary art material proved inordinately complicated. As a Việt Kiều, Lê was treated with suspicion and his project was ultimately buried in "official" paperwork. Frustrated, realizing not only the political limits of showing critical work in Vietnam but also the social difficulties of being a Việt Kiều, these four friends who shared similar backgrounds, interests, and motivations logically concluded that they should come together to create their own platform, or sàn, for art.

Other artist collectives in Saigon were founded for similar reasons. For example, Atelier Wonderful (2006) and Mogas Station (2006–8), though short-lived, worked to bring great international exposure to the art scene of the south, while current artist enterprises such as Himiko Nguyễn's Himiko Visual Art Salon, Sue Hajdu's a little blah blah, Nguyễn Như Huy's Zerostation, and Rich Streitmatter-Tran's dia/projects (*dia* means "territory"), powered by shoe-string budgets and personal commitment, continue to act as valuable hives of activity. It is critical to recognize that today's longest-running and most

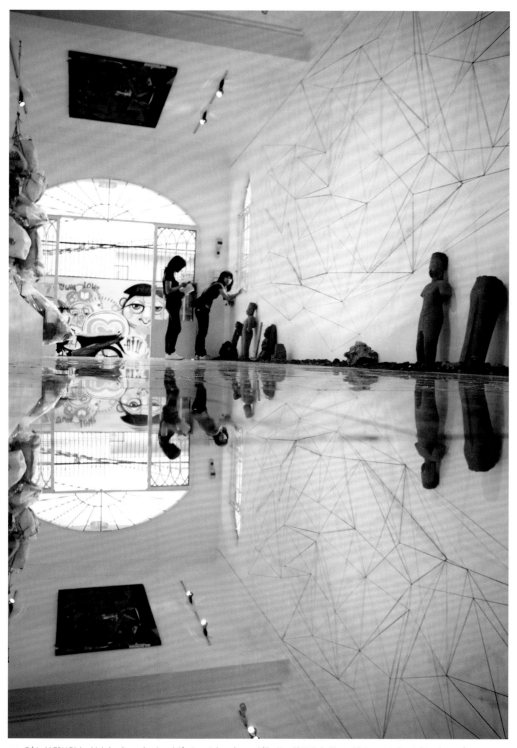

198. *Gửi tới TPHCM với tình yêu: một tác phẩm "social sculpture"* (To Ho Chi Minh City with Love: A Social Sculpture), an art project by Phong Bui, in collaboration with local artists. Installation view at Sàn Art, 2011

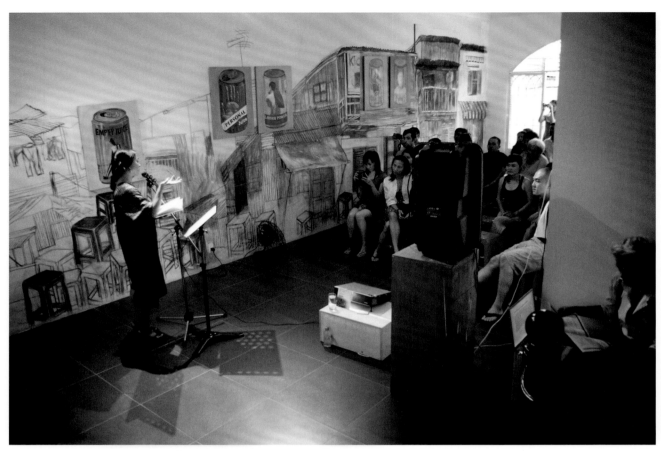

199. A reading by writer and poet lê thị diễm thúy, Sàn Art, May 15, 2010

active contemporary art hubs in Saigon began with a desire for more education about, and exposure to, the international contemporary art world. Galerie Quynh, a great supporter of experimental practices and arguably the most internationally reputable commercial gallery in the country, began in 2000 as an online resource dedicated to the Vietnamese art scene and quickly grew into a key venue for the promotion of Saigon's contemporary artists. (In its early days, the gallery occupied the space that would become Sàn Art's first location.) The arrival of Sàn Art in this fledgling art community was a welcome development, although many locals (including its founders) wondered how long it would last. Financial anxieties constantly threaten the sustainability of independent art organizations like Sàn Art, as does the ceaseless badgering of government officials determined to restrict the growth of the cultural community. In Sàn Art's case, the government has not taken kindly to the group's efforts to provide educational programs. Ironically, the Cultural Ministry's strict policing of Sàn Art's activities—including, for example, enforcing the requirement that Sàn Art obtain a permit for gatherings of more than five people, while allowing other Saigon art spaces to disregard this edict without repercussion—has serendipitously increased its reach: to skirt such restrictions, Sàn Art must collaborate with local businesses, which as noncultural entities are not subject to the same ministry scrutiny, and thereby gains access to new audiences. From its inception, Sàn Art very consciously operated aboveground, vowing not to engage in the deception or bribery of authorities. This stance reflects the founders' beliefs that open dialogue and engagement with the official

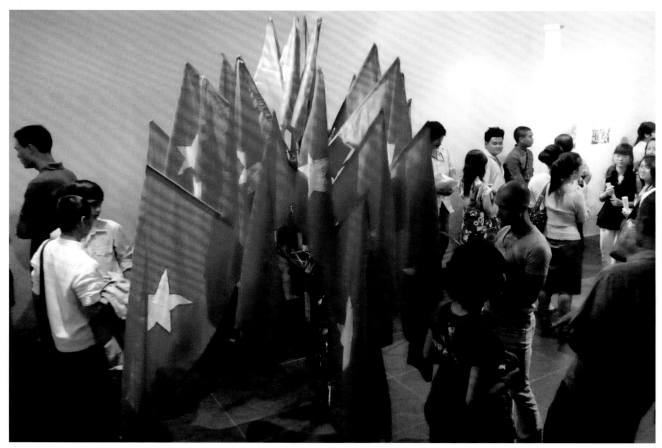

200. *Cú pháp Ngữ âm* (Syntax and Diction), a group exhibition featuring Arlette Quynh-Anh Tran, Dinh Q. Lê, Ha Do, Tran Minh Duc, Tuan Andrew Nguyen, Nguyen Duc Thinh, and Tammy Nguyen. Installation view at Sàn Art, 2010

system was the only way to change the ministry's views of contemporary art in Vietnam. Foresight and flexibility have been crucial to Sàn Art's continued existence, as has the group's positive and innovative approach to what is popularly labeled "censorship" but in reality is not dissimilar from the dulling effects of government bureaucracy felt worldwide.

Despite the odds, Sàn Art quickly attained an important position in the local and international art world as a critical entry point to understanding the context of Vietnamese artistic production. By August 2009, a roster of shows had been organized featuring local and foreign artists, and Sàn Art had received support from international foundations and organizations. The exhibition *Time Ligaments*, co-organized with 10 Chancery Lane Gallery (Hong Kong) and scheduled to coincide with the 2009

Hong Kong International Art Fair, was a particularly notable promotional coup. Sàn Art could sense that it was on the cusp of much larger developments in the local art scene. The rising international profile of contemporary southeast Asian art was reflected in the growing number of collectors and curators passing through Vietnam for exotic holidays that included visits to art spaces and artists' studios. The Sàn Art founders were in great demand, with their individual work increasingly showcased internationally in museums and biennials, and they realized that they needed an arts manager and curator to help them direct their growing organization. In late 2009, they asked if I would consider taking on a directorial role. I was already serving as their international advisor, and I had been involved with Sàn Art almost since its inception in 2007, when I had accepted a

201. Sàn Art statement for *No Soul For Sale: A Festival of Independents,* Tate Modern, London, May 14–16, 2010. Design by Thuy Khanh Xiu Tran

three-month curatorial residency there. As someone with a demonstrated research interest in contemporary Asian art in general and artistic practice in Vietnam in particular, I could feel that global interests were shifting toward this region from the large, established markets in China, Korea, Japan, and India. For me, however, the most exciting aspect of this challenging new position was not only my sense of Sàn Art's international potential and my belief that it served a crucial role in the diversifying landscape of Vietnamese contemporary art. It was also the thrilling realization that I, a museum-trained curator, would once again be employed by a group of artists in a communist country greatly lacking in any arts infrastructure, who were joining their own ideas and experience of contemporary art production to fashion a platform of their own.

Today, Sàn Art is considered "the most professional venue for contemporary art in Vietnam."[7] The programs of this small arts organization include other artist-run events in Vietnam (New Space Arts Foundation in Hue and DocLab in Hanoi), collaborations with independent initiatives in the region (such as Green Papaya in Manila, SA SA BASSAC in Phnom Penh, and the Asia Art Archive in Hong Kong), and inclusion in international exhibitions (*No Soul For Sale: A Festival of Independents* at the Tate Modern, London, and *Encuentro Internacional de Medellín* [*MDE11*], Colombia). As the Vietnamese art community has come to recognize Sàn Art as a venue for international as well as local exhibitions, Saigon's business organizations and educational institutions have come to appreciate its unique expertise. Sàn Art shares its space with The Propeller Group, an artist collective-cum-film and media production house whose directors are also among the gallery's cofounders. The ground floor of our Vietnamese villa on the central city border between District Bình Thạnh and District 1 may be a meager forty by thirteen feet (twelve by four meters), but the steady stream of visitors—including artists, filmmakers and production teams, researchers, curators, historians, performers, teachers, and many others—has made the site a dynamic nexus of contemporary talent. Sàn Art's initial mission to serve as a space where contemporary artists could gather and share ideas has since broadened to include the goal of fostering a supportive arts community. There is also growing demand for Sàn Art to participate in conferences and panel discussions that address the burgeoning art

scene in Vietnam in relation to international developments in contemporary art.[8] In addition, the group has increasingly been approached to create classes for multinational architectural companies and advertising agencies that want their Vietnamese employees to be more informed about the intersections between art and other social and cultural disciplines.

The artistic landscape in this unpredictably governed society is a challenging context for producer and facilitator alike. Priorities must be carefully weighed, and the understanding of what constitutes contemporary practice is continually realigned. In 2012, the Year of the Dragon, Sàn Art celebrates its fifth anniversary with the initiation of Sàn Art Laboratory, the country's first studio/residency mentoring program for emerging Vietnamese artists. This year, for the first time, the organization secured private foreign funding that will cover its operating costs and ensure a period of institutional growth. In the midst of these successes, we continue to grapple with questions: How can Sàn Art remain rooted in its local context? In our structure, psychology, and financial strategy, are our feet resting too comfortably on the handlebars of a well-oiled foreign system? Are our chosen pathways forging innovative relationships between local and international talent? How can we create a curatorial platform that challenges international assumptions about art practice in Vietnam while also encouraging local artists to think beyond their immediate environment? The answers lie in exposing the tendrils of historical consciousness, teasing it into articulation, and creating space for its visual prodding. This is the ground we must travel; these are the tasks that we, as xe ôm drivers of the mind, hope to achieve.

1. A literal translation of *xe ôm* is "motor hug," after the manner of traveling on a motorcycle taxi: the passenger sits behind the driver and may hold onto him for safety.

2. Pork rolls, meat-filled sandwiches, and sweet iced milk coffee.

3. Rather than Ho Chi Minh City, the name that has been in place since the communist takeover of South Vietnam in 1975, I have chosen to use Saigon, the name preferred by the city's local population.

4. Việt Kiều literally translates as "Vietnamese sojourner." It commonly refers to the overseas Vietnamese diaspora, particularly the boat refugees of the Vietnam War. The Việt Kiều community, until the mid-2000s, was heavily ostracized by locals and government alike. The need for specialist expertise in trade and communications, qualifications earned by Việt Kiều abroad and now employed within Vietnam, is greatly contributing to a positive and inclusive national shift in social attitude.

5. Dinh Q. Lê, in conversation with the author, December 2011.

6. Many of the works in Vietnam's museum collections are considered by the international art community to be copies, or fakes. The need to protect the original works from destruction or looters during wartime was cited as justification for the practice of producing and displaying forgeries.

7. "Alternative Spaces, Mainstream Problems," *Thanh Nien News*, updated December 23, 2011, http://www.thanhniennews.com/2010/pages/2C111223-alternate-spaces--mainstream-problems.aspx.

8. For example, REDCAT's "State of Independence: A Global Forum on Alternative Practice" (Los Angeles, July 2011; presentation by Zoe Butt); the San Francisco Museum of Modern Art's panel discussion introducing the exhibition *Six Lines of Flight: Shifting Geographies in Contemporary Art* (San Francisco, September 2011; presentation by Tuan Andrew Nguyen); and Zentrum für Kunst und Medientechnologie's conference "Curating in Asia," part of its *Global Contemporary: Art Worlds after 1989* exhibition (Karlsruhe, Germany, December 2011; presentation by Zoe Butt).

Tiffany Chung

b. 1969, Da Nang, Vietnam; lives and works in Ho Chi Minh City

In her embroidered canvas maps, cartographic drawings, videos, performance works, and installations, Tiffany Chung investigates the shifting topography of urban landscapes. Her work reminds us that maps do not simply reflect geography; they encapsulate particular, and subjective, moments in time. In *one giant great flood 2050* (2010, pl. 202), for example, the artist simultaneously charts the existing and planned transportation networks of Ho Chi Minh City, overlaying them with vibrant spheres and dots of paint marker and washes of ink that signal the impact of the extreme flooding projected to transform the city by mid-century. Often based on old urban plans and gridlike official surveys, Chung's vivid, abstracted maps foreground the cultural memories and histories specific to each region. By intertwining fact and fantasy, she unveils the myth of cartography as an objective discipline, revealing its political agendas and constructed landscapes.

For her 2010 exhibition *scratching the walls of memory*, Chung focused on an unspoken past, creating works inspired by handwritten messages discovered beneath layers of paint on the walls of Hiroshima's Fukuromachi Elementary School, which was used as a shelter after the atomic bomb was dropped in 1945. The exhibition centered on an installation of the same name, which comprised small chalkboards and cloth satchels that had been hung on two of the gallery walls, and a wooden school desk. The chalkboards and satchels were inscribed or embroidered with the writings of the Japanese victims of the nuclear attacks, as well as those displaced or separated from their families by conflicts in Vietnam, Cambodia, Germany, and other countries. Their messages reflected their trauma and suffering, documenting a history that has not been officially recorded or acknowledged. The maps that accompanied the installation similarly depart from the realm of established historical practice, outlining the topography that resulted from many of the twentieth century's most devastating conflicts: the Berlin Wall, the demilitarized zones (DMZs) in Korea and Vietnam, the atomic blast zones in Hiroshima and Nagasaki. Layered with intricate embroidery, beads, rhinestones, and metal grommets, these richly textured works on canvas and vellum possess a beauty that is wholly incongruous with the fraught histories they represent.

In her earlier works, Chung explored communist imagery, twisting it through the lens of popular culture to create unexpected representations of Vietnamese life. Some of the photographs in *Play* (2008) depict Vietnamese youths in jumpsuits similar to those worn by the manual laborers who are powering the country's rapid urbanization. Although their poses are modeled on classic gestures from government propaganda, they are wielding pool cues, megaphones, and water guns. Here, too, Chung investigates boundaries and borders, using appropriation not to critique but to create a utopian space in which traditional frameworks such as social conventions, class hierarchy, and cultural categories are temporarily transgressed and suspended.

More recently, the potential of urban planning to shape spatial and cultural transformation in developing regions has served as an anchor point for the artist. In *The River Project* (2010) she explores the implications of constructing hydropower dams along the Mekong River. Her contribution to the Singapore Biennale 2011, the mixed-media installation *stored in a jar: monsoon, drowning fish, color of water, and the floating world* (2011, pl. 203), is a miniature model of a floating town that draws on vernacular architecture and ways of life in the floating communities of the Mekong Delta and Srinagar, India, as well comparative studies of farmhouses in coastal and inland prefectures of Japan. Questioning and reassessing a failed utopian vision—the Arcology design movement, which aimed to minimize human impact on natural resources while enabling extremely high population density—Chung proposes new ways of adapting vernacular structures to address environmental issues and to reshape the present and future global landscape.

—*Xiaoyu Weng*

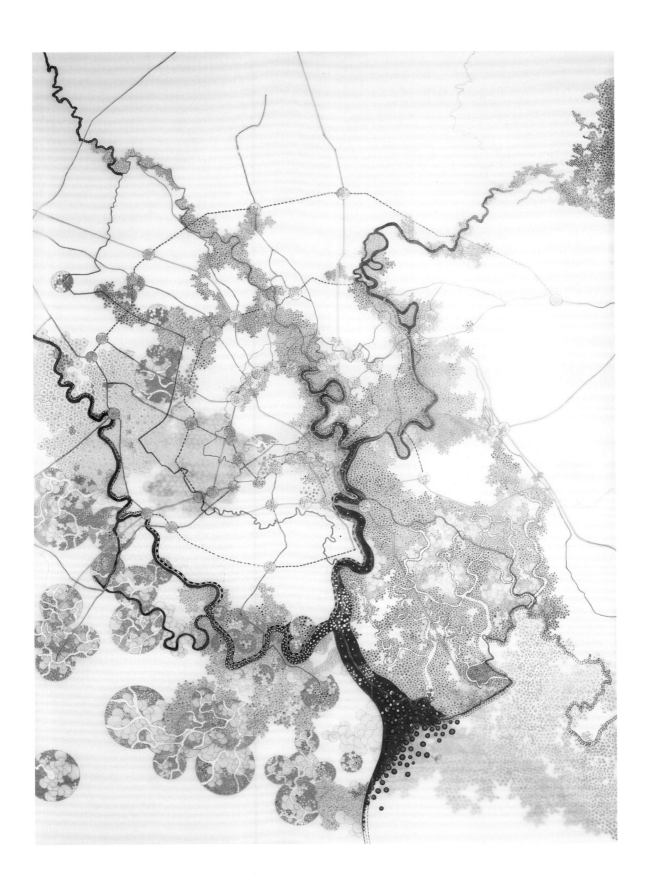

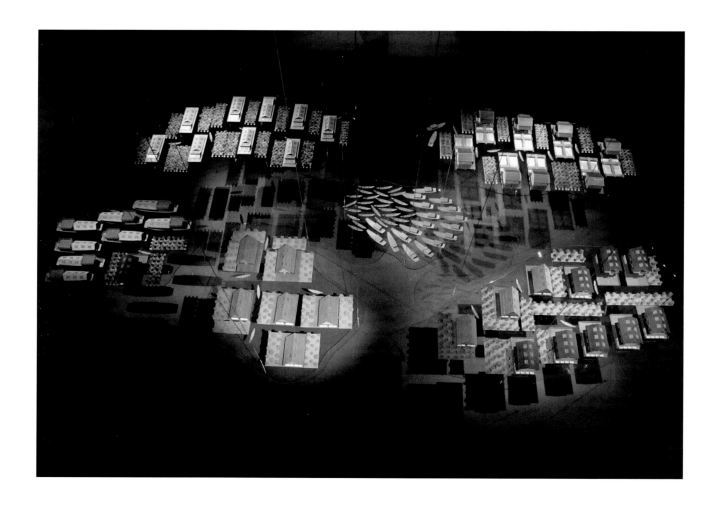

202 (previous page)

Tiffany Chung, *one giant great flood 2050*, 2010

Micropigment ink and oil and Copic marker on vellum and paper,
43⅛ × 27½ in. (110 × 70 cm)

Courtesy the artist and Tyler Rollins Fine Art, New York

203

Tiffany Chung, *stored in a jar: monsoon, drowning fish, color of water, and the floating world*, 2011

Mixed media (Plex glas, wood veneer, plastic, aluminum, paint, steel
cable, foam, and copper wire), 236¼ × 141¾ in. (600 × 360 cm). Installation
view at the Singapore Biennale 2011

Courtesy the artist and Galerie Quynh, Ho Chi Minh City

204

Tiffany Chung, *The Growth of Cali—city boundaries:*
1780, 1880, 1921, 1930, 1937, 1951, 2012

Micropigment ink, gel ink, and oil marker on paper, 38½ × 53¼ in.
(98 × 135 cm)

Courtesy the artist and Tyler Rollins Fine Art, New York

Dinh Q. Lê

b. 1968, Hà-Tiên, Vietnam; lives and works in Ho Chi Minh City

Dinh Q. Lê's artistic practice centers on his understanding of the political and social conditions in his native Vietnam. As a refugee who fled with his family via Thailand in 1978 and immigrated to the United States in 1979, Lê interweaves the experiences that helped shape his identity with Vietnamese national mythologies, collective memory, and expanded cultural histories. Often incorporating imagery from a variety of sources, such as archival photographs, documentaries, Hollywood films, and Vietnamese iconography, Lê's investigations raise critical questions about the distribution, reception, and consumption of images and how visual culture may inform a national identity.

For Lê, the act of recycling and appropriating imagery is a means of rescuing both the images and the memories embedded within them. The large-scale photo-tapestry *Một cõi đi về* (Spending One's Life Trying to Find One's Way Home, 2000/2005) weaves together hundreds of found Vietnamese photographs, dating from the 1960s to 1975, that depict everyday activities as well as celebrations such as weddings and birthdays. By monumentalizing these personal moments—in contrast to the iconic imagery commonly used to represent Vietnam to Western audiences—Lê foregrounds the subjective realities of the Vietnamese people, which might otherwise be lost in the shadow of the country's traumatic past. The exploration of a lost identity is continued in Lê's immersive installation *Erasure* (2011), a response to the fatal December 2010 shipwreck off Australia's Christmas Island coast of a boat carrying Iraqi and Iranian refugees. The tragedy had resonance for Lê and many other Vietnamese immigrants: forced migration and other traumas caused by war were experiences they had undergone a few decades earlier. Creating a kind of ghostly sublime reminiscent of the Romantic landscapes and marine paintings of British artist J.M.W. Turner (1775–1851), *Erasure*'s video projection of an eighteenth-century sailing vessel in flames evokes the early European settlement of Australia. In the installation, innumerable found photographs of Vietnamese families are strewn around the wreckage of a boat. All the images are face down; sometimes an inscription is visible. Viewers are encouraged to pick up and examine the photographs, and to imagine narratives for these forgotten family moments.

Other projects from Lê's recent practice emphasize close engagement and collaboration with local communities in an effort to understand day-to-day life in contemporary Vietnam and the many challenges facing its people. Along with The Propeller Group (see pp. 146–49), he worked with farmer Le Van Danh and mechanic Tran Quoc Hai on *The Farmers and The Helicopters* (2006), an installation composed of a helicopter and a three-channel video. The helicopter had been built by Danh and Hai from scrap parts. The video—which includes clips from Western documentaries and Hollywood films about the Vietnam War, juxtaposed with interviews in which Vietnamese farmers relate their memories of the conflict—reflects different perspectives on the symbolic nature of the war machine. Here, the local manufacture of the helicopter has become a manifestation of the Vietnamese people's desire to write their own version of history: the helicopter has moved beyond its role as a ubiquitous symbol of war-torn Vietnam. A similar juxtaposition of narratives can be found in photo-tapestries such as *The Locust* (2008, pl. 205), in which Lê layers images of Muslim men and women in head scarves with pictures of soldiers, shackled prisoners, and military fighter jets that bear down like the biblical plague of insects referenced in the work's title. Made from decontextualized media images, the weaving retains a handmade tactility that emphasizes the personal tragedies of war while rendering them on an epic scale. In both works, Lê joins multiple perspectives and sources of imagery, offering glimpses of war that emphasize the interchangeability of fiction and reality and the problems inherent in a static and monotonous historical view.

—*Xiaoyu Weng*

205

Dinh Q. Lê, *The Locust*, 2008

Chromogenic print and linen tape, 45½ × 89 in. (115.6 × 222.⁄ cm)

San Francisco Museum of Modern Art, Accessions Committee
Fund purchase

206–35 (following pages)

Dinh Q. Lê, *Sound and Fury*, 2012 (stills)

Three-channel video installation, color, sound, 20 min.

Courtesy the artist; Shoshana Wayne Gallery, Los Angeles; PPOW Gallery,
New York; and Elizabeth Leach Gallery, Portland, Oregon

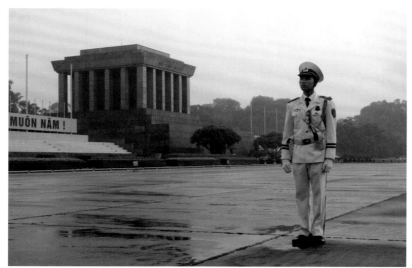

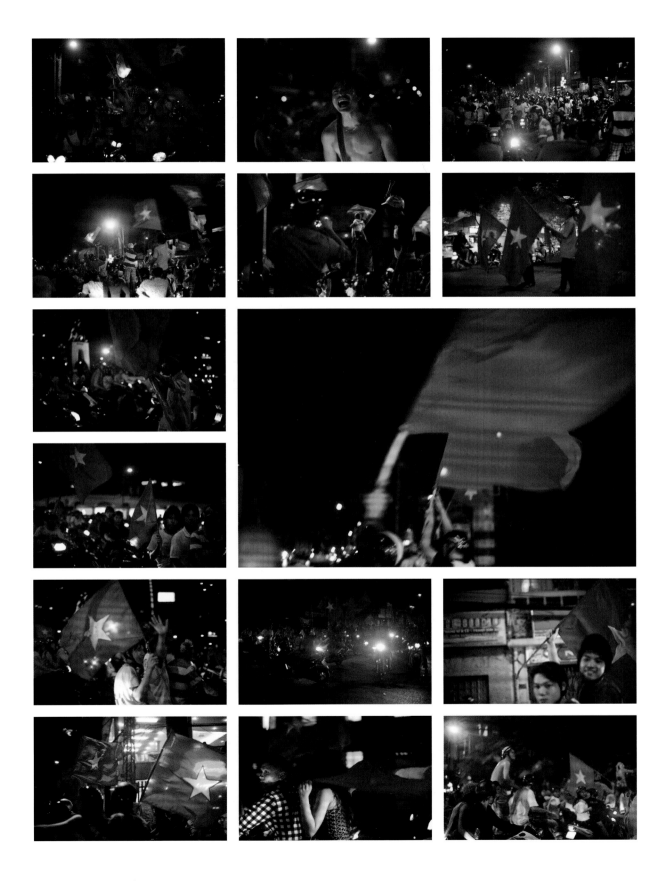

The Propeller Group

Tuan Andrew Nguyen — b. 1976, Ho Chi Minh City; lives and works in Ho Chi Minh City
Phunam — b. 1974, Ho Chi Minh City; lives and works in Ho Chi Minh City
Matt Lucero — b. 1976, Upland, California; lives and works in Ho Chi Minh City

The Propeller Group (TPG) is an art collective founded in 2006 that consists of Tuan Andrew Nguyen, Phunam, and Matt Lucero. Working with local and international television, film, and music producers, the group creates multimedia projects that, while adopting the aesthetics and language of popular culture, also undermine existing strategies for the dispersion and consumption of cultural content. Like the Situationists (1957–72), whose artworks often addressed political issues through provocative combinations of appropriated images and slogans, TPG believes that the most effective way to change a system is to work within it to create a shift in perspective. Engaging the same platforms and strategies employed by mass media, the collective aims to enact social, cultural, and political transformation by subtly and humorously challenging prevailing ideological systems, while also testing the boundaries of the art world.

The Propeller Group's projects are characterized by a deep commitment to social and political awareness, expressed through irony and wit. *Television Commercial for Communism* (*TVCC*), for example, examines the contradictions between communist ideology and the realities of a global capitalist marketplace, exploring both historical and contemporary tensions in these disparate eco-political systems. For this project, ongoing since 2011 (pls. 237–44), TPG commissions leading advertising agencies to create a series of marketing campaigns, which the group plans to release through various media distribution methods. Its first collaboration—with the advertising team of TBWA\Viet Nam, whose clients include Apple, Nissan, and Adidas—comprises the commercial the firm produced as well as a synchronized five-channel video installation that documents the agency's brainstorming sessions. Partially realistic, partially quixotic, *TVCC* provocatively pairs communist ideology with capitalism's advertising machine, forging a seemingly paradoxical alliance to investigate the deeper questions raised by nation branding. TPG has thus sought to question the ways in which nationalistic and political associations are made, how those associations are perceived in the world, how they become filtered using the framework of mass media, and how they are consumed by the public. Significantly, the project tests not only the effectiveness of advertising and propaganda strategies but also the audience's ability to discriminate between the two channels.

In the documentary film *Nhu cầu vẽ bậy* (Spray It, Don't Say It, 2006), the short video *Uh . . .* (2007), and the media campaign *Viet Nam The World Tour* (*VNTWT*, ongoing since 2010, pls. 3, 236, 245), TPG focuses on Vietnam's underground graffiti scene. Foregrounding the subversive and symbolic gestures of graffiti artists, these works explore issues including national and cultural identity, urban transformation, and the shifting boundaries between private and public space. Presenting alternative views of contemporary life in Vietnam is among the key strategies TPG has used to challenge the heavily mediated stereotypes of the country propagated by many Western media outlets. *VNTWT*—which has featured numerous local and international cultural figures in a series of projects presented on the internet—represents the group's own initiative to rebrand the country's identity. TPG's ambitious efforts to work beyond the gallery and museum spaces that circumscribe the established circuit of the art world bring to mind the following lines from the essay "Dispersion" by conceptual artist Seth Price: "Hasn't the artistic impulse always been utopian, with all the hope and futility that implies? . . . It is demonstrably impossible to destroy or dematerialize Art, which, like it or not, can only gradually expand, voraciously synthesizing every aspect of life."[1] Precisely with the intention of merging art and life with communicative actions, TPG applies new means of distribution through which free debates and discussions are fostered.[2] Ultimately, these efforts are about not only a different Vietnam but also the positioning of perceptions of culture, nation, identity, politics, and history in flux.

—*Xiaoyu Weng*

1. Seth Price, "Dispersion," in *10,000 Lives: The 8th Gwangju Biennale*, ed. Massimiliano Gioni and Judy Ditner (Gwangju, Korea: Gwangju Biennale Foundation, 2010), 183–84.

2. Visit www.the-propeller-group.com/tvcc and vietnamtheworldtour.com to learn more.

236
The Propeller Group, *Viet Nam The World Tour* (2010–ongoing):
El Mac, *Kosoom by the Mekong*, Ho Chi Minh City, 2010
Spray-paint on concrete, 13.1 × 9.8 feet (4 × 3 meters)
Courtesy The Propeller Group

237–44

**The Propeller Group, *Television Commercial for Communism,*
2011–ongoing**

Multimedia installation (five-channel synchronized video and animatic) at the
Singapore Biennial 2011, dimensions variable. Top: stills from five-channel video
installation; bottom: stills from animatic

Courtesy The Propeller Group

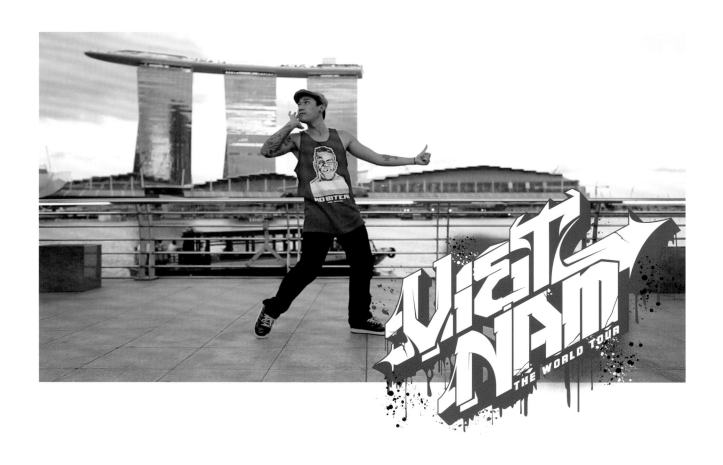

245

The Propeller Group, *Viet Nam The World Tour* (2010–ongoing):

Tony Transformer from Kaba Modern Legacy freestyles for a crowd of tourists at Marina Bay in Singapore, 2010 (performance still)

Courtesy The Propeller Group

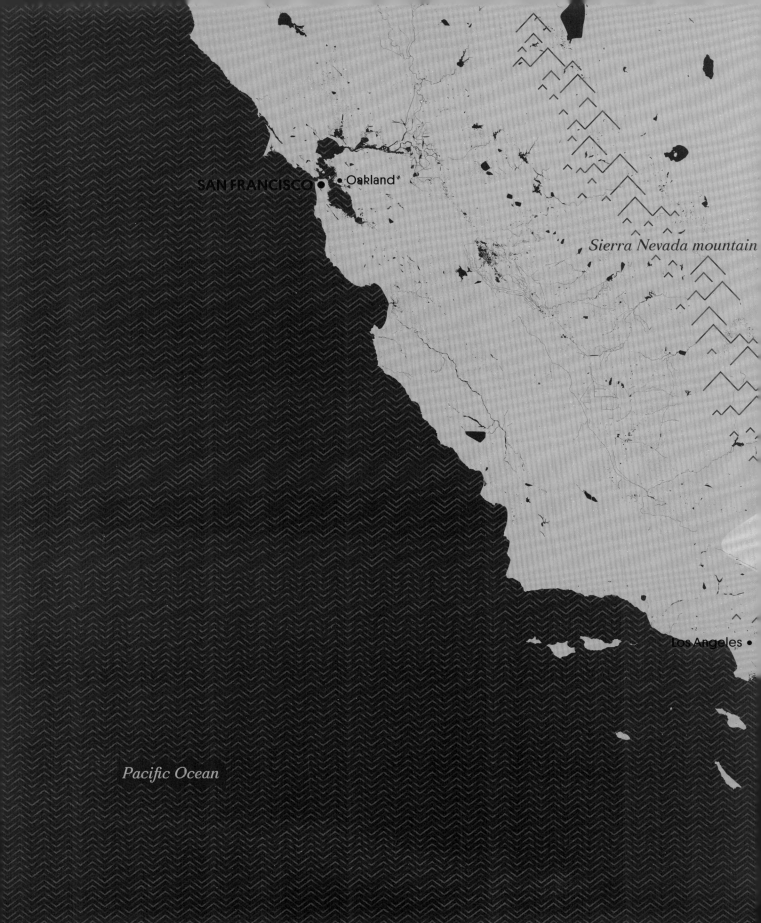

SAN FRANCISCO ● ● Oakland

Sierra Nevada mountain

Los Angeles ●

Pacific Ocean

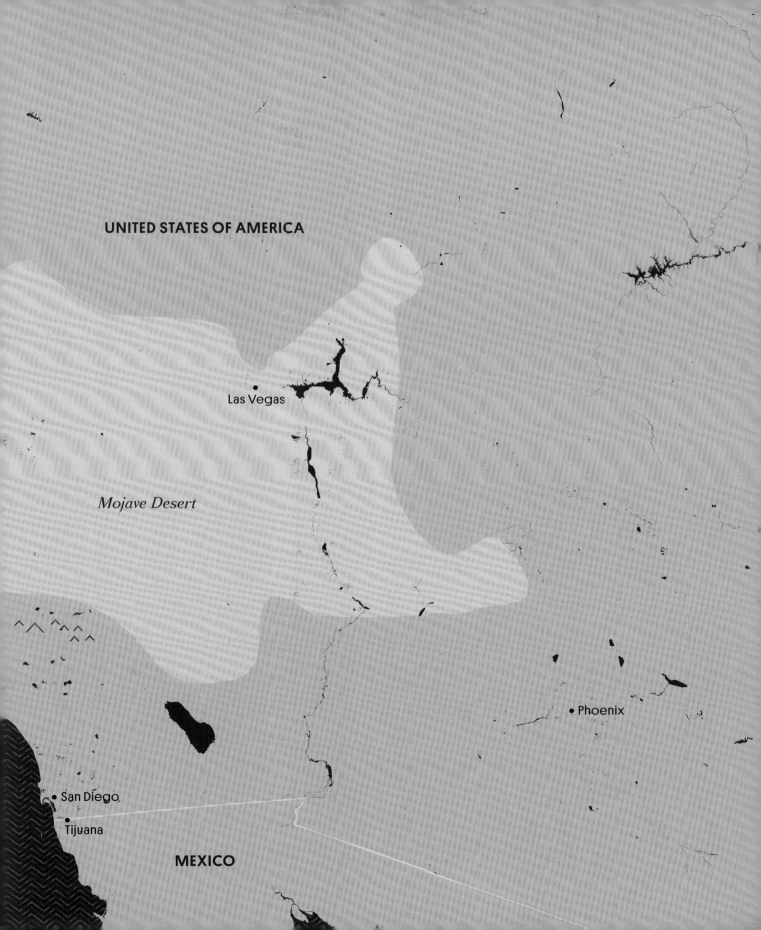

UNITED STATES OF AMERICA

Las Vegas

Mojave Desert

Phoenix

San Diego

Tijuana

MEXICO

246. Aerial view of Facebook Headquarters, 1601 Willow Road, Menlo Park, California, with the San Francisco Bay in the background

BAY AREA ART AND THE (COUNTER) CULTURE OF SILICON VALLEY

JOSEPH DEL PESCO AND CHRISTIAN NAGLER

In his introduction to the exhibition catalogue for *Bay Area Conceptualism* (1989), Nayland Blake wrote that the West Coast variety of this subgenre was "at once less rhetorical and more direct than that of New York,"[1] despite having emerged from similar aesthetic, literary, and theoretical predecessors. To further qualify this distinction, we could also say that the Bay Area's form of conceptual practice was, and perhaps still is, less about forging an airtight strategy for dematerializing the object or replacing it with a nexus of reflexive language and more about improvising purportedly direct paths that evade the commodity form while subtly contesting the closest supporting power structure, making it liable to deep, informed critique. This thread is recognizable not only in the work of Futurefarmers but also in the collective endeavors now claimed as the uncategorized progenitors of "social practice." Distinct from, but not unrelated to, the personality-driven, direct political addresses of the Beats and the later self-reliant community micromarkets of the Mission School art scene, this aspect of the region's aesthetic history is one of methodical excavation and hypothesis testing, of hands-on approaches to power. It finds its aesthetic less in the coherence of its ethos, formal sensibility, or community and more in the crafting of a somewhat shared, decentralized attention to the ideological networks that define, often invisibly, the Bay Area's globally implicated form of the local.

This practice found a home in the antiestablishment and market-resistant critical philosophy of the alternative-space movement that crystallized in San Francisco in the 1970s. Artists in this decade, in addition to engaging in new modes of production such as installation and video, sought to challenge political disenfranchisement and to participate in decision-making processes on a larger scale. They also brought this level of commitment into an art world they recognized as rigidly hierarchical and conservative. This was, in part, a response to activist predecessors such as the Students for a Democratic Society (SDS), which through its analysis of larger social and political forces saw the arts as "organized substantially according to their commercial appeal" with aesthetic values "subordinated to exchange values, and writers [and artists] swiftly learn[ing] to consider the commercial value as much as the humanistic market place of ideas."[2] These critical values are felt today in the putatively noncompetitive atmosphere of camaraderie among artists and in an appreciation of forms that frustrate or deny easy packaging for the market. Alternative nonprofit art spaces can sometimes appear overcommitted to a parochial sense of corrective multiculturalism, while the international art establishment has clarified its exchange routes on a global scale, along with a more complex rendering of identity. The nonprofits may be peripheral to mainstream U.S. culture and the cosmopolitan art market, but they are still loved by (and provide a platform for) the many imbricated cultural communities of San Francisco. However, an anxiety about alternative spaces surfaced as early as the 1980s, when it seemed that "their continued existence helps perpetuate the conditions they were initially trying to alleviate, by relieving institutions of the obligation or desire to expand the scope of their programs."[3] The artists discussed here—Futurefarmers and their predecessors—have been less reliant on traditional or alternative art spaces, preferring instead the wider, functionally complex topography of the city and its environs.

Stepping back from the arts and looking onto the larger cultural field, we see that San Francisco has often shown itself to be surprisingly prescient regarding national and global cultural paradigms, particularly those transitional currents that quietly emerge from the creative fields and propagate as shifts in mass culture. In the 1950s and 1960s, the transitions registered as reverberations of a mass counterculture; in later decades, they were expressed in the entrepreneurial ventures of a high-tech screen culture, as televisual information streams became interactive in the personal computer. Often, these currents seemed naive, "feel good," utopian, primitivist, or reactionary when they first appeared on the

247. Futurefarmers, *After the Market*, October 8, 2011. Intervention at a derelict marquee on Market Street between Fifth and Sixth Streets, San Francisco. Courtesy the artists

holodeck of local culture. The engineers, inventors, and authors of this time boldly proposed sets of tools for a new social future, although in retrospect we might say these visions were shortsighted. And subsequently (after being metabolized by the wider world's skepticisms), these currents have often found hybrid forms capable of figuring contradictions in global contemporary life. Bay Area artists' communities rub up against (and are occasionally funded by) the power centers of wealthy risk-takers, disciples of innovation who possess the will to promote social transformation while remaining largely uncritical of (or actively complicit in) military technology and the erosion of civil guarantees of access to resources. This proximity

is often quietly tolerated or completely ignored, but it occasionally becomes a potent basis for critique, both of the neoliberal "utopian" solutions on offer and of the dilemmas those solutions are engineered to address.

In a 1985 lecture delivered at San Francisco State University, the scholar and popular intellectual Theodore Roszak outlined a dialectic he claimed was central to countercultural life in the Bay Area: the tension between the Reversionaries and the Technophiles. The Reversionaries—communitarians, eco-logues, and acolytes of the type of individual liberation promoted by certain branches of the Human Potential Movement—believe that

248. Cutaway view of the Stanford Torus, a proposed design for a space colony developed during the 1975 NASA Summer Study program at Stanford University

"industrialism is the extreme state of a cultural disease that must be cured before it kills us. . . . They look forward to the day when the factories and heavy machinery will be left to molder, and we will have the chance to return to the world of the village, the farm, the hunting camp, the tribe."[4] In contrast, the Technophiles are those philosophically inclined engineers, designers, and tinkerers who look persistently to the future—what Roszak terms "the climax of the industrial process"—for the liberation of society. They advocate Buckminster Fuller's utopian design platforms, Norbert Wiener's concepts of biofeedback and neurocybernetics, Gregory Bateson's systems theory, and Marshall McLuhan's idea of the global village enabled by communications technology. According to Roszak, the Technophiles believe in a more or less technical version of Marxist history, in which society must proceed through inevitable stages of techno-elaboration before reaching a state of illuminated transparency and collective insight. Today, we might recognize this in Ray Kurzweil's idea of the "singularity,"[5] the dream of a benevolent worldwide über-Google of the collective mind.

The poles identified by Roszak—the hippies and the techies—are familiar in the history of the Bay Area's divergent communities almost to the point of caricature, and he hints in the text at the societal potency of their love/hate relationship. Since 1985,

The Dolphin Embassy
VIEWED FROM DIRECTLY ASTERN

249. Ant Farm, *The Dolphin Embassy Viewed from Directly Astern*, 1977. Color photocopy from an original drawing for a never-realized Australian sea station proposed by the artists in *Esquire* magaz ne in 1974, 8½ × 11 in. (21.6 × 28 cm). University of California, Berkeley Art Museum and Pacific Film Archive, purchase made possible through a bequest from Thérèse Bonney, by exchange, a partial gift of Chip Lord and Curtis Schreier, and gifts from an anonymous doncr and Harrison Fraker

however, it has become apparent that the region's broader cultural influence was the direct product of various dynamic complicities and tensions between the two. Roszak was formulating these thoughts at a time when there was perhaps the most optimism about the utopian possibilities of the internet. It was the same year that Jaron Lanier founded VPL Research, the first virtual reality company, and that publisher Stewart Brand and tech entrepreneur Larry Brilliant founded the WELL,[6] one of many computerized communications systems burgeoning worldwide. The WELL

was the latest in a series of projects that began with Brand's hugely popular *Whole Earth Catalog*, which had been synthesizing and promoting speculative philosophies, tools, and practical advice for the back-to-the-land set since the 1960s.[7] One year later, in 1986, Larry Harvey organized the first small Burning Man gathering on Baker Beach, and it quickly became a mecca for the counterculture curious. In this way, Burning Man followed in the footsteps of the Esalen Institute, the Synanon commune, the Midpeninsula Free University, and Est training centers as sites of the

Human Potential Movement, although Burning Man put more emphasis on the engineering aspect of the social-engineering strategies (Gestalt, psychodrama) explored by those earlier groups. Burning Man, now the domain of techno-primitivists, is also a prime networking retreat for Silicon Valley power brokers; although this conjunction had been developing for years, working its way into the popular imagination, it received little to no critical notice until about 2001.

In the early to mid-1990s, however, the particular combination of that decade's high-tech innovation and 1960s idealism came to the attention of an international array of scholars and theorists, most of whom had pro-development business leanings. They attempted to describe the secret formula for collective risk taking and idea sharing that characterized Silicon Valley. A mythos developed around the region's early speculators—for example, researcher and professor of engineering Frederick Terman and his students William Hewlett and David Packard—who had cultivated the scene in the semiarid, pastoral flatlands of the San Francisco peninsula in the 1930s and 1940s by forging close relationships between entrepreneurs and universities, by fostering a proto-hacker garage culture of tinkerers and social thinkers, and by encouraging a community ethic of nonproprietary collaboration and collective land use while also courting investment from the military-industrial complex.[8] From these idiosyncratic and idealistic roots, the region has grown into a base for "the largest accumulation of wealth in history."[9]

Throughout the 1990s, Silicon Valley became the object of not only admiration but also critique and resistance. In 1995, British social scientist Richard Barbrook and new-media designer Andy Cameron collaborated on an essay, "The Californian Ideology." In this text, which was widely circulated online,[1] Barbrook and Cameron explicated their view of the Silicon Valley ethos, especially as manifested in *Wired* magazine: a combination of libertarian, free-market ideology and hip techno-bohemianism that would result in both class hyperstratification as well as a kind of virtual-age Horatio Algerism in which the public was expected to compete through hard cognitive work and technological know-how in order to adapt to an atomized, accelerated sphere of social communication. In his critical rebuttal to Barbrook and Cameron's views, Italian autonomist philosopher Franco (Bifo) Berardi argued that Silicon Valley, the economic

ascendancy of which was a foregone conclusion, represented a deeper and more systemic shift in the nature of social relations and in the composition of power. Articulating a growing paranoia, Bifo maintained that "discipline is no longer imposed on the body through the formal action of law—it is printed in the collective brain through the dissemination of techno-linguistic interfaces inducing a cognitive mutation."[11] Bifo here underscores the biopolitical stakes of Silicon Valley, referencing current continental theories of the subject and making the point that technology may be determining the way we think more than ever before.

This was the moment that the Bay Area, with its multilayered creative communities and its freelance, start-up labor economy, began to be identified as the regional apotheosis of the "post-Fordist" era of global capitalism, in which there is a "technological and material dependence . . . on the capitalist form of social relations."[12] This critique had been anticipated since the 1950s by many Bay Area artists' collectives, which had been experimenting with, and thus making visible and liable to criticism, the relations between social behavior and technology. Some of their explorations posited direct formulations of the two, while others reimagined the more general role of formal mediation in regimes of communication, movement, and exchange. For example, Anna Halprin's San Francisco Dancers' Workshop, founded in 1955, moved from improvisatory performance into social interventions in urban space, culminating with the iconic *City Dance* (1960–69) as well as a collaboration with Los Angeles's Studio Watts School for the Arts, *Ceremony of Us* (1969), which explored barely submerged racial tensions. In the mid- to late 1960s the group the Diggers, working in and around Golden Gate Park, challenged the hegemony of normative and alienated forms of resource distribution by promoting nonmonetized exchange via Free Food, Free Stores, and Free Clinics, thereby rebranding the park in relation to a "surplus society." Inspired by the maturation of collective and communal initiatives of the 1960s, many artists later formed loosely affiliated, quasi-performative organizations. Two of the most memorable—the Museum of Conceptual Art, founded in 1970 by Tom Marioni and others, and The Farm, founded in 1974 by Bonnie Sherk and others—continue to be touchstones for artists exploring the long history of social practices in the

250. Josh On with Futurefarmers, *They Rule*, 2001. Screenshot of *Too Big to Fail Banks*, created by BigALinJax on August 12, 2011. Courtesy the artists

Bay Area. Ant Farm, an artists' group founded by architects Chip Lord and Doug Michels in 1968 and active through 1978, developed a hybrid practice between architecture and public art; their projects included inflatable dwellings, the *House of the Century* (1972), iconic sculptural and performance works including *Cadillac Ranch* (1974) and the unrealized *The Dolphin Embassy* (first conceived in 1974, pl. 249), and *Media Burn* (1975).[13] The performance art group T. R. Uthco, founded in the 1970s by Diane Andrews Hall, Doug Hall, and Jody Procter, deployed bureaucratic aesthetics for behavioral enactments, using art and impersonation to disrupt power roles in everyday situations. Founded in 1978 by Mark Pauline and others, Survival Research Laboratories staged volatile performances of tech-on-tech violence for live audiences into the 1990s. In 1990 the artists' group silt (Keith Evans, Christian Farrell, and Jeff Warrin) developed their cinematic installations, which often derived from explorations of the Bay Area's

varied exurban environment and employed the raw materials of the landscape. The Center for Land Use Interpretation (CLUI), while headquartered in Southern California, was actually founded in Oakland in 1994 by Matthew Coolidge, Melinda Stone, and others. CLUI began with critical interventions into tourism and grew into a quasi-nongovernmental organization "dedicated to the increase and diffusion of knowledge about how the nation's lands are apportioned, utilized, and perceived."[14]

Founded in the mid-1990s as a design collective, Futurefarmers combined a hacktivist art sensibility with early web-design innovations, often for blue-chip start-up clients such as Twitter. They were key players at the height of a widespread bid to render as image the cyber utopia that had been previously theorized, and they succeeded in conjuring the atmosphere of internet space as literal territory: a nonthreatening, nonabstract environment of grassy digital hills and valleys. This design aesthetic also drew somewhat on

251. Futurefarmers, *Free Soil* bus, 2006. Courtesy the artists

the prismatic color schemes and ambiguously folksy flatness of the Mission School artists, with whom they were personally and professionally involved. In this way, Futurefarmers pioneered some of the friendly avatars, organic formalism, and playful interactive interfaces that have since become ubiquitous. They were also one of the first groups to delve into the internet's nascent sociability, a direction that would, in less than a decade, transform the web into the multi-billion-dollar domain of social media.

In the early years, Futurefarmers shared with much of the Bay Area a rising skepticism toward their marriage of art/activist-culture and web-design work; over time, the group's parallax view of both the radical social future of the internet and its military-industrial origins came to the forefront of their practice. In 2000 (just after the Y2K scare, when it appeared that an incidental oversight by a few early programmers could cascade into the collapse of the technological infrastructure), Bill Joy, cofounder of

Sun Microsystems and cochair of the President's Information Technology Advisory Committee (1999), wrote an article titled "Why the Future Doesn't Need Us" for *Wired* magazine. He warned his fellow technophiles: "I think it is no exaggeration to say we are on the cusp of the further perfection of extreme evil, an evil whose possibility spreads well beyond that which weapons of mass destruction bequeathed to the nation-states, on to a surprising and terrible empowerment of extreme individuals."[15] In this climate of doubt, Futurefarmers launched their 2001 web project, *They Rule* (pl. 250), a pivotal attempt to provide an interactive tool for tracking and mapping techno-corporate power networks and the wealthy individuals presiding over them. As Futurefarmers' projects progressed, their techno-utilitarian design aesthetic began to serve a participatory DIY conceptualism that revived and updated the ideas of the Bay Area's earlier radical collectives for the cyber generation. Some of their projects leaned toward

reversionism, and they maintained an acute awareness and deep critique of the triumph of profit-driven technophilism. In 2006 they initiated *Free Soil*, their biodiesel bus tour from San Jose to Menlo Park (pl. 251), revealing to participants the "idealistic roots of high-tech culture as well as the environmental effects of the computer industry on the local landscape."[16] *Free Soil* was part of a larger series of workshops, lectures, and other participatory events called Gardening Superfund Sites, which similarly juxtaposed the fantasies of cosmopolitan mobility and the frictionlessness of the internet age with the realities of the wealth, material waste, and aesthetic banality of Silicon Valley, while weaving together propositions of ecological sustainability and community resource sharing. This project segued into their Victory Gardens 2007+ (see p. 162), which coalesced a growing urban-ag subculture around the charged historical trope of 1940s wartime can-do collectivism, although as an expression of anti–Iraq war sentiment rather than patriotic duty.

Futurefarmers can be too easily confused with the uneasy phenomenon of the Rise of the Creative Class that could be said to inflect Bay Area sensibilities. On the surface, their projects might appear to fold into the territories of so-called lifestyle activism, the false promises of a global village, and the suburbanization of the urban sphere. On another level, however, their practice is a deep scouting for strategies of critique and transformation, making them comparable to other artists who follow lines of inquiry into fields of expertise that offer sharper edges of resistance to power than are traditionally seen in the annals of art history. Theirs is a collectivism that owes less allegiance to notions of the "scene" than to the idea of tactical alliances across disciplines, a strategy that is also evident in the work of some of Futurefarmers'

Bay Area contemporaries. Amy Balkin, for example, worked with environmental justice groups, industry agents, and legal scholars to carve out a juridical/utopian aesthetic that complicates the institutional definitions of land-ownership and atmospheric policy through concise and well-crafted conceptual heuristics. Trevor Paglen collaborated with satellite technicians, amateur surveillance enthusiasts, and investigative journalists to produce elegant photographic images that not only provide stark evidence of abuses of power but also speak to the history of landscape photography. Rick and Megan Prelinger collaborated with experimental archivists, anarchist librarians, and experimental geographers in their film, publication, and library projects. And Sergio De La Torre, working with maquiladora workers and Chinese immigrants, coproduced or reenacted film projects that address the complex political tensions of borders and make visible the fraught but submerged imperial attitudes and legacy of the United States.

In all of these artists' works, we see an expanded form of collective practice in which cross-field collaborators serve not as populist tokens of authenticity or as mass ornaments but as indispensable sources of expertise. And although these artists, by and large, have not participated heavily in the current concretization and institutionalization of "social practice" discourse, they may represent its future. As it becomes clearer that the status quo—politically, materially, and symbolically—rests on a precarious mass of hyper-engineered flows and relations, it seems that artists interested in articulating the contested "ethical" line of social practice might have to simultaneously concentrate and ventilate their knowledge bases. More than ever before, they may have to treat seriously the conjunction between art and life.

1. Nayland Blake, *Bay Area Conceptualism: Two Generations* (Buffalo, NY: Hallwalls, 1992), 7.

2. Tom Hayden and Students for a Democratic Society, *The Port Huron Statement: The Visionary Call of the 1960s Revolution* (New York: Thunder's Mouth Press, 2005), 73.

3. Mark Johnstone and Leslie Aboud Holzman, *Epicenter: San Francisco Bay Area Art Now* (San Francisco: Chronicle Books, 2002), 18.

4. Theodore Roszak, *From Satori to Silicon Valley: San Francisco and the American Counterculture* (San Francisco: Don't Call It Frisco Press, 1986), 25.

5. Ray Kurzweil, *The Singularity Is Near: When Humans Transcend Biology* (New York: Viking Penguin, 2005).

6. WELL is an acronym for Whole Earth 'Lectronic Link. It can be found online at www.well.com.

7. For more recent in-depth scholarship on this history, see Fred Turner's "Where the Counterculture Met the New Economy: The WELL and the Origins of Virtual Community," *Technology and Culture* 46, no. 3 (July 2005): 485–512 (also available at http://www.stanford.edu/~fturner/Turner%20Tech%20&%20Culture%2046%203.pdf), and Lee Worden's incisive essay "Counterculture, Cyberculture, and the Third Culture: Reinventing Civilization, Then and Now," in *West of Eden: Communes and Utopia in Northern California*, ed. Iain Boal, Janferie Stone, Michael Watts, and Cal Winslow (Oakland, CA: PM Press, 2012).

8. For a thorough discussion of the historical development of Silicon Valley, including Terman's contribution, see Stuart W. Leslie, *The Cold War and American Science: The Military-Industrial-Academic Complex at MIT and Stanford* (New York: Columbia University Press, 1993).

9. John D. Kasarda and Greg Lindsay, *Aerotropolis: The Way We'll Live Next* (New York: Farrar, Straus and Giroux, 2011), 12.

10. Richard Barbrook and Andy Cameron, "The Californian Ideology," *Mute* 1, no. 3 (1995); the article is available at the Hypermedia Research Centre, http://www.hrc.wmin.ac.uk/theory-californianideology-main.html.

11. Franco (Bifo) Berardi, "Proliferating Futures (re: Californian Ideology)," *Mute* 1, no. 4 (1996); the article is available at the Hypermedia Resource Center, Responses to the Californian Ideology, http://www.hrc.westminster.ac.uk/hrc/theory/californianideo/response/t.4.2.6%5B1%5D.html.

12. Ibid.

13. In 2004, a retrospective exhibition at the Berkeley Art Museum and Pacific Film Archive, *Ant Farm: 1968–1978*, brought the group back into the public eye.

14. Center for Land Use Interpretation, "About the Center," http://www.clui.org/section/about-center.

15. Bill Joy, "Why the Future Doesn't Need Us," *Wired* 8.04 (April 2000); also available at http://www.wired.com/wired/archive/8.04/joy.html.

16. Futurefarmers, "Free Soil Bus Tour," http://www.free-soil.org/tour/.

Futurefarmers

Futurefarmers, the San Francisco–based art and design collective founded in 1995 by Amy Franceschini (b. 1970),[1] is known for interdisciplinary projects that intervene in everyday experience to create vibrant platforms for learning, exchange, and social engagement. In *Lunchbox Laboratory* (2008), for example, the group worked with the Biological Sciences Team at the National Renewable Energy Lab to make an edition of lunch boxes that enable young scientists nationwide to test algae strains for their viability as sources of biodiesel. For *This Is Not a Trojan Horse* (2010, pl. 252), Futurefarmers aimed to explore social and economic transformation in Italy's Abruzzo region. With architect Lode Vranken, they built a human-powered wooden horse and rolled it through local villages as a means of initiating conversations with residents about changing attitudes toward agriculture. Throughout their work, Futurefarmers consistently imagine new ways of relating notions of audience, authorship, utility, and spatial politics to art practice.

Many Futurefarmers projects seek to inspire community action. For example, Franceschini's Victory Gardens 2007+, modeled after the American Victory Garden program popular during World Wars I and II, included the creation of a community "demonstration garden" in front of San Francisco's City Hall. For *Shoemaker's Dialogues* (2011, pls. 253–55) at New York's Solomon R. Guggenheim Museum, the collective created a nine-day "urban thinkery." In the spirit of the philosophical discussions Socrates was said to have had with Simon the Shoemaker and Athens youths at the shoemaker's workshop (the source of the work's title), they invited writers to deliver "sermons," or lectures, that served as the basis for public discussion at various New York venues.[2] Another facet of the project was linked to the city's first air quality study, performed in 1935 by the Works Progress Administration, which called on New Yorkers to place soup cans on their rooftops to collect soot. Drawing on this cooperative model, Futurefarmers gathered soot from around the city and used it to create

ink for the project's public printmaking intervention, *Pedestrian Press*.

The group continues to propose new ways of understanding and engaging with the world in *A Variation on the Powers of Ten* (2010–12, p. 6, pl. 256), a project that draws inspiration from *Powers of Ten* (1968), a short documentary directed by Charles and Ray Eames that depicts the relative scale of the universe.[3] The film opens with two people having a picnic; the camera at first moves out, in factors of ten, toward the edges of space, and then reverses course, moving inward to the subatomic level. Franceschini and Michael Swaine (b. 1971) restaged the Eames picnic blanket as a discursive space, inviting ten scholars from major universities, each assigned a power of ten, to sit with them for individual alfresco feasts featuring menus and conversation topics of the scholar's choosing.[4] From the intimate vantage point of these gatherings, the project looks both inward and outward in search of new perspectives on contemporary society. A bird's-eye view is used to document each picnic photographically, recalling the Eames film and the broad perspectives from which the collective's inquiries stem. As Ananya Roy explained during her picnic, *A Variation on the Powers of Ten*, like so much of the work Futurefarmers have produced, reminds us of the ways that art allows us "to step outside of certain safe ideas and . . . reimagine what we thought we knew."[5]

—Tomoko Kanamitsu

1. Members as of 2012 include Dan Allende, Ian Cox, Sascha Merg, Josh On, Stijn Schiffeleers, and Michael Swaine.

2. Historian Bruce Laurie, poet Bernadette Mayer, anthropologists Neil Smith and Michael Taussig, and writers Rebecca Solnit and Cooley Windsor participated.

3. The Eameses co-authored the script with Philip Morrison and his wife Phylis. Morrison, then an MIT professor of physics and former member of the Manhattan Project, also narrated the film.

4. As of February 2012, scholars include Kenneth Brecher (Boston University), Ignacio Chapela (University of California, Berkeley), Walton Green (Harvard University), Ananya Roy (University of California, Berkeley), Sara Seager (Massachusetts Institute of Technology), Arthur Shapiro (University of California, Davis), Laura Stoker (University of California, Berkeley), and Ignacio Valero (California College of the Arts).

5. "Raw/Unedited Transcription of Picnic Discussion with Ananya Roy at the base of the Campanile Clock Tower," Futurefarmers, April 14, 2011, accessed January 25, 2012, http://futurefarmers.com/powersoften/transcripts /ananyaroy.pdf.

252
Futurefarmers, *This Is Not a Trojan Horse*, 2010
Intervention in Abruzzo, Italy, 12 days
Courtesy the artists

253–55

Futurefarmers, *Shoemaker's Dialogues*, 2011

Installation view of *Intervals: Futurefarmers* in the rotunda of the
Solomon R. Guggenheim Museum, New York, and documentary
photos of *Pedestrian Press*, 2011

Installation view courtesy The Solomon R. Guggenheim Foundation,
New York. *Pedestrian Press* photos courtesy the artists

256 (right)

Futurefarmers, *A Variation on the Powers of Ten*, 2010–12

Amy Franceschini and Michael Swaine, Futurefarmers; with Ignacio Valero
(10^{00}), cultural anthropologist, California College of the Arts; and photographer
Jeff Warrin, at the University of California Botanical Garden at Berkeley, 2011
(production photo)

Courtesy the artists

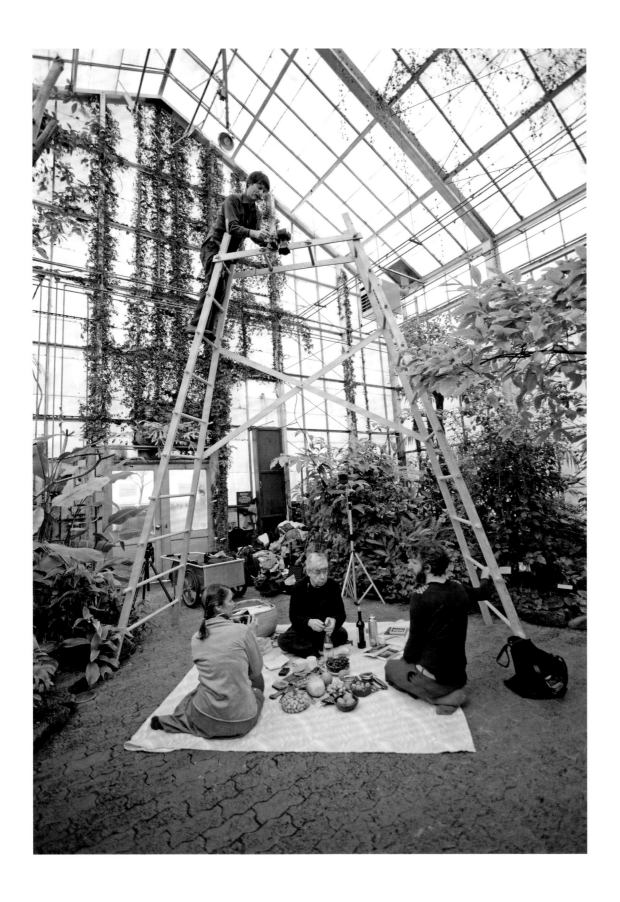

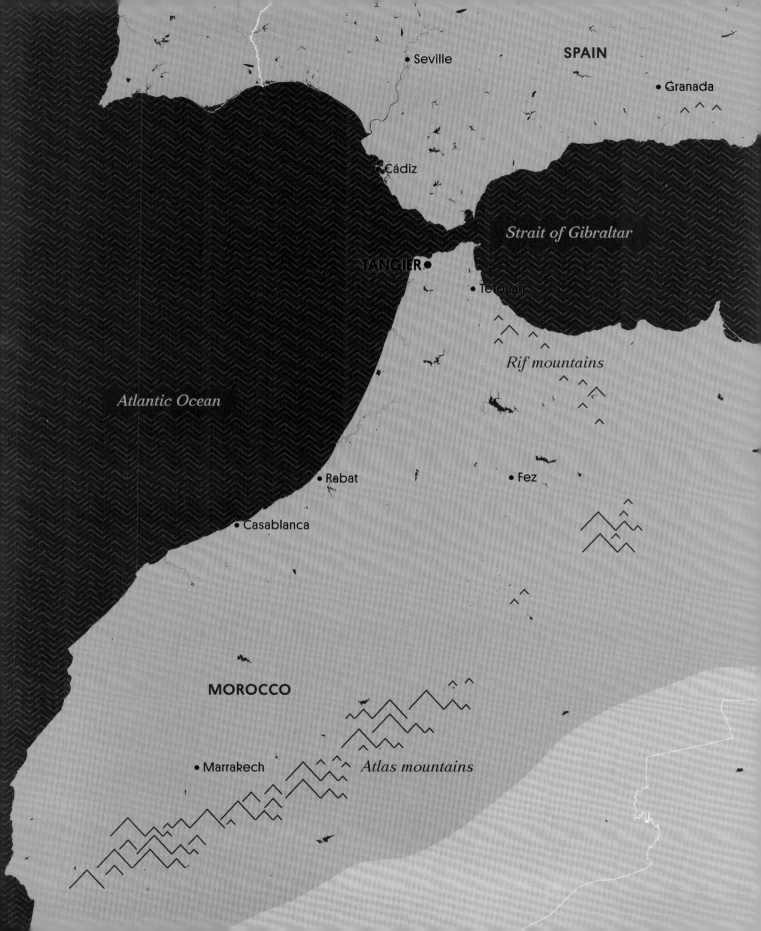

Mediterranean Sea

ALGERIA

Sahara

257. Yto Barrada, *The Strait of Gibraltar, reproduction of an aerial photograph, Tangier,* 2003, from the series *A Life Full of Holes: The Strait Project.* Chromogenic print, 23⅝ × 23⅝ in. (60 × 60 cm). Courtesy the artist and Galerie Polaris, Paris

THE STRAIT'S PASSAGE

ABDELLAH KARROUM

A BASE

To write about Tangier through the lens of a local cultural project such as the Cinémathèque de Tanger requires returning to the city's multiple histories and its "acticity."[1] This means considering the city's activities of production and the spaces of exchange where commerce is engendered. Just as the same urban space is inhabited differently according to the aspirations of each citizen, no single urban plan, whether national or colonial, defines the city's architecture. Without discounting the influence of strategic sites built by empires—beginning with the Imazighen[2] and the Phoenicians and extending through the colonial regimes of the Age of Enlightenment—we must acknowledge the extent to which cities are developed over centuries in response to the coexistence of indigenous and external forces that have limited territorial, political, or military control.

Tangier is not a new city in world geography, but it is new within the postmodern landscape. In the art world, and particularly within art history, globalization is too often considered from perspectives defined during the nineteenth century. To understand Tangier's place in this world, it is imperative to see it in relation to a broader history, one that reflects the diversity of all of its inhabitants, and not only through the history of the elites who constructed the city's grottoes, palaces, and bidonvilles.[3] Indeed, Tangier has been formed by many layers of history, from the uncertain traces of the mythical Atlantis to the region's fabled pirate coves, from the *Peuples de la mer* (Sea Peoples)[4] to the young voyagers unrestricted by the usual mechanisms controlling the flow of human migration. Above all, Tangier is a city of margins and proximities. Many Phoenician, Arab, and European boats traversed its waters, both before and after explorers discovered the existence of the Americas and India. When Ibn Battuta, a

fourteenth-century voyager, left Tangier to search for other cultures across the Eastern Hemisphere,[5] his explorations were oriented south and eastward. Travel narratives such as his *Rihla*, which speaks of the faraway territories he visited, contributed to "anthropological" knowledge at a moment when this science was as yet unknown. Both mythology and history have cast the Strait of Gibraltar—the body of water along the city's shores that separates Africa and Europe and joins the Atlantic Ocean to the Mediterranean Sea—as the ultimate geographic passage to other worlds, whether physical or cultural. As far as "universal" history and its accompanying history of art is concerned, this international city is synonymous with political neutrality, cosmopolitanism, leisure, and relaxation, and known for offering all visitors a space for observation and encounter. Indeed, before famously traveling to Algiers in the early years of the French conquest (1830–47), the French painter Eugène Delacroix, along with many artists, spies, and soldiers, was based here.

Over time the strait has become a contact zone. But instead of interrogating the region's social and political context, its (art) history has been primarily read through the prism of nationalism and oriented toward the surface of the objects these encounters produced. It is easy, for instance, to overlook the fact that Henri Matisse's *Window at Tangier* (1912) was painted in Tangier in the same year that the French and Spanish established "protectorates" in Morocco, an elision that underscores the gaps between history and art history. Just as these disciplines dwell neither on the conditions of the artists' female models nor on the context of their lives, they discount the fact that many masterpieces were produced in an Africa on the verge of colonization.[6]

Tangier's status as an international and "precolonial" city positioned on the edge of two continents has made it an ideal base and staging ground for imperial power, exploration, and cultural negotiation. It was from this region that the Africans (Moors) invaded Andalusia in the eighth century, and it was here that the twentieth-century French and Spanish colonial conquest of Morocco was launched. Significantly, the French based their offensive on information gathered during a series of surveys and studies of the country, believing that understanding the nation's geography and culture would better enable them to control its natural resources and its

258. Yto Barrada, *Tectonic Plate*, 2010. Painted wood, 48 × 78⅞ in. (122 × 200 cm). Courtesy the artist and Sfeir-Semler Gallery, Beirut and Hamburg

inhabitants.[7] This was no easy task in a city where everything from the architecture to the identity of its residents was and continues to be hybrid. The contemporary Moroccan relationship to the colonial past—including assimilated anthropological and social knowledge, both of which are notably absent from the country's educational system[8]—is structured by a new historicity that does more than practice history from afar. Despite its geographic position, Tangier is defined by Western history as "The Orient." This reading prompts an interrogation of the contradictions of "universal" art history and its blind spots, as suggested by the aforementioned examples of Delacroix and Matisse. A new historicity requires a dis-Orient-ing of Morocco in relation to inhabitants of the Atlas mountains in general and the Rif mountains in particular.[9] It also demands consideration of the country's erased memories and its hidden archives.[10] In order to move away from a history based on the hegemony of colonial powers of all kinds—which, as complicit postcolonial systems of control, includes that of Arab dynasties and their oligarchic incarnations—a number of questions need to be asked: What new methodological approaches are necessary to write a history about cultural production that comes from the countries themselves and considers their particular geographies and historical contexts? How can we rethink the construction of written history for the present generation so as to bring about these new approaches? (Or, at least, through what means can we delineate our positions vis-à-vis the generation that inherited colonialism?) And how do we extract ourselves from colonial structures that possess goals often based on the diffusion of European histories as the primary point of reference? Recently, independent artistic initiatives in Morocco, such as Yto Barrada's Cinémathèque de Tanger, Hassan Darsi's La Source du Lion in Casablanca, and L'appartement 22[11] in Rabat have begun responding to these questions.

The way forward lies in a return to Tangier, a city situated at the extreme northwest of Africa along the edge of Bahr Al-Dulumat (literally, "the Sea of

Darkness," an early name for the Atlantic Ocean), facing the "old continent" of Europe. Interest in Tangier is not intrinsic to the city itself but derives from its image as fabricated by external sources. "Vitalized" by its exterior, Tangier is the meeting place for the human and botanical energies of the Rif mountains. The human flow from Tangier is uneven: the crossing from north to south is increasingly dominated by tourism, whereas that from south to north is one of economic exile. The city is marked by the Strait of Gibraltar as a space of transit, one made vivid by the movement of travelers seeking adventure, as well as the migration of youth from *ad-dakhil* (the interior), who come in search of opportunities, and the immigrants who cross toward *al-kharej* (the outside)[12] in order to feed the families they have left behind. In the last few years, the youth of Tangier have been among the most active in demanding political change and social justice. The thousands of protestors who gather each day in organized marches now chant "long live the people" in place of its precursor, "long live the king," which the *makhzen* promoted and force-fed to the Moroccan people since its ascendancy to power in 1956, with the end of Spanish and French colonial rule.[13] It remains true that, in every civilization, cities construct themselves through encounters, which can take the form of dialogue or conflict. Spaces for sharing, whether they are cultural, economic, political, or scientific, can be created by those in power as well as those who contest it. In Tangier, colonial powers built cinemas, theaters, churches, and even a bull-fighting arena. After 1956, during the postcolonial period, nationalists closed the majority of these spaces; they then either simply ignored the sites, or they destroyed them to build hotels and apartment buildings for European tourists. In the 1960s and 1970s, the lack of investment in local culture by the *makhzen* had pushed the nation's youth to immigrate to Europe. The artists working in Morocco in the first few years of the new millennium, a group I call the Generation 00s, brought a new form of rupture, this time not in history but in the prevailing artistic vocabulary.

259. Mohamed Melehi, *Belkahia Chebaa Melehi*, 1966. Letterpress, 39⅜ × 25½ in. (99.8 × 64.2 cm). The Museum of Modern Art, New York, gift of the artist

GENERATION 00s (PEOPLE)

During the early postcolonial period of the 1960s and the 1970s, many artists working in Morocco developed aesthetic conventions for painting that

260. Batoul S'Himi, *Sans titre* (Untitled), from the series *Monde sous pression* (World under Pressure), 2009. Cut and painted aluminum pressure cooker, 11 in. (28 cm) high. Private collection, Marrakech

were inspired by antifascist resistance. But with their hybrid use of calligraphy, ornamental forms, and traditional materials that marked a rejection of painting, which they saw as a symbol of colonialism, artists such as Farid Belkahia, Mohamed Melehi (pl. 259), and Hassan Slaoui also cultivated a certain kind of Arab nationalism. Others active at that time assumed styles that represented multiple points of view, notably in the use of Amazigh[14] signs or through the adoption of pictorial sonorities that were asserted as tribal (African) or socialist (international). The subsequent *années de plomb* (years of lead)[15] suffocated any attempts for *souffle* (breath)[16] or engaged initiatives. In the immediate postcolonial period, for example, the 1960s Moroccan student movement and its claims for individual rights were brutally repressed by the state. In the decades that followed, suspected political dissidents were tortured or disappeared, and

philosophy and sociology were banned in universities. It was necessary to wait for the Generation 00s—those Moroccan artists living in the country or abroad who began making work in the years just before and after the turn of the century—to map a new artistic course. The passage into the twenty-first century coincides with the history of "democratic transition" and *politique alternance* (political alternation) in Morocco, when the king incorporated members of the former opposition into the ruling government as a means of protecting the monarchy. This occurred at the same moment as the development of new tools for communication that enabled all social classes to have access to knowledge about world events. Injustice became increasingly tangible. Yet censorship and Moroccan social conventions have allowed few, if any, means for citizens, including artists, to express their convictions, beliefs, and opinions. Some artists, such as Mounir

261. Younès Rahmoun, *Ghorfa #4, Al-âna/Hunâ* (Room #4, Now/Here), 2007–8. Stones, earth, wood, and concrete, interior dimensions 84¼ × 92⅞ × 72⅖ in. (214 × 236 × 185 cm). Laouzat Koukkouh fields, Beni-Boufrah, Rif, Morocco. Courtesy the artist

Fatmi, who was born in Tangier but now lives in Paris, have chosen to live and work abroad rather than compromise their work by softening its social critique.

Younès Rahmoun and Safaa Erruas, two artists based in the north Moroccan city of Tétouan, are part of this new generation, and they have contributed to the emergence of an artistic language that includes ethical as well as aesthetic considerations. Rahmoun, after numerous interventions in the haystacks of the Rif, created *Ghorfa #4* (2007–8, pl. 261), a site-specific sculptural intervention inspired by the architectural form of his studio in Tétouan and built on a hilltop in the Rifian village of Beni Boufrah. With this *ghorfa* (Arabic for "room"), the artist offers the surrounding space to the local inhabitants and questions notions of property and of belonging to either nation or tribe. Erruas, who has doggedly pursued her formal obsessions with white medical

gauze, razor blades, and sewing needles, also testifies to the situation in Morocco, where any possibility for improving the status of women depends on negative representations, thereby preventing any real change. Other artists and intellectuals also began to respond to the lack of space for expression—both physical and symbolic—by formulating new spaces centered on artistic production. Here, the content of the work is more important than the volume of its container. Among the most emblematic artists asserting a position that is de-linked from official cultural politics are Hassan Darsi, based in Casablanca, and Tangier native Yto Barrada, both of whom fashioned places for creative encounters in relationship with their own artistic projects and their desire to act in and on the city. Darsi's La Source du Lion, a series of projects produced in sites around Casablanca, was a temporary, collaborative nexus for action, transforming

numerous semi-abandoned urban locations into places for living and producing. Barrada's Cinémathèque de Tanger (pls. 262–64, discussed in depth below) transformed the Cinéma Rif, an old Bollywood theater, into a new site for cultural production, encounters, and archives. The Generation 00s are connected more by ideology than by a particular medium. Inscribing an elastic time, this generation is carefully conscious of history and also demands a space for education; however, to inspire an alternative form of citizen action, this education would first require unlearning the schemas of traditional national schools.

A lucid examination of Moroccan society can be found in Salé-based artist Mustapha Akrim's *We Had a Dream* (2011), which was produced and presented at L'appartement 22. For this piece, inspired by a famous speech by Dr. Martin Luther King Jr., the artist rewrote the line "I have a dream" in past tense as a way of speaking to the future. Writing in English in either neon or pencil on the gallery wall, Akrim inscribes this message in a historical time: it is an artwork-action because it appears in a Moroccan context where the political space is confused with economic issues that extend beyond organizations, tribes, and nations. Referring to this memory of a struggle for freedom and equality, the artist appropriates the vocabulary of the American civil rights movement directly into his artistic language as a means of commenting on the current political situation in Morocco.

GENERATION 00s (PLACES)

In Tangier, art spaces comprise not only galleries, museums, and movie theaters but also the city's cafés, the walls around its port, and the hallways of cheap hotels with their magnificent views of the strait. The city was a meeting point for the savants of the oral storytelling tradition from the Rif and Fez's medina as well as for New York intellectuals. Many writers have visited or lived here, including Paul Bowles, Tennessee Williams, Jean Genet, and Mohamed Choukri. Some were seeking an exotic land or refuge from world wars; others fled misery, such as the 1942 famine that pushed Choukri to leave the Rif and immigrate to Tangier in order to survive. Cinémathèque de Tanger (CdT) is located on the Grand Socco plaza, where Choukri spent time on café terraces. There, in 1952,

just a few years before Morocco gained independence, Choukri witnessed the increased tension between Moroccans and the colonial powers, describing it in his autobiography *Le pain nu* (1980).[17] Later, in the 1960s, the city continued to be a place of convergence and refuge for young intellectuals, writers, and musicians, as well as for European and American activists fleeing their nationalist obligations and the war in Vietnam. Members of the Beat Generation who stormed the free zones of Morocco counted Tangier, the port city of Essaouira, and the Rif among their preferred spots.

Tangier's long history as a gathering place forms a key element of CdT's heritage. Throughout the 2000s in Morocco, numerous independent spaces were created where the histories of individual authors and artists mixed with sociopolitical concerns. Yto Barrada, who had long examined the city's streets and environs in her artwork, established CdT after many years of research and planning by a working group she initiated that included sociologists, writers, architects, and filmmakers. The only art-house theater in North Africa, CdT is committed to the careful collection and archiving of film and the diffusion of cinematic production. The cinémathèque is also a transnational project, and reflects its founder's transnational experience as the Paris-born child of Moroccan parents, who after spending most of her childhood in Tangier studied in Paris and New York (among other cities) before again taking up residence in the city where she was raised. It has become a meeting space and a cultural center for artists in transit as well as for Moroccan youth seeking a place for development and exchange, both among themselves and with visitors to the city. When the cinémathèque opened in 2005, the city's inhabitants—both locals and visitors, including European, African, and Middle Eastern investors—were filled with the desire for change. The creation of a cultural space such as this, in a city and country where the awakening of the people is not a state priority, is a political gesture by an artist who bears witness to her time.

CdT shows how a space created by an artist, here the cinema and production center founded by Barrada, can function as a continuation of the artist's creative projects and thinking. Such projects are not autonomous and should not be perceived as revisionist but rather as explorations of art's reality. For Barrada, the most efficient means of examining her society

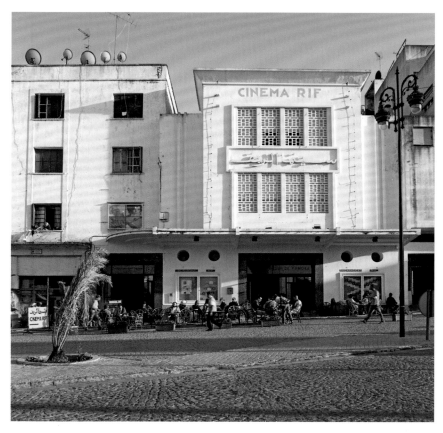

262–64. Cinémathèque de Tanger, Place du 9 Avril, Grand Socco, Tangier

and culture is to adopt a documentary approach, collecting archival elements and fragments that make up the memory of Tangier, its inhabitants, and its visitors. Many of her visual works reflect a similar strategy, underscoring her interest in place. Barrada's film *Beau Geste* (2009), for example, takes one of the city's open plots of land as a revealing example of Tangier's uniformization project. In her narration for the film, the artist says, "Some five thousand building permits were issued in the city this year. As people move down from the mountains in search of work, the city sprawls out into the surrounding pastureland. The population will soon reach one million. A patchwork of vacant lots rings the city." Artistic gestures such as this transform the fatalist conception of history into a concrete, ecological project.

1. *Acticity* (*activity* plus *city*) offers a new way of speaking about activities connected to urban life and their implications.

2. Meaning "free people," Imazighen (the adjectival form is Amazigh) denotes North Africa's indigenous ethnic group and the language that they speak. The word *Berber*, which dates to the Roman Empire, also denotes this same population and its language; however, it is frequently considered pejorative because of its etymological relationship to *Barbary* and *barbarian*, which have long been used by the West to refer to North Africa and its inhabitants. See *Oxford English Dictionary*, 2nd ed. (online version, March 2012; accessed April 27, 2012), s.v. "Barbary," and Cynthia J. Becker, *Amazigh Arts in Morocco: Women Shaping Berber Identity* (Austin: University of Texas Press, 2006), 3.

3. The word *bidonville* comes from the French *bidon* (metal can, or canteen) and *ville* (city). In English it is defined as "a settlement of jerry-built dwellings on the outskirts of a city (as in France or North Africa)." See *Merriam-Webster's Dictionary* (online version, accessed June 1, 2012), s.v. "bidonville."

4. "Sea Peoples" is the name given by modern historians to a group of aggressive seafaring invaders who arrived in Tangier and North Africa from other Mediterranean regions in the late twelfth century BC (the Late Bronze Age) and who contributed to the destruction of civilizations near the coast.

5. Ibn Battuta (1304–1377) was a famous Tangier-born voyager and writer whose *Al Rihla* (The Journey) detailed the many decades he spent traveling across much of the Eastern Hemisphere. See his three-volume *Voyages d'Ibn Batoutah*, translated from Arabic into French by C. Défrémery and B. R. Sanguinetti (1858), with an introduction by Stéphane Yerasimos (Paris: F. Maspero, 1982).

6. An important exception is Alastair Wright's "Seeing Difference: Looking Otherwise at Matisse's Morocco," in his *Matisse and the Subject of Modernism* (Princeton, NJ: Princeton University Press, 2006).

7. Much of the information gathered in these surveys was presented in the *Archives marocaines*, a series of scholarly journals first published in 1904 by the Mission scientifique du Maroc, a research organization founded in Tangier by the French. See E. Michaux-Bellaire, *La mission scientifique du Maroc* (Rabat, Morocco: Service des Renseignements, 1925); L. Abrams and D. J. Miller, "Who Were the French Colonialists? A Reassessment of the *Parti Colonial*, 1890–1914," *The Historical Journal* 1 (September 1976): 685–725; and Edmund Burke III, "The Creation of the Moroccan Colonial Archive, 1880–1930," *History and Anthropology* 18, no. 1 (2007): 1–9. Some issues of the *Archives marocaines* are available online through the Bibliothèque national de France: http://gallica.bnf.fr/ark:/12148/cb32701470c/date.r=archives+marocaines.langEN.

8. The educational system in Morocco is based partly on the French colonial educational system, which it inherited, and partly on the traditional Islamic model of instruction at Koranic schools. For a discussion of education in Morocco during French colonization, see Spencer D. Segalla, *The Moroccan Soul: French Education, Colonial Ethnology, and Muslim Resistance, 1912–1956* (Lincoln: University of Nebraska Press, 2009).

9. The Rif mountains line the northern edge of Morocco along the Mediterranean; the Atlas mountains (divided into the High and Low Atlas) begin in central Morocco and extend northeast across Algeria and into Tunisia. The Rif and its inhabitants have had a particularly vexed relationship with both the Spanish colonial powers (who controlled the region from 1912 to 1956) and the central Moroccan government. The violence of the Rif War (1920–26), including Spain's use of chemical weapons against the Rifian people (who were led by Abdelkrim el Khattabi), incited the European Left to condemn colonialism, as most notably articulated in surrealist André Breton's lecture "What is Surrealism?" (June 1, 1934). In 1959, soon after Morocco's independence from colonial rule was established in 1956, then Crown Prince Hassan (later King Hassan II) led a brutal repression of an uprising in the Rif; for more about this uprising, see David Seddon, *Moroccan Peasants: A Century of Change in the Eastern Rif, 1870–1970* (Kent, England: Dawson, 1981), 29, 180. For a discussion of the Surrealists' 1931 anticolonial exhibition, see Patricia A. Morton, *Hybrid Modernities: Architecture and Representation at the 1931 Colonial Exposition, Paris* (Cambridge, MA: MIT Press, 2000). An English translation of "What is Surrealism?" is available in Franklin Rosemont, ed., *André Breton: What is Surrealism? Selected Writings* (New York: Pathfinder Press, 2000), 151–87; for his mention of the Moroccan war, see 157. For a recent documentary on Spain's colonial presence in this region in the early twentieth century, General Francisco Franco's reliance on Rifian men as cannon fodder in the Spanish Civil War, and the lingering effects of this history on contemporary Rif-Spain relations, see Julio Sánchez Veiga's film *The Moroccan Labyrinth* (2009).

Anchored by such spaces, the Generation 00s carry out projects that are resolutely turned toward the production of committed and engaged artwork. The art scene in Tangier progresses considerably at this moment, when the work of artists and the productions of independent spaces put into play their own skills and the certainties of previous generations. The Generation 00s engage the questions of freedom and of shared spaces for collaboration, ever conscious that belief and conviction are private affairs, whereas ideology and politics are public. Change is underway.

Research and translation by Emma Chubb.

10. In a recent essay, I noted: "The perception that we have today of Morocco's recent history is still based on oral memories which are hardly possible to transmit from one generation to another. Taking into account what is taboo or forbidden and the reasons of the State, there is a tremendous gap between this memory of the lived experiences people recount and that of written history. There might be two explanations for this diversity in the narratives: either the Moroccans who recount these memories fabricate them, or written history is not entirely based on the reality of the events. . . . Despite the authoritarianism of the Moroccan power, which considerably limited the flowering of artistic production, intellectuals were able to share some works and to take a position in the international and local cultural landscape. Notebooks were filled and piled up in drawers and in the bottoms of suitcases." See my essay "The Time of Plastic for 'Ripped Shoes': The '60s in Morocco"; it is available online in English (http://appartement22.com /spip.php?article293) and French (http://appartement22.com/spip .php?article292). This essay was presented at "Art Activities and Vocabulary," a conference co-curated by myself (L'appartement 22) and Georg Schöllhammer (tranzit.at) in Marrakech, November 22–25, 2010. For more on the theoretical, political, and ethical problems of the archive and the violent erasures that structure it, albeit in an American context, see Saidiya Hartman, "Venus in Two Acts," *Small Axe* 26 (June 2008): 1–14.

11. L'appartement 22 is an independent art space I founded in 2002.

12. The majority of Tangier's residents are from the neighboring Rif mountains; they use the term *ad-dakhil* (literally, "the interior") to refer to people from the Moroccan cities of Fez, Rabat, and Casablanca. *Al-kharej* (literally, "the outside") is used to refer to Europe, the destination of many immigrants. The term *al-kharej* dates to the period following independence, when many Moroccans went to Western Europe seeking employment during the Continent's post–World War II reconstruction.

13. Morocco became independent from colonial rule in 1956. The *makhzen*, or central government, refers to the succeeding system of absolute power and control in Morocco that was connected to the monarchy and is centered in the coastal cities of Casablanca and Rabat, respectively Morocco's economic and political capitals. It marks a zone that David Seddon describes as "one where the central government (the *makhzen*) was supreme, taxes were collected, governors governed and laws were respected." This area has historically been counterposed to the "dissident" Rif region, the site of violent war and repression both before and after independence. See also note 9 above and Seddon, *Moroccan Peasants*, 29.

14. See note 2 above.

15. Also, *les années noires* (the black years). Both of these French terms refer to the period that immediately followed independence: more than two decades of imprisonment, censorship, torture, forced disappearance, and other forms of persecution of political dissidents, opposition leaders, activists, and intellectuals. The Arabic terms for this period are *zaman al-rasas* (the time of lead/bullets) or *al-sanawat al-sawda* (the black years).

16. Here, *souffle* is a reference to the Moroccan literary and artistic journal *Souffles*, which was published by the poets Abdellatif Laâbi and Mustapha Nissabouri between 1966 and 1972.

17. Describing one such anticolonial protest and the repressive retaliation, Choukri writes: "'Didn't you hear the gunshots?' 'Yes, but from far away. What happened?' 'The police are shooting at Moroccans.' 'Why?' 'Because of the anniversary of March 30.' 'What are the Moroccans defending themselves with?' 'Stones.' 'Were people killed?' 'They are shooting at every Moroccan.'" Mohamed Choukri, *Le pain nu*, trans. Tahar Ben Jelloun (Paris: François Maspero, 1980), 99. (Choukri's book, titled *Al-Khubz al-ḥāfī* in Arabic, was first translated into English by Paul Bowles and published in 1973 as *For Bread Alone*.)

Yto Barrada

b. 1971, Paris; lives and works in Paris and Tangier

Yto Barrada's work, which includes photographs, short films, and sculptures, speaks to the complex realities of identity, closeness, distance, and immigration as they impact daily life in Tangier, a city poised on the northern coast of Morocco, along the Strait of Gibraltar. By focusing on everyday scenes from Tangier and the strait—a body of water separating Africa from Europe by a mere handful of miles—Barrada distills from the mundane a poetics of intense proximity,[1] which charges her photographs with an unmistakable sense of stillness.

Her *A Life Full of Holes: The Strait Project* (1998–2004), a series of large, square photographs (see pl. 257), is an exemplary study of the simultaneous conditions of nearness and estrangement the strait has produced. Revealing both the fine details and the extensive vistas of the northern Moroccan terrain, images such as *Tunnel—Disused Survey Site for a Morocco-Spain Connection* (2002) suggest the awkward and uneven development occurring at water's edge, while others, such as *Landslip* (2001), present gaps and crevices in lush landscapes, obliquely nodding to the unavoidable reality of a topography that divides. The series also includes enigmatic portraits: studies of figures who defer their address to the camera, looking at indeterminate points just outside the frame or, in other cases, merely elsewhere. The lone figure in *Girl in Red* (1999), leaning against an ornate mosaic wall and absorbed in a game of jacks, reveals only her back to the viewer. The scene pictured in *Rue de la Liberté, Tangier, 2000* (pl. 265) is equally ambiguous: The central figure faces the blank wall in the background, his body nearly concealing that of the man locked in his embrace.

Whether developed as hushed portraiture or through quasi-documentary glimpses of the region, such scenes of deferral seem to define Barrada's project, a self-described attempt to reveal the metonymic character of the strait—and its corresponding implications for Africa's fraught relationship to Europe. According to the artist, *The Strait Project* probes a tension existing between the city's "allegorical nature and immediate, harsh reality."

For centuries, Tangier's close geographic proximity to Europe has served to structure the commercial and political relationship between the two continents: trade zones (such as those located adjacent to the autonomous Spanish city of Ceuta, which lies on the Moroccan side of the strait) help promote the passage of massive amounts of freight between the continents and elsewhere. Yet at the same time, and particularly in the wake of the 2004 Madrid bombings, the Spanish border has grown increasingly impermeable, characterized by heightened surveillance technologies and aggressive border patrols. Against this geopolitical backdrop Tangier has evolved into a contentious staging ground, a point through which thousands of Africans flow in their attempts to pass into Europe.

Barrada's asymptotic understanding of the region as such a hub, which she has called "the destination and jumping-off point of a thousand hopes," also informs *Public Park* (2006), a series of large, sensuous, mostly black-and-white photographs simultaneously evocative of garden portraiture and Walker Evans's surreptitious camera work. Subjects are seen lying down in public parks, heads covered. But far from napping leisurely, these rumpled figures appear almost lifeless, exhausted and consumed. Suggestive of those who seek a different life on the other side of the strait (but never so explicitly presented), they are covered in plain sight, their presence evocative of a purposeful absence.

—James M. Thomas

1. For more on the concept of "intense proximity," see Okwui Enwezor's exposition of the theme in his curatorial essay "Concerning the Disappearance of Distance" in *Intense Proximity. La Triennale 2012* (Paris: Réunion des Musées Nationaux/Artlys, 2012), 18–34. Barrada's work was included in La Triennale 2012.

265

Yto Barrada, *Rue de la Liberté, Tangier, 2000*, 2000

Chromogenic print mounted on aluminum, 49 3/16 × 49 3/16 in. (125 × 125 cm)

San Francisco Museum of Modern Art, purchase through a gift of
Mark McCain in honor of Frish Brandt

266–68
Yto Barrada, *Hand-Me-Downs*, 2011
16mm film transferred to video, black and white and color, silent, 14 min. (stills)
Courtesy the artist and Sfeir-Semler Gallery, Beirut and Hamburg

269

**Yto Barrada, *Construction Site Barrier (Ferry),
Avenue d'Espagne, Tangier, 2007*, 2007**

Chromogenic print, 23⅝ × 23⅝ in. (60 × 60 cm)

San Francisco Museum of Modern Art, purchase through a
gift of Jane and Larry Reed

LOCATION AND PRACTICE: A ROUNDTABLE DISCUSSION

AMY FRANCESCHINI AND MICHAEL SWAINE
Futurefarmers, San Francisco

ADRIAN GHENIE AND MIHAI POP
Plan B and Fabrica de Pensule (The Paintbrush Factory),
Cluj-Napoca

LAMIA JOREIGE
Beirut Art Center, Beirut

SALLY MIZRACHI AND OSCAR MUÑOZ
Lugar a Dudas, Cali

TUAN ANDREW NGUYEN
The Propeller Group and Sàn Art, Ho Chi Minh City

AKRAM ZAATARI
Arab Image Foundation, Beirut

with APSARA DIQUINZIO and DOMINIC WILLSDON
San Francisco Museum of Modern Art

This text is excerpted from a conversation between several artists who have developed unique arts organizations in the cities featured in Six Lines of Flight *and SFMOMA curators Apsara DiQuinzio and Dominic Willsdon. Their discussion was recorded at the museum on August 30, 2011, as part of a series of conversations between these artists and a range of San Francisco Bay Area curators and scholars. A public presentation by the artists took place at SFMOMA on September 1, 2011. Oscar Muñoz's remarks were translated by Angela Zawadzki. Yto Barrada was unable to attend.*

APSARA DIQUINZIO: We would like to start by asking each of you to describe the ways that the character of your work is shaped by its location—by the particular cultural, political, and economic conditions in your respective cities and regions and by the issues and opportunities those locations present.

AKRAM ZAATARI: The question of location starts with a personal decision to position oneself in a place. That decision may be based on emotional, pragmatic, or political ties to that place, or on a refusal to leave for somewhere more comfortable. In any case, it raises a question about institutions, because once you decide to stay, you have to rely on the local institutional structures. Very often, in peripheral places—although, I'm skeptical about that term . . .

DIQUINZIO: Yes, it is a complicated term.

ZAATARI: Well, we can use it for the sake of conversation. So as I was saying, once you decide to stay in a peripheral place, where there is no infrastructure, where there are so many chains, and missing links, you are asked to assume several roles. This is true even for artists: you have to be a producer, you have to secure a space, you have to make that space ready for an exhibition, you have to build a community. So I don't know where to start when talking about the question of location. Especially given that there are many political factors, and sometimes legal ones, that forbid you to do things the way you would like to do them. Some countries still have censorship. Some countries have limited financial resources, and in order to work in those places you have to rely on funds coming from elsewhere. Outside funding is helpful, but it is also problematic.

DOMINIC WILLSDON: Maybe we should start by addressing the problems concerning the concept of the peripheral. Is it the case that we feel awkward about it but are nevertheless compelled to use it for the purposes of the discussion we're having? If so, what is the awkwardness around it?

ADRIAN GHENIE: I am perfectly happy with this term. I am from the periphery and I am not ashamed to say that. I don't think this is a problem, because I see it and accept it historically. For me, the periphery is a place that receives something, rather than broadcasting something. So in Cluj, for example, as part of Transylvania and Eastern Europe, and as part of the former Austro-Hungarian Empire, we always looked to the center, which was Paris or Germany. The generations before us (for many political, economic, and social reasons) developed the mentality that we have to look to other places to receive their ideas, and then create a local version of modernism, or the avant-garde. This changed with our generation, because we had access to other cultures. We were able to travel,

and we have the internet. We are the first generation in Cluj to have these things, along with the ambition to say, "We have to change this pattern—*You* have to be the receiver." We like to think that in the city of Cluj *we* can do something innovative and relevant, and *London* can be the receiver, or can be interested.

ZAATARI: I'm happy with calling my territory a peripheral territory, at least in terms of discussing the transmission of ideas that come from or develop around the periphery, but I would not be happy for those ideas to be stigmatized as peripheral.

GHENIE: I don't associate the periphery with something negative . . .

ZAATARI: I would like to strip away its negative connotations. But even then, a periphery must be opposed to a center.

MIHAI POP: The periphery can be a productive base for working. It's silent there, and that enables you to develop your work. As long as you can exhibit all over the world afterward, I see it as a big advantage to be working in a silent place. I look at the people I know in London, for example, and from the beginning of their careers they were pushed to be *in* the art scene.

GHENIE: To be competitive too early.

POP: Yes, and looking back on our development I see now that the almost ten years of relative isolation we had in Cluj was really a gift. We were left alone to develop, and that gives you strength.

GHENIE: . . . And time to think. It's like raising your kids in the suburbs. [*laughter*] When I moved to London, for example, I met all kinds of artists who as students had to deal with excessive attention and expenses. Now they can't even afford to have studios. They have to get jobs to survive. I have come to appreciate how different it was in Cluj. I wasn't paralyzed: I had a studio, everything was cheap, I had time to think, and there was no pressure. There was no notion of competition. I was really focused on my work. If you live in a major art center like London, you are exposed from the very beginning to a kind of nightmare situation that gets bigger and bigger because of all the pressures.

MICHAEL SWAINE: I'm curious, Akram, about the missing links that you mentioned at the beginning. It seemed like you were searching for a word and then you came up with a metaphor of bondage, of a chain. I think we can all relate to this. We can all see some area that is missing a link in the chain, and either we break the chain or we fill it in because we need it to stay connected. There is something valuable about that image, because it has a different connotation than the center-periphery model that is used so much in urban thought. It seems like there is a lot of potential to import meaning or construct a narrative if we focus on the missing links in the chain. Are we breaking the chain? Are we keeping it together? Is there a chain-link fence between the center and the periphery? It seems like a nice starting point to talk about location.

DIQUINZIO: Oscar, Cali has been referred to as "the periphery of the periphery." Could you explain where that comes from?

OSCAR MUÑOZ: My thoughts on the periphery have changed since the eighties. Now I am interested in the atomization of the centers and in how Cali, as a provincial city, could become a center while also occupying a position on the periphery. I think of Cali as a secondary city—especially in the context of Latin American countries, because these countries have very specific characteristics. A commonality among Latin American countries is that they have large concentrations of people in their capital cities—like Caracas, Bogotá, Lima, and Buenos Aires. Those are the big centers, and power and money are, of course, concentrated there, and cultural policy is developed there. The second-tier cities are marginalized; they settle below the first-tier cities like sediment. In the sixties and seventies, the capitals had very important art museums, but most of the Latin American museums that were powerful at that time are no longer. What is interesting now, and this is something I am passionate about, are the smaller private institutions, some of which are run by artists. They are managing their work and trying to operate in a different way.

DIQUINZIO: The problematic connotations of the term *periphery* stem primarily from the idea of a geographic division existing between the first world and the third world. This dynamic was what defined

the notion of the periphery in the eighties, and it is why it is such a loaded term now: the first world was—and arguably still is—associated with the primary art centers, whereas the third world was reduced to the periphery, or to being receivers, as Adrian suggested earlier. I guess I'm wondering whether or not this division exists. Have we really outgrown it? It seems to me that this distinction does still exist, although maybe in different forms, but we don't want to acknowledge it anymore. Or perhaps, because we know we are not supposed to refer to it anymore, we are reinventing it, or renaming it. Or has something really changed?

ZAATARI: Whether or not we accept the terms *center* and *periphery*, there are differences between the places those concepts describe. I like to see it in terms of wealth. I don't think it's about a poverty of ideas—or at least that angle is something that does not interest me. I'm going to give a few examples. For a few billion dollars, Abu Dhabi will be able to build a Guggenheim and a Louvre as part of the Saadiyat Island Cultural District—which will include at least four major museums. If you have the money, you can buy everything. Abu Dhabi has spent enough to become a very important cultural center in the Middle East.

Another example is the curator Catherine David. One of the things that struck me in a text she wrote shortly after coming to Beirut was her discussion of the absence of art spaces in the city. Why did this interest her? Because she was having problems in Rotterdam at the Witte de With Center for Contemporary Art, where she was the director. If left to her desires, the exhibition spaces of the Witte de With would have remained empty, because she was interested in doing projects for the museum elsewhere in the world. She was not that interested in programming an exhibition space in Rotterdam, even though there is money and a cultural infrastructure there. She did projects there from time to time, but her ambition pushed her beyond the limits of that space. She was doing collaborative projects with the Tàpies Foundation in Barcelona, and working in the Middle East. At the Witte de With she did several important publications about Middle Eastern artists, such as the two-volume project *Tamáss: Contemporary Arab Representations* [2002–4], but the conservative art establishment in Rotterdam, particularly under the

policies of the government back then, did not support her work.

LAMIA JOREIGE: Yes, but why were her shows never presented in the Arab world? They were only shown in Europe—that is strange.

ZAATARI: What I would like to say is that she was someone who was learning from a geographic "periphery" that she did not consider peripheral. It is pointless to come to a place to work if you think it is peripheral. If you don't have the humility to say, "I'm here to learn," then I think you will go back without learning anything. This is why it depends on who uses that term. I may decide, for political reasons, to say, "I am from the periphery." This can be both a pragmatic and a political choice. You can say, "I choose to live on the periphery because I pay one-tenth of the rent that I would be paying elsewhere." Or you might say, "I would like to live on the periphery, because I'm not interested in the power structures of the center." There are different ways of looking at it. Sometimes you might refuse to be designated as someone on the periphery, because of the stigma it carries—there's an implied absence of power for those at the margins. So, back to Catherine David, who was at the center of power and not satisfied there. She was in a post-museum phase, and working within the confines of a designated space and location was not what she was after. The museum for her was something else, beyond a particular physical space. So she came to Beirut, a place where art structures were nomadic and not confined to specific sites, and that reality corresponded with what she was looking for. This is what she wrote about. She described it as a fragile and temporary situation that would either become further marginalized or be eaten up by larger structures. Now I see that, in a way, she foresaw how this might link to the future, to new power structures of the Middle East like the Saadiyat Island project.

JOREIGE: But it's strange that you are giving as an example, in reference to the question of locality, someone who comes from elsewhere. I respect very much the work that she did, but in citing someone who came from the West you are choosing as a model someone whose very presence demonstrates that Beirut is moving away from the periphery and becoming a central place—

ZAATARI: By taking her as an example I'm not suggesting her as an ideal model, I'm simply examining how she looked at this landscape.

JOREIGE: Well, she is a serious researcher who was truly interested in the Arab world and developed important research on the region. But for me, to go back to what Apsara said, we can't deny the fact that the problem still exists. However, I would like to differentiate between the ways this model impacts production and the ways it structures reception, as you suggested earlier, Adrian. As artists in Beirut, when we started out I don't believe that we cared much about the reception of our work in terms of integrating a circuit of local or international galleries or institutions; we worked with the few venues that were available. I would think that that is every artist's experience. A serious artist does not think at first, "Oh, I want to be in this museum or in that gallery." That is not the reason why you do the work.

GHENIE: Up to a point. But then you *do* think about those things.

JOREIGE: That is something different. By that point, it becomes a question of reception. The reason I started working as an artist was to express and reflect on certain issues that were important and were related to the context in which I live and work, the history of the recent Lebanese wars and the aftermath of war in Beirut. Only after the situation transformed and evolved in Beirut did people start to come and visit from abroad. Once exchange with the international world became possible, we started to feel that the West was still the center. Actually, let's not use the terms *center* or *periphery*. Being acknowledged by the West mattered, but it was not the only thing that mattered. What really made a difference was when people came to Beirut from all parts of the world, from Europe, Latin America, et cetera. The idea that what we were doing was international (and did not just come from the West) mattered. It meant something to be able to reach out. This is why we have to distinguish between the reasons for producing work and the effect and impact it has. What is happening in our region now is impossible to evaluate. What is happening with Saadiyat Island, the creation of art fairs in the Gulf region, and the rise of a new market— it is going way too fast. Of course, it is a speculative

market and there are many things about it that are not necessarily positive, and that might actually destroy what Adrian was describing. Although I now codirect an art institution, I agree that those ten or fifteen years in Beirut—when there were no art centers and only a few galleries and foreign cultural centers—were like a laboratory for experimentation. The work we were doing felt really important; there was a sense of excitement, of being part of a community of artists. We cared less about what the rest of the world thought.

WILLSDON: Rather than following the model of center and periphery, we could say that there are times and places where cultural power and capital are concentrated, and then there are other times and places. It is about relationships of inequality, but the center-periphery model makes those relationships seem more fixed and stable, more diagrammatic than they are.

GHENIE: Is there a different meaning of *periphery* in terms of geography, politics, and/or identifying provincial attitudes? In Cluj, I was not bothered by the fact that I was in Eastern Europe. I was bothered by the fact that people in my town had provincial attitudes. That made me feel inadequate. I wanted to go to London, not to have money or power but to meet people who were open-minded and urbane. This is the main problem for me. For example, before the German reunification, Düsseldorf was the center of industry and capital. Düsseldorf is almost smaller than Cluj [*laughter*], and Germany, at that time, had no real center. The capital was Bonn, which was purely political and very small, and the cities were almost the same. Berlin was totally irrelevant. So in Düsseldorf they formed the academy and created a cultural scene. This is key: if you build a contemporary art space in Cluj or in Cali, you import a cultural mentality to that location. Success in Cluj, for me, means that the people of Cluj have started to think more open-mindedly.

The weird thing about contemporary art is that it is taboo-free. Yet, if you are homophobic, or anti-Semitic, you are immediately expelled from the contemporary art world. You can't survive as a curator or artist if you have that attitude. This is the biggest ideological achievement of contemporary values— you can't hate.

ZAATARI: That is true. Can we look for a term for this?

WILLSDON: Apsara and I have been talking about cosmopolitanism. I was going to ask, Adrian, if the opposite of the provincial is the cosmopolitan?

ZAATARI: I don't know. The framework we are talking about belongs to a set of new values that are shared within the contemporary art scene and less shared outside it.

GHENIE: Do you really hope that in one hundred years, all those issues you have now in Beirut will be over? I mean, religious—

ZAATARI: Yeah, issues of nationalism, issues of religion, of identity, of a lack of tolerance.

POP: This is something we have in common. We all come from provincial places where these issues are key factors.

GHENIE: That's why we don't have support from the state: in their mind, we are not important.

ZAATARI: Yes, the state thinks that artists don't contribute.

GHENIE: But in London, Berlin, and New York, the state thinks that artists are important.

ZAATARI: This reminds me of what happened in countries like Syria, Iraq, and Egypt in the sixties and seventies. Because their political structures were closer to Communism, they had huge state infrastructures for the arts—huge theaters, national ballet companies and choirs, schools for music, an opera, and a cinema fund. They put a lot of money into culture and the arts, and they produced a lot of excellent films in that era. But those productions had to correspond to a certain vision of the state—a reduced vision. In contrast, in Lebanon the state did not put any money into culture or the arts. Many considered this a deficiency, but in the nineties, my generation thought, "Thank God they did not put money into it, because they would have ruined everything."

JOREIGE: But let's face it, we did not have a state. I mean, our state was really fragile. The question of national identity, and of the state, is still at stake in Lebanon in very different ways than it is in Syria or Egypt, which have a stronger identity and state vision.

POP: But going back to the issue of what to call the center and the periphery, I would say we shouldn't put everybody under one term. There are such big differences between what we can call peripheries. It would be vulgar, somehow, to collapse all of these different circumstances, histories, and stories. On the other hand, I think what is happening *here* is problematic because it's setting up the old dynamic: SFMOMA is the center and we are all from the periphery.

DIQUINZIO: Well, not necessarily . . .

WILLSDON: Sort of.

DIQUINZIO: We don't think of ourselves in terms of being the center—

ZAATARI: But let's face it, you are trying to overcome the fact that you are the center.

DIQUINZIO: I think it is necessary to stress the importance of context here. In the context of the U.S., it is difficult to think of San Francisco as a major art center.

ZAATARI: We are not meeting in Romania, though, or in Beirut

POP: The Polish art historian Piotr Piotrowski developed a theory about the center and the periphery that claims that traditionally, peripheral areas are mediated by the center. So of course we are meeting here. He supports the idea of rewriting our art histories, freeing ourselves from geographic hierarchies, and even changing the viewing angle to ask how marginal observers can modify the perception of the art of the center. He would prefer that when we meet we not do so in the center.

GHENIE: But to do what? To meet and to conspire to conquer the center? We can meet in Transylvania if you want, but unconsciously we all want to go to Europe . . .

ZAATARI: Yes and no. The center is everywhere, and there are struggles everywhere.

MUÑOZ: It could be that there is a multiplicity of small centers. We each build our own center in relation to other centers, and it is autonomous, but at the same time it could circulate. This is what happened, for instance, in Cali. I am not speaking for all of Colombia—I'm not really interested in the idea of Colombia as a country. I'm much more interested in the local sphere and in the world—especially places where other battles are being fought. I think that is the whole point. This is what I doubted when I named Lugar a Dudas [A Place to Doubt]. It struck me that there are several centers on the periphery. But are we saying that we have one large, united center and then the periphery?

DIQUINZIO: I would like hear Amy and Michael's perspective on this, because for artists in the U.S. it can be difficult if you don't live in New York or Los Angeles. Many San Francisco artists have felt pressure to move to either New York or L.A.—larger artistic centers—in order to gain a certain visibility within the art world. What do you two think about living and working in San Francisco, specifically in relation to this question?

AMY FRANCESCHINI: I think I am in alignment with what you were saying earlier, but somehow I feel outside of this art world conversation we're having because, as Futurefarmers, that has not been our trajectory, to be participating in the art world per se. We feel very lucky that we are able to participate in this global art conversation, because it's liberating. We have been doing projects based in San Francisco that are reacting to a certain time and place, but our work is always connected to a larger conversation. We could have moved to New York, or Berlin, or Los Angeles. A lot of our friends did, in fact. There was a huge exodus of people in the late nineties to Los Angeles and Berlin that left a gap in the city. Until that point, there were a lot of artist-run spaces in garages and a vibrant culture of—let's say peripheral—spaces that weren't large institutions. It was exciting, and as that faded away we had to recalibrate and consider where our community of artists is located. Another important aspect of San Francisco is that I think of it as a kind of hiding place, like Adrian suggested earlier. A lot of the people here that we have surrounded ourselves with, academics and activists, are almost running away from centers, and have found this spot at the edge. There is also a frontier history here of people coming to make

their fortunes and then busting—it has a history of rising and falling. We've been called the backyard or the shadows of the art world, but I think that is a fine place to be.

SALLY MIZRACHI: But when you say it is not a center, you mean in relation to New York or L.A.?

FRANCESCHINI: Yeah.

MUÑOZ: Not Cali—

POP: Yeah, and you see, that is a luxurious position.

DIQUINZIO: Well, that is why I say that it depends on context: we have to examine the specific circumstances of living and working in each particular location. These are relative situations.

GHENIE: I have another example. If you speak with gallerists or artists in Europe and you ask, "Where would you like to live: Paris, London, or Berlin?" everybody says, "I won't move to Paris, it's so provincial now. Nothing happens there." What if these centers slowly start to become provincial in part because they live under the heavy weight of a glorious past? When a center like Paris becomes too big, too famous, and too heavily dominated by tourism, it slowly dies. If you asked me now where I would prefer to live, Paris or Beirut, I would answer Beirut.

JOREIGE: Me, too. That's horrible. [laughter]

GHENIE: It's because it is more real—

JOREIGE: It's not a matter, for me, of real or not real; it's more about where you can actually work. I lived in Paris for a long time and I was never able to produce one thing there. I always had to go to Lebanon to make work, and then go back to Paris; I lived between the two.

POP: I will give you another example. We have good friends in Cluj who are urbanists and have the opportunity to redesign public space there now—there is a lot of work to do in urbanism after Communism. They have to rethink the center of the city in terms of traffic, public space and its relation to historical monuments, the needs or expectations of residents, and

economic necessities. And we also have the chance to do something new there now, to create alternative institutions, to build the art scene. That is very exciting. You cannot do that in Paris.

DIQUINZIO: Tuan, could I ask your opinion on this point, because you were born in Vietnam, but your family lives in L.A. now. You were primarily raised in the U.S., but then you decided to move back to Vietnam to live and work.

TUAN ANDREW NGUYEN: I think initially I didn't feel like I could engage in this conversation much, because Vietnam isn't even on the map. But at the same time I think of Sàn Art as being the center, one of many cultural centers in Vietnam where ideas are being questioned and challenged. It's obvious that this term is still problematic, and that it is getting more complicated. In fact, many of our peers are now challenging this notion of the periphery on so many different levels. It's funny to hear you say that San Francisco is not the center; that you are on the periphery. Then for us to say you *are* the center. [*laughter*] And then, on the other hand, I'm insisting Sàn Art is the center and not the periphery. So at any given moment, the centers can shift. It's not a two-dimensional field anymore. Sàn Art plays with that all the time. A lot of our money comes from the U.S. and, recently, from supporters based in Australia, so the distinction between center and periphery is increasingly blurred. I was thinking about what was said earlier: Is the relationship between center and periphery determined by money, or capital? Or is it determined by a wealth of ideas? I think it's both at the same time. For example, my collaborator Dinh Q. Lê goes to the U.S. to raise money, and then brings it back to Vietnam. He was recently given the Prince Claus Award, and when they asked him to go to the Netherlands to receive it he said no, and instead asked them to come to Vietnam to give it to him. We try to challenge these notions of center and periphery all the time. This debate could go on and on because these notions have been fluctuating for decades.

DIQUINZIO: I know. Is it possible to escape it?

WILLSDON: Well, we can set it aside. It is not the only way of thinking about the meaning of location. The center-periphery discussion is so much about supposed

relationships between places, even about imagining networks, systems, hierarchies of places. But there is also the matter of how a certain place relates to itself, to its own history and particularity, its own condition and circumstances—and the question of how cultural practices are shaped by that. Would someone want to speak about how the history of your place—including, perhaps, the activity of previous generations of artists there—informs what you continue to do?

JOREIGE: I think both Akram's work and my work, for instance, is completely informed by the recent history of Beirut, and strangely enough, we relate very little to the generation before us. Maybe you do, Akram, a little bit more than I do.

ZAATARI: With only a few people.

DIQUINZIO: Can you explain why that is?

JOREIGE: It's hard to pinpoint exactly. It could be the war; it could be that we studied abroad. There is a generation of painters and sculptors in Beirut who are now in their late fifties and sixties and never stopped working during the war. In its aftermath, some of them became slightly invisible. Their production has not slowed down, but when our generation started working in the mid-nineties, we tended to use different mediums. But more important was the fact that we did not relate to them. It's not that we rejected them, we just had different references. Our references were more from French cinema, for instance, or contemporary art from other places in the world. This created a gap between us and them.

ZAATARI: This is what Mihai is trying to bridge with his work in Romania—

JOREIGE: We did one show at Beirut Art Center where we invited a gallerist to do a sort of historical show, to look back at the work of these artists who were addressing the subject of war during a time of war. There is a rupture between their practice and that of our generation.

ZAATARI: Personally, going back to the discussion of the history, the politics, and the constraints of place, I can't imagine myself working outside of Beirut. I have been saying that for fifteen years, so maybe I should

change. But my work is about the archaeology of that place, so I cannot go and do it elsewhere.

MUÑOZ: The conditions in our cities can make us neurotic. This year in Cali, we have decided to study and rethink our city. Caliphilia and Caliphobia are the subjects we are exploring. I would like to talk about Cali a little bit. We have had a war in Colombia for the last fifty years—an endless war. It's a very strange situation. We see the conflict as if it were far away, on the horizon, away from the city centers, from the epicenters. Nonetheless, it is right there. And it has shaped daily existence; we have developed this quotidian routine of living with the situation, and therefore it approaches normalcy. In the eighties, when drug trafficking was established in Cali, things became fractured. Before then, the city held the promise of becoming an important center. It was thriving. But it never became that center; it was limited by the situation. This created a sense of malaise, of frustration; but at the same time, many of us developed a deep desire to overcome that and to build something there. These are two forces that I see and live with.

POP: Perhaps there is a resolution somewhere for all of us. Being so deeply involved in these places makes you suffer to a certain extent, but at the same time it fosters a kind of love/hate relationship that is necessary. These locations are not paradise, yet we remain committed to them nonetheless.

ZAATARI: I agree.

POP: We want to run away, but we also want to stay and build something. And sometimes we want to have distance.

JOREIGE: To escape.

POP: Yeah, it is double edged.

NGUYEN: Yeah, I think we all feel the same. We talk about it at Sàn Art all the time. It's the "I love it, I hate it" cycle.

JOREIGE: And you, in San Francisco?

SWAINE: [laughs] No. We just love it.

FRANCESCHINI: Sometimes I wish I hated it enough to leave. It is a bad drug, because of how expensive it is to be here. It puts certain pressures on our practice. We are continually scrambling, teaching at different schools, doing design work, freelancing, and art becomes our hobby in a way. Being in one place and committed to that place is something that became really important to us about six years ago. The history of the Bay Area has definitely influenced our work, in terms of the active resistance that happened here in the sixties within the political and academic realms. Activism was fueled by the wars that were going on and the military research that had been happening in this area since the late forties—it was the most powerful military research in the world, and resistance to it was very strong. Using that as a historical precedent, we looked at archival records on students at Stanford who were studying computer science in the sixties. They went there to think about the development of personal computers for liberation, and found that they—their intellect—was being used to develop electronic warfare. So a group of these students dropped out and asked their professors to teach alternative curricula like Maoist theory, alternative Western civilization, et cetera. The classes were taught in rooms that were squatted. For about a month, there was a kind of alternative school at Stanford, and then it got pretty popular and they were kicked out. The students started their own school, called the Midpeninsula Free University. They hosted classes in garages, bookstores, and surplus spaces around the Bay Area. There is a huge archive on this at Stanford, and it has been really inspirational for a lot of artists here in terms of thinking about alternative education and free education, especially in the midst of all these universities that cost so much money to attend.

When you are in a place for a long time, you are able to tune in to the nuances of that place. There are moments that open up politically. Like in 2003, when Matt Gonzalez, a Green Party candidate, ran for mayor of San Francisco. Electing a Green Party candidate would have been a huge deal in the United States. He was very popular, and two days before the election, former president Bill Clinton came to campaign for his opposition, Gavin Newsom, who was running as a Democrat. Clinton came because the United States was afraid of a progressive city like San Francisco having a Green mayor—that could

have had a huge impact nationally. Anyway, Clinton came and campaigned, and Gonzalez lost in a run-off race, forty-seven percent to fifty-three percent. But in that moment the city became politicized in a way that I hadn't seen since the very early nineties, during the Gulf War. A moment emerged in which people's minds opened, and there was a shift, even in the art community, in how they thought about themselves in relation to the city and to politics, and how they thought about the city's potential as a medium that can be sculpted.

WILLSDON: It's very interesting to hear you talk about this, because we were aware that across several of the contexts represented here, there was in each case some kind of engagement with a history of trauma. I guess we thought that San Francisco was the exception to that, but there is a way in which the always-missed, or lapsing, possibility of some sort of major social transformation in this region is in itself a problem to work through—though it is not a violent trauma.

DIQUINZIO: The same thing happened recently with Prop 8, the ballot measure that banned same-sex marriage in California. That was a real lapse, or nega-tion, of a very positive social transformation.

FRANCESCHINI: Maybe the trauma is more invisible here.

WILLSDON: It's a contained trauma.

DIQUINZIO: I have to say, though, that San Francisco does not get off the hook, because we have a huge problem with homelessness and drugs in this city. If you go to the Tenderloin it is total disaster, and we overlook it every day. A kind of malaise has devel-oped, coupled with the sense of normalcy that Oscar mentioned in reference to Cali. The third world exists in the first world and vice versa; they are not neces-sarily separate spheres.

WILLSDON: Yes, that's true; and the city organizes itself to create and maintain separation between these worlds. But this idea of trauma in the history of a region—to what extent does it inform what you do there?

POP: In Cluj we have a strange story of ultranationalism in the nineties and the early 2000s. We had an

ultranationalist mayor. It was similar to the situ-ation in the former Yugoslavia, but without war. All the public spaces were marked as Romanian; the city was systematically painted all over in red, yellow, and blue—the colors of the Romanian flag. Everything—even the trash cans, the benches, and the playgrounds.

DIQUINZIO: You are referring to the policies enacted by Mayor Gheorghe Funar in Cluj.

POP: Yes. And it was a negation of what the intellec-tuals had achieved. Suddenly the city belonged to the Romanian peasants again. It is a city that also has large German and Hungarian populations living there; not everyone is Romanian. This painting over history and diversity was a serious trauma that informed much of our earlier work.

ZAATARI: Why did they do to it?

GHENIE: Marking the public spaces as Romanian was a way of declaring a nationalist agenda. It would be the equivalent of putting swastikas everywhere and declaring that foreigners, particularly Hungarians, aren't welcome.

POP: They used technology to promote this ultra-nationalist rhetoric, too. For example, if you stopped at a red light in your car you might see a big panel with electronic writing that was not an advertisement but included fragments of the Romanian constitution.

GHENIE: We lived under this regime for twelve years.

DIQUINZIO: And that brand of nationalism was seen as an antidote to Nicolae Ceaușescu, in a certain way.

POP: Yeah.

GHENIE: No. Ceaușescu was ultranationalist, too. He was like Slobodan Milošević.

DIQUINZIO: I know, but Funar's actions followed Ceaușescu, and were presented as a kind of solution to Communism . . .

GHENIE: Exactly, and yet it was a continuation of the same—

POP: The difference was that it had a religious component. Ceaușescu had developed a communist base of national values. By adding a layer of Orthodox Christianity to this ultranationalism, Funar's supporters thought they were creating a new kind of freedom.

ZAATARI: This is part of the provincial attitudes that you were talking about. It's not just about political ideology.

JOREIGE: But the question for me is not about trauma, it's really more about our capacity to be politicized. Isn't that what we are all trying to do with our spaces, or organizations, or our work as artists? Do we actually believe we can change things? Can we really participate? This is where the despair, or love and hate, comes into it. I'm not going to go through the history of Lebanon now, but our war is not really over; we feel stuck, without a horizon, while all the revolutions are happening around us. Nothing is happening in Lebanon.

So let's say that fifteen years of war didn't lead to any resolution. A lot of us, as artists, think that the war is not actually over, that it has just assumed other forms. Today we are more divided than we were thirty years ago. Anything could happen. But the question that I always ask myself is: Why do I want to leave suddenly? Or why do I want to escape? Sometimes I feel it is unbearable to be there, and I feel that my actions have no consequences. That I cannot actually do anything about what is happening. I'm a citizen, but it is as if I'm nothing. My vote wouldn't count. Beirut Art Center wouldn't count, my work as an artist wouldn't count. We would still be in a situation where an oligarchy of dictators would make tons of money, be corrupt, and we would still accept their leadership. There is always this fear. There is always this relation to a community, a sect that prevails over being a citizen or being secular. This is something that deeply affects me as a person, and therefore as an artist. Sometimes I feel really desperate about it, and sometimes I believe that, yes, Beirut Art Center is a platform—even if it has an effect on only a few people, it is actually fostering a dialogue, et cetera. But then there are other days where I wonder who we are working for and why we are doing this. These are unresolved questions, and it seems they are valid everywhere, at different scales. In 2005, when Rafik Hariri [the former prime minister of Lebanon] was assassinated, I felt that we had become re-politicized, but then the momentum died again. Now we are very concerned about what's happening in Syria, but none of us is truly doing everything we could or risking our lives for the possibility of real change. We may have believed in that kind of activism once, but it didn't work. So I think the question of who we are doing this work for and why is very personal.

MUÑOZ: I think it is about activating resistance.

JOREIGE: Civic resistance, yes.

MUÑOZ: How can we measure impact? You have to wait. Change is measured in small deeds, small acts. I think the work we are doing is an act of resistance. I agree with you, Lamia, but I also feel that there is no other way.

TRICONTINENTAL DRIFTS

TAREK ELHAIK AND DOMINIC WILLSDON

BASTA!

This will be part reminiscence, part exorbitant allegory. We begin in Tangier, on a July evening in 2007, the last occasion either of us attended a screening at the Cinémathèque de Tanger. The film playing that night was the claustrophobic, noirish political thriller *J'ai vu tuer Ben Barka* (I Saw Ben Barka Get Killed, 2005)—directed by *Cahiers du cinéma* critic-turned-filmmaker Serge Le Péron. It relates one of the most notorious political scandals of the decolonization era: l'affaire Ben Barka. It is a bewildering story. On October 29, 1965, in Paris, the Moroccan opposition leader and anticolonial activist Mehdi Ben Barka was abducted and disappeared. He was picked up by police outside the Brasserie Lipp, and taken (willingly, so it seems) to the suburb of Fontenay-le-Vicomte, to the house of the gangster Georges Boucheseiche, where he is thought to have been tortured and murdered. His body was never found, and complicity between the French police, organized crime, and the Moroccan authorities has long been suspected. *J'ai vu tuer Ben Barka* alleges another level of complicity, that of film and filmmaking, especially political filmmaking. Ben Barka had been on his way to a meeting with director Georges Franju, journalist Philippe Bernier, and a shady would-be film producer named Georges Figon, whose culpability seems clear (Figon himself was found dead some months later). He had agreed to act as special advisor to Franju and his collaborator, Marguerite Duras—two celebrated figures of internationalist political cinema—on a documentary chronicling worldwide struggles for independence from the colonial powers. The film was to be composed of newsreel footage and filmed reconstructions, and it

had the working title *Basta!* Le Péron presents Franju and Duras as unwitting accomplices in the kidnapping; they let themselves, and *Basta!*, be used to bait the trap. Their desire, and Ben Barka's, was to see all those revolutionary energies rendered as visual culture; that desire proved fatal. Le Péron has it stand for all the ways in which, as so often in those years, political and artistic ambitions were intertwined.

Ben Barka has since been enshrined by a certain leftist-nationalist historiography, to be sure, but he was a shrewd synthesizer of third world insurgencies.[1] At the time of his disappearance, he was secretary of the Tricontinental Organization for Solidarity of the Peoples of Africa, Asia, and Latin America, an international web of solidarities he was weaving from his other base and place of exile, Cairo. The Tricontinental was a project to assemble places, cities, and nations according to an emergent cosmopolitanism. It was a gathering of disparate movements called for by the unequal distribution of geopolitical and geocultural power. Ben Barka was planning what would be its first formal assembly, the Tricontinental Conference, to take place in Havana in January 1966, and he had wanted to screen *Basta!* there, perhaps as its keynote. But Ben Barka, of course, never made it to the conference, and *Basta!* never went beyond the planning stages. Yet what it might have been appears in Le Péron's film in the form of a look-alike. The director included nonnarrative segments, ostensibly from early 1960s newsreels, that document the visual and political cultures of the epoch: footage of speeches, meetings, and the arrests of iconic political leaders (including Che Guevara and Patrice Lumumba) to less spectacular sequences that capture the synergetic capacity of the cinematic and the political to generate a new set of encounters among peoples in the throes of wars of liberation while also reflecting the shock of these upheavals. There is something else, too: brief segments from *Les maîtres fous* (The Mad Masters, 1955), Jean Rouch's anti-colonial ethnographic film experiment. It is those volatile and very much alive faux-documentary *images survivantes*, inserted in the narrative of Le Péron's contemporary political thriller, that today continue to work and await incarnation—liberation, so to speak, from the optical, political, and ethnographic unconscious of Tricontinental culture.

270. View of the Escuela Nacional Cubana de Ballet (Cuban National Ballet School), Havana, 1997. Courtesy John A. Loomis

271. Mehdi Ben Barka (third from left) is greeted in Havana by a Cuban delegation, January 1, 1965. Gamma-Keystone via Getty Images

On January 15, 1966, Fidel Castro gave the Tricontinental Conference's closing speech at Havana's Cine Charles Chaplin (venue of the Cinemateca de Cuba), where *Basta!* would have had its premiere. After speaking at length in support of the anti-imperialist struggles of the Vietnamese, after saluting Ben Barka and calling for his killers to be brought to justice, he closed the conference with these words:

> Our country, which, as you have been able
> to see, is made up of various ethnic groups,
> a result of the intermingling of people from
> the various continents—deeply linked to Latin
> America because of this fact, deeply linked with
> Africa, deeply linked to all of the people from all
> continents—has done its utmost to make pleasant
> the stay of the delegations here. . . . They bid
> them farewell with an embrace . . . as a symbol
> of their sentiments of fraternity and solidarity
> toward the other people who struggle, and for

whom they are ready, also, to offer their blood. Fatherland or death, we will win![2]

You can hear it here, the spirit of the Tricontinental: beautiful yet preposterous, dangerous yet ethical. It was a form of universalism and popular humanism (beyond the racialized figure of Man imagined by colonial modernity) that affirmed national identities yet was nonetheless suspicious of parochial nationalisms. It sought the radical transformation of discrete national cultures while simultaneously assembling and connecting three continents, Africa, Asia, and Latin America, and their emblematic cities.[3] Indeed, its distinctive achievement is to imagine a political community founded in the linkage of those seeming opposites: cosmopolitanism and nationalism.[4] We might call it, excuse us, the cosmonational. It had not only an ethics but also a politics. By comparison, other forms of cosmopolitanism can seem tenuous, even pious.

That screening in Tangier, specifically the look-alike *Basta!* (for us, the most compelling sequence in Le Péron's film), released the energy and ghosts from those years; it conjured the project of Tricontinental culture, the hopes of the generation that preceded us, and also the failures. We know that the cosmonational failed in all kinds of ways, that there are all kinds of darkness in its heart. Yet we struggle to disavow it. The cosmonational carries a belief in the possibility of an assemblage of places that is not arbitrary, and that is based on something other than an idea of what those places lack. It evokes an image of political community that is no longer operative, perhaps— we cannot say the things Castro says, and would not wish to—but which helps us understand and live with our attenuated relationships to both adopted and given cultures. It depends on who and where you are. If your life, indirectly, and your parents' lives, directly, have been produced by the shifting geographies of decolonization, the Tricontinental remains an inescapable and unapproachable moment. It doesn't mean so much for everyone. It does for us.

ESCUELAS NACIONALES DE ARTE

In July 1965, six months before the Tricontinental Conference, three months before Ben Barka was killed, Castro made another speech: he declared open the new Escuelas Nacionales de Arte (National Art Schools) of Cuba. If you are aware of Felipe Dulzaides's video *Next time it rains* (1999–2010), which is part of his larger project *Utopía posible* (1999–ongoing), or John Loomis's *Revolution of Forms* (1998)[5] or the eponymous opera based on that book, the story of the schools will be familiar to you. It is another episode in the story of the disappearance of the cosmonational. In conception, they had been the most vivid act of architectural decolonization imaginable: a complex of five schools (theater, dance, music, ballet, and plastic arts) for a liberated Cuba and its sibling nations worldwide (students might come from Egypt or Palestine, Vietnam or Angola), repurposing the site of a former country club and golf course. The architects Ricardo Porro, Roberto Gottardi, and Vittorio Garatti—a Cuban and two Havana-based Italians, a cosmopolitan team— produced a set of designs intended to express a new Cuban identity. It was an architecture to contend with

272. René Portocarrero for the Instituto Cubano del Arte y la Industria Cinematográficos (Cuban Institute of Cinematographic Art and Industry: ICAIC), *Saludamos Primera Conferencia Tricontinental* (We Salute the First Tricontinental Congress), 1966. Silkscreen, 34 × 21 in. (86.5 × 53 cm). International Institute of Social History, Amsterdam

the New York–based International Style dominant in the postwar era—the style, for example, of the American embassy in Havana (1953) and the Havana Hilton (1958). The designs were created according to certain guiding principles: respect for the landscape of the former country club (the schools were sited at the periphery of the golf course); use of local materials (the U.S. blockade and trade embargo meant that imported materials, such as steel and concrete, were unavailable in any case); and a hybrid vernacular that sought to express an Afro-Hispanic Cubanidad. The Catalan vault *bóveda* from Spain and North Africa was the essential structural form. Porro used this form, combined with the concept of an African village, in the design for the School of Plastic Arts, paying homage to the négritude movement: he called it an *arquitectura negra*.

The schools had been under construction for four years, and were not yet finished, at the time of their opening in 1965. Work had been suspended: the political will required to complete them no longer existed. Their architectural designs, their symbolic ambitions, their social and political intent, none of these remained in alignment with the path taken by Castro's regime. Over the following decades, the buildings fell into various states of ruin—the ballet school was absorbed by the jungle (pl. 270)—and they became an emblem of the revolution's fate. There were multiple reasons why the project was abandoned. Following the October 1962 Missile Crisis, Cuba began to redirect energies and resources toward security concerns. It also moved closer to the Soviet Union politically, economically, educationally, and even architecturally, as the first of many Soviet-made prefabricated buildings arrived in the country in 1963. Cuba became absorbed into a style that was differently international, with an emphasis on rationality rendered as efficiency. Castro spoke against the schools: they were not a rational use of resources, and they were ideologically awry. They were too individualistic in their style, too historicist. Others were skeptical of the schools' Africanness, questioning a style deemed "folkloric," and references to "hypothetical" Afro-Cuban roots; this is cosmonationalism failing to subsume racial divisions. In 1963 the schools were a venue for the 7th Congress of the International Union of Architects; the theme: Architecture in Underdeveloped Countries. The schools did not see

another gathering of international visitors until the 1994 Havana Biennial.

Architecturally, they are not unparalleled. Though the term seems too tame, they belong to a regionalist tendency, a decolonizing regionalism. This is not the European regionalism of *Heimat* mythmaking. It is, each time, a Tricontinentalist assemblage: the *bóveda catalana* with the arquitectura negra. If architecture had a term for this, it might be cosmoregionalism. This calls to mind a distinction made, in the postwar era, by a California architect, Harwell Hamilton Harris. Harris distinguished between a Regionalism of Restriction and a Regionalism of Liberation: he considered the former to be anticosmopolitan and antiprogressive, "a cloak for misplaced pride"; and the latter to be "the manifestation of a region that is especially in tune with the emerging thought of the time" and "more than ordinarily aware and more than ordinarily free," with "significance for the world outside itself."[6] Now that we think of Harris, and recollect the West Coast regionalism to which he was central, it is tempting to suppose correspondences between Tricontinental cosmoregionalism and a California variant. The San Francisco Bay Area became a noted site of the regionalist impulse. It was institutionalized here in the mid-twentieth century, when William Wurster founded the College of Environmental Design at the University of California, Berkeley, and Lewis Mumford was hired by Stanford University to found the humanities department. The regionalism of the Bay Area and the Western United States also understood itself in opposition to the International Style promoted by the Museum of Modern Art and New York intellectual circles. Does it distort too much to think of Bay Area architecture after the war as having a postcolonial relationship with New York City, a relationship that corresponds to that felt in Havana and around the world of the Tricontinental? In the end, yes it does. Relationships of inequality are not equivalent.

Thinking in the medium of cinema inclines to a flickering, fleeting relationship to place. Architectural thinking does not. It compels decisions about the location of culture. The cosmoregionalism of the Escuelas Nacionales de Arte reveals, by contrast, the merely cosmopolitan desire, the Jet Age fantasy, that animated the International Style. If we could affirm a cosmoregionalist version of the Tricontinental, we would. A region is a shared lifeworld, a felt zone,

>> This is the San Francisco Americans pretend does not exist.

273. James Baldwin, *Take This Hammer*, 1963 (still). 16mm film transferred to video, black and white, sound, 45 min. Courtesy Thirteen/WNET

bounded by the hazy horizons of the cultural space that matters to you. Let's call it, for the sake of clarity, the field of desires and pleasures, interests and investments, where the cultural producer, the researcher, the curator, the anthropologist, and other professionals of culture are immersed. It may not even map to any continuous territory. It is something more diffuse, and something unmoored from any national-cultural logic. It is discontinuous with the nation and the nation-state, and it is no kind of administrative category. It is experiential and subjective, even volitional. The national is imagined and inherited. The cosmopolitan is your alibi. The regional: you adopt it, and it adopts you, by tracing a line that traverses the politico-affective promises of the national and the cosmopolitan. In the global economies of capital and culture-power, the region is not secondary, nor tertiary; it is not even part of the

center-periphery scheme. It thus escapes the grim competition between global cities and would-be global cities. It attaches the city to its hinterland. Thinking regionally, the center at hand appears inseparable from its internal or proximate peripheries, from all those relationships of inequality that lie within a lived space. Regionalist thought frames the relations of inequality within places, not only between places. And so, to San Francisco.

TAKE THIS HAMMER

"San Francisco? Oh man! I'm going to tell you about San Francisco." From its first lines, spoken by one of a number of African American men in the Bayview district of San Francisco, in the spring of 1963, *Take This Hammer* (pl. 273) sets out to

expose a falsehood—namely, that San Francisco is cosmopolitan. The film was made for KQED and National Educational Television[7] by poet and activist Richard O. Moore. With an investigative, cinema verité fervor, Moore drives James Baldwin around the city, filming as the writer interviews groups of young black men in black neighborhoods about the conditions under which they live. Baldwin visits the Fillmore, the new housing projects by the shipyards, the Booker T. Washington Hotel. He hears about the removal of African Americans to ghettos in Hunters Point, Haight-Ashbury, and South of Market. His interviewees testify to the systemic racism that limits their access to housing and jobs and shapes their relationships with city authorities. It is a film about San Francisco as a facade. Its facade—as stated at the beginning of the film—is that of a liberal and cosmopolitan city, perhaps even the most liberal and cosmopolitan city in the United States. Baldwin says, "There is no moral distance . . . between the facts of life in San Francisco and the facts of life in Birmingham." In San Francisco, he continues, it is easy to imagine that "everything was at peace . . . it certainly looks that way, you know, on the surface . . . it's easier to hide in San Francisco. . . . You've got the San Francisco legend, too, which is that it's cosmopolitan and forward-looking. But it's just another American city. It's just a somewhat better place to lie about." In the year that he toured the South for the Congress of Racial Equality, in the year of the March on Washington, Baldwin comes to San Francisco, in particular, to show that everywhere is Birmingham, everywhere is the South, even here. San Francisco is an indictment of the nation as a whole.

Evidently, it takes a cosmopolitan perspective to reveal this. Baldwin appears, in the film, very much as the mobile, worldly intellectual. He arrives, directly from the airport, to assess San Francisco according to standards acquired elsewhere. Any feeling of surprise at how Baldwin explodes the image of San Francisco hides some complicity with a still-dominant idea of how cosmopolitanism should be defined. He was no cosmonational. In his very being, his cosmopolitanism indexed a distinct form of life, a different assemblage of cities, a different road map. Baldwin's judgment of San Francisco should be understood in relation to this, to his own errant movements between Paris and New York (those twin centers of modern culture, of cosmomodernism), for example, to his detachment

from any given culture, and justifiable ambivalence toward his native land. This generates anxieties, and they course through the preface to his *Notes of a Native Son* (1955). That very title suggests some kind of montage of Richard Wright's *Native Son* (1940) and Aimé Césaire's *Cahier d'un retour au pays natal* (Notebook of a Return to the Native Land, 1939), summoning affinities between modernist aesthetics, African American struggles, and the wars of national liberation worldwide. *Take This Hammer* is just one occasion on which Baldwin searches for a level of comfort with those affinities, aims to locate himself in the complex web of detours that constitutes a decolonizing modernity.

There were other such occasions. In 1956, while he still wavered between Paris and the U.S., a year before he returned to join the civil rights movement, Baldwin attended the Congress of Black Writers and Artists at the Sorbonne, as an observer. Wright and Césaire were both there, along with many other lucid voices of the decolonizing era. Alioune Diop, co-organizer of the conference and the founder and editor of *Présence africaine*, called it a second Bandung.[8] The event anticipated the emergence of the Tricontinental. Césaire spoke of the necessity for colonized and decolonizing nations to affirm their cultural differentiation from Europe, and the audience thronged around him to shake his hand and kiss him. Baldwin recoiled in ambivalence:

> I myself felt stirred in a very strange and disagreeable way. For Césaire's case against Europe, which was watertight, was also a very easy case to make. . . . He had certainly played very skillfully on their emotions and their hopes, but he had not raised the central, tremendous question, which was, simply: What had this colonial experience made of them and what were they now to do with it? For they were all, now, whether they liked it or not, related to Europe, stained by European visions and standards. . . . He had penetrated into the heart of the great wilderness which was Europe and stolen the sacred fire. And this, which was the promise of their freedom, was also the assurance of his power.[9]

He would be a Tricontinental if he had access to the national—where *nation* stands for any substantive, affirmable political community. But he did not, partly

due to his European affinities, and partly because his native land did not afford it. You can hear him savor, unhappily, the predicament in which the U.S. delegation finds itself, disconnected from the Africans: "This is a very sad and dangerous state of affairs, for the American Negro is possibly the only man of color who can speak of the West with real authority, whose experience, painful as it is, also proves the vitality of the so transgressed Western ideals."[10] There is one scene, one exchange, in *Take This Hammer*, in which Baldwin recoils in a similar way. One of the men interviewed proposes that the answer to their predicament is the Nation of Islam. Behind the facade, Tricontinental cosmonationalism is at work, here in San Francisco, and—more than anywhere, indeed—across the Bay, in Oakland, the U.S. locus classicus of anticolonial sentiments, black nationalism, and internationalist politics during the 1960s.

Baldwin's ambivalence points to both the decaying nature of a form of cosmopolitan modernism unanchored from national feelings, the supposedly beneficent cosmopolitan ideal celebrated in contemporary culture, and the simultaneous rise of cosmonationalism that clamors, problematically, to be sure, for an assemblage of given cultures. Maybe San Francisco irritated him because it exposed the fragility of his own cosmopolitics. The Sorbonne conference saddened him because of certain rigid or closed tendencies in decolonizing and postcolonial thinking. We welcome his ambivalence. What else can we do? Perhaps Baldwin, always one to escape affective determinations, was inventing a line of flight. It perhaps even shows a way out of postcolonial obsessions with centers and peripheries, cities and provinces, as well as out of the liberal, postnational cosmopolitan pieties that continue to circulate.

1. Simone Bitton's documentary film *L'équation marocaine* (2002) presents a nuanced and complex portrait of Ben Barka.

2. Fidel Castro, "Speech at the Ceremony in Havana's Chaplin Theater Marking the Closing of the Tricontinental Conference," January 16, 1966, transcript, University of Texas at Austin, Latin American Network Information Center, Castro Speech Data Base, http://lanic.utexas.edu/project/castro/db/1966/19660216.html.

3. If one even briefly browses the magazines and journals of the Tricontinental period, it will be clear that the prefix *cosmo-* stands for a wholly transnational geography of desire and thought. Founders of the radical magazine *Souffles*, in Morocco, for instance, were passionately reading 1920s Brazilian Antropofagia poet Mário de Andrade. Che Guevara wrote his most moving essay, "Socialism and Man in Cuba" (1965) during his African episode, inspired by Frantz Fanon's *The Wretched of the Earth* (1961). The list of cosmonational correspondences between the Mediterranean, Africa, and the Americas is long.

4. In his *Spectral Nationality: Passages of Freedom from Kant to Postcolonial Literatures of Liberation* (New York: Columbia University Press, 2003), and in other writings, Pheng Cheah judiciously explores the conceptual affinities between cosmopolitanism and nationalism, arguing that the two are profoundly intertwined. They are linked via the notion (which originates with Kant) of freedom as transcendence from a given culture, as well as the very idea of culture as transcendence of the given. This politico-philosophical structure underpins, according to Cheah, many historical and contemporary cosmopolitanisms, from Marx's proletarian internationalism to the postnationalism of a certain postcolonial high-theory. It is a compelling argument. It prompts our gesture in this essay toward Tricontinental "cosmonationalism" with its nontranscendental deployment of the given culture of national culture in an internationalist historical context.

5. We wish to thank John Loomis for providing the image of the Cuban National Ballet School on page 192. For further discussion and images of Cuba's National Art Schools, see John A. Loomis, *Revolution of Forms: Cuba's National Art Schools* (1999; repr., New York: Princeton Architectural Press, 2012).

6. Harwell Hamilton Harris, from "Regionalism and Nationalism" (1954), reprinted in *Architectural Theory*, vol. 2, *An Anthology from 1871–2005*, ed. Harry Francis Mallgrave and Christina Contandriopoulos (Malden, MA: Blackwell Publishing, 2008), 288.

7. The film can be viewed online as part of San Francisco State University's Digital Information Visual Archive (DIVA), https://diva.sfsu.edu/bundles/187041.

8. At the time, the French name for this gathering (*Congrès des écrivains et artistes noirs*) was more commonly translated as "Congress of Negro Writers and Artists." The Bandung Conference, held April 18–24, 1955, in Bandung, Indonesia, was intended to promote Afro-Asian economic and cultural cooperation and to oppose colonialism. Attendees included representatives of twenty-nine Asian and African states (many of which were newly independent).

9. James Baldwin, "Princes and Powers," in *Nobody Knows My Name: More Notes of a Native Son* (1961; repr., New York: Vintage, 1993), 36–37.

10. Ibid., 19.

274. Yto Barrada, *Bricks*, 2003, printed 2011. Chromogenic print, 59⅟₁₆ × 59⅟₁₆ in. (150 × 150 cm). Courtesy the artist and Sfeir-Semler Gallery, Beirut and Hamburg

BRICS AND MORTAR: THE GLOBAL ART WORLD BETWEEN MARKETS AND MILITARISM

PAMELA M. LEE

Far from the usual stomping grounds of the global art world, those notoriously clubby havens of insiders and elites, the 798 Art Zone (colloquially known as "798") might seem to embody a distinct change in ambience—a building up and opening onto a more accessible space for art. A sprawling gallery district in the Dashanzi neighborhood of Beijing, 798 marks an obligatory stop in the lengthening itineraries of the contemporary art market. Yet this popular destination is restricted neither to the cognoscenti of collectors, dealers, curators, and their ilk, nor to the pioneering artists who colonized the district two decades earlier. These days, middle-class Beijingers flock to 798's cafés and bars; extended families might enjoy a spectacle for free; and the fashion-industry crowd routinely stages photo shoots and hosts media events. And tourists, both domestic and international, clutch their guide-books expectantly as they wend their way through the district's countless art spaces, marveling at the brave new world of artistic product on offer.

The guidebooks undoubtedly encourage this curiosity, for the history of 798 that they dutifully recite is a fable about art after 1989 and the events following that signal year: the toppling of the Berlin Wall, the demise of the Soviet Union, the opening of the Eastern Bloc, and the uprising in Tiananmen Square. And this story, in turn, inadvertently flags sociologist and political theorist Giovanni Arrighi's striking genealogy of China's "market socialism," in which the éminence grise of the free market, eighteenth-century economist Adam Smith, all but predicted the ascent of the People's Republic of China two centuries in advance.[1] Appearing to give concrete form to these ideas, 798 is a bricks-and-mortar case study in the transition from the Maoist days of old to what sociologists and pundits alike call "the post-industrial society."[2] A former electronics factory built in collaboration with East Germany in the 1950s ("798" refers to one of the central buildings), the district still bears the vestiges of its Comintern past in the galleries' bluntly industrial architecture. That a site of communist manufacture has undergone such a radical metamorphosis, emerging phoenixlike as both a touristic idyll and entertainment destination, seems to confirm the belief that the free market has laid triumphant waste to Marxist ideology, clearing the way for economies based on service and information, "experience" and "creativity."

But the reality is far more complicated. At 798 and at other international art and cultural institutions, including those represented in *Six Lines of Flight*, conditions on the ground sit uneasily with this happily-ever-after picture. The bright future suggested by commercial success is countered with a litany of traumatic histories and current realities, to which the title of this essay serves notice. Indeed, in the construction of the contemporary art world, "BRICs and Mortar" has as much to do with the entangle-ments of new markets and old militarism as it does the recently built or repurposed spaces for art in formerly underrepresented locations. Whatever the predictions made about the coming economic superpowers (Brazil, Russia, India, and China, or BRIC, although the N-11 countries could be included here as well) and their flourishing art markets, such forecasts are presaged by cataclysmic historical events, often of bellicose char-acter.[3] You could say that the precarious foundation of this new art world order—the virtual launching pad from which this exhibition's diverse practices depart—is the recent sedimentation of such events, and that the emergence of new scenes for art both responds to and is continuous with this shifting and unstable ground.

Here, 798 will function as a peculiar allegory for the other locations represented in *Six Lines of Flight*, capturing the contradictions that animate the production of art in cities as far-flung as Tangier and Cali, Cluj, Ho Chi Minh City, San Francisco, and Beirut. On my first trip to 798 in over five years, I could only be impressed by the throngs of young and old, Chinese and Western tourists, artsy and not-so-artsy, all enjoying art on a frigid November afternoon: a far cry from the rarefied habitats of New York's Chelsea or its equivalents in other art world capitals. Yet one gallery, the Mansudae Art Studio Museum, gave the

lie to this art-market utopia, its presence offering a jaundiced perspective on the dream of a globalized art world. The museum is a state-approved branch of the Mansudae Creation Company; founded in North Korea in 1959, the company fabricates art and is in effect a "group of large, departmentalized studios under the administration of various government organizations."[4] The museum is also a relentlessly dour affair, befitting its role as cultural emissary of the Democratic People's Republic of Korea (DPRK). Absent foot traffic, let alone anything resembling vanguard art, it sells postcards, stamps, and other souvenirs in its dimly lit lobby, while the main gallery features socialist-realist paintings crowded with the stock characters of a certain ideological imaginary (pl. 275). The contrast between the gallery's murky interior and the images on the walls is striking. Well-fed peasants tend plentiful harvests in scenes overflowing with wheaten abundance. Streaming ribbons, rosy-cheeked girls whirl deliriously in traditional Korean dress known as *hanbok*. There are pictures of military might of a distinct vintage, emblematized by the heroic profiles of soldiers, muscular and proud. And then there is more anodyne subject matter for sale—birds and flowers and other saccharine topics, decorously complementing the blinkered nationalism of the other works exhibited.

At first glance, it all looks very 1965, as if an aesthetic synonymous with the Cold War had been thawed out for the historical edification of contemporary viewers. Leaving aside the inconvenient realities of present-day North Korea (a fledgling arsenal of nuclear weapons, periodic bouts of famine), it would seem that the iconography of the Cultural Revolution had been repurposed for the current situation of P'yŏngyang. What has changed, though—and this is critical—is that China's big-brother status to the DPRK now extends to accommodating its debut onto the scene of contemporary art, laying out the proverbial welcome mat to the new citizenship of the global art world. Mansudae's site at 798, it turns out, is the company's only storefront venue outside its tourist-sanctioned gallery in North Korea. (Mansudae's digital presence and international profile are discussed below.) While allusions to the Cultural Revolution might seem a foregone conclusion within this regionally specific context, they need to be radically updated in light of the global market for contemporary art.

To begin, as an institution representing a closed totalitarian society—a nation whose claims to sovereignty are effectively staked on its global *invisibility*—the gallery is situated in one of the most visible destinations of the contemporary art world. Objects are sold to both Western buyers and Chinese nationals ("politically exotic kitsch" is how one journalist described the attractions of the postcards for sale),[5] and the "museum" is stationed yards away from the Pace Gallery, whose expansive Beijing outpost is as glossy and sleek as the North Korean space is grim. Contradictions scarcely end with the art and architecture, finding mercantile expression on the most banal level. To wit: What could be more fitting than the over-priced Coca-Cola being hawked in the lobby? In the spirit of the new capitalism, a gallery assistant attempted to sell a can to a friend for an eye-watering ¥45 RMB (about $7 USD).

Placing such emphasis on Mansudae might seem to run in direct opposition to the interests of *Six Lines of Flight*, an exhibition that showcases novel organizational platforms for art and collaboration in burgeoning artistic centers. Both aesthetically and ideologically, one can't help but fail to bridge the distance between Cali's Lugar a Dudas and the strong-armed propaganda machine of the Kim dynasty; the self-reflective media of the Arab Image Foundation and the *retardataire* investments of the Mansudae Creation Company. Yet I would argue that the lessons this gallery offers are not just cautionary or sensationalistic. They speak to the dark underbelly of conditions that historically made the works in this exhibition possible: that is, the ways in which contemporary art increasingly brokers the interests of politics, economics, and society. This is especially acute in both present and former communist countries, two of which (Vietnam and Romania) are represented in this show. Three of the remaining four countries have recently undergone or are currently subjected to paroxysms of civil war, insurrection, terrorism, and mass violence, suggesting that art assumes a double-edged role in these scenes, at once internalizing a country's domestic vexations while externalizing that art's global outlook and reach.

To dramatize this point, consider the following proposal: that Mansudae is itself emblematic of a global art world, as both transnational player in the market and signatory of a kind of inverted cosmopolitanism. It is an admittedly heretical idea when positioned against the received wisdom. When the phrase "global art world" appears in the mainstream art press, it typically trades on

275. Song Jae Chol, *Art Room*, 2003. Ink on paper, 59 × 37⅞ in. (150 × 96 cm). Courtesy the Mansudae Art Studio, P'yŏngyang, DPRK

connotations of visibility and prestige and is associated with the culture of biennials, auctions, and art fairs; the traveling class that flocks to such events; and the incursions that countries such as Russia, India, and China have made in cornering new segments of the art market. Although Mansudae, by literally satisfying the terms of its art market, is technically "global," it is so in ways that fail to be captured by these associations. While its storefront presence is restricted to P'yŏngyang and Beijing, its website sells works internationally, mediated not by associates in North Korea but, perhaps surprisingly, by an Italian collector.[6] That alone warrants reflection, as do the larger motivations behind making such works more widely accessible. "Selling artwork," as one critic writes on Mansudae, "has long proven one of the state's most hassle-free means of generating foreign exchange (the Euro is the preferred currency)."[7] There was a time when the underground arms trade seemed the market of choice for regimes such as that of North Korea. Today, contemporary art seems to fulfill a homologous

(if obviously demilitarized) purpose, defanged of violent consequences and with economic transactions taking place in the clear light of day.

But it is not just the Western seeker of "politically exotic kitsch" who might take advantage of this newly opened art market, nor the legions of art world speculators hoping to catch a break before prices escalate. More and more, Overseas Projects, the commercial export wing of Mansudae, has produced monumental sculptures for governments that are not troubled by international sanctions against the DPRK or by the country's treatment of its people. In addition to sculptures made for Angola, Botswana, and Namibia (the last of which represents the Namibian president brandishing an AK-47), Mansudae's most infamous sale was to Senegal for a work completed in 2010.[8] To commemorate Senegal's fifty years of independence from France, President Abdoulaye Wade commissioned the company to produce *African Renaissance* (pl. 276), a monument that, at 164 feet (fifty meters), stands higher than the Statue of Liberty. A gargantuan bronze screed depicting a father, mother, and child striding purposefully toward the future, the work, installed outside Dakar, was controversial for a number of reasons, not least of which was its exorbitant price tag, with some estimates ranging as high as $70 million USD.

Contemporary art and totalitarianism make ugly bedfellows, of course, and it bears repeating that the situation of the DPRK cannot be seamlessly mapped onto the other sites of art in this exhibition. So what might this strange narrative tell us beyond the local exigencies of P'yŏngyang and Dakar? In drawing the connection between the two cities in the production and marketing of such monuments, we travel a far more subterranean network than usual in art world conversation but detect a strategy pervasive to the general interests of contemporary culture nonetheless. We confront the ways in which art progressively brokers a country's economic interests as parallel to its political agendas—and vice versa. The scholar George Yúdice refers to such brokering relative to "the expedient" character of culture, by which he means the capacity of art to be used as a kind of resource. The materials of art—*materiel* in its militaristic formulation—will act as a vector for the increasingly itinerant flights of global capital, no matter the origin or destination.

Yúdice moves beyond traditional claims about art's instrumentalization by the market economy (claims most famously linked to the critical theory of

276. Mansudae Art Studio, *African Renaissance*, Ouakam, Senegal 2010. Bronze, 164 feet (50 meters) high. Courtesy Le monument de la Renaissance africaine, Dakar

the Frankfurt School, well known for its relentlessly dour accounts of the "Culture Industry") to describe culture as a crucial sphere of capital investment, a discussion organized around art's *performativity*, a term with both economic and aesthetic significance. "Art has completely folded into an expanded conception of culture that can solve problems, including job creation," he writes, continuing:

> Its purpose is to lend a hand in the reduction of expenditures and at the same time help maintain the level of state intervention for the stability of capitalism. . . . Culture is increasingly being invoked not only as an engine of capital development. . . . Some have even argued that culture has transformed into the very logic of contemporary capitalism. . . . This culturalization of the economy has not occurred naturally, of course; it has been carefully coordinated via agreements on trade and intellectual property, such as GATT and the WTO, laws controlling the movement of mental and manual labor (i.e., immigration laws), and so on.

In other words, the new phase of economic growth, the cultural economy, is also political economy.[9]

Yúdice's "cultural economy" stems from "the expropriation of the value of cultural and mental labor." The rapprochement between culture and community in the global era is, then, "at the crossroads of economic and social agendas." In the case of other locations of art making featured in this exhibition, the closing distance between cultural economy and political economy seems very much to the point.

It is true that students of biennial culture and large-scale exhibitions will recognize something familiar in this conceit. They will read, in the chronicles of such shows, the increasingly diplomatic function art assumes in countering the recent catastrophes of history. We need only point to one of the most famous of such exhibitions—Documenta—to illustrate the thesis.[10] It is well known that Germany's signal international art exhibition, which takes place in

Kassel every five years, was established as a means of cultural, political, and economic redress after World War II. With several munitions factories nearby, Kassel played as ignoble a role as any German city during the war (indeed, it housed a local subcamp to Dachau), and three years of Allied bombing raids would nearly obliterate the historic city center. In 1955, during the first generation of reconstruction, Documenta opened as a means to both correct and efface that history, highlighting the work of modern artists who had been vilified by National Socialism as "degenerate" just a short decade earlier.

While this model of art's palliative, ambassadorial, and ultimately economic role has been generalized elsewhere in the making of large-scale exhibitions, the tenor of such transformations changed dramatically after 1989.[11] With the globalization of the art market and its increasingly speculative interests, the speed with which such initiatives take place has accelerated, buoyed by the capital investments flooding these new markets. If 798 (and by extension the Mansudae Art Studio Museum) represents a paradigm shift in the culture of contemporary galleries, the recent history of Bucharest's Palatul Parlamentului (Palace of the Parliament) is especially suggestive for museums and other art institutions. As one of the largest civilian administrative buildings in the world, a neoclassical behemoth constructed under the brutalizing regime of Nicolae Ceaușescu, this former monument to totalitarian arrogance has, at least in part, taken on a new identity. In the west wing of the building is installed Romania's Muzeul Național de Artă Contemporană (National Museum of Contemporary Art). Established in 2004, it stands adjacent to another institution whose very interests effectively paved the way for the art museum's emergence: the Muzeul și Parcul Totalitarismlui și Realismului Socialist (Museum and Park of Totalitarianism and Socialist Realism).[12]

1. Giovanni Arrighi, *Adam Smith in Beijing: Lineages of the 21st Century* (London: Verso, 2007). The notion that Smith was a free-market advocate *avant la lettre* needs to be highly qualified, as Arrighi made clear throughout this volume.

2. The reference is to Daniel Bell, *The Coming of Post-Industrial Society: A Venture in Social Forecasting* (New York: Basic Books, 1973); also pertinent here is Francis Fukuyama, *The End of History and the Last Man* (New York: Harper Perennial, 1993).

3. BRIC was coined by Jim O'Neill of Goldman Sachs in his 2001 report "Building Better Economic Global BRICs," http://www2 .goldmansachs.com/our-thinking/brics /building-better.html. The BRIC countries were grouped together because they were seen to be at a comparable stage of emerging economic development. Among other things, O'Neill argues that the rise of such economies demands that "world policy-making forums should be re-organised and in particular, the G7 should be adjusted to incorporate BRIC representatives." N-11, which stands for Next Eleven, has recently entered into common economic parlance as well. The term, likewise introduced by Goldman Sachs, identifies eleven countries—Bangladesh, Egypt, Indonesia, Iran, Mexico, Nigeria, Pakistan, the Philippines, Turkey, South Korea, and Vietnam—as nations that might become the next centers of global economic growth in the twenty-first century.

4. Angie Baecker, "Long Live Mansudae," *Leap: The International Art Magazine of Contemporary China* 8 (April 2011), http://leapleapleap.com/2011/04/long-live -mansudae. For the best general history of Mansudae and North Korean art, see Jane Portal, *Art under Control in North Korea* (London: Reaktion Books, 2005). For more specific accounts of this work, see Rüdiger Frank, ed., *Exploring North Korean Arts* (Vienna: Verlag für Moderne Kunst, 2012). The essays in this volume accompanied a symposium held in conjunction with a controversial 2010 exhibition at MAK Museum in Vienna entitled *Flowers for Kim Il Sung: Art and Architecture from the Democratic People's Republic of Korea*.

According to an online press release for Mansudae: "The Mansudae studio is the most famous industry working for the North Korean government. It was created in 1959 and gathers over 4,000 workers, including artists. The commercial department which handles exportations is called Mansudae Overseas Project and offers a vision of North Korean art abroad." See Art Media Agency, "North Korean Contemporary Art," http://www.artmediaagency.com/en/tag /north-korean-art/.

5. Baecker, "Long Live Mansudae."

6. Art Media Agency, "North Korean Contemporary Art."

7. Baecker, "Long Live Mansudae."

8. Christina Passariello, "Monuments to Freedom Aren't Free, but North Korea Builds Cheap Ones," *Wall Street Journal* (January 28, 2010), http://online.wsj.com/article/SB1000 14240527487039062045750274004403 09756.html.

9. George Yúdice, *The Expediency of Culture: Uses of Culture in the Global Era* (Durham, NC: Duke University Press, 2003), 13.

10. On such histories, see Documenta, *50 jahre documenta, 1995–2005* (Göttingen, Germany: Steidl/Documenta, 2005).

11. For example, South Korea's Gwangju Biennial was established in response to the May 1980 uprising against the military junta of dictator Chun Doo-hwan, which led to the massacre of countless citizens. According to Yongwoo Lee, the biennial's first curator, the exhibition "has a quite different purpose compared to other biennales of the West"; it is "about probing Korea's modern history and treating its wounds." Cited in Charlotte Bydler, *The Global Artworld, Inc.: On the Globalization of Contemporary Art* (Uppsala, Sweden: Uppsala University, 2004), 13.

12. On this history, see Mariusz Czepczyński, "Post-communist Landscape Cleansing," in *Cultural Landscapes of Post-Socialist Cities: Representation of Powers and Needs* (Aldershot, England: Ashgate, 2008), 127.

277. Shanghai 2010 World Expo site under construction in January 2010, 108 days before the opening

GESTURES OF LOVE, OR *L'INSURRECTION QUI VIENT?*[1]

HOU HANRU

1

Over the past several decades contemporary art has become a genuinely global affair. The borders of the art world have expanded, and the myriad forms of expression comprising contemporary artistic practice have been widely embraced around the globe, moving far beyond established international art capitals such as Paris, London, and New York. In fact, it could be argued that much of today's most energetic and innovative artwork is being made outside the traditional art circuit. With the rapid creation of new markets in Asia, Latin America, and Africa, and with the equally rapid establishment of contemporary art organizations, festivals, and biennials in regions that were once considered "peripheral," the validity of the timeworn divide between center and periphery has become increasingly difficult to quantify. The most spectacular face of the new globalization can be found in the recent boom in museum construction throughout the non-Western world, especially in Asia, home of the new economic superpowers. In effect, a kind of unquestioned, or unquestionable, consensus about the virtue of this "museum fever" has emerged. In developing regions that wish to demonstrate their openness toward social progress, innovation, and the creation of a brighter future, the establishment of contemporary art museums is considered a necessity by the art community, the general public, and political and economic authorities.

The business sector in particular has come to value the development of cultural organizations as both a good investment and an opportunity to demonstrate a commitment to "social responsibility." We see this reflected in the construction of a cluster of "world-class" museums on Abu Dhabi's Saadiyat Island, including the Zayed National Museum as well as outposts of the Louvre and the Guggenheim. Singapore's new National Art Gallery, at close to fifteen acres in size, is scheduled to open in 2015, and Hong Kong's West Kowloon Cultural District, which boasts more than a dozen art and culture facilities, will soon be home to the world's largest contemporary art museum, M+, also projected to open in 2015. An unprecedented number of museums are currently in the planning stages or under construction across China.[2] Much of this activity—including Beijing's Today Art Museum and Shanghai's Minsheng Art Museum, Rockbund Art Museum, and Zendai Museum of Modern Art, all of which opened in the first decade of the twenty-first century—is sponsored by Chinese corporations; like their Japanese and Korean counterparts a decade ago, Chinese business groups have come to appreciate the political benefits of cultivating ambitious cultural projects. The Chinese government likewise recognizes the importance of building "soft power" through the development of art and culture. Plans for a national museum of contemporary art are underway in Beijing, and the Shanghai Contemporary Art Museum is under construction, with its opening (National Day, October 1) scheduled to coincide with that of the 9th Shanghai Biennale in 2012. Located in the converted power plant that was the site of the 2010 World Expo's Pavilion of the Future, this new museum resembles a larger version of London's Tate Modern and is part of the local government's effort to ensure that all Shanghai residents will soon have a museum or other cultural venue within a fifteen-minute walk from their homes.[3]

Most of these new museums have more or less been modeled on existing Western institutions. But such endeavors do not always translate smoothly to developing regions, where they can be undermined by inadequate planning and insufficient long-term financial support, as well as an absence of expertise and curatorial vision. Faced with such challenging circumstances, even the most enthusiastically conceived projects can be jeopardized by unforeseen crises (one thinks of the 2008 earthquake in China, where poor construction practices and shoddy building materials led to an extremely high death toll and widespread devastation). In addition, many of these projects are based on a relationship to the market system that is drawn from the entertainment industry (rather than the cultural field) and therefore

278. Arrow Factory, 38 Jianchang Hutong, Beijing, 2009. Works on view by Ken Lum (interior) and Patty Chang and Rania Ho (rooftop). Courtesy Arrow Factory

encourages the spectacularization of artistic production. Obviously, this trend has evolved hand in hand with the logic of neoliberal capitalism—evidenced in the art market's domination of both the regional and global art scenes. Increasingly, artistic and cultural projects that take a critical and emancipatory approach and attempt to resist the new oligarchy and its cultural alliances are emptied of real political substance and neutralized through the process of commodification. At the same time, the fervent embrace of iconic architecture (which often translates into museums that are oversize and extravagantly grotesque) and the inflexible replication of the conventions of Western artistic modernism (such as "white cube" gallery spaces) have a devastating tendency to undermine the most inventive and original aspects of local cultural and creative energy.

The incongruities created by structuring a contemporary art scene around an armature of outdated institutional conventions are inevitable and not limited to the East. Contemporary art is universally the product of intense negotiations between a true multitude of expressions, and it reflects a variety of singular interpretations of local contexts that are necessarily complex, improvisational, and open to continuous change. New institutional models are needed. The search for alternatives in Asia began more than a decade ago, when art institutions established in Japan and Korea revealed flaws in the prevailing system. A great number of self-organized, artist-run spaces were formed when the members of nascent contemporary art communities—known for their emphasis on artistic and social experimentation—found that their activities could not be accommodated by traditional venues. The major museums in these areas (if they existed at all) have, for one reason or another, not been effective in responding to the vital transformative impulse of

279. Yan Lei, *Locals Only*, 2009. Performance and installation at Arrow Factory, Beijing. Courtesy Arrow Factory

these smaller, more innovative grassroots efforts. As a result, many artists collectively turned away from these institutions, founding independent spaces where they manifest their creative commitment by developing various strategies of occupation. These spaces quasi systematically thrive on everyday life; they have to adapt rapidly and efficiently in the face of urban expansion and economic growth, processes that are often rife with the inherent tensions of attempting to envision a better future and the inevitable social conflicts that impede the possibility of positive change. Indeed, it is important to recognize that an almost tangible desire to be engaged socially and politically is the raison d'être for many artists in these countries to act as "contemporary" and "avant-garde" agents.

Many such efforts could be compared to what Hakim Bey identified as a Temporary Autonomous Zone (TAZ).[4] They take over the urban center and form "a certain kind of 'free enclave' resisting against the mainstream, state power structure" (here I would add big corporations, too). Their actions are "an essay ('attempt'), a suggestion, almost a poetic fancy" that encourages "uprising," or "insurrection," against state (and corporate) power; they are situated beyond all established forms of organization. According to Bey, "The TAZ is like an uprising which does not engage directly with the State, a guerrilla operation which liberates an area (of land, of time, of imagination) and then dissolves itself to re-form elsewhere/elsewhen, *before* the State can crush it." It is invisible, always shifting, "a microcosm of that 'anarchist dream' of a free culture." Moreover, the TAZ "is an encampment of guerrilla ontologists: strike and run away." It has a "temporary but actual location in time and a temporary but actual location in space. But clearly it must also have 'location' *in the Web*" In the end, "*The TAZ is somewhere*. It lies at the intersection of many forces, like some pagan power-spot at the junction of

mysterious ley-lines, visible to the adept in seemingly unrelated bits of terrain, landscape, flows of air, water, animals." It can bring about ultimate liberation "on the condition that we already know ourselves as free beings."[5] Such zones of resistance open platforms for experimental, critical, and transgressive expression in the face of chaotic and increasingly oppressive social realities. They also bring about new visions of social organization that deconstruct and even destroy the established centrality of the institutional system, proposing new forms of social production based on a continuous renegotiation of relations between independent actions and institutions, between periphery and center, between a static boundary and open space. These spaces encourage a limitless approach to creation that puts productivity and process at the very heart of the generation of culture. In other words, alternative models like TAZ present a fundamental challenge to the static institutional systems that have dominated the production and display of art.[6] They compel us to redefine the concept of the contemporary in relation to social engagement, and they manifest the real singularities of artistic production in different regions at a time when contemporary art is proliferating in new cultural centers across the world.[7]

Above all, alternative structural and cultural models make it clear that the globalization of contemporary art does not have to mean the distribution of a single institutional infrastructure or the widespread adoption of a homogenizing representational system. Instead, the art world and its networks should foster experimental processes for imagining and inventing paradigms that honor and emphasize the many possible ways of defining and constructing contemporaneity. The organization of biennials, for example, offers an ideal means of regularly testing and examining new approaches to the presentation of contemporary art. I have advocated such explorations in my own curatorial practice. As a co-curator of the 4th Gwangju Biennale in 2002[8] I worked to assemble representatives from more than twenty artist-run spaces—including Cemeti Art House in Yogyakarta, Videotage and Para/Site in Hong Kong, Borges Libreria in Guangzhou, IT Park in Taipei, Plastic Kinetic Worms in Singapore, and Pool in Seoul—with the aim of forming transregional and transcontinental connections that would create a basis for future long-term collaborations. This initiative was intended to build an independent network representing the originality and diversity of contemporary art in Asia, one that would provide a new infrastructure for truly experimental activities reflecting the various definitions of art and its social functions in different parts of the world. It aimed to reveal, rather than flatten, the differences and multiplicity that lie at the heart of the global art system. In essence, it was also a gesture toward claiming a new "glocality" in the face of the hegemonic model of the "global museum."[9]

2

During the past ten years, the contemporary art scene has experienced a major structural transformation. The market is usurping biennial culture to become the center of focus: art fairs, which emphasize sales as much as creative expression, are the new gathering points for the global art community. More and more, museums and other cultural institutions are finding themselves at the mercy of market forces, while artistic production itself increasingly resembles a commodity industry. In the case of Asia and similar emerging economic powers on the front lines of this mutation, it is particularly apparent that the status, function, and conditions of survival of independent art organizations are more threatened than ever, yet it is equally clear that they have never been more necessary as a force of critical resistance.

In this era of market dominance, the privatization of urban space and the retreat—and even disappearance—of the public sphere is a real threat that we must face. This is a matter of particular urgency for the art world. The transformation of the urban landscape—driven by aggressive gentrification and ambitious real estate development—is uprooting the very terrain for art's social engagement and contributing to the dismantling and destruction of grassroots communities that might once have stemmed the tide of rising market forces. Fostering solidarity and collaboration between art communities and the wider public is now vital to the survival of both the art world and urban society as a whole, and it is imperative that we invent new ideas and strategies for the preservation and protection of the public sphere. Independent art organizations and other grassroots activists have answered the call by creating projects and events that encourage interaction between artists and local audiences.

There is fresh momentum to reestablish public spaces where all citizens can come together and collectively reimagine society through artistic actions.

In Asia, as elsewhere, such efforts are emerging within a rapidly changing cultural landscape. Many historically significant independent organizations have shut down; others, having survived, seem to have been transformed into partially or fully commercial galleries—Guangzhou's Vitamin Creative Space and Beijing's Long March Project and Boers-Li Gallery (previously named Universal Studios) come to mind. New organizations have in turn been founded across a much wider geographic area, especially in regions once considered "secondary" to the international art circuit such as Vietnam, Cambodia, and Myanmar. Indeed, since 2005, several remarkable art projects, including Sàn Art and a little blah blah in Ho Chi Minh City, SA SA BASSAC in Phnom Penh, and New Zero Art Space in Yangon, have been formed. Like their elder "sisters" in Beijing, Guangzhou, Hong Kong, and Shanghai (China); Tokyo (Japan); Singapore (Singapore); Seoul (South Korea); Taipei (Taiwan/China); Bangkok (Thailand) and elsewhere, they have become important sites of artistic production, exhibition, and exchange, both in their home cities and beyond. Notably, education and public outreach are fundamental to many of these independent organizations (a trend that is also evident among the spaces included in *Six Lines of Flight*). For example, in 2005 Korean curator Sunjung Kim founded Samuso in a traditional residential area in Seoul, the space has organized lectures, performances, conferences, and enduring public art programs (such as Platform Seoul and City Within the City) in which international artists and others are invited to investigate the city and produce site-specific projects that reinterpret the urban environment. The fact that the space and its programs are so well integrated—from development to execution—into the local community makes Samuso a model platform for public engagement with contemporary art, broadly defined.

Civic engagement is also central to Arrow Factory (pl. 278). Based in Beijing—the new El Dorado of the art boom, where galleries flock to become profit-making ventures—this 161-square-foot (15-square-meter) space heroically rises up against the grain. Distancing itself from the purpose-built art districts on the city outskirts, Arrow Factory (which shares its name with the narrow *hutong*, or alley, where it

280. Occupy Wall Street demonstration at One Police Plaza, headquarters of the New York City Police Department, on September 30, 2011. Stan Honda/AFP/Getty Images

is located) is based in a traditional neighborhood in the oldest part of the capital. Separated from the bustle of the street by only a thin plate-glass window, the space both draws on and merges with its environment, hosting site-specific installations, exhibitions, performances, and informal gatherings that are visible to passersby twenty-four hours a day. Founded in 2008 by artists Rania Ho, Wang Wei, and Wei Weng, along with curator Pauline Yao, Arrow Factory remains committed to establishing ongoing dialogues with the local community. With minimal financing (raised both locally and internationally), the artists produce significant projects that are economical, flexible, and spontaneous as well as ephemeral, humorous, and above all critical. By recontextualizing familiar objects and responding to the immediate environment, the works presented at the space mix poetry and provocation, revealing the creative potential in the everyday.

Significantly, Arrow Factory focuses on staging participatory interactions with the hutong dwellers (who are generally from lower social classes and might not otherwise frequent art spaces). For example, artist Yan Lei installed an air conditioner in the space and gave a key to a neighbor so that he and his family could live there for a month (pl. 279). Another "special event" transformed (or reverted) the space into a bakery where neighbors could enjoy, in some cases for the first time, an espresso and Western-style cakes and pastries. These interventions achieved the ideal union of art and life by strategically adapting everyday gestures to disseminate critical messages. Through such projects, the space has gradually become a distinct focal point of energy and creative production within the social ecology of the neighborhood. In the context of the rapid privatization and gentrification that is taking place in many Chinese cities, Arrow Factory claims a space for the protection and sustenance of local customs and ways of life. Their projects demonstrate how integration with the local community can produce highly political and even metaphysical messages of resistance that filter into the subconscious of the local population, mobilizing self-emancipation while also preserving and developing natural ways of living and socializing. Above all, such actions are gestures of love. The imaginative and courageous work of Arrow Factory is like Cupid's arrow hitting the heart of a city that is so much in need of love.

3

At a time when global crises of all kinds seem to be multiplying, independent art and cultural organizations everywhere are interrogating the significance of their work and their ethical positions. As Dan S. Wang, founder of the Chicago-based experimental cultural center Mess Hall, states in an essay written for *3 Years: Arrow Factory, 2008–2011*:

> What does the necessity of Arrow Factory say about the historical vector at work, defining the parameters of political and expressive possibility, in Beijing or wherever one finds oneself? One answer is that as the structural crisis of capitalism hurtles toward bifurcation and multiple planetary systems approach collapse,

the revolutionary legacies of modernity— unrealized, defeated, or overturned—deserve reconsideration as the dreamworks of humanity. But these legacies, if they are to be useful at all in the bewildering political-cultural landscape of multiple and overlapping subject positions, incomplete emancipations, extreme wealth disparities, and uneven developments that now make up the mosaic of daily life, must be renewed outside of their historically and context-specific vocabularies. In its first three years as an organic blip on the urban texture, Arrow Factory has been this mutation chamber, where idealistic potentialities at the socially granular level can be made into signposts of the future without depending on the overdetermined language of critical theory. At Arrow Factory self-sufficiency comes into the conversation where before there was only class-consciousness, market-resistant forms get created by blue-chip artists, and the sometime focal point of a randomly surviving hutong makes its own history—of art, of Beijing, of the possible.[10]

This reading of Arrow Factory's sociopolitical context echoes Alain Badiou's description of the "localization stage," which he identifies as the prelude to "the reawakening of history" and the attendant emergence of new possibilities for the emancipation of humanity. In his recent book *Le réveil de l'histoire* (The Reawakening of History), Badiou considers the stages of revolution through the lens of the ongoing Arab Spring and the actions of Los Indignados/ Les Indignés (The Outraged) across Europe, rebellions that inspired the American Occupy movement (pl. 280).[11] Drawing a parallel between Europe's antimonarchy revolutions of 1848 and the current protests against the global financial powers (which masquerade as "democracies"), Badiou predicts the emergence of new public spheres and uprisings that will subvert the dominant system in favor of one that is truly democratic and egalitarian. A more radical call for revolution is found in Comité Invisible's *L'insurrection qui vient* (The Coming Insurrection).[12] Echoing Hakim Bey's vision and strategy for Temporary Autonomous Zones, the Comité Invisible emphasizes direct action (for example, the guerrilla-style occupation of social spaces) and the mustering of communal forces to overturn prevailing power

structures and usher in a new era of emancipatory universalism. The resonances between the efforts of Arrow Factory and other independent spaces can, and should, be recognized as parallel claims for a new world order in the international contemporary art community.

Are these acts gestures of love? Or calls to arms for the coming insurrection? The two are by no means separate. At the brink of the reawakening of history, insurrection is both the condition for, and the expression of, love.

1. *L'insurrection qui vient* (The Coming Insurrection), written by an anonymous group of contributors under the name Comité Invisible (Invisible Committee), was first published in French in 2007. Pointing to symptoms such as the financial crisis and a variety of environmental disasters in the late 2000s, it hypothesizes the imminent collapse of capitalism. The English edition, which was published in 2009, has greatly influenced the American anarchist movement. See Comité Invisible, *L'insurrection que vient* (Paris: La Fabrique éditions, 2007–9), available at http://zinelibrary.info/files/pdf_Insurrection.pdf; and The Invisible Committee, *The Coming Insurrection* (Los Angeles: Semiotext(e), 2009), also available at http://tarnac9.wordpress.com/texts/the-coming-insurrection/.

2. In 2005 the Chinese government pledged to construct "1,000 new museums by 2015, including 32 in Beijing in time for the 2008 Olympics and 100 in Shanghai before the opening of the 2010 World's Fair." See A. Craig Copetas, "China Is Racing to Get Its Art Treasures Back," *New York Times* (October 13, 2005), http://www.nytimes.com/2005/10/13/world/asia/13iht-china.html. Recent figures reported by government-controlled news agencies indicate that more than one hundred new museums are opened in China each year. See "Beijing Ranks Second in Number of Museums," *English China News Service* (October 10, 2011), http://www.ecns.cn/2011/10-10/2883.shtml.

3. "China Pavilion to be 'Art Palace'," *Time Out Shanghai*, last updated November 14, 2011, http://www.timeoutshanghai.com/features/Blog/4758/China-Pavilion-to-be-Art-Palace.html.

4. Here I am referencing my essay "Initiatives, Alternatives: Notes in a Temporary and Raw State," in *How Latitudes Become Forms: Art in a Global Age*, ed. Philippe Vergne (Minneapolis, MN: Walker Art Center, 2003), 36–39, also available at http://latitudes.walkerart.org/images/text/hanru_latitudes.pdf.

5. Throughout this paragraph, quoted material is from Hakim Bey, *T.A.Z.: The Temporary Autonomous Zone, Ontological Anarchy, Poetic Terrorism* (Brooklyn, NY: Autonomedia, anti-copyright, 1985, 1991), also available at http://hermetic.com/bey/taz_cont.html.

6. The rise of alternative organizational models in non-Western countries has begun to shape the ways Western museums position themselves internationally. One notable example is the "Museum as Hub" project that occupies the fifth floor of New York's New Museum. Under the curatorial leadership of Eungie Joo, the Hub organizes collaborations among various museums and art spaces including Townhouse Gallery (Cairo), Insa Art Space/Arko Art Center (Seoul), Museo Tamayo (Mexico City), and Van Abbemuseum (Eindhoven).

7. See note 4 above.

8. I co-curated *P_A_U_S_E*, the 4th Gwangju Biennale, with Sung Wan-kyung and Charles Esche.

9. This idea was further developed in special projects for the Second Guangzhou Triennial, *BEYOND: an extraordinary space of experimentation for modernization*, which I directed and co-curated, with Hans Ulrich Obrist and Guo Xiaoyan, between 2004 and 2006. The organizations that took part in the triennial mingled with other independent educational initiatives, settling in a postindustrial site that became a new cultural center in Guangzhou.

10. Dan S. Wang, "A Smooth Pebble in the Stream of (the) Capital," in *3 Years: Arrow Factory, 2008–2011*, ed. Rania Ho, Wang Wei, and Pauline Yao (Beijing: Arrow Factory; Berlin: Sternberg Press, 2011), 79.

11. See Alain Badiou, *Le réveil de l'histoire*, Circonstances 6 (Paris: Éditions Lignes, 2011). "Arab Spring" is the term used for the widespread demonstrations and protests against government corruption and repression that began in Tunisia on December 18, 2010, and spread across other countries in the Middle East and North Africa. The movement is known for its organizers' use of social media to galvanize support. As of February 2012, the Arab Spring has overthrown governments in Tunisia, Egypt, Libya, and Yemen, and led to uprisings and protests in numerous other countries. See Garry Blight, Sheila Pulham, and Paul Torpey, "Arab Spring: An Interactive Timeline of Middle East Protests," *The Guardian* (January 5, 2012), http://www.guardian.co.uk/world/interactive/2011/mar/22/middle-east-protest-interactive-timeline, and "The Arab Spring," Institute for War and Peace Reporting, accessed April 16, 2012, http://iwpr.net/programme/arab-spring. For more information about the European movement Los Indignados/Les Indignés, see Anne Myriam, "Bastille Square: A New Era for Civil Disobedience á la Française," Waging Nonviolence (July 15, 2011), http://wagingnonviolence.org/2011/07/bastille-square-a-new-era-for-civil-disobedience/. The movement takes its name from a pamphlet titled *Indignez-vous!* (Time for Outrage), which was published in 2010 by French diplomat and writer Stéphane Hessel.

12. See note 1 above.

Selected Readings

Compiled by Tomoro Kanamitsu

General

Appadurai, Arjun, ed. *Modernity at Large: Cultural Dimensions of Globalization*. Minneapolis: University of Minnesota Press, 1996.

Appiah, Anthony. *Cosmopolitanism: Ethics in a World of Strangers*. New York: Norton, 2006.

———. *The Ethics of Identity*. Princeton, NJ: Princeton University Press, 2005.

Augé, Marc. *Non-places: An Introduction to Supermodernity*. 2nd ed. London: Verso, 2008.

Ault, Julie, ed. *Alternative Art New York, 1965–1985: A Cultural Politics Book for the Social Text Collective*. Minneapolis: University of Minnesota Press, in collaboration with The Drawing Center, New York, 2002.

Baker, Gideon. *Politicising Ethics in International Relations: Cosmopolitanism as Hospitality*. London: Routledge, 2011.

Bernstein, Richard J. *The New Constellation: The Ethical-Political Horizons of Modernity/Postmodernity*. Cambridge, MA: MIT Press, 1992.

Bhabha, Homi K. *The Location of Culture*. London: Routledge, 1994.

———, ed. *Nation and Narration*. London: Routledge, 1990.

Boym, Svetlana. "The Off-Modern Mirror." *e-flux journal* 19 (October 2010). http://www.e-flux.com/journal/the-off-modern-mirror/.

Bydler, Charlotte. *The Global ArtWorld Inc.: On the Globalization of Contemporary Art*. Uppsala, Sweden: Uppsala University, 2004.

Camnitzer, Luis, Jane Farver, Rachel Weiss, and László Beke. *Global Conceptualism: Points of Origin, 1950s–1980s*. New York: Queens Museum of Art, 1999.

Castells, Manuel. *The Information Age: Economy, Society, and Culture*. 3 vols. Oxford, UK: Blackwell Publishers, 2000–2004.

Certeau, Michel de. *The Practice of Everyday Life*. Trans. Steven F. Rendall. Berkeley: University of California Press, 2008.

Cheah, Pheng, and Bruce Robbins, eds. *Cosmopolitics: Thinking and Feeling Beyond the Nation*. Minneapolis: University of Minnesota Press, 1998.

Chong, Doryun, and Yasmil Raymond. *Brave New Worlds*. Minneapolis, MN: Walker Art Center, 2007.

David, Catherine, and Jean-François Chevrier, eds. *Politics, Poetics: Documenta X, the Book*. Ostfildern-Ruit, Germany: Cantz, 1997.

Deleuze, Gilles, and Félix Guattari. *A Thousand Plateaus: Capitalism and Schizophrenia*, 5th ed. London: Continuum Books, 2004. First published by University of Minnesota Press.

Doherty, Claire, ed. *Situation*. London: Whitechapel Gallery; Cambridge, MA: MIT Press, 2009.

Enwezor, Okwui, ed. *Documenta 11_Platform 5*. Ostfildern-Ruit, Germany: Hatje Cantz, 2002.

Esche, Charles, Sung Wan-kyung, and Hou Hanru, eds. *Project I: P_A_U_S_E Gwangju Biennale 2002*. Kwangju: Gwangju Biennale Foundation, 2002.

Filipovic, Elena, Marieke Van Hal, and Solveig Øvstebø, eds. *The Biennial Reader: An Anthology on Large-Scale Perennial Exhibitions of Contemporary Art*. Bergen, Norway: Bergen Kunsthall; Ostfildern, Germany: Hatje Cantz, 2010.

Fisher, Jean, ed. *Global Visions: Towards a New Internationalism in the Visual Arts*. London: Kala Press in association with the Institute of International Visual Arts, 1994.

Foster, Hal. *The Return of the Real: The Avant-Garde at the End of the Century*. Cambridge, MA: MIT Press, 1996.

Gadamer, Hans-Georg. *Truth and Method*. 2nd ed. Trans. Joel Weinsheimer and Donald G. Marshall. London: Continuum International Publishing Group, 2004.

Habib, Khalil M., and Lee Trepanier, eds. *Cosmopolitanism in the Age of Globalization: Citizens without States*. Lexington: University Press of Kentucky, 2011.

Hannula, Mika. *The Politics of Small Gestures: Chances and Challenges for Contemporary Art*. Istanbul: Art-ist, 2006.

Hardt, Michael, and Antonio Negri. *Commonwealth*. Cambridge, MA: Belknap Press of Harvard University Press, 2009.

Harvey, David. *Cosmopolitanism and the Geographies of Freedom*. New York: Columbia University Press, 2009.

Hughes, John. *Lines of Flight: Reading Deleuze with Hardy, Gissing, Conrad, Woolf*. Sheffield, England: Sheffield Academic Press, 1997.

Husserl, Edmund. *Cartesian Meditations: An Introduction to Phenomenology*. Trans. Dorion Cairns. The Hague: Martinus Nijhoff, 1973.

———. *Ideas Pertaining to a Pure Phenomenology and to a Phenomenological Philosophy*. 3 vols. Trans. F. Kersten, Richard Rojcewicz, André Schuwer, Ted E. Klein, and William E. Pohl. The Hague: Martinus Nijhoff, 1982.

Joo, Eungie, and Ethan Swan. *Art Spaces Directory*. New York: New Museum, 2012.

Kester, Grant H. *The One and the Many: Contemporary Collaborative Art in a Global Context*. Durham, NC: Duke University Press, 2011.

Kim, Clara, Aram Moshayedi, and Lesley Ma, eds. Unpublished reader for the symposium "State of Independence: A Global Forum on Alternative Practice," REDCAT, Los Angeles, July 23–24, 2011.

Latour, Bruno. *Reassembling the Social: An Introduction to Actor-Network-Theory*. Oxford: Oxford University Press, 2005.

Lippard, Lucy R. *The Lure of the Local: Senses of Place in a Multicentered Society*. New York: New Press, 1997.

Lorraine, Tamsin. *Irigaray & Deleuze: Experiments in Visceral Philosophy*. Ithaca, NY: Cornell University Press, 1999.

Martin, Jean Hubert. *Magiciens de la terre*. Paris: Editions du Centre Pompidou, 1989.

Mercer, Kobena, ed. *Cosmopolitan Modernisms*. London: Institute of International Visual Arts; Cambridge, MA: MIT Press, 2005.

Merewether, Charles, ed. *The Archive: Documents of Contemporary Art*. London: Whitechapel Gallery; Cambridge, MA: MIT Press, 2006.

Merleau-Ponty, Maurice. *Phenomenology of Perception*. Trans. Colin Smith. New York and London: Routledge, 2002.

Meskimmon, Marsha. *Contemporary Art and the Cosmopolitan Imagination*. London and New York: Routledge, 2011.

Michaud, Philippe-Alain. *Aby Warburg and the Image in Motion*. Trans. Sophie Hawkes. New York: Zone Books, 2004.

Papastergiadis, Nikos. *Cosmopolitanism and Culture*. Cambridge, UK: Polity Press, 2012.

Parr, Adrian, ed. *The Deleuze Dictionary*. New York: Columbia University Press, 2005.

"Questionnaire on 'The Contemporary.'" *October* 130 (Fall 2009): 3–124.

Richard, Nelly. *Margins and Institutions: Art in Chile since 1973*. Melbourne, Australia: Art & Text, 1986.

Rogoff, Irit. *Terra Infirma: Geography's Visual Culture*. London and New York: Routledge, 2000.

Said, Edward W. *Culture and Imperialism*. New York: Vintage Books, 1994.

Smith, Terry. *What Is Contemporary Art?* Chicago: University of Chicago Press, 2009.

Smith, Terry, Okwui Enwezor, and Nancy Condee, eds. *Antinomies of Art and Culture: Modernity, Postmodernity, Contemporaneity*. Durham, NC: Duke University Press, 2008.

Soja, Edward W. *Postmodern Geographies: The Reassertion of Space in Critical Social Theory*. London and New York: Verso, 1989.

Spivak, Gayatri Chakravorty. *An Aesthetic Education in the Era of Globalization*. Cambridge, MA: Harvard University Press, 2012.

Walker Art Center. *How Latitudes Become Forms: Art in a Global Age*. Minneapolis, MN: Walker Art Center, 2003.

Weiss, Rachel, et al. *Making Art Global (Part 1): The Third Havana Biennial 1989*. London: Afterall Books; Vienna: Academy of Fine Arts Vienna; and Eindhoven, Netherlands; Van Abbemuseum, 1989.

Yúdice, George. *The Expediency of Culture: Uses of Culture in the Global Era*. Durham, NC: Duke University Press, 2003.

Beirut, Lebanon

Art Journal 66, no. 2 (Summer 2007): 8–20.

Bassil, Karl, and Akram Zaatari, eds. *Akram Zaatari: Earth of Endless Secrets*. Hamburg: Sfeir-Semler Gallery; Beirut: Beirut Art Center; and Frankfurt am Main: Portikus, 2010.

———. *Hasam el Madani: Promenades*. Beirut: Arab Image Foundation and Mind the Gap, 2006.

Bassil, Karl, Zeina Maasri, and Akram Zaatari, eds. *Mapping Sitting: On Portraiture and Photography*. Beirut: Arab Image Foundation and Mind the Gap, 2002.

Boullata, Kamal. "Modern Arab Art: The Quest and Ordeal." *Mundus Artium* 10, no. 1 (1977): 107–33.

Cotter, Suzanne, ed. *Out of Beirut*. Oxford: Modern Art Oxford, 2006.

David, Catherine, ed. *Tamáss 1: Contemporary Arab Representations—Beirut/Lebanon*. Barcelona: Fundación Antoni Tàpies, 2002.

Gumpert, Matthew, and Jalal Toufic, eds. *Thinking: The Ruin*. Istanbul, Turkey: Rezan Has Museum, 2010.

Hadjithomas, Joana, and Khalil Joreige. "OK, I'll Show You My Work." *Discourse* 24.1 (Winter 2002): 85–98.

———. "A State of Latency." In *Iconoclash: Beyond the Image Wars in Science, Religion, and Art*, edited by Bruno Latour and Peter Weibel, 242–74. Karlsruhe, Germany: Zentrum für Kunst und Medientechnologie; Cambridge, MA: MIT Press, 2002.

Haus der Kulturen der Welt. *DisORIENTation: Contemporary Arab Artists from the Middle East: Literature, Film, Performance, Music, Theatre, Visual Arts = Zeitgenössische arabische Künstler aus dem Nahen Osten*. Berlin: Haus der Kulturen der Welt, 2003.

Joreige, Lamia. *Ici et peut-être ailleurs / Hier, und vielleicht anderswo*. Berlin: Haus der Kulturen der Welt, 2003.

———. "Notes on *3 Triptychs*." *Afterall/Online*, February 23, 2010. http://www.afterall.org/online/notes.on3.triptychs.

———. "Object Lessons" *Artforum* 45, no. 2 (October 2006): 241.

Kassir, Samir. *Beirut*. Trans. M. B. Debevoise. Berkeley: University of California Press, 2010.

LeFeuvre, Lisa, and Akram Zaatari, eds. *Hashem el Madani: Studio Practices*. Beirut: Arab Image Foundation, Mind the Gap, and The Photographers' Gallery, 2004.

Tohmé, Christine, and Mona Abu Rayyan, eds. *Home Works: A Forum on Cultural Practices in the Region*. Beirut: Lebanese Association for Plastic Arts, Ashkal Alwan, 2002.

Toufic, Jalal. *Forthcoming*. Berkeley, CA: Atelos, 2000.

———. *The Withdrawal of Tradition Past a Surpassing Disaster*. Forthcoming Books, 2009, http://www.jalaltoufic.com/downloads/Jalal_Toufic,_The_Withdrawal_of_Tradition_Past_a_Surpassing_Disaster.pdf.

Wright, Stephen. "Tel un espion dans l'époque qui naît: la situation de l'artiste à Beyrouth aujourd'hui" [Like a Spy in a Nascent Era: On the Situation of the Artist in Beirut Today]. *Parachute* 108 (October–December 2002): 12–31.

Zaatari, Akram. *Another Resolution*. Beirut: Mind the Gap, 1998.

———. *Portraits du Caire: Van Leo, Armand, Alban*. Arles, France: Actes Sud, 1999.

———. *The Vehicle: Picturing Moments of Transition in a Modernizing Society*. Beirut: Arab Image Foundation and Mind the Gap, 1999.

Cali, Colombia

Caicedo, Andrés, Luis Ospina, and Ramiro Arbeláez, eds. *Ojo al cine*. Cali, Colombia, 1974–76.

Elena, Alberto, and Marina Díaz López, eds. *The Cinema of Latin America*. London: Wallflower Press, 2003.

Faguet, Michèle. "*Pornomiseria*: Or How *Not* to Make a Documentary Film." *Afterall* 21 (Summer 2009). http://www.afterall.org/journal/issue.21/pornomiseria.or.how.not.make.documentary.film.

Franco, Fernell. *Fernell Franco: Amarrados [BOUND]*. New York: Americas Society, 2009.

Giraldo, José Tomás. "Lugar a Dudas." *BOMB* 110 (Winter 2010): 44–45.

González, Fernán E., and Sebastián López, eds. *Guerra y pá: Simposio sobre la situación social, política y artística en Colombia* [War and Peace: Symposium on the Social, Political, and Artistic Situation in Colombia]. Zurich: Daros-Latinamerica, 2006.

González, Miguel. *Cali: visiones y miradas*. Cali, Colombia: Impresora Feriva, 2007.

———. *Colombia: visiones y miradas*. Cali, Colombia: Impresora Feriva, 2010.

Guillermoprieto, Alma. *Looking for History: Dispatches from Latin America*. New York: Vintage Books, 2002.

Helena Producciones. *Festival de Performance de Cali-Colombia*. Cali, Colombia: Helena Producciones, 2006.

Herzog, Hans-Michael. *Cantos cuentos colombianos: Arte Colombiano contemporaneó*. Zurich: Daros-Latinamerica; Ostfildern, Germany: Hatje Cantz, 2004.

Humberto, Junca. "Sin Lugar a Dudas." *Arcadia* 17 (February 2007): 13.

King, John. *Magical Reels: A History of Cinema in Latin America*. London and New York: Verso, 1990.

Mayolo, Carlos. *La vida de mi cine y mi televisión*. Bogotá: Villegas Editores, 2008.

Ministerio de Cultura, Universidad de los Andes. *Ensayos sobre arte contemporáneo en Colombia, 2008–2009: Premio nacional de crítica: quinta versión*. Bogotá: Universidad de los Andes, 2009.

Muñoz, Oscar, et al. *Documentos de la amnesia*. Badajoz, Spain: Museo Extremeño e Iberoamericano de Arte Contemporáneo, 2009.

Navarro, Alberto. "Entrevista con Luis Ospina." *Cinemateca* 1 (1977): 24.

Ospina, Luis. *Palabras al viento: Mis sobras completas*. Bogotá: Editora Aguilar, 2007.

Pérez, Daniela, and Ana Paula Cohen. *Crónicas de la ausencia: Oscar Muñoz y Rosângela Rennó*. Mexico City: Fundación Olga y Rufino Tamayo, 2009.

Philadelphia Museum of Art. *Philagrafika 2010: The Graphic Unconscious—Works by Oscar Muñoz and Tabaimo*. Philadelphia: Philadelphia Museum of Art, 2010.

Roca, José. *Oscar Muñoz: Protografías*. Bogotá: Museo de Arte del Banco de la República, 2011.

Solanas, Fernando E., and Octavio Getino. *Cine, cultura y descolonización*. Mexico City: Siglo XXI Editores, 1978.

Taussig, Michael T. *The Devil and Commodity Fetishism in South America*. Chapel Hill: University of North Carolina Press, 1980.

———. *My Cocaine Museum*. Chicago: University of Chicago Press, 2004.

Cluj-Napoca, Romania

Badovinac, Zdenka, ed. *Body and the East: From the 1960s to the Present*. Cambridge, MA: MIT Press, 1999.

Boia, Lucian. *History and Myth in Romanian Consciousness*. Budapest: Central European University Press, 2001.

———. *Romania: Borderland of Europe*. London: Reaktion Books, 2001.

Codrescu, Andrei. *The Disappearance of the Outside: A Manifesto for Escape*. Reading, MA: Addison-Wesley, 1990.

Ghenie, Adrian, Martin Coomer, and Juerg M. Judin. *Adrian Ghenie: Shadow of a Daydream*. London: Haunch of Venison, 2007.

Grigorescu, Dan. *From Poison to Coca-Cola: Notes on the Twilight of Postmodernism*. Bucharest: Editura Minerva, 1994.

———. *Idea and Sensitivity: Trends and Tendencies of Romanian Contemporary Art*. Bucharest: Meridiane Publishing, 1998.

Hoptman, Laura, and Tomáš Pospiszyl. *Primary Documents: A Sourcebook for Eastern and Central European Art since the 1950s*. Cambridge, MA: MIT Press, 2002.

Judin, Juerg M., ed. *Adrian Ghenie*. Ostfildern, Germany: Hatje Cantz, 2009.

Man, Victor. *Victor Man*. Ed. Alessandro Rabottini. Zurich: JRP/Ringier, 2009.

———. *Victor Man: Attebasile*. Ed. Nigel Prince and Chiara Parisi. Birmingham, UK: Ikon Gallery, 2008.

Mircan, Mihnea, ed. *Ciprian Mureşan*. Berlin, Germany; Cluj, Romania: Plan B, 2009.

Morton, Tom. "Shape Shifter." *Frieze* 119 (November–December 2008): 160–65.

Neal, Jane. "The New Roman(ian) Order." *Modern Painters* (September 2009): 54–61.

Niculescu, Alexandru, and Adrian Bojenoiu, eds. *Romanian Cultural Resolution: Contemporary Romanian Art*. Ostfildern, Germany: Hatje Cantz, 2011.

Pejić, Bojana, and David Elliott, eds. *After the Wall: Art and Culture in Post-Communist Europe*. Stockholm: Moderna Museet, 1999.

Petresin, Natasa, and Christine Macel, eds. *Promises of the Past: A Discontinuous History of Art in Former Eastern Europe*. Zurich: JRP/Ringier; Paris: Centre Pompidou, 2010.

Pop, Mihai, ed. *Colectia Mircea Pinte Cluj* [Mircea Pinte Collection Cluj]. Berlin, Germany, and Cluj, Romania: Plan B and the Museum of Art Cluj-Napoca, 2010.

Sandqvist, Tom. *Dada East: The Romanians of Cabaret Voltaire*. Cambridge, MA: MIT Press, 2006.

Serban, Alina, and Mirela Duculescu, eds. *The Seductiveness of the Interval: Stefan Constantinescu, Andrea Faciu, Ciprian Mureşan*. Stockholm: Romanian Cultural Institute of Stockholm, 2009.

Soros Center for Contemporary Art. *Experiment in Romanian Art since 1960*. Bucharest: Soros Center for Contemporary Art, 1997.

subREAL: Art History Archive: Romanian Pavillion—La biennale di Venezia 1999. Bucharest: Romanian Ministry of Culture, 1999.

Unwin, Richard. "City Report: Cluj." *Frieze blog*, January 3, 2010. http://blog.frieze.com/cluj/.

Ho Chi Minh City, Vietnam

"Alternative Spaces, Mainstream Problems." *Thanh Nien News*, December 23, 2011. http://www.thanhniennews.com/2010/pages/20111223-alternate-spaces--mainstream-problems.aspx.

Butt, Zoe. "Artists as Engineers in Vietnam." *Dispatch, Independent Curators International*, April 1, 2010. http://curatorsintl.org/journal/the_pilgrimage_of_inspiration_-_artists_as_engineers_in_vietnam.

———. "Scratching the Walls of Memory." In *Scratching the Walls of Memory*. New York: Tyler Rollins Fine Art, 2010. http://trfineart.com/pdfs/reviews/0000/0218/Essay_by_Zoe_Butt.pdf.

Ciric, Biljana. "Searching for Tomorrow's Alternative China, Vietnam, and Cambodia." In *Playing by the Rules: Alternative Thinking/Alternative Spaces*, edited by Steven Rand, 47–59. New York: Apex Art, 2010.

Furuichi, Yasuko, ed. *Art Guide to Asia: Cambodia, Laos, Myanmar, Thailand, Vietnam*. Tokyo: Japan Foundation, 2009.

Hajdu, Sue. "Saigon Open City." *Contemporary Visual Arts+Culture: Broadsheet* 36, no. 1 (March 2007). http://www.suehajdu.com/pdf/saigon_open_city-suehajdu.pdf.

Lê, Dinh Q. *Dinh Q. Lê: From Vietnam to Hollywood*. Ed. Christopher Miles and Moira Roth. Seattle, WA: Marquand Books, 2003.

———. *A Tapestry of Memories: The Art of Dinh Q. Lê*. Ed. Stefano Catalani. Bellevue, WA: Bellevue Arts Museum, 2007.

———. *Vietnam: Destination for the New Millennium: The Art of Dinh Q. Lê*. Ed. Deanna Lee. New York: Asia Society, 2005.

Lê, Viêt. "All Work, All Play: Of Workers and Cosplayers, or, POP-aganda: The Art of Tiffany Chung." In *PLAY*. New York: Tyler Rollins Fine Art, 2009.

Sherman Contemporary Art Foundation. *Dinh Q. Lê: Erasure*. Paddington, New South Wales: Sherman Contemporary Art Foundation, 2011.

Streitmatter-Tran, Richard. "Mapping the Mekong." In *The 6th Asia Pacific Triennial of Contemporary Art*, edited by Nicholas Bonner, 120–23. South Brisbane: Queensland Art Gallery, 2009.

———. "Phases and Conditions for Contemporary Art Production in Vietnam Post-*Doi Moi*: Vietnamese Art after the 1990s." In *Essays on Modern and Contemporary Vietnamese Art*, edited by Sarah Lee and Nguyen Nhu Huy, 94–102. Singapore: Singapore Art Museum, 2009.

Tai, Hue-Tam Ho, ed. *The Country of Memory: Remaking the Past in Late Socialist Vietnam*. Berkeley: University of California Press, 2001.

Taylor, Nora A. "Whose Art Are We Studying? Writing Vietnamese Art History from Colonialism to the Present." In *Studies in Southeast Asian Art: Essays in Honor of Stanley J. O'Connor*, edited by Nora A. Taylor, 143–57. Ithaca, NY: Cornell University, Southeast Asia Program Publications, 2000.

———. "Why Have There Been No Great Vietnamese Artists?" *Michigan Quarterly Review* XLIV, no. 1 (Winter 2005). http://quod.lib.umich.edu/cgi/t/text /text-idx?cc=mqr;c=mqr;c=mqrarchive;idno =act2080.0044.123;rgn=main;view=text ;xc=1;g=mqrg.

San Francisco, USA

Anker, Steve, Kathy Geritz, and Steve Seid, eds. *Radical Light: Alternative Film & Video in the San Francisco Bay Area, 1945–2000*. Berkeley: University of California Press, 2010.

Barbrook, Richard, and Andy Cameron. "The Californian Ideology." *Mute* 1, no. 3 (1995). http://www.hrc.wmin.ac.uk/theory -californianideology-main.html.

Blake, Nayland. *Bay Area Conceptualism: Two Generations*. Buffalo, NY: Hallwalls, 1992.

Boal, Iain, Janferie Stone, Michael Watts, and Cal Winslow. *West of Eden: Communes and Utopia in Northern California*. Oakland, CA: PM Press, 2012.

Foley, Suzanne, and Constance Lewallen. *Space, Time, Sound: Conceptual Art in the San Francisco Bay Area, the 1970s*. San Francisco: San Francisco Museum of Modern Art, 1981.

Franceschini, Amy, and Mike Davis. *Victory Gardens 2007+*. San Francisco: Gallery 16 Editions, 2008.

Franceschini, Amy, and Myriel Milicevi. *Beneath the Pavement: A Garden*. London: Radar, 2011. http://www.futurefarmers.com /beneaththepavement/beneath_web.pdf.

Franceschini, Amy, and Daniel Tucker. *Farm Together Now: A Portrait of People, Places, and Ideas for a New Food Movement*. San Francisco: Chronicle Books, 2010.

Helfand, Glen. "The Mission School." *San Francisco Bay Guardian*, April 10–16, 2002.

Johnstone, Mark, and Leslie Aboud Holzman. *Epicenter: San Francisco Bay Area Art Now*. San Francisco: Chronicle Books, 2002.

Jones, Caroline A. *Bay Area Figurative Art, 1950–1965*. San Francisco: San Francisco Museum of Modern Art, 1990.

Pritikin, Renny. "Artists Who've Left Town." *Open Space*, SFMOMA Blog, February 9, 2010. http://blog.sfmoma.org/2010/02 /artists-whove-left-town/.

Pritikin, Renny, René de Guzman, and Arnold Kemp, eds. *Bay Area Now: A Regional Survey of Contemporary Art*. San Francisco: Center for the Arts, Yerba Buena Gardens, 1997.

Roszak, Theodore. *From Satori to Silicon Valley: San Francisco and the American Counterculture*. San Francisco: Don't Call It Frisco Press, 1986.

Royer Scholz, Zachary. "San Francisco and the Art World of Tomorrow." Parts 1–3. *Art Practical*, 2011. All three articles are available at http://www.artpractical.com /contributor/zachary_royer_scholz/.

Solnit, Rebecca, and Susan Schwartzenberg. *Hollow City: The Siege of San Francisco and the Crisis of American Urbanism*. London: Verso, 2000.

Tangier, Morocco

Barrada, Yto. "Iris Tingitana Project." In *Think with the Senses, Feel with the Mind: Art in the Present Tense* (52nd Venice Biennale), edited by Robert Storr, 26. Oxford: Windsor Books, 2007.

———. *A Life Full of Holes: The Strait Project*. London: Autograph ABP, 2005.

———. *Palm Project*. Artist's edition. Rabat, Morocco: Yto Barrada, 2009.

———. *Riffs*. Ostfildern, Germany: Hatje Cantz, 2011.

Barrada, Yto, and Charlotte Collins. "Morocco Unbound: An Interview with Yto Barrada." *Open Democracy*, May 16, 2006. http:// www.opendemocracy.net/arts-photography/ barrada_3551.jsp.

Burroughs, William S. *Interzone*. Ed. James Grauerholz. New York: Penguin Books, 1990.

Daki, Aziz, and Kay Wilson, eds. *Installations: Seven International Artists with Roots in Morocco*. Grinnell, IA: Faulconer Gallery, Grinnell College, 2008.

Demos, T. J. "Life Full of Holes." *Grey Room* 24 (Summer 2006): 72–87.

Downey, Anthony, and Lina Lazaar, eds. *The Future of a Promise* (54th Venice Biennale). Tunis, Tunisia: Ibraaz Publishing, 2011.

Edwards, Brian T. *Morocco Bound: Disorienting America's Maghreb, from Casablanca to the Marrakech Express*. Durham, NC: Duke University Press, 2005.

Karroum, Abdellah. "The Time of Plastic for 'Ripped Shoes': The '60s in Morocco." *L'appartement 22*, November 26, 2010. http://appartement22.com/spip .php?article292.

———. "Yto Barrada: A Modest Proposal." *Nafas Art Magazine* (February 2010). http://universes-in-universe.org/eng/nafas /articles/2010/yto_barrada.

Orlando, Valérie. *Screening Morocco: Contemporary Film in a Changing Society*. Athens: Ohio University Press, 2011.

Pieprzak, Katarzyna. *Imagined Museums: Art and Modernity in Postcolonial Morocco*. Minneapolis: University of Minnesota Press, 2010.

Powers, Holiday. "Yto Barrada: Tangier's Changing Cosmopolitanisms." *Nka: Journal of Contemporary African Art* (Spring 2011): 130–39.

Salti, Rasha. "Sleepers, Magicians, Smugglers: Yto Barrada and the Other Archive of the Strait." *Afterall* 16 (Autumn/Winter 2007): 99–106.

Tazi, Nadia. "The State of the Straits." *Afterall* 16 (Autumn/Winter 2007): 91–98.

Acknowledgments

This exhibition received instrumental early support through a generous curatorial fellowship from The Andy Warhol Foundation for the Visual Arts. Their confidence in the project from its outset enabled me to conduct the necessary research for such an ambitious undertaking. I extend profound gratitude to Joel Wachs, Pamela Clapp, Rachel Bers, James Bewley, and the entire board of the Foundation. I am particularly grateful for the encouragement and advocacy that Gary Garrels, SFMOMA's Elise S. Haas Senior Curator of Painting and Sculpture, proffered throughout the process of developing this exhibition, from inception to installation; his abiding support has enabled this project to develop to its fullest potential. SFMOMA Director Neal Benezra and Ruth Berson, Deputy Museum Director, Curatorial Affairs, further paved the way for the realization of *Six Lines of Flight*. I am deeply thankful to Neal for embracing the adventurous, global spirit of this endeavor.

While conducting research and traveling throughout the various regions included in the project, I had conversations with many individuals, each of whom has informed and shaped my understanding of the unique contexts and histories of these locales. I am enormously grateful for the kind assistance, discourse, and hospitality offered by the following people during my visits. *For Colombia*: Andres Sandoval Alba, Víctor Albarracín, Felipe Arturo, Carlos Bonil, Camilla Botero, Johanna Calle, María del Carmen Carrión, Catalina Casas, Nicolás Consuegra, Wilson Díaz, Danilo Dueñas, Tony Evanko, Jaime Avila Ferrer, Miguel González, Elias Haim, Helena Producciones, José Antonio Suárez Londoño, María Wills Londoño, Beatriz López, Mateo López, Ana Mejía Mac Master, José Horacio Martínez, Víctor A. Muñoz Martínez, Susanna Mejia, Juan Melo, Ana María Millán, Sally Mizrachi, Delcy Morelos, Luis Mosquera, Carlos Motta, Oscar Muñoz, Bernardo Ortiz, Rafael Ortiz, Luis Ospina, Mónica Páez, Nicolás Paris, Libia Posada, Camilo Restrepo, José Roca, Victor Manuel Rodríguez, Miguel Ángel Rojas, Doris Salcedo, Rosemberg Sandoval, Claudia Patricia Sarria-Macías, Gabriel Sierra, Taller 7, Carlos Uribe, Conrado Uribe, Jairo Valenzuela, Lucas Ospina Villalba, and Icaro Zorbar. *For Lebanon*: Zeina Arida, Tarek Atoui, George Awde, Saleh Barakat, Tony Chakar, Carla Chammas, Dolly Chammas, Peter Currie, Sandra Dagher, Pascal Hachem, Joana Hadjithomas and Khalil Joreige, Lamia Joreige, Jared McCormick, Rabih Mroué, Joanne Nucho, Haig Papazian, Walid Sadek, Lina Saneh, Andrée Sfeir-Semler, Hamed Sinno, Christine Tohmé, Graziella and Jalal Toufic, and Akram Zaatari. *For Morocco*: Mustapha Akrim, Cyriac Auriol, Yto Barrada, Abdellah Karroum, Faouzi Laatiris, Younès Rahmoun, Batoul S'Himi, and Katharina Wulff. *For Romania*: Dan Acostioaei, Liliana Basarab, Matei Bejenaru, Marius Bercea, Adrian Bojenoiu, Geta Brătescu, Tudor Bratu, Mircea Cantor, Radu Comșa, Alexandra Croitoru, Adrian Ghenie, Catalin Gheorghe, Mihai Iepure-Górski, Marian Ivan, Victor Man, Mihnea Mircan, Alex Mirutziu, Sebastian Moldovan, Ciprian Mureșan, Șerban Nacu, Vlad Nancă, Jane Neal, Mihai Nicodim, Mircea Nicolae, Alexandru Niculescu, Livia Pancu, Dan Perjovschi, Daria D. Pervain, Mihai Pop, Cristian Rusu, Șerban Savu, Florin Tudor, Gabriela Vanga, and Raluca Voinea. *For Vietnam*: Phong Bui, Zoe Butt, Hoang Duong Cam, Tiffany Chung, Robert Cianchi, Nguyen Thi Chau Giang, Bùi Công Khánh, Dinh Q. Lê, Sandrine Llouquet, Matt Lucero, Tammy Nguyen, Tuan Andrew Nguyen, Quynh Pham, Phunam, Rich Streitmatter-Tran, Post Vidai, and Tomas Vu-Daniel.

From August 29 to September 1, 2011, some of the artists in the exhibition and members of the San Francisco art community gathered at SFMOMA for a series of conversations. I thank the following individuals for their intelligent and probing presentations and comments: Joseph del Pesco, Amy Franceschini, Adrian Ghenie, Hou Hanru, Lamia Joreige, Pamela M. Lee, Sally Mizrachi, Oscar Muñoz, Tuan Andrew Nguyen, Mihai Pop, Rick Prelinger, Renny Pritikin, Ted Purves, Moira Roth, Blake Stimson, Michael Swaine, and Akram Zaatari. I extend thanks to my colleagues in Education and Public Programs, who helped to conceptualize and organize these events: Gina Basso, Megan Brian, Stella Lochman, Frank Smigiel, Suzanne Stein, and in particular my co-host for the various events, Dominic Willsdon. In the Painting and Sculpture Department, Nadiah Fellah coordinated the travel for many of the artists. Additionally, the Kadist

Art Foundation, San Francisco, hosted a reception for the artists, and Dolly and George Chammas were warm dinner hosts.

Throughout the process of organizing this project I have depended upon the capable staff at many galleries, including the Andreiana Mihail Gallery, Bucharest; Blum & Poe, Los Angeles; Casas Riegner Galería, Bogotá; La Central, Bogotá; CRG Gallery, New York; David Nolan Gallery, New York; La Fábrica Galería, Madrid; Gladstone Gallery, New York; Jenny Villa Galería, Cali; Marian Ivan, Bucharest; Mihai Nicodim Gallery, Los Angeles; Galerie Mor • Charpentier, Paris; Plan B, Cluj/Berlin; Galerie Quynh, Ho Chi Minh City; Sfeir-Semler Gallery, Beirut and Hamburg; Shoshana Wayne Gallery, Los Angeles; Sicardi Gallery, Houston; Tyler Rollins Fine Art, New York; and Valenzuela Klenner Galería, Bogotá. In addition, the staff and members of the many organizations and collectives involved in the project helped gather images and information. I thank the Arab Image Foundation, Beirut Art Center, Cinémathèque de Tanger, Fabrica de Pensule (The Paintbrush Factory), Futurefarmers, Helena Producciones, Lugar a Dudas, The Propeller Group, and Sàn Art.

I extend deep gratitude to the catalogue's many contributors; their insightful texts amplify our knowledge of the myriad cities, artists, and themes addressed in this project. For being thoughtful interlocutors throughout the research and organizational process, I thank Zoe Butt, María del Carmen Carrión, Emma Chubb, Joseph del Pesco, Brian Droitcour, Tarek Elhaik, Michèle Faguet, Hou Hanru, Tomoko Kanamitsu, Abdellah Karroum, Pamela M. Lee, Catalina Lozano, Mihnea Mircan, Christian Nagler, Sarah A. Rogers, James M. Thomas, Xiaoyu Weng, and Dominic Willsdon.

The richness and precision of the catalogue is largely due to SFMOMA's Publications Department. Chad Coerver, who oversees Publications, contributed insight and character to the project. My profound thanks go to Amanda Glesmann, who brought herculean organizational skills, expertise, and an indefatigable good spirit to every step of the book's production. I salute her professionalism, thoroughness, and acumen. Jennifer Boynton's careful and adept editorial eyes were similarly indelible assets. The dynamic and powerful design of the catalogue was created by Dan McKinley, under the guidance of Jennifer Sonderby. I thank Dan for his patience and perfectionism. Brett MacFadden and Scott Thorpe of MacFadden & Thorpe designed the maps that divide each section of the book. I was honored to become reacquainted with Kari Dahlgren, who joined forces with us as the sponsoring editor for our copublishing partnership with University of California Press. I owe special thanks to Tomoko Kanamitsu, whose invaluable administrative support as project intern shaped both the catalogue and exhibition in numerous ways. Her cheerful, productive demeanor was a godsend. I also benefited from the organizational efforts of several other capable interns throughout the process, including Sarah Bonnickson, Alex Fialho, Simone Krug, and in particular Fabian Levya-Barragan, who generously translated many emails to and from Spanish and English.

I deeply appreciate the true collaborative spirit and ambitious public programming organized in conjunction with *Six Lines of Flight* by my SFMOMA colleagues. In Education and Public Programs, Willsdon and Smigiel and their team produced a week-long festival, and Peter Samis and Erica Gangsei helped to engineer engaging interpretive media interviews. Tim Svenonius, Morgan Levey, Dana Mitroff Silvers, Andrew Delaney, and Bridget Carberry assisted with the production of exhibition-related videos and web content. Emily Lewis in the Exhibitions Department oversaw the exhibition logistics, with the assistance of Sarah Choi. In the Development Department thanks are due to Jonathan Peterson, Jennifer Mewha, and in particular to Andrea Morgan and Misty Youmans. Olga Charyshyn adeptly handled the often challenging transport of works of art to and from far-off locations around the globe. Greg Wilson and Theresa Brown framed many of the photographs and works on paper, and conservators Theresa Andrews, Michelle Barger, Paula De Cristofaro, and Amanda Johnson provided attentive care, with the assistance of James Gouldthorpe. Susan Backman and Doug Kerr offered invaluable assistance

with coordinating photography and providing access to onsite artworks during color proofing for the catalogue. As always, Kent Roberts and Brandon Larson and their team expertly managed the installation, and particular thanks are due to Joshua Churchill, Steve Dye, John Holland, and Collin McKelvey. I thank Christine Choi, Juliet Clark, Peter Denny, Willa Koerner, Lisa Macabasco, Katie Tamony, Stacey Silver, and Wynter Martinez, who under the direction of Robert Lasher, Deputy Museum Director, External Relations, brought this project to the attention of the public through media and marketing efforts. Anne Bast Davis assisted in securing copyright and image permissions. In the MuseumStore, thanks are due to Annie Conde, Jana Machin, and Tobey Martin. The Trust for Mutual Understanding generously provided travel funding for the Romanian artists in the exhibition.

The project has benefited in various ways from the feedback and involvement of the following colleagues and friends: Rabih Alammedine, Omar Berrada, Page Bertelsen, Janet Bishop, Natasha Boas, Maureen Boland, Cecilia Brunson, Julia Bryan-Wilson, Daniel Byers, Paula Duràn, Vincent Fecteau, Jennifer Dunlop Fletcher, Rudolf Frieling, Juan A. Gaitán, Cesar Garcia, Alison Gass, Kathy Geritz, Abigail Heald, Glen Helfand, Jens Hoffmann, Jordan Kantor, Geoff Kaplan, Ali Kashani, Corey Keller, Tina Kukielski, Aaron Levy, Trevor Paglen, Sandra S. Phillips, Carolina Ponce de Léon, R. H. Quaytman, María Inés Rodríguez, Marisa Sánchez, Debra Singer, Lisa Sutcliffe, Elizabeth Thomas, Nato Thompson, and Austin Zeiderman. I thank Lawrence Rinder, Lucinda Barnes, and my new colleagues at the Berkeley Art Museum and Pacific Film Archive for generously allowing me to finish my duties at SFMOMA before joining them on the eastern shores of the Bay.

I reserve my fullest thanks for the artists who participated in this exhibition. Their thoughtful work and collaborative nature have broadened my own thinking. Through their ambitious endeavors, they expand the ground on which to reflect on the nature and composition of our ever-shifting yet interconnected environment. I salute them for their generosity, critical approach, determination, and exceptional vision, all of which inspire a rich engagement with and understanding of our increasingly complex human experience.

—Apsara DiQuinzio

Contributors

Zoe Butt is executive director and curator for Sàn Art, an independent, artist-initiated gallery space and reading room in Ho Chi Minh City (www.san-art.org). Previously she was director of international programs at Long March Project, a multiplatform, international artist organization and arts project based in Beijing. From 2001 to 2007, she was assistant curator of contemporary Asian art at the Queensland Gallery of Modern Art, Brisbane. For more than ten years she has organized exhibitions and contributed to publications devoted to contemporary Asian art.

María del Carmen Carrión, a curator and art critic based in Quito, Ecuador, holds an MA from the Curatorial Practice program at California College of the Arts, San Francisco, and currently teaches at the Universidad Católica, Quito. She cofounded Constructo, an international collective platform devoted to the research and debate of art and visual culture. Since 2009 she has been a member of the curatorial college of ceroinspiración, an exhibition and residency space in Quito. Carrión was associate curator at New Langton Arts, San Francisco, and research coordinator at Quito's Museo de la Ciudad.

Joseph del Pesco is an independent curator and art journalist. He is currently the program director of the Kadist Art Foundation in San Francisco, and he previously worked as a curator for Artists Space in New York. He has curated exhibitions at Yerba Buena Center for the Arts, San Francisco; Galerie Analix, Geneva; the Rooseum, Malmö; Articule, Montreal; the Banff Centre, Alberta; and the Nelson Gallery at the University of California, Davis. He has contributed interviews, reviews, and other texts to *Flash Art International*, *X-TRA*, *Proximity*, *Fillip*, and *Nuke Magazine*.

Apsara DiQuinzio is curator of modern and contemporary art and Phyllis C. Wattis MATRIX curator at the Berkeley Art Museum and Pacific Film Archive. Formerly, she was assistant curator of painting and sculpture at the San Francisco Museum of Modern Art, where she organized solo exhibitions with Vincent Fecteau, Mai-Thu Perret, R. H. Quaytman,

Felix Schramm, Paul Sietsema, and Katharina Wulff as part of the *New Work* series. While at SFMOMA she also organized *The Air We Breathe: Artists and Poets Reflect on Marriage Equality*; *Abstract Rhythms: Paul Klee and Devendra Banhart*; and the 2010 and 2008 SECA Art Award exhibitions. Her research for this project is supported by a spring 2010 curatorial fellowship from The Andy Warhol Foundation for the Visual Arts.

Brian Droitcour has contributed to *Artforum* and was a curatorial fellow and staff writer for Rhizome at the New Museum in New York. He spent five years in Moscow as a translator, editor, and writer for several publications, including *The Moscow Times* and *ArtChronika*. He is currently completing a dissertation in the Department of Comparative Literature at New York University. His research interests include Soviet cultural and intellectual history, theories of media and the everyday, and the intersections of contemporary art and visual culture.

Tarek Elhaik is an anthropologist, moving-image curator, and assistant professor of cinema at San Francisco State University. His interest in cinema and experimental media is informed by archival research on avant-garde film and the ethnography of curatorial laboratories in Mexico City, as well as previous work as a curator of Middle Eastern and North African cinema. He has curated numerous experimental film programs and published in many journals, including *Framework: The Journal of Cinema & Media*, *Roots-Routes: Research on Visual Cultures*, and *Revista de antropología social*.

Michèle Faguet is a writer and independent curator. As director of nonprofit exhibition spaces (Or Gallery, Vancouver; Espacio La Rebeca, Bogotá; and La Panadería, Mexico City), and as adjunct curator of the Alliance Française in Bogotá, she organized numerous exhibitions and coordinated the presentation of many new works by artists from Europe and the Americas. She taught critical theory at the Universidad de los Andes, Bogotá, and has been a visiting curator at the Banff Centre, Alberta, and a guest lecturer at the

Curatorial Practice program of California College of the Arts, San Francisco. In 2008 she received a grant from Creative Capital | Warhol Foundation Arts Writers Grant Program for her research on *pornomiseria*. She currently lives in Berlin and writes regularly for *Artforum*, *Art Agenda*, and *Afterall*.

Hou Hanru is a prolific writer and curator and a consultant to several international cultural institutions, including the Guggenheim Museum, New York; the Deutsche Bank Collection; the Times Museum, Guangzhou; and the Rockbund Art Museum, Shanghai. He was recently the director of exhibitions and public programs and chair of the Exhibition and Museum Studies program at the San Francisco Art Institute. Hou received undergraduate and graduate degrees from the Central Academy of Arts, Beijing, and has curated major biennials in Johannesburg, Shanghai, Gwangju, Venice, Istanbul, and Lyon. He is currently organizing the 5th Auckland Triennial, New Zealand. A guest editor for *Flash Art International*, *Yishu*, and *ArtAsiaPacific*, he is published regularly in books and contemporary art journals.

Tomoko Kanamitsu is an emerging curator, critic, and interaction designer. She holds an MA in Modern Art: Critical and Curatorial Studies from Columbia University, New York, where she co-curated the exhibition *Common Love, Aesthetics of Becoming* (2011) at the Wallach Art Gallery and co-organized the lecture series *Curating Time* (2010–11). She was curatorial intern at the San Francisco Museum of Modern Art for *Six Lines of Flight*.

Abdellah Karroum is an independent art researcher, publisher, and curator. He is the founder and artistic director of L'appartement 22 (www. appartement22 .com/site), an experimental space for encounters, exhibitions, and artists' residencies established in 2002 in Rabat, Morocco, and founder of Éditions Hors'champs, an art publishing collective established in 1999. In 2007, Karroum served on the jury for the Golden Lion at the 52nd Venice Biennale. In 2011, he curated *Working for Change*, a project for the Moroccan Pavilion at the 54th Venice Biennale, and he was associate curator of La Triennale 2012, Paris. He is currently artistic director for the Prix International d'Art Contemporain of the Fondation Prince Pierre de Monaco and curator of the 2012 Biennial Benin.

Pamela M. Lee is an art historian who specializes in the art, theory, and criticism of late modernism, with a historical focus on the 1960s and 1970s. Her publications include *Object to Be Destroyed: The Work of Gordon Matta-Clark* (2000), *Chronophobia: On Time in the Art of the 1960s* (2004), *Forgetting the Art World* (2012), and *New Games: Postmodernism after the Contemporary* (2012). Her work has appeared in *October*, *Artforum*, *Assemblage*, *Res: Anthropology and Aesthetics*, *Les Cahiers du Musée national d'art moderne*, *Grey Room*, *Parkett*, and *Texte zur kunst*, among other journals. She is a professor in the Department of Art and Art History at Stanford University.

Catalina Lozano is a curator and researcher whose interests and curatorial practice are focused on the revision of dominant historical narratives in contemporary art. Her recent exhibitions include *Modelling Standard* (2010) at FormContent, London; *Divan: Free-Floating Attention Piece* (2010) at the Freud Museum, London; and *¿Tierra de nadie?* (2011) at the Centro Cultural Montehermoso, Vitoria-Gasteiz, Spain. Between 2008 and 2010 she was responsible for the Gasworks International Residency Programme in London. Lozano has a degree in history from the Universidad Nacional de Colombia, Bogotá, and an MA in visual cultures from Goldsmiths College, London; she is a PhD candidate at the École des Hautes Études en Sciences Sociales, Paris. She cofounded de_sitio, a curatorial platform in Mexico City.

Mihnea Mircan is the artistic director of Extra City Kunsthal, Antwerp, Belgium, where he organized the exhibitions *A Slowdown at the Museum* (2011) and *1:1: Hans van Houwelingen and Jonas Staal* (2011–12). Other curatorial projects include *History of Art, the* (2010) at the David Roberts Art Foundation, London, and *Image to be projected until it vanishes* (2011) at Museion, Bolzano, Italy. Mircan curated the Romanian Pavilion in 2007 at the 52nd Venice Biennale; the group exhibition *Since we last spoke about monuments* (2008) at Stroom Den Haag, the Netherlands; and *Under Destruction* (2004–5), a series of site-specific interventions at the Muzeul Național de Artă Contemporană (National Museum of Contemporary Art), Bucharest. He has contributed to monographs of the artists Pavel Büchler and Nina Beier, as well as to *Mousse* magazine and *Manifesta Journal*.

Christian Nagler is a writer, translator, and performer, and his articles and essays have appeared recently in *Fillip*, *Aufgabe*, and the book *Somatic Engagement* (2011). In spring 2012 he was an artist in residence at the Headlands Center for the Arts, Sausalito, where he conducted his ongoing project *Market Fitness*, an experiment in the pedagogy of global finance. He is working on a novel and a book of essays.

Sarah A. Rogers received her PhD in 2008 from the History, Theory, and Criticism program of the Department of Architecture at the Massachusetts Institute of Technology; her dissertation is titled "Postwar Art and the Historical Roots of Beirut's Cosmopolitanism." Her research on modern and contemporary art of the Arab world has been published in *Parachute*, *Arab Studies Journal*, and *Art Journal*. Rogers is a founding member and president-elect of the Association for Modern and Contemporary Art of the Arab World, Iran, and Turkey (AMCA). She is currently editing a collection of essays on the Khalid Shoman Private Collection.

James M. Thomas is completing a dissertation in the Department of Art and Art History at Stanford University that explores the intersections between experimental design and architecture of the early 1970s and research conducted by NASA during the Apollo spaceflight program. He was assistant curator and managing editor of publications for the 2nd Seville Biennial and the 7th Gwangju Biennale and served as executive editor of *Intense Proximity: An Anthology of the Near and the Far* (La Triennale 2012). He is currently the Chester Dale Fellow at the Center for Advanced Study in the Visual Arts at the National Gallery of Art, and was previously a Guggenheim Predoctoral Fellow at the National Air and Space Museum. He is based in San Francisco and Washington, D.C.

Xiaoyu Weng is a curator and writer based in San Francisco. She has organized exhibitions and events for San Francisco venues such as the Wattis Institute for Contemporary Arts at California College of the Arts, Yerba Buena Center for the Arts, the Kadist Art Foundation, and Queen's Nails Projects, as well as for the Minsheng Art Museum in Shanghai. She was awarded a residency by the Gwangju Biennale Foundation in South Korea in 2010. She won the

Artforum Critical Writing Award in 2011, and she has contributed to *Artforum* online; *Leap: The International Art Magazine of Contemporary China*; *Contemporary Art and Investment*; and *Art World Journal*. Weng is director of the Asian Contemporary Arts Consortium and the Asia programs of the Kadist Art Foundation, both in San Francisco.

Dominic Willsdon is the Leanne and George Roberts Curator of Education and Public Programs at the San Francisco Museum of Modern Art. From 2000 to 2005, he was curator of public events at Tate Modern. He has taught at the Royal College of Art, London; California College of the Arts, San Francisco; and the San Francisco Art Institute. He is a former editor of the *Journal of Visual Culture* and co-editor of *The Life and Death of Images: Ethics and Aesthetics* (2008).

Postcards of War, from the project
*Wonder Beirut, the Story of a
Pyromaniac Photographer*, 1997–2006
Eighteen original postcards,
each 4 ⅛ × 5 ¾ in. (10.5 × 14.7 cm)
Courtesy the artists and CRG Gallery,
New York
pls. 23–40

*Wonder Beirut #1, Greetings from
Beirut*, from the project *Wonder Beirut,
the Story of a Pyromaniac Photographer*,
1997–2006
Chromogenic print mounted on aluminum,
27 ¾ × 41 ½ in. (70.5 × 105.4 cm)
Collection of Dolly and George Chammas
pl. 41

Wonder Beirut #15, Rivoli Square, from
the project *Wonder Beirut, the Story of a
Pyromaniac Photographer*, 1997–2006
Chromogenic print mounted on aluminum,
27 ¾ × 41 ½ in. (70.5 × 105.4 cm)
Courtesy the artists and CRG Gallery,
New York
pl. 42

Wonder Beirut #21, Beaches in Beirut,
from the project *Wonder Beirut,
the Story of a Pyromaniac Photographer*,
1997–2006
Chromogenic print mounted on aluminum,
27 ¾ × 41 ½ in. (70.5 × 105.4 cm)
Collection of Dolly and George Chammas

Lamia Joreige
Lebanese, b. 1972

Beirut, Autopsy of a City, 2010
Mixed-media installation,
dimensions variable
Commissioned by Mathaf, Doha, Qatar
Courtesy the artist
pls. 48–53

Dinh Q. Lê
Vietnamese, b. 1968

The Locust, 2008
Chromogenic print and linen tape,
45 ½ × 89 in. (115.6 × 222.1 cm)
San Francisco Museum of Modern Art,
Accessions Committee Fund purchase
pl. 205

Sound and Fury, 2012
Three-channel video installation, color,
sound, 10 min.
Courtesy the artist; Shoshana Wayne
Gallery, Los Angeles; PPOW Gallery,
New York; and Elizabeth Leach Gallery,
Portland, Oregon
page 5, pls. 206–35

Victor Man
Romanian, b. 1974

Untitled (The Lotus Eaters), 2009–11
Oil on canvas, 86 ¼ × 126 in.
(219.1 × 320 cm)
Courtesy the artist and Gladstone Gallery,
New York
pl. 174

A.D., 2011
Oil on canvas, 13 ¾ × 18 ⅛ in. (35 × 46 cm)
Courtesy the artist and Plan B, Cluj/
Berlin

Untitled (Judith and Holofernes), 2011
Oil on canvas, 39 ⅜ × 26 ⅜ in.
(100 × 67 cm)
Courtesy the artist and Gladstone Gallery,
New York
pl. 16

Untitled (portrait of S.D.), 2011
Oil on canvas, 20 ¾ × 16 ¾ in.
(52.7 × 42.6 cm)
San Francisco Museum of Modern Art,
Accessions Committee Fund purchase
pl. 175

Virgács (St. Nicholas), 2011
Oil on linen mounted on panel,
13 ⅜ × 18 ⅛ in. (34 × 46 cm)
San Francisco Museum of Modern Art,
promised gift of Mary Zlot
pl. 176

Untitled (E.O.P), 2012
Oil on canvas, 11 ¹³⁄₁₆ × 15 ¾ in.
(30 × 40 cm)
Courtesy the artist and Plan B,
Cluj/Berlin
pl. 2

Untitled, 2012
Oil on canvas, 9 ¹³⁄₁₆ × 6 ¹¹⁄₁₆ in.
(25 × 17 cm)
Courtesy the artist and Gladstone Gallery,
New York

Carlos Mayolo and Luis Ospina
Colombian, 1945–2007
Colombian, b. 1949

Agarrando pueblo (aka *The Vampires
of Poverty*), 1978
16mm film transferred to video, black and
white and color, sound, 28 min.
Courtesy Luis Ospina
pls. 155–57

Oscar Muñoz
Colombian, b. 1951

Narcisos secos (Dry Narcissi), 1994
Charcoal powder on paper and Plexiglas,
nine drawings, each 28 × 28 × 1 ⅛ in.
(71 × 71 × 3 cm)
The Museum of Fine Arts, Houston; gift
of Leslie and Brad Bucher, Dr. Luis and
Cecilia Campos, Mary and Roy Cullen,
Margaret C. and Louis Skidmore, Jr.,
Samuel F. Gorman, Frank Ribelin, Frances
and Peter C. Marzio, Dr. and Mrs. Miguel
Miro-Quesada, and Dr. Don Baxter at the
Latin Maecenas Gala Dinner, 2003
pl. 147

Haber estado allí (Having Been There),
2011
Charcoal powder on acrylic, four pieces,
each 28 ¾ × 33 ½ in. (73 × 85 cm)
Courtesy the artist; La Fábrica Galería,
Madrid; Galerie Mor · Charpentier, Paris;
and Sicardi Gallery, Houston

Horizonte (Horizon), 2011
Single-channel video, black and white,
sound, 17 min.
Courtesy the artist; La Fábrica Galería,
Madrid; Galerie Mor · Charpentier, Paris;
and Sicardi Gallery, Houston
pl. 150

Horizonte (Horizon), 2011
Charcoal powder on acrylic, four pieces,
each 33 ½ × 28 ⅞ in. (85 × 73.5 cm)
Courtesy the artist; La Fábrica Galería,
Madrid; Galerie Mor · Charpentier, Paris;
and Sicardi Gallery, Houston
pl. 14

Untitled, from the series *El testigo*
(The Witness), 2011
Charcoal powder on acrylic, two pieces,
dimensions variable
Courtesy the artist; La Fábrica Galería,
Madrid; Galerie Mor · Charpentier, Paris;
and Sicardi Gallery, Houston
pls. 148–49